SUBMERGED

Other books by Daniel Lenihan

Wake of the Perdido Star (with Gene Hackman)

Underwater Wonders of the National Parks (with John Brooks)

The Shipwrecks of Isle Royale National Park:
The Archeological Survey (Editor)

SUBMERGED

Adventures of America's Most Elite Underwater Archeology Team

Daniel Lenihan

Newmarket Press
New York

Chapters 5, 6, 12, and 18 appeared in different versions in *Natural History*.
Chapter 17 appeared in part in *American History*.

This book is published in the United States and in Canada.

First Edition

10 9 8 7 6 5 4 3 2 1

Library of Congress Cataloging-in-Publication Data

Lenihan, Daniel.
Submerged : adventures of America's most elite underwater archeology
team / by Daniel Lenihan.
p. cm.
ISBN 1-55704-505-4
1. Underwater archaeology—United States. 2. United States. National
Park Service. Submerged Cultural Resources Unit. 3. Marine archaeolo-
gists—United States. 4. United States—Antiquities—Collection and
preservation. 5. Excavations (Archaeology)—United States. 6. Ship-
wrecks—United States. 7. Treasure-trove—United States. I. Title.
E159.5 .L46 2002
930.1'028'04—dc21
2001007967

3/21/02 OCLC 930.1
Len

QUANTITY PURCHASES
Companies, professional groups, clubs, and other organizations may qualify
for special terms when ordering quantities of this title. For information,
write Special Sales Department, Newmarket Press, 18 East 48th Street, New
York, NY 10017; call (212) 832-3575; fax (212) 832-3629; or
e-mail mailbox@newmarketpress.com.

www.newmarketpress.com

Manufactured in the United States of America.

The opinions expressed in this book are solely those of the
author and do not necessarily reflect the official position of the
National Park Service, the U.S. Department of the Interior, or
the U.S. government.

Table of Contents

PART I
Caves, Dams, Shipwrecks, and Dreams

PART II
The SCRU Team

PART III
Reaching Out

To Calvin R. Cummings

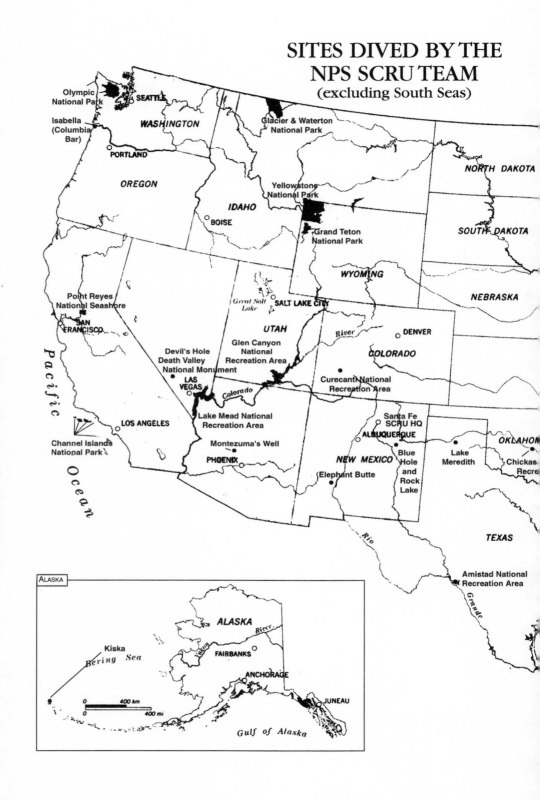

SITES DIVED BY THE
NPS SCRU TEAM
(excluding South Seas)

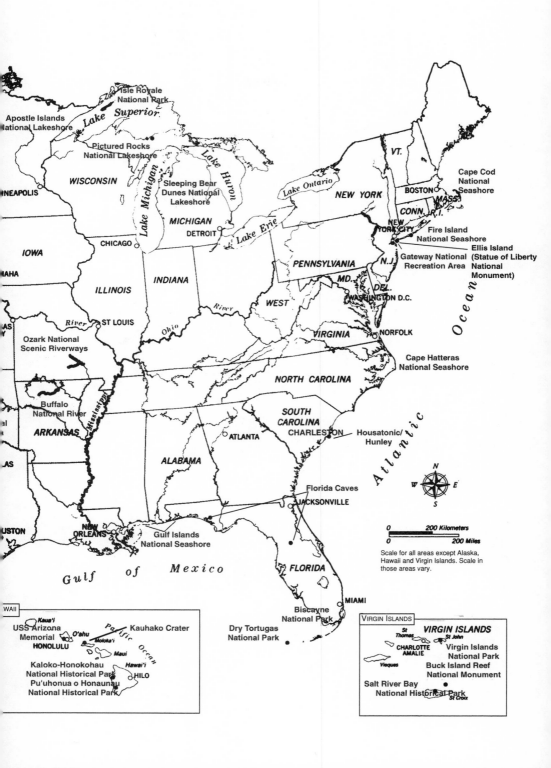

SUBMERGED

PART I
CAVES, DAMS, SHIPWRECKS, AND DREAMS

A passion for extreme diving combines with a
vocation as a Park Ranger/Archeologist. Diving caves in
Florida and Mexico and shipwrecks in the frigid water
of Lake Superior and behind dams in the desert southwest
hone the skills needed to form a permanent cadre of
underwater archeologists in the National Park Service:
The Submerged Cultural Resources Unit or "SCRU Team."

CHAPTER ONE
FOR WHOM THE HORN WAILS

———✦———

The foghorn from the Rock of Ages light at the southern end of Isle Royale National Park wails ominously every five seconds. Its usual dreamy quality is strangely foreboding, oppressive this afternoon. There is no fog about our boat, though the lighthouse is shrouded with wisps of Lake Superior mist. Patches of sunlight play over the glass-calm water surrounding five National Park Service divers grouped on the fantail of the thirty-eight foot motor vessel *Superior Diver*. The date is June 15, 1982. No one speaks as we intently study the emerald-green expanse of Lake Superior from the stern of our anchored vessel. No flicker of movement, no slick undulating circle disturbs the verdant glass—nothing that would indicate the presence of a diver's bubbles boiling to the surface. They are late . . . very late, and unspoken fear is tangible. The rising tension has become a sixth member of the team gathered on the deck.

A stopwatch suspended to a clipboard at the divemaster station ticks relentlessly. The mundane instrument has suddenly assumed an unprecedented degree of importance. If the ticking isn't an indicator that hope is fleeting fast, the foghorn's plaintive wailing leaves no room for doubt.

I am conscious of a faint slapping against the hull from the wake of a passing boat, and the damp smell of lake water steaming off the recently doffed neoprene dive suits lying on the deck. Body heat, a sign of life; it's not hard to make a connection to the two suits still more than one hundred feet below in the thirty-four degree lake water.

Lake Superior is not the Caribbean—it is cold, harsh, and extracts heavy penalties for even small mistakes. I have dived over the hulks of many ships that have felt its power, when its explosive temper had

3

turned the placid lake surface into a raging cauldron of foam and freezing spray. Twisted steel and smashed wood mingled at the bottom with the toys of children, bodies of sailors—it is the story we are here to tell. Our task is to unravel the archeological residues of the human dramas that played out in these waters and match them to the written records of the past.

Below us lie the casualties that resulted from the pursuit of great profits in the industrial hotbed of the Great Lakes at the turn of the twentieth century. One more voyage, just one more capital-driven run, taunting the gales of November. How easy it is for us, swimming over the cadavers of ships through silent depths, ice water in our veins, to relate to the victims of disaster; archeology and history had come alive to us on this lake. Now two of our people, like many a Great Lakes ship, had "gone missing."

Our divers are meticulous about tracking their bottom time—the period from leaving the surface until the return to the decompression area, a place under the boat that serves as a safe haven. Here they can switch from air tanks on their backs to breathe pure oxygen from regulators attached to long hoses suspended from large green cylinders strapped to the deck; they have unlimited time to slowly complete a safe ascent.

Before they had exceeded their planned arrival time by a full minute, the surface spotter registered enough concern that others began gathering around him, peering into the distance and checking the clipboard notation of the divers' descent time. When I heard the shuffling of feet and spied the hunched-over form heading toward my bunk, I was already getting my shoes on. The voice inflection of the crew, lack of an undercurrent of banter, and sudden muting of the Waylon Jennings tape alerted me that something was wrong as effectively as an alarm bell.

During the previous decade supervising hazardous diving operations, I had occasionally wondered how I might react to losing a member of my team. I find now that part of my consciousness is operating at warp speed, looking for solutions, while another part stifles images of drowned divers that, unbidden, keep trying to emerge from my memory.

Seconds later, I become strangely detached, reflective. I notice little things, like Jerry Livingston's hands. Our diving illustrator has

strong sensitive hands, those of an artist. Where he leans on the rail, his knuckles are starkly white. He has spoken not a word but his hands tell it all: He thinks they're in serious trouble. If this lake were a forgiving place, we wouldn't be here, anchored off Isle Royale, diving on the broken hulks of ten large ships. Archeologists seldom get to pick where they will dive but almost by definition the area won't be benign.

Ironically, nothing has occurred that would signal a casual observer that we have a problem. No distress calls, no evidence of an accident, but the lack of any sign of the dive team as each precious minute ticks away is a chilling testament that the potential of a tragedy is fast becoming a probability.

Larry Nordby, the blond Viking of a land archeologist who has become a regular on our expeditions, crosses and uncrosses his arms, repeatedly exhales loudly through his nose, and raises his eyebrows in a this-isn't-happening look when he catches my eye. I know exactly what is going through his mind. Less than four months earlier, he was on the back deck of a park patrol boat in Texas as we surfaced with a lost diver. He's remembering now how it felt, as we handed up the stiff, lifeless body for him and another ranger to pull into the boat. He's thinking, I didn't even know that fellow and these are my friends.

Whatever has happened, the responsibility ultimately rests with me. But there will be time for self-recrimination later. I keep going over the possible scenarios that would result in my divers not being back beneath the boat at the decompression stop, more than forty minutes after their descent. Their maximum depth was to be 120 feet, the absolute limit of their discretion for bottom time, thirty minutes. Even the thirty minute exposure would mean they could no longer come straight to the surface. Both divers must decompress in increments at twenty and ten feet to release excess nitrogen. They are essentially diving under a ceiling, an invisible ceiling they can't pass through unharmed.

But John and Toni are disciplined divers; they don't make mistakes like this. They had a long underwater swim to the drop-off, much of it through shallows. Maybe the unusual topography has thrown off their timing . . . I know I'm grasping at straws.

In the Great Lakes, 120 feet is deep. Much deeper than 120 feet in the Bahamas from whence John Brooks had come to join our project. A skilled underwater photographer, he is experienced at greater

depths in the tropics: clear, turquoise water, where oppressive cold doesn't freeze equipment, savage one's exposed skin, and conspire with the frigid gloom to create a sense of menace that increases in lockstep with depth. John freely admits that the nitrogen narcosis affects his mental acuity here much more severely than it does at identical depths in the Caribbean. He is not alone; it is our third season here, and the rest of us have simply had more time to acclimate.

Then, there is our (my) decision to use "dry suits," which utilize air rather than a thin film of water, as do wetsuits, for insulation against the teeth-cracking cold. They keep you much warmer but there's a tradeoff. Even the newest versions in 1982 are capable of overinflating and sending you in a rush of bubbles, inverted and uncontrolled, toward the surface—something you definitely want to avoid. Lungs can overexpand as pressure drops. Tissue can rupture, allowing air to rush into the bloodstream creating an embolus, or blockage of blood supply to the brain. The effect is much like a massive stroke, resulting in paralysis or death. Because of this "Polaris syndrome" as our divers grimly refer to it, some agencies had banned the use of dry suits.

But no one is on the surface, no bubbles in sight. What the hell has happened? One of them could have gone through an uncontrolled ascent and embolized, but two? Even in that event, they would still be visible from the boat, unless they hit the surface unconscious, vented, and dropped—but the divemaster would have seen this. Maybe they experienced heavier narcosis or gas problems if the drop-off was deeper than anticipated—but two at the same time?

John's dive partner is Toni Carrell, who has been with SCRU since its inception. In her mid-thirties, she is well-trained, in good physical shape, experienced in cold water but has only minimal practice with deep diving. She is also a single mother with two children; it's her birthday and she's out there because I sent her.

Someone can chase after them, but with no clue where to look, he or she could quickly become part of the problem. Also, all of us have accumulated a nitrogen load from dives this morning that would make us even more likely candidates for a third accident.

"Whaddya wanna do, Dan?" Larry Sand, the boat operator, has edged out onto the deck. His voice is low, tight in his throat.

"Wait."

He indicates with a hitchhiking motion of his thumb a thick blanket of fog moving in from behind us, off the bow. "White-out coming."

"Jesus."

I can't send in a search team now without an added complication.

Ordinarily, divers following our underwater baseline back to the boat over the quarter mile jumble of wreck timbers wouldn't be bothered by the occurrence of the thick fog. But it would be different for rescuers who would have to stray far from the reference lines in search of lost divers. Sound carries well in fog, much as in water; but also as in water, it's almost impossible to tell where it's coming from. Stressed divers fifty feet away in a white-out might not be found until they had succumbed to hypothermia. In fifteen minutes our day has turned from the routine of research diving to the gut-wrenching throes of accident management.

Goddamn time! That's what's so desperate about the scene of a lost diver compared to other rescue endeavors. No gathering the troops, no reassuring smell of hot coffee, the crinkle of topo maps spread on engine hoods of police cruisers, the knowledge that "helo" support, search dogs, and fresh faces are on the way. No "Houston, we have a problem," and a world-class infrastructure of modern technology leaping in to help. We have only ourselves and time—very little time before their air runs out. Just minutes ticking away with any hope we have; we are it and we have run out of ideas.

More silence, more ticking, more horn blares. Suddenly, we hear a distinct sizzling, then foaming of bubbles far to the left of where we'd been looking. And then, from across the water we hear finally, a male voice: "Is she there?"

John is alive, and all right; we know it from the way he sounds—maybe with a latent case of the bends, but a survivor. But from his words we know that the team is separated and that Toni, less experienced in deep diving, is still unaccounted for.

A suited surface swimmer goes to assist John, but he waves him off. Even through the neoprene hood and glass face mask covering much of his head, John's expression registers the stress of his emotions. His voice is strained, husky. "I'm okay—Christ, she's really not here?"

John is several minutes short on decompression, but he decides it

is worth the risk of not finishing his required stop to fill us in on what happened—to feel like he is helping in some way. Back on board, he shows no symptoms of decompression sickness, but we place him on oxygen to help purge excess nitrogen from his system. Before donning the respirator mask he tells us what he knows. While they were taking photos, Toni swam off on a misunderstood signal; he had no idea how far she had gone or in what direction. In searching for her he had gotten lost himself and overstayed his time.

I am the freshest diver in the group. I reach for my suit. "I'm going in."

Larry Sand says softly, almost under his breath, "You don't find her, she's dead. You find her it's only cause she's dead anyway—let's wait."

"Cold-water drowning," I say.

He understands my meaning, but he just shrugs. Sand knew that people can be revived after as much as an hour in cold water without brain damage. However his gesture serves as a dismissal, eloquent in its simplicity, of the merit he sees in looking for a corpse to resuscitate. Toni will either make it back on her own or she won't make it. The young boat skipper was raised on the Lakes and is speaking from wisdom beyond his years. But inactivity is no longer possible for me to accept; I am ready to leap out of my skin. "I'm going in," I repeat, and start to suit up. I hear Nordby breathe a sigh of approval. He doesn't disagree with Sand, but, like me, he just can't handle the waiting.

Suddenly, another flurry of bubbles and Toni's head pops to the surface, much closer to the boat than had John's. She calls breathlessly, "John, is he here?" The blanket of tension evaporates like fog in a sunburst. Loud voices booming in response from the crew reveal the strain of the last twenty-five minutes.

Toni's voice is choppy, like someone trying to speak loudly while shivering uncontrollably. Our anxious hands drag her almost too roughly onto the dive platform, as if we are afraid the lake will reclaim her if we don't snatch her from its icy grip. We gather from her staccato commentary through blue lips and chattering teeth that she had been able to decompress in open water after becoming lost. She had held her buoyancy stable for twenty minutes with no line to grasp onto until she completed venting excess nitrogen. The splotchy sun-

then-fog lighting conditions we had been experiencing probably precluded any of us from seeing her bubbles. She is shaken but unhurt.

My suddenly rubbery legs carry me below where I sit on my bunk. Toni is all right, John is all right; we'll unravel the details later. The fog bank has missed us, and the sun is brighter than ever. The rest of the team begins preparations for another dive. Out a side window in the V-berth I spy the green jeans of one of our rangers. He is hunched over, face in his hands, out of sight of his comrades on the fantail. He is sobbing. I know how he feels. Unlike his, my eyes are dry—so is my mouth. I don't trust myself to be around the others right now.

No one died on this dive; no one was seriously injured. It was one of thousands of dives I would supervise or take part in over the course of my career. No one did anything particularly foolish, no strict diving protocols were broken, but there was no doubt in anyone's mind that events had begun snowballing toward a fatality. What was most harrowing to me about the experience was that we did nothing to create the problem and we did nothing to solve it. I had no control over the outcome of that incident at any point. That snowball had, through good fortune, stopped on its own before it had rolled us up into a tragedy.

I had always been wont to say that good divers make their own luck, that fortune is in our hands. Even though well before that day on Lake Superior I had felt the loss of friends and retrieved the bodies of fellow divers on numerous occasions, I always felt with certainty that it would never happen to me or those diving under my supervision.

Now, anytime I feel that overwhelming sense of confidence and hubris in our preparations for a dive, even two decades later, humility comes easier. I tend to hear the distant echo of a foghorn at Rock of Ages light in Lake Superior.

CHAPTER TWO

SCRU

F or twenty-five years I led a group of National Park Service
divers with a unique mission. My handpicked cadre of archeol-
ogists and technicians were charged with finding and preserv-
ing historic shipwrecks and other sites important to American
heritage in U.S. Parks and territorial waters. Officially designated the
Submerged Cultural Resources Unit, it was quickly dubbed the
"SCRU team" in the parks.

Formally declared a permanent entity in 1980, SCRU evolved
from a five-year pilot project called the National Reservoir Inunda-
tion Study (NRIS) that began in 1975 in the Southwest. The program
was born within the Park Service and heavily influenced by the
agency's philosophy regarding archeological remains: They are non-
renewable public resources and should be removed from where they
lay with only the strongest of justifications. Because of the inherent
dangers in our profession and the intense pressure exerted on ship-
wrecks from commercial treasure-hunting interests, our efforts
evolved into a crusade—one that came to involve serious risk and un-
expected rewards.

During the span of years that SCRU has operated, peace was de-
clared in Vietnam, war declared in the Gulf, AIDS came, the Cold
War went, bombs killed smartly, and we all became worried about
computer viruses. This is a retrospective on a special group of people
who kept focused on the preservation of a little piece of the world
during these turbulent times. It is also a personal story—after a quar-

ter century at the helm of the organization our destinies became in-
tertwined.

The SCRU team still dives today although at the turn of the mil-
lennium it became the Submerged Resources Center—leaving us to
mourn the loss of one of the finest acronyms in government. Happily,
that is all we have to mourn. At this writing, the team has never suf-
fered a serious diving-related injury. This is a record of which we are
proud but which we know could change any moment. Although the
exploits of this team often equaled those of people involved in ex-
treme diving, climbing, and caving, the driving force was not con-
quest, or "because it is there." I can relate to such motives personally
but not in my role as head of SCRU.

Rather this is a recollection of adventures, triumphs, failures, and
close calls of a tightly bonded group of divers in the context of a seri-
ous research program. The scientific, historic preservation, and pub-
lic service goals were as real as the danger that attended them.

Because we were expected to work on short notice in the full
range of diving environments present in the National Park System
(including deep, cold, and under ceilings in caves and shipwrecks), I
felt compelled to select personnel that had not only the credentials of
archeologists, illustrators, or photographers but people who were ex-
ceptionally good divers. They had to be ready on short notice to shed
lightweight diving "skins" appropriate to the warm, clear waters of
Florida to board a plane and confront an entirely different set of chal-
lenges.

They might rendezvous with their bulky dry suits, heavy double
cylinders, and deep/under ceiling dive gear that had been air-
freighted to places like Alaska, Lake Superior, or Crater Lake. They
might leave sea-level diving one day at Cape Cod and arrive two days
later to dive in risky high-altitude environments such as Yellowstone
Lake at an elevation of 8,000 feet. There, the danger of bends esca-
lated, and the water dropped to almost freezing within fifty feet of the
surface.

Then, to add to the unique calling of this group, there was the
dual nature of their mission as ranger/archeologists. When they com-
pleted a research diving task off the coast of California, they might
have to rush back to a reservoir in the desert Southwest where their
special skills were needed to help execute the difficult recovery of a

victim of drowning. Such events forced them to switch psychological gears as quickly and definitively as they switched diving equipment. They were expected to behave as archeologists in ranger uniforms in the presence of other researchers and to serve as rangers, who happened to also be archeologists, when the mission turned to one of rescue or law enforcement rather than research.

But why all the fuss about historic preservation? What of the romantic lure of treasure? What is underwater archeology? Is there a difference between harvesting antiquities for profit and doing it for science? Are old shipwrecks and prehistoric artifacts going to rot away down there if we don't get them up for people to enjoy? To understand SCRU, it will be necessary to answer these questions. As we recount the team's adventures over the course of this book, the answers should become clear.

Perhaps it would be most useful to begin with the observation that neither I nor any other member of SCRU was born a preservationist. I decided to stop being a schoolteacher and go to graduate school in anthropology at Florida State not because of a scholarly lust for knowledge or commitment to protection of archeological sites. Rather, it was because I thought I might eventually find a job in which someone would actually pay me to dive a lot and to look for old treasures underwater.

Mark Twain wrote in *Tom Sawyer*, "There comes a time in every rightly constructed boy's life when he has a raging desire to go somewhere and dig for hidden treasure." I certainly am not immune to that desire.

Even as a child growing up on the Lower East Side of New York City in the 1950s, I was fascinated by stories of sunken ships of gold under the ominous tidal swirls of the East River. When I first ventured beneath the water's surface in the late 1960s, I found my hands attracted like magnets to anything old and mysterious, regardless of value.

I found old bottles in the Virgin Islands and War of 1812 cannonballs in the Patuxent River off my backyard in Maryland. Even my Labrador retriever was an inveterate artifact hunter in those days. He

once showed up on the porch, sopping wet and muddy from a foray along the riverbank, clutching an old bayonet in his mouth. It must have been dropped by a British soldier on his way to torch Washington, D.C., during the War of 1812.

When I arrived in 1970 at Florida State to study anthropology, I spent my weekends exploring water-filled sinkholes and river bottoms, often diving alone and with an ethic regarding artifacts only slightly more sophisticated. By that time, I had come to believe the mastodon bones and projectile points I regularly stumbled across in my dives should be part of our collective heritage and not pilfered— so what was wrong with grabbing up these treasures and taking them to a museum or university? I would be greeted as a hero! Not exactly.

In one of the thousands of "sinks" in the limestone Swiss cheese that comprises the Florida karst, I saw a particularly interesting display of archeological stratigraphy. Groundwater mixes with surface water in the "River Sinks" area of Tallahassee, producing the classic case of a river moving under the earth, then bobbing to the surface briefly, before dropping away again. I descended eighty feet into a large, cavernous opening of a sinkhole that was the siphon end of a spring-siphon system.

On this crisp autumn day, the water in River Sink was clear with a dark green tinge, so I was startled all the more by a contrasting flash of bright yellow off to my right. Yellow is one of the first colors of the spectrum to filter out as water gets deeper; eighty feet from the surface it is nonexistent in ambient light. But I was carrying an artificial spectrum in the form of a dive lamp, and its beam had chanced across something metallic yellow.

Moving closer to investigate, my nitrogen-laden mind sluggishly sorted out the identity of the mysterious feature. It was a newspaper vending machine, upside down in the silt. A few feet away and further downslope was another and not far from that one, yet another. The Star Trek sense of discovery that accompanied me on these lonely dives in backwoods sinkholes was momentarily shaken.

I noticed between the angle iron legs of the first box of soggy *Tallahassee Democrats* another man-made feature. Perhaps an old pail, it was barely extruding from the organic silt that had begun to settle on the boxes. Obviously it had been here longer than the newsstands.

I reached down to give it a tug, and my hands told me what my

eyes hadn't: this wasn't an old pail, it was an old ceramic pot. In fact it was a very old ceramic pot. Back in the anthropology lab at FSU, the ceramic wizards declared it "Wakulla check-stamped," a local type of prehistoric pottery. It had been sitting there for two millennia until it was unceremoniously joined by the *Tallahassee Democrat* dispenser, several soft drink bottles, and a can of Busch Bavarian beer.

The geological and human processes that occasioned the creation of such artifactual assemblages were the source of considerable interest to me. The newspaper vending machines were there because sinkholes are excellent places to quickly and quietly dispose of things you don't want found. The upsurge of diving in the area was causing certain inconveniences to the region's criminally inclined, and not just vending machine vandals. Leon County sheriff's deputies, alerted by sport divers, were pulling stolen cars and occasional bullet-ridden human bodies from some of the more popular sinkholes.

The angle of repose of sediment in a sinkhole could create bizarre associations of modern-day felons and thousand-year-old victims. In some places, the human remains were dating to mind-boggling ages of ten thousand years ago. And it wasn't a few nondescript slivers of long bone or a possible carpal that were the prizes waiting to be found. Warm Mineral Springs in Florida produced a human cranium with brain material in it predating the rise of Egypt.

No, I wasn't greeted as a hero for bringing the pot to the FSU lab. I was given a corner of a table to document the find, a form to fill out, and a lecture on the inadvisability of moving artifacts from context, particularly if I intended to get my masters in anthropology from Florida State. I learned the hard way that one doesn't remove artifacts without stringent controls nor bestow them as "gifts" on institutions not prepared to cope with them.

The stern voice of Professor Percy, whose finger was pointed in my face, asserted that carefully documenting the precise location could have determined if this pot was a primary, intentional deposition, or a secondary wash-in from surface runoff. Samples of the surrounding sediment could have been dated and residues in the pot that I had conscientiously "cleaned" could have revealed the function of the pot. Careful, painstaking removal of the edges of the broken bottom of the ceramic vessel could have determined if the pot had been broken from some mundane use or ceremonially "killed" as a sacri-

fice. The nature of the silt on the pot as opposed to that covering the newspaper machines was important, and by the way, what was the date of the newspapers?

"You're kidding, the date of the newspapers?"

"Ever consider that you had a tight control of how fast sedimentation occurs in River Sink with a dated, flat receptacle gathering silt like a laboratory experiment?"

"No."

Even the different layers of sediment caught in curves of the pot could have been microscopically examined for pollen to reconstruct the prehistoric micro-environment and contribute to our understanding of regional climate changes over the past two thousand years. The list went on and on. In short, I had behaved like an idiot. I had removed a trinket that might have fetched a few bucks on the antiquity market—but archeologically, my moving it made it next to worthless for unraveling any mysteries of the human past.

I would learn later that shipwrecks were even more powerful archeological sites. They were discrete collections of artifacts from particular cultures at a specific point in time. They offered a snapshot of the whole range of shipboard life. They told about trade, fishing, warfare, social stress, play, community life, personal hygiene, and even sexual preference. They did, that is, unless you fooled with them.

Over the years working with the past in a park setting, I learned that we are diminished in a very real way when we lose a piece of the puzzle from its natural resting place. But relics tell us on more than one level about our roots—not only what we can intellectualize but what we can comprehend in a much deeper sense.

The maritime and naval history of the United States is a compelling story as gleaned from a combination of the written record and archeology. But once the relics have been passed through the hands of the best technicians and displayed in the finest museums and once the historical records have been digested and passed through the heads of the finest historians, there is still an element of distance.

But that distance disappears when one journeys to the depths. Playing one's light over the twisted remains of hull, the encrusted muzzles of cannon, the gleam of bronze fasteners emerging from wooden beams, while hearing only the sound of air rushing into your

lungs—that is a bridge to the past that can be found nowhere but in the natural museums under the sea.

My conviction, which has emerged from thirty years of diving, is that shipwrecks and underwater caves are places where one can touch the past in the most special of ways. SCRU embodied the principle that respecting the past underwater is not a luxury—it's a necessity.

Our mission didn't carry the urgency of a researcher creating a new vaccine or a cure for cancer or a successful experiment in creating cold fusion—one has to have perspective. But once the wars are fought and the crises of the moment addressed, we still have the human race trying to comprehend itself. We look to our roots, some in literature, some in the ground, some of the most dramatic on the bed of the sea. Our past is writ large there in shipwrecks, ancient projectile points, ceramic pots, and newspaper vending machines. These artifacts are part of our world, a shrinking world, the only world we've got.

THE FLORIDA CAVES

⟶ ∿∿∿ ⟵

If there is one place that archeology and extreme diving, two signature elements of the Submerged Cultural Resources Unit, come together, it is in the Florida caves. Due to a fluke of geomorphology, the underwater caves that compose the Florida "karst" hold the potential for archeological and paleontological finds of great significance.

The process is pretty much the same in all these karst areas—karst being a type-name for this sort of geology taken from a plateau in Yugoslavia. Vegetation grows rampant in the soils of the Southeast, given the moist, warm climate. When leaves fall and vegetation dies, it piles thick on the limestone mantle and decays. When rainwater is added, a mild solution of carbonic acid results, which, given thousands, sometimes millions of years, eats away the porous sedimentary limestone base. Eventually water follows fractures and weak spots in the rocks and makes underground rivers, some quite near the surface. In most dry caves the solution is still trickling in or has ceased. In Florida where the water table is so shallow, the caves still have the solution in them.

And sinkholes? Visualize a water-filled cave running thirty feet underground when the overlying weight causes it to collapse at a weak point. Voilà, sinkhole! The process is gradual but not so slow that sinkholes don't still make headlines in Florida when roadways and houses suddenly disappear. Nothing like a dynamic landscape to keep one humble and, in my case, absolutely enthralled.

Sea level changes during the last period in the Ice Age resulted in

17

a Floridian peninsula much larger and different in climate than today. Human inhabitants of the region 10,000 years ago had exciting company—a time of big elephants, small horses, and saber-toothed cats. Owing to a drier and cooler climate, the attraction to the freshwater sources in the Florida springs was great. The water surface in the springs and sinkholes had dropped with the sea level, and the chances of falling in and drowning were increased. What was misfortune for late-Pleistocene megafauna and early man was a bonanza for scholars of the past; total freshwater immersion followed by siltation makes ideal conditions for preservation. A few archeologists had already realized that potential by the early 1970s, and startling finds had been made at Wakulla Springs, Warm Mineral Springs, and other karst features in Florida—more were soon to come.

I had never seen a sinkhole before moving to Florida, and had but few times set foot inside a cave. The fact that mini–Carlsbad Caverns exist all over the state was unknown even to many who lived there. There are places where superhighways rushing people to Disney World are passing over sunken catacombs that would make any theme park seem trivial in comparison.

Graduate school in anthropology at Florida State became what I did to sustain myself in the world of career expectations and practicalities. My evenings spent clambering down the sides of sinkholes with more than a hundred pounds of air cylinders and lights strapped to my body—that was what I lived for.

It makes eminent sense that a young graduate student in anthropology with a penchant for underwater exploration might embrace cave diving to achieve scholarly recognition in archeology. A neat, elegant story perhaps—but it would be a lie. The truth is I would have pursued this passion for cave diving if early man had never been near Florida and elephants never fell into wet holes in the ground.

It is hard for most to understand the draw of these water-filled mazes, particularly when the price their exploration exacted in human life came to be widely publicized. I had found a world of storybook magic; moon walking, star travel, the kingdom of the silent night—all were available a thirty- to ninety-minute drive from my graduate teaching assistant office in the Bellamy Building at Florida State. The only catch was that mistakes in this world carried capital punishment

as their penalty. There were no in-betweens. You either did it right or became the subject of the grim, black humor of fellow cave divers.

The problem with this form of diving, to put it simply, is that you can't go up when things go wrong. And in underwater caves the number of things that can go wrong are many, and few of them are predictable without direct experience. Unfortunately, obtaining the experience is usually impractical, because caves are not conducive to incremental learning. Once you have entered the cave even a little ways, you are in over your head in more ways than one.

Imagine stopping by the side of a fairly well-traveled road and seeing a beautiful patch of crystal-clear water surrounded by the tannic acid brown soup of the Suwannee. A sign says "Little River" and perhaps another, smaller sign warns of dangers in diving there. Then, consider that you learn from locals that cave divers have placed a half mile of permanent guideline in that cave and you are a diving instructor or experienced open-water diver from New Jersey. You are prudent, however, and decide that you will not tempt fate in a strange environment; you venture in only a hundred feet, not even as far as the beginning of the three thousand feet of line that has been laid in the cave's passages. By 1975, twenty-five divers who made that reasonable decision died in Little River Spring.

The late 1960s and early seventies were a developmental period in cave diving; techniques and technologies that would be regarded as "obvious" or common sense in later years were learned through trial and error. The rules regarding air consumption, protocols for laying guidelines, techniques of buoyancy control, deep-diving considerations, and the numbers and types of lights to carry were learned at a frightening price.

There was little in the way of formalized instruction in cave diving in 1971. Only one unlikely individual taught the arcane practice in Tallahassee. Before long, several friends and I were spending countless hours underwater, often late at night, in the capacious Florida State University outdoor swimming pool.

Under the tutelage of Larry Briel, we used up double tanks of air in the shallow water, sometimes until past midnight, following lines with our masks blacked out with tinfoil. The scholarly Briel was not himself particularly athletic or capable of great feats of exploration, but he was able to convey the most important tenets of cave diving:

focus, discipline, and monklike devotion. He was more the Yoda than the Darth Vader-type.

Our imaginary caves were composed of pool-side furniture spread along the bottom as obstacles through which the guideline was carefully strung. We removed our tanks and pushed them ahead of us while sharing regulators, "buddy breathing" in every conceivable position. We concocted emergency situations and replicated them again and again in the controlled environment of the pool.

On other nights we drove to backwoods sinkholes in the Tallahassee area. At first we stayed in the open basins, avoiding areas under ceilings. We practiced swimming over the silty bottom until we found ways to propel ourselves like ghosts, stirring no silt, expending minimal energy. Only then did we start pushing past the cave entrances to the unexplored realms beyond. Within months, the students had outgrown the resident master and were pushing limits only the obsessed would consider worth the risks. Within a year we had extended the few lines that were already in caves in our part of the state to several times their original length. Then we began industriously weaving our nylon webs through many more.

Long evening drives in Tex Chalkley's old Mustang, after my daily teaching obligations, to a newly discovered sinkhole; after a brief, bloody skirmish with killer mosquitoes while donning wetsuits and tanks, we were magically transformed into poor man's astronauts. Effortlessly, we slipped through passageways in crystal-clear water, below the swamps and warm Florida nights. Trailing our thin nylon lines along bedding planes, smooth-bottomed, carved-out limestone layers, five feet high and fifty feet wide, we sometimes dropped through holes in the floor to find we had, in fact, entered through the ceiling into a room that could comfortably hold a twenty-story building. Playing our powerful sealed-beam lights on white limestone walls, we let ourselves fall motionlessly into voids, occasionally wrinkling noses against the face plates of our masks to clear our ears.

As depth increased, we could feel the increased pressure thicken the air flowing through our regulators into our lungs, and we noted with fascination the narcotic numbness beginning to take effect as nitrogen molecules in the air anesthetized our nervous systems. Euphoria accompanied this nitrogen "high" sometimes; on other occasions, minor worries magnified into major anxiety as our reflexes slowed to

three-quarter time along with our breathing rates. The extreme limit for depth in the sport diving community was 130 feet. We regularly undertook long under-ceiling swims at depths ranging from 180 to 240 feet. Some in our group ventured well past 300 feet on air.

Cave divers bonded like soldiers. We developed the intimacy of people who must depend on each other to stay alive but with an emotional quick release. We employed a dark humor regarding the unbelievable death rate in those years. I've seen partners on a dive chalking a number on their sleeve to designate that they would be #6 if "Jim" came back without them.

The world of underwater cave exploration was an extremely hazardous, yet somehow orderly and tranquil world for me. If one communicated well with one's partners and anticipated problems, it was a predictable and controllable environment. Starkly beautiful, mysterious; alien yet inviting. I loved these caves for being there, for forcing me to focus every moment I spent in them.

Their uncompromisingly lethal nature for the careless or the preoccupied made them a special refuge for the devoted. I have never been more relaxed than after executing a precision cave dive—perhaps the same feeling as that of the male black widow spider who, after being sated, successfully escapes the embrace of his lover.

My comrades and I were called at times to retrieve the bodies of fellow cave divers who had not managed to avoid the widow's kiss. Emblazoned forever in my mind are scenes of incredible terror, when the inexperienced or untrained had comprehended the hopelessness of their situation, panicked and drowned. But my first direct association with death in this world of wonder and beauty wasn't searching for novices who had wandered in a short distance, it was something quite different.

As I became more and more enamored with cave diving, the death toll among its practitioners was starting to escalate out of control. It wasn't just the untrained and inexperienced who were dying, although that group did comprise the steepest bump in the statistical curve. There were more and more serious cave divers pushing the limits and even members of our own tight little group were succumbing at an

alarming rate. My dive log indicates the first date that I had to deal directly with the dark side of cave diving was when a North Florida summer was preparing to become fall in 1972.

September 17th is significant in America as the single bloodiest day in our history—the battle of Antietam. But on September 17, 1972, my mind was focused on the grim business of recovering the bodies of three divers from a cave near Mariana, Florida.

I had just returned from a week in Stony Brook, New York, where I was certified as an instructor in an institute run by the National Association of Underwater Instructors (NAUI). Ironically, I was fresh from delivering my graduation presentation at the Institute in which I took the staff to task for their dim view of cave diving. Many in the general diving community could find no rational explanation for the multitude of cave and deep-diving fatalities occurring in inland Florida. They could only conclude it was a foolish, extreme perversion of the sport they were so devoted to promoting. They felt the death rate was particularly disturbing because it created an unfair public perception of the dangers of scuba diving in general.

It was difficult for them, as well as the public, to understand how water-filled caverns could be so fascinating that they were drawing divers to take what, from a distance, seemed unconscionable risks. Without benefit of experience or adequate knowledge, they condemned the practice, ridiculed the foolishness of some who had died taking "insane" chances, and urged wise divers to keep their distance.

I said nothing until the last day of the institute, when, secure that I performed well and could speak from a position of strength, I delivered an indictment of those who had been attacking my passion on what I felt to be unfair grounds. I accused them of spreading misinformation and innuendo, and of castigating as fools people whom they knew only through reputation, and whom I knew through intimate association. I was particularly adamant that real cave divers died not from ignorance but from actions based on calculated risks that they were willing to take. "They knew the risk and they accepted the consequences" became my refrain throughout the talk.

Also, I pointed out that by far the greatest number of people who died in underwater caves were not cave divers but people diving in caves—often perfectly adequate open-water divers, including instructors like them, who had no business dabbling in caves without special

training. Luckily for me, the directors and staff of the institute were secure in their own abilities and, to their credit, took the lambasting with good humor. They gave me high grades and promised to be fairer in their appraisal of this specialized "art form," as I had referred to it.

Now, hardly unpacked from my trip and barely dismounted from my sanctimonious high horse, I was heading off to recover three experienced cave divers. Tex Chalkley, my closest cave-diving buddy at the time, called to tell me he'd pick me up at 6 A.M. and we'd head to Mariana to meet with Sheck Exley from Jacksonville and Dave Desautels from Gainesville and a couple of others, all experienced in cave-diving recoveries.

In a sense, the other guys were coming into our territory—Tex and I had become over the previous year pretty much the acknowledged experts on the caves in the Florida Panhandle. Tex was, to all appearances, the total opposite of me in the politically self-conscious world of university life in the 1970s. He was clean-shaven, finishing up his law degree, wore white buff shoes, coat and tie, and thick glasses. His mannerisms were lawyerly, and he almost had "Republican" tattooed on his forehead. I had a full beard, taught undergraduate-level anthropology, and associated with professors and students who thought SDS, SNCC, and Abbie Hoffman were too damn conservative. Cave diving made interesting bedfellows; Tex could have dressed in drag for all I cared, when the chips were down 200 feet deep and 2,000 feet back in, his was the face I wanted to see beside me. Tex had ice for nerves.

Unfortunately, we had never dived this place called Hole-in-the-Wall. The cave which ran at an average depth of about ninety feet, emptied from a depth of fifteen feet into a large quiet body of clear, spring-fed water known as Merritt's Mill Pond. We were familiar with the pond but not this particular spring conduit.

On our arrival the sheriff came over and expressed his appreciation for responding to his call but reassured us that the situation was well in hand. While we were en route, Navy divers from the Navy Dive School in Panama City had agreed to handle the matter and would save us the trouble and trauma. I could tell that the sheriff was puzzled over the reaction of the assembled cave divers. As a group

they could muster up the most pregnant silences I have ever witnessed.

Tex asked if the Navy contingent had seen the cave opening yet, and the sheriff said, "No, but their Master Chief was heading out there now to scout it out."

In response, Sheck gave the sheriff a winning smile and drawled in his lazy Southern accent that he "reckoned we'd just kinda wait and see for a bit."

Sheck was a low-key fellow, several years younger than Tex and I, but his reputation had already reached legendary proportions in the world of cave diving. He held most records for penetration and depth, and was on the way to claiming most others. He was also one of the people listed by name at the institute in Stony Brook as being a lunatic. He was no lunatic, just clearly and admittedly obsessed, as were most of us. He was also on the way to becoming a close friend of mine when I heard the "lunatic" comment, which is probably what provoked at least the vehemence of my reaction at the institute.

Although Tex and I had been exploring a lot of caves, most of the accidents that were the focus of so much attention in Florida at the time occurred in the popular springs more toward the mid-part of the state. We were often put on standby in case things were drawn out over days, but the present company out of Gainesville and Jacksonville did most of the recoveries.

In fact, this was to be my very first body recovery, and I was still relatively new to the interplay of egos and law enforcement politics that accompanied this sort of tragedy. I knew it would be insane for these Navy divers to attempt the recovery, and all of us present knew at least secondhand, Sheck firsthand, of the disastrous attempt that the Navy made to effect such a recovery in a place called Madison Blue not too many years ago. It wasn't that the Navy didn't have good divers; it was just that they were not trained in cave diving and if their chief decided to macho his way through this situation we were probably going to see a tragedy transform into a disaster. Hole-in-the-Wall was much worse than Madison Blue because you were forced to traverse a serious constriction within the first minute of the dive.

As it turned out, we should have given the Navy chief more credit. He came back to shore and, after saying a few brief words to the sheriff, walked over and introduced himself. A personable man but all

professional, he simply asked to take a peek at our dive gear. Sheck swung open the door of his van, revealing the sets of large double-cylinders, customized lighting systems and line reels neatly stowed but well-worn. "You boys done this a lot before?"

"Yessir."

"Sheriff, I'm sorry, but I've taken a look out there, and I'm not putting my men in that hole. I'm thinkin' these boys here cut their teeth on these damn caves, and they're the right ones for the job."

I was impressed. The man was a pro who knew his limits and wasn't going to endanger his men over storytelling rights. He had the savvy to know that there was absolutely nothing in the extensive training regimen of Navy divers that prepared them to don scuba gear and swim through tight holes in the ground filled with silt and a catacomb of dead ends.

The sheriff tried not to show his consternation but was obviously at a bit of a loss. As he set about re-establishing his demeanor of authority and control, he couldn't quite accept the fact that the Navy was going to back out of this thing. The whole responsibility and liability issue was back on his shoulders. Tex, a law student and mellow of tongue, assured him that all would be okay. We were covered by waivers and had worked effectively in many other counties, and he simply needed to relax: Let us do a recon dive, and we would work up a recovery plan for his approval afterward.

Soon, we were sitting, two divers to a jon boat, with a deputy motoring each of the three flat-bottomed craft out to the cave mouth. Here, we were met by another surprise. There was a fully equipped cave diver from Alabama standing chest deep in the water near the shoreline ready to join us. He had been there from the previous night and the sheriff seemed reluctant to tell him he couldn't go with us.

It was a touchy situation. After the incident with the Navy we were loathe to tell the sheriff that we couldn't possibly let this man dive with us. Not only didn't we know him, we did know that these were his friends who had died and he had been up all night grieving and steeling himself to enter the cave to find them. He had already made a solo attempt.

But, by this time, we were reaching our own limit of frustration with the proceedings and decided we wouldn't try to stop him. The sheriff simply didn't have the inclination to run him off, and we had

lost patience and weren't going to delay the operation any longer. We figured we would let him accompany us on the recon, which we hoped would be fairly straightforward, but would put our collective foot down about the recovery operation itself. In retrospect it was a mistake—a mistake that could have cost us our lives.

All six of us did the recon dive. This was unusually large for a cave-diving team, but it was getting late in the day, and we all needed to see what we were facing. Our six turned into seven as the unknown diver joined us when we descended to the cave mouth. The first thing I noted was that, as we had been told, there was indeed a real tight fit right at the entrance. We could make it through with tanks on but not much else. This constriction was what we were going to have to exit through with the bodies. Tex fixed me in his gaze underwater as we waited our turn to squeeze through and just shook his head. The un-invited diver joined us and Tex swept his hand in an "after you" gesture to the man. I almost turned back after seeing how nervous he appeared squeezing through. Who knows what he might have been like in normal conditions, but he was in a state I could only character-ize as "on the edge."

Moments later, Tex and I had worked ourselves through the tight spot and dropped down into clearer water, where we could see the #18 gauge (about a sixteenth of an inch in diameter) permanent line that someone had installed. I noticed that it was twisted, not braided, which was not comforting. Braided line took abrasion and pulling much better. Also, the thought was running through my mind that I didn't know who had installed this line. But it sure as hell wasn't Tex and I. That meant we didn't know how well it was wrapped and what kind of condition it was in. I later learned the line was installed by Billy Young, Paul DeLoach, and Ron and India Henley.

Lines are one of the most critical element of cave diving. When the uninitiated first see $\frac{1}{16}$th-inch nylon string stretching into the re-cesses of an explored cave they are usually shocked at how thin and frail it appears. In fact, in the earliest days of cave diving, lines were considerably heavier until the techniques and equipment evolved to the point where longer and longer penetrations were possible. The line is rarely touched by experienced cave divers unless rising silt is causing a blackout. In such a case, they form an okay signal with their fingers around the line and run their hands along it gently until they

can see it again, even dimly, and follow it with their light. It is the nylon equivalent to the mythical bread crumbs that lead one to light from land caves—underwater they are also leading one to air.

The laying of line so that it is always visible and accessible to fingers when necessary, but out of harm's way when not needed, is a matter of pride to cave divers. The manner in which it is wrapped around projections and laid taut and firm so it doesn't snag equipment is all subject to scrutiny and critique by divers who follow.

Offshoot lines to side passages are always separated from the trunk line. The dive team usually carries small "jump reels" to temporarily bridge the gap and home-made arrows, or sets of clothespins that can be adhered to the line in a manner that definitively points the way out. Line-laying technique is important enough to cave divers that entire chapters of manuals are devoted to the subject.

As we had now dropped through the vertical chute from the constriction, we were totally dependent on the line for orientation. While I examined the nylon string, I couldn't help but notice that our helper (diver #7) was already showing his stress: erratic arm movements and sloppy buoyancy control. Tex stopped dead in the water to watch him as Sheck and the rest of us began moving smoothly down the line. Tex did not like this fellow being between us and the entrance and would be damned if he would let him trail behind.

I was having my own problems, psychological ones. The water was eerily clear and the formations pleasing, as we moved down the passage. But I had a disturbed man behind me, and I was searching for the bodies of cave divers, not open-water divers who had just strayed into where they shouldn't be. These folks, judging from the one survivor of the expedition, had the right equipment and a fair amount of experience but they hadn't come out. "They knew the risks and accepted the consequences," my refrain from the institute kept running through my head. Did they really, I wondered?

Typically, in Florida, where about 99 percent of the cave diving in the United States takes place, experienced cave divers only drowned when they mixed serious depth with caves, usually well in excess of two hundred feet. I didn't know of any passage here much deeper than the ninety to hundred foot conduit we were presently in. The inexperienced died a stone's throw from the opening from panic, disorientation, and because they just didn't have any way to go up. Experienced

cave divers were usually found very far from the entrance or very deep.

Also, I was, for want of a better word, spooked. At this point in my career I hadn't seen much death, and I wasn't looking forward to it. I settled into the easy, deliberate pace that Sheck set in the lead. He had his buddy next to him, then Dave and Dale Malloy, also skimming along both sides of the line but never touching it. They were followed by me, my new friend who had pulled up to my right, and Tex trailing behind a few feet, watching the progress of #7 like a hawk.

I noted my new partner's breathing getting more erratic, and the movement of his light beam was choppy. These are two clues to the mental state of their partners that cave divers are very keyed into. It might appear an expert cave diver in a lead position is inattentive to his buddy because he rarely glances backward. But invariably, he is monitoring the even play of his partner's light beams on the walls ahead from the corner of his eye. Flashing light rapidly on an object in front of your partner is an all-stop signal in cave diving. Repeated movements in a diver's beam that are jerky or erratic might alarm team members to the point that they will call the dive.

Then, there is the breathing. If one pays attention in water, it is usually possible to monitor another's breathing rate, but in open water, people seldom bother. In the dark confines of a cave, the only sounds are your own breathing and the sounds of air rushing through the extended airways of metal and rubber hoses of your partner's regulator. You can see the bubbles, but that can be deceptive; it's the sound that alerts you—fast, shallow intakes of air and no clear pattern of exhalation.

Seconds after I became aware of these clues, I noticed Tex had already stopped again and was intently watching. Who knows what demons the stranger was confronting. My irritation that the man had forced himself onto the dive was softened by my sympathy for what he must have been going through. I felt a knot in my stomach on this foray, and I was looking for strangers—these were his buddies. Suddenly, he grabbed at the line for some sense of security, I suppose, and the old piece of twisted nylon snapped.

I then witnessed one of the most impressive reflex reactions I have ever seen underwater. The nylon line, which was under tension, recoiled in both directions. Sheck's partner grabbed the end heading

into the cave, and Sheck, in a remarkable feat of athleticism, inverted from his face-forward swimming posture, whipped under me, and when the silt cleared, he was kneeling on the bottom with the end that led out gripped tightly in his hand.

But the ambivalence toward #7 was over. Tex and someone else I couldn't make out in the rising cloud of silt were physically escorting him toward the exit. They came back surprisingly quickly and I learned later that just before reaching the constriction, he had bolted from them and was last seen clawing his way through the tight crevice toward the dim light. They left him—the logic was they couldn't help a panicked diver, anyway. If he made it fine; if not, they'd collect him on the way out. Sounds cold, but that was reality.

Without the burden of our traumatized companion, our progress was much improved. Sheck and I repaired the line, and off the six of us went. After ten more minutes of swimming, I saw Sheck's light hit something shiny and fix there; my heart leapt into my throat. When I caught up to him I could see in living color the first of our missing divers. He was on his side, only a few feet from the line; double tanks, an extra pony bottle (he was carrying a lot of air), and all his equipment including his mask were in place. What burned itself into my memory was the absolute serenity of the scene, so different from what I expected: no signs of panic, nothing—a very orderly looking, very dead diver. The chill of the seventy two-degree water seemed to suddenly creep right through my suit into my bones.

Tex moved carefully above him so as not to disturb the silt and checked his air-pressure gauge. He held his light up to illuminate his own face and lightly slashed at his throat with his fingertips. He was signaling to us that the man had totally drained his tank. Sheck pointed at the pony bottle, and Tex pressed the purge valve of the regulator—nothing. This fellow had used everything in his double tanks and his spare bottle and was still almost a thousand feet from the entrance . . . and not lost. This was getting stranger all the time. I looked down at my own gauge and saw plenty of air remaining to continue our search. What had happened? Cave divers typically enter on a third of their supply, exit on a third and save a third for emergencies. This would have been the air-consumption miscalculation of all time.

We left the man in place and continued on. Our plan was not to attempt a removal until we had scoped out the whole scene. We

hadn't advanced 150 additional feet before we found the second fellow. Same ritual checking, same result. For some reason, I wasn't surprised when about 200 feet farther we found the third victim. Same again, except for the curious anomaly that he had a full pony bottle but no regulator attached. We were now well over a quarter mile back in the cave, and it was time for us to swim back out, decompress, warm up, and regroup.

On the surface we motored back to the boat landing to change tanks and debrief. The sheriff alerted the coroner when we planned to do the recovery dives so he would be present to receive the bodies. We divers were stumped, however, when it came time to give a reason for the accident. They were next to the line and headed out, so obviously not lost, no apparent panic, no apparent malfunctions, too shallow for deep-diving gas effects like nitrogen narcosis or oxygen poisoning, no nothing! I listened with interest and then took my time assembling my gear for the recovery.

I needed to gather myself. This business had shaken me; for some reason, the beautiful, crystal-clear serenity of the environment had gotten to me the worst. It was like these caves that I loved had lied to me. I could accept succumbing in a particularly difficult constriction, at 250 feet deep when you were tiptoeing on the razor's edge, lost, entangled, but why here? This was a crystal-clear reach of passage, just under a hundred feet deep, large enough to negotiate side by side, and these guys were all headed out within arm's reach of the line. Did they know the risks? Hell, did I? I knew one thing, for sure: I wasn't ready to accept the consequences I had just seen.

I went over the recovery plan in my head, step by step. First Sheck and his partner, Steve, were going to retrieve the farthest guy in. Then Tex and I would retrieve #2 and bring him out right behind Dave and Dale, who would be exiting with #1.

"Tex."

"Yo."

"You know that part about following Dave and Dale through the constriction?"

"Yeah."

"Ain't gonna do it."

"Well, the plan's made, and Dave and . . . , hell those guys are good."

"They're better than good, that's not the point. Dave is also ... big. Also, these guys, the victims, they look stiff to me."

"Well, they oughta."

"No, I'm not kidding. They've got rigor mortis and I don't think they're gonna slide through that constriction real easy—point being, I don't want to be inside waiting for those guys to clear that constriction. I mean, what if they can't?"

Tex chewed on a plant stem (he was always chewing on a plant stem) and considered my question. "Hmmm, I guess that would be kinda disappointing."

"What?"

"If they couldn't get through and we were behind them."

"Indeed."

In this manner we had analyzed the problem and come to the conclusion that we should either reverse order or do our recovery separately. For reasons I'll never understand, Dave and Dale just decided to reverse order. They were more confident than I was that Tex and I could make our way through with a victim.

An hour later, Tex and I followed Dave and Dale into the room-size spring basin, where we passed Sheck and Steve decompressing, with the body of a diver held between them. The basin was very silty from all our activity getting down and from them getting the fellow through the constriction. My light picked up a pinkish tinge to the water around the victim; the effects of pressure had made his lungs rupture on the way up, common in diver recoveries but no less disconcerting.

I could hear the scrabbling of Dave and Dale in the tight spot; soon they were through, and I was next. In totally blacked-out visibility, I felt and pulled my way through the rock crevice, feeling the limestone scrape my tank and skin my knees and wrists even through the quarter-inch-thick rubber suit.

Then we were in surreal city. The crystal-clear water at the bottom of the entrance was reduced in visibility to about six or seven feet, due to the team exiting with the body. It improved slightly as we moved further in but it just wasn't the same cave anymore. I watched the line move by as we flutter-kicked quickly toward our victim. I was in no mood for sight-seeing.

As soon as we reached our destination, I quickly grabbed the de-

ceased by his tank valve and turned toward Tex. We had planned to swim him out between us, with me on the right and Tex on the left. It worked for a while but in the reduced visibility, it became too difficult, causing both of us to repeatedly bang our knees and elbows against projections in the cave floor and wall.

Finally, Tex turned and placed his hands underneath the man's arms from behind, and I lifted his legs. This worked better. For most of the swim out, Tex back-pedaled facing me, and I nodded my head one direction or the other to signal him to turn so he wouldn't have to look behind himself. It's a swim that will always be with me. The man's name was embossed on black tape on his Scubapro decompression meter. On every kick it popped up into my field of vision as if reminding me that he had been a person with a history—a name other than "victim." Regardless, my mood had improved—probably because we were doing, rather than anticipating, and it would soon be over. Then we got to the constriction.

Here I had the opportunity to thank my instincts about insisting on the order of exit. We could not fit our victim through the crevice. His rigor had frozen his arms in a half-extended position as if he was trying to embrace someone. A mess of straps and ancillary gear made removing his tanks impossible in any reasonable period of time.

Both Tex and I crawled into the crevice and with one hand each on his tank manifold, we pulled for all we were worth. He seemed to give, moved several feet, then wedged in hard. He was seriously stuck! My nightmare had come true, only it wasn't me on the wrong side of the constriction. I find it hard to admit but, in honesty, my dominant emotion was relief. As worried as I was for my comrades, I couldn't help but be overwhelmingly relieved that it was them and not me on the other side of that constriction.

The situation was serious and on its way to becoming dire. The man was truly stuck. Tex and I were wearing ourselves out in our awkward position, frantically trying to pull him through. Finally Tex motioned me aside. His instinct told him that we were working to some degree at cross-purposes in the confined area, and he might do better alone. He lay on his back, head pointed out, removed his fins, and, with my help pushing, situated himself with both hands on the man's manifold. His legs wrapped around the prostrate victim's upper body, with his feet planted solidly on the projecting wall of the cave. It be-

came totally black in the crevice; with my light, I tried to illuminate down Tex's torso as far as possible. Dimly, I could see his hands tense on the manifold and I knew he was pushing his feet against the rock with all his might. Only his head was visible in the muck—his neck tendons standing out with the strain. Suddenly, with a crumbling sound of limestone projections giving way, Tex and his ward sprang through the opening.

I gasped with relief, pulled them the remaining few feet into the basin, and then dove back into the crevice to see if I could help the others. To my amazement, I found myself grabbing not Dave or Dale but another body. These guys were pushing him through ahead of them! As fortune would have it, this fellow was in just the right body attitude, and he slipped through comparatively easy. I dropped back into the basin and sat in the murk with my arms around Tex and our victim. We would go through this decompression together.

I had a lot to think about as the silent procession of Jon boats made their way back to shore. Dave and Dale were never aware how close they had come to being statistics, and Tex and I didn't see much need to belabor the point. The discussion was more on what had happened to the three victims. Their buddy, diver #7, who had tried to help, had apparently made it up safely and had left the scene.

The divers, still with their equipment on, were stretched out in one of the boats with a white sheet draped over each one. The sheets had turned crimson where they draped over their faces. The lungs of the dead divers, ruptured from being removed to a lower pressure were still oozing a bloody froth through the nose and mouth. A natural process, but I was happy for the sheets—I only wished they were some other color than white.

As the metal boat bottoms scraped on the sandy shore, I heard one of our people say, "No shit, an offshoot line?" Sheck looked over at Tex and me with a grimace and said, "Well, guess that's it." The team had come to a conclusion about what had happened, and in retrospect it was the only thing that made sense. One of our divers said an offshoot line could be seen from the trunk line. There was no sign it had been jumped with a reel, and, worse, the tally of equipment

found on the bodies and in the cave revealed no arrows and no clothespins.

It can never be proved, but we all knew in our hearts what had happened. They had jumped to that offshoot line and after exploring to its end, had come back to the trunk. Then, they had looked at the trunk line quizzically for a few seconds—I swear I could vividly see them doing this in my mind, as my comrades reconstructed this hypothetical scenario—and they had gone the wrong way. That was all it took, the leader heading the wrong way; caves look different on the way out. The less experienced assumed he must be right and followed. I couldn't dwell on what it must have felt like, when they found that damn trunk line wrapped off deep in the cave and realized they were turned around.

The whole way out they knew there was no way in hell they were going to make it. The fact that they were so close together meant they probably tried to buddy-breathe, to share the last of the remaining air supply. It's curious how this knowledge affected the members of the cave-diving fraternity as they quietly packed their gear. There was a new-found respect for the victims. Sheck murmured to the rest of us, "Ole boys did all right, considering." There were nods all around. It was what passed for a eulogy among cave divers. Consequences accepted—I knew the men under those sheets would have been proud to hear those words.

CHAPTER FOUR
TIME FOR A CHANGE

My infatuation with the exploration of underwater caves slowed not a beat after the incident at Hole-in-the-Wall—more archeological finds, more natural wonders discovered, more tragedy, including people I had dived with. But the increasing notoriety of the caves was having a strange effect on the general diving community; they were becoming more and more fascinated and visited the Florida karst in record numbers. Almost a year to the day from the incident at Hole-in-the-Wall, I found myself taking part in a recovery of two divers from the other steep bump in the statistical curve, novice divers. It was September 23, 1973. Only a few weeks earlier President Nixon had told us to "put aside our backward looking obsession with Watergate," and the last American soldiers were on their way home fron Vietnam.

Four of us had entered and penetrated the farthest reaches of Ginnie Springs before finding the first victim. These young men had obviously overbreathed their equipment. Extreme demands to breathe by the panicked diver made the air suck through the restricting airways of the regulator like a thick milkshake through a thin straw. They had madly torn the offending gear from their bodies and strewn it around the cave. Air tanks still half filled with air that was inaccessible to gasping lungs, hands showing signs of having clawed the ceiling, lips frozen in some final protest—it was time to shut down our emotions and switch to automatic pilot.

I was partnered with Dave Desautels, who was leading the dive. He knew Ginnie well and allowed us only a few seconds to absorb the

scene. He glanced at our two partners and pointed at the victim, indicating they should act quickly to remove him. We proceeded to find the second body. Dave knew that in the passages farthest back in Ginnie silted out almost immediately, from gin clear to zero, which is why they were so treacherous to the uninitiated. Even if you were motionless, your bubbles dislodged thick clouds of reddish-brown muck from the ceilings.

We proceeded into a narrow, silty passage with clay walls. The soft clay walls presented their own special challenge. There was no permanent line in Ginnie, so I had to deploy the line from a reel all the way in. I had selected a heavier gauge than the usual #18 because I knew that when we exited, the place would be blacked out and the line would work its way into the walls at each turn. Few things are more gut-churning than blindly following a lifeline out of a cave right into a solid wall. One had to pull it gently back and forth in zero visibility, hoping to find the groove it had made on entry.

Our stress level rose when we squeezed into the last chamber that could accommodate a diver and found it empty. What in the hell? We passed the man's partner and a pile of gear over a hundred feet back—there was absolutely no place else to go. I knew I had roughly ten seconds before my air bubbles dislodged enough silt from the ceiling that the crystal-clear water would become opaque, even to the most powerful dive light. Then, I spied feet, bare feet, extruding from a narrow crevice. This poor kid had removed even his wet-suit boots. I felt that shiver that was becoming all too familiar pass through me—what level of panic, what unfathomable psychological process—what would make a person remove the last of his gear, including tanks half full of air, and in total darkness squeeze himself into a jagged rock tomb?

I had plenty of time to contemplate an answer to that question—the twenty minutes in absolute darkness it took to swim out of one of the siltiest tunnels I had ever entered. Dave, with the deceased under his arm, was feeling his way back along the line with his other hand, removing the line from where it embedded in the clay, with me following.

I had the simpler of the two jobs; I just wound up the line behind Dave as he blindly forged ahead. This was perfect work for Dave—we used to kid him about his lousy silt control but then he seemed totally

unfazed by silt. As long as you weren't trying for a record penetration in clear water, he was an ideal partner for a body recovery. He worked in a hospital hyperbaric unit, was familiar with death, and had probably performed more body recoveries than anyone on record.

There had been many deaths in the popular Ginnie before, even an infamous accident involving four victims, but this one did it— enough was enough. Three of our associates from Miami, Tom Mount, Paul DeLoach, and Jim Nangle, installed a grate in the spring, where the inviting open chamber narrowed to a conduit. This cavern was inviting to novices in the light-bathed mouth and lethal just a little way down its throat.

I was usually against grating caves but supported this decision. In 1973, eighteen divers died in the state's underwater caves, and a shocked public began a hue and cry to ban diving in the "killer caves of Florida." While public meetings were being held in different parts of Florida to legislate us out of existence, we kept exploring. Our position wasn't helped when twenty-six died in 1974, by no means all novices either.

But something was going on in inside me. The lure hadn't diminished, but the mathematics of survival were starting to become a bit unnerving. I visited four cave-diving associates who lived together in Gainesville in 1972, and I reflected in 1974 that only one was left alive; the others had gone in three separate accidents.

Another, diving solo, finding he was hopelessly lost, took the time to write his wife and son a brief, but loving farewell note on his plastic slate. He breathed the rest of his air, even that which remained in his buoyancy vest, and then accepted death. The business of consequences being accepted was starting to wear thin on me. Although I felt privileged to be at the center of a whirlwind of adventure and exploration, I was starting to believe it might be reasonable to drift over toward the slow lane for a while.

I had no intention of leaving cave diving, but I thought perhaps it was time to cool the obsession; maybe use what I had learned from dancing on the razor's edge to pursue goals in my chosen profession of underwater archeology. In truth, I came to realize that I was addicted, not just to adrenaline but "to going where no man had gone before." I didn't intend to go cold turkey but to slow down enough

that I might consider accepting a different consequence—that of longevity.

So the world of cave diving provided a back door for me to a profession that was also a passion. I pursued my studies at Florida State in anthropology during the day, and learned by night from the water-filled limestone, that diving was not a simple tool to be applied to an academic problem—it was the key to experiencing a whole dimension of the planet.

When the National Park Service (NPS) came to town in the form of the Southeast Archeological Center, George Fischer hired me as a "Park Ranger/Archeologist" to help further the agency's early efforts in underwater archeology. George was about to undertake a shipwreck survey at Gulf Islands National Seashore. He gave me free rein to whip his assorted group of sixteen project participants into a disciplined team. The professional capabilities of the archeologists, historians, and technicians was respectable and consistent. But their diving abilities varied from pretty-darn-good to hopeless.

George made a decision, however, that neutralized any of the weaknesses in the divers' abilities. He backed up his new GS-4 ranger/archeologist in decisions about diving, regardless of whom it affected. As it turned out, George and his assistant project director, Calvin Cummings, were both unable to pass my stringent water test for buddy rescue. His reaction was to disqualify himself and Cal from taking part in diving operations until they did finally pass the test near project's end. When the project was spot-checked for compliance to NPS diving standards by then Southeast Region diving officer, Don Weir, it passed with flying colors. Whatever the Gulf Islands project lacked in funding and equipment, its diving operations had broken the glass ceiling of acceptance among the old-line hard-core ranger ranks.

Cal Cummings, who happened to be in charge of NPS archeology in the Southwest Region and who would eventually become the chief promoter of SCRU, took careful note of these happenings. Within a year he had hired me. I had worried about how seriously diving would be taken in the Service, and I now had my answer.

The Service provided me the opportunity to transform myself from an underwater adventurer to an underwater archeologist. In turn, I brought to NPS underwater archeology an intensity of pur-

pose and devotion to diving discipline that were rare, found only among Florida cave divers and a few other widely dispersed communities around the world.

On New Year's eve of 1974, I had already decided I would soon be leaving Florida to accept a promotion with the NPS in Santa Fe. That night I met Larry Murphy. A former commercial diver, weightlifter, and archeological field agent for the state of Florida, Larry was forced to witness the state-sanctioned destruction of the better part of the Spanish maritime heritage in the United States.

Larry represented the "state's interest" while monitoring private salvage boats blasting dump-truck-size holes in the seabed with prop-wash deflectors to find Spanish doubloons and pieces-of-eight. In one of the more short-sighted decisions in bureaucratic history, the state of Florida allowed itself to be snookered into partnership with treasure salvage companies, which, in a quest for riches, ran most of the state's maritime heritage through an underwater blender.

This experience is seminal to understanding Larry. Lacking only a dissertation for a Ph.D. in anthropology from Brown University, Larry can change temperament as quickly as the Great Lakes—from animated, intellectual discussions of maritime archeology and social history to tight-jawed, brow-lowered, red-faced diatribes on "treasure pukes," whose very existence on his planet he finds offensive. His love for the underwater world, ships, and history under the sea is boundless.

We had an inauspicious first meeting at a New Year's Eve party at the home of his boss, the mercurial Sonny Cockrell, Florida's state underwater archeologist. Sonny had a recent brush with death at the cave in Warm Mineral Springs. Though advised to consult with me several times in the past, Sonny had been slow to talk to a graduate-student, cave-diving monk about his problems. Hell, he was a professional diver and should be able to handle it—How different could it be?

Treating the caves like just another serious diving environment was a common mistake, one that had almost killed Sonny's predecessor, Carl Clausen. Carl, a big, brash fellow, had once interviewed me

for a job with the state. I heard from his own lips of his attempt to pound a core sleeve into the silty bottom of Little Salt Spring in water more than two hundred feet deep. In short, he almost didn't return, and cave divers I knew from Miami had retrieved the core from the spring some days later. It wasn't in the bottom. Carl, in his nitrogen-mind-altered state, had pounded it into the side of the spring. Whatever else the qualifications for being State Underwater Archeologist of Florida in the early 1970s, it took strong personalities with strong egos.

On this night, Sonny, aided by copious amounts of wine and mescal, was able to swallow his pride and vent his anxiety over the close call he had just experienced. I didn't need the assistance of the alcohol coursing through my own veins to appreciate the intensity or verity of his story—Sonny really had been close enough to see the Grim Reaper's smile. He had strayed into the cave opening at the bottom of Warm Mineral Springs at 230 feet deep. Following a poorly laid line in, he lost it in a silt-out. He swallowed his rising panic long enough that he happened to find the line again . . . and follow it the wrong way. Luckily, it was a short line. Realizing his error in time, he had sufficient air to make it back out.

"Dan. Man, I'm back from the dead. I was fucking dead! I mean I stumbled out of there through blind luck, I'm asking your help, man."

This was an important development. Fischer, Clausen, and now Cockrell, directors of underwater archeological projects in Florida, were coming to a realization that research diving was not some variant of sport diving, and cave diving was a world to itself. Cockrell was particularly important in this regard because he would be running some major diving research programs in the near future in Warm Mineral Springs. This Larry Murphy fellow was to be his field director and dive officer. I was delighted Sonny had given me the opportunity to influence his approach to that project.

I thought the best way to make believers of people in the intricate nature of the special techniques needed to dive caves safely was to show them, not tell them. Watching a well-equipped cave diver lumber about on land with an impossible assortment of tanks and lights and reels brought home the first revelation—this must be serious stuff. Next, underwater, the real transformation occurred as the hodge-podge of wires and lights and tanks magically fell into place

when the diver assumed a swimming position. Finally, the smooth, fluid motions as a good team began progressing through a cave—no silt, no wasted movements, lines handled with confidence and care—a true thing of beauty that makes all other diving pale in comparison. Once you see people move expertly through underwater caverns, it's hard to settle for less.

For Sonny and Larry's experience I chose a place called Peacock Slough near Mayo, Florida. There was a short (300 feet) transit that one could make to another sink, dubbed a "pothole" by cave divers, after which the cave meandered on to other "Karst windows" or water-filled sinks, for several kilometers. With the right equipment and techniques, the underground swim to the pothole was a comparatively benign dive. Because two novices were involved (novices that is, to cave diving—both were experienced divers, Murphy having already logged more than one thousand hours), I had a friend and fellow cave diving instructor, Barry Kerley, accompany us.

The dive itself was uneventful, but the effect on our wards extraordinary. Sonny executed a competent dive and carefully observed the special techniques and procedures Barry and I employed during the penetration. He later insisted that these techniques be applied to his project at Warm Mineral Springs.

Larry, however, had a religious experience. I thought he might have been stressed at the decompression stop, where I had arranged for us to turn off our lights and sit under the crystal-clear water ten feet deep until our eyes adjusted. It's a soulful experience on a moonless night, to see the stars through a water column. What I took for a bit of restlessness or unease was in fact Larry bursting out of his skin with enthusiasm.

The quiet, introspective person I had met at Sonny's party had transformed into a raving lunatic. "Goddamn, man," he bellowed on hitting the surface. "What the hell? Are you kidding me?" Barry and I just blinked, not sure if we had done something wrong.

Larry then turned to me, pointed a big blunt fingertip in my face, and said, "You are going to teach me how to cave dive if it's the last thing you ever do."

"Guess you liked it, huh?"

During the next four months as I closed out my affairs in Tallahassee and made ready to take the position with the National Park

Service in Santa Fe, I taught Larry the art of cave diving. It was like teaching an orca to swim in the ocean. This was a fairly disrupted, impoverished period in my own personal life (divorce and postgraduate school destitution making their marks), so I took some bucking-up from Larry as well. When I felt too soul-whipped to bother with the next dive, he showed up at my hovel with pumped tanks and charged lights. We spent many weekends and nights driving to backwoods sinkholes, diving, and then debriefing on the dives.

We also debriefed about our past: Both of us had been campus radicals of one sort or another in the 1960s, and received our undergraduate degrees in philosophy. Larry had graduated from a commercial diving school after college, trained in hard-hat diving, underwater cutting and welding, and demolitions. His plans for the future were just forming, but he knew they would involve diving and underwater archeology. They would *not* involve condoning what he perceived as the disgusting giveaway of his nation's submerged historical resources to commercial treasure salvors, a practice against which his boss, Sonny, was fighting a losing battle.

In a far cry from the drunken debauch of New Year's Eve, 1974, Larry would find himself one year later at midnight, Dec. 31st, 1975, pulling his way through an underwater labyrinth in a ritual greeting of 1976. He would again be high as a kite, but not this time, from alcohol: It would be from adrenaline and the sense of mastery of an environment as potentially hostile as it was alluring. He would be following the skillful lead of a fellow named Sheck Exley, and be glancing back at regular intervals to check on me bringing up the rear, proud to note that the passage between us was totally clear. Larry had learned the art of swimming lightly beneath the earth.

We became fast friends by the time I departed for the wilds of New Mexico. The synergy of that relationship was a major ingredient in the recipe for the development of the National Park Service SCRU Team.

What I couldn't have guessed is that the major project that would bring all the formative elements of the unit together—the people, the specialized approach to diving, the philosophy—would be hundreds of miles from oceans or caves. It would take place behind dams in man-made lakes and be called the National Reservoir Inundation Study.

Before we embark on that journey, however, it may serve to reflect on the effect that working in parks, and for the Park Service, was having on my developing vision of underwater archeology and maritime preservation. It is true to the chronology and spirit of this story to discuss my assignment later in 1974, to appraise the contract work being carried out by the state of Florida in what was known then as Fort Jefferson National Monument. Today it is called Dry Tortugas National Park, and as coincidence would have it, the field director of the study was a fellow named Larry Murphy.

DRY TORTUGAS

———❧❧❧———

His stories were what frightened people worst
of all. Dreadful stories they were; about hangings,
and walking the plank, and storms at sea,
and the Dry Tortugas.
 –from *Treasure Island* by Robert Louis Stevenson

Frigate Birds soar majestically on the thermals that rise over Fort Jefferson in Dry Tortugas National Park. They seem mesmerized by the panorama of blue-green reefs and maritime history spread beneath them. Since I first hitched a ride in a Park Service seaplane out to what was known as Fort Jefferson National Monument on May 15, 1974, this park has played a major role in the development of SCRU and my personal sense of what being an underwater archeologist is all about.

"Do you mind holding this screwdriver across the terminals till we get her goin'?" The pilot was indicating a battery partially emerging from beneath my seat. A friendly sort, he had agreed to give me a lift from the Key West airport out to the fort but was having problems with the recalcitrant starting system on the plane.

I know very little about planes, or engines in general for that matter, but I was uneasy with this proposal. The aircraft was a two-seater seaplane, with the engine facing toward the tail. Common sense told me that if there was something wrong with that design, the pilot would have noticed by now—I was willing to give him the benefit of the doubt on that, but hold a screwdriver . . .

"Uh, no, I mean yes. I rather would mind. Don't mean to be difficult here, appreciate the ride you know, but . . ."

"Hah!" accompanied by a hearty slap to my back. "No problem, sport, we'll just go into town and find us [whatever one finds to avoid

needing to hold a screwdriver across terminals] and we'll be off." So began my first visit to the Dry Tortugas.

Whether flying or sailing from Key West, the bright white slash of sands that identify East Key are the first harbinger of the Tortugas. Then, low on the horizon to the right, the dull reddish-brown form of the fort starts to take shape. "Las Tortugas," as they were first recorded and named by Ponce de Leon in 1513, lie in the Gulf of Mexico at its juncture with the Atlantic Ocean and Caribbean Sea.

The Florida Current wraps around these islands before it joins the Gulf Stream and heads through the straits of Florida and north toward the Carolinas. The stream carries with it a rich diversity of life and lore that saturates everything it touches. Ernest Hemingway, who resided for a decade in Key West, was so intrigued with Cuba, Bimini, and other "islands in the stream," that they were the focus of his last major work. He often took his friends on fishing trips to the Tortugas.

After buzzing the fort to let the staff know of our imminent landing, we banked around for a final approach. I noticed there was activity on the dock, a patrol boat warming up, another ranger standing alert with his hands on the mooring line. I pointed down. "Coming to greet us?"

"Ah, that's protocol, ever since this bugger porpoised one time, they've been nervous Nellies." I was sorry I had asked.

Located sixty-five miles west of Key West, the park boundaries contain a combined terrestrial surface area of forty acres, roughly a twentieth the size of Central Park in Manhattan. Several small keys are nestled amid one hundred square miles of coral reefs, sand flats, shoals, and open ocean. The keys have no fresh water (hence the "Dry") and no arable soil. They are composed of sand and coral rubble covering little in the way of bedrock suitable for supporting large structures. Though scarcely meriting pinpoints on a map of the United States, the diminutive islets have been the focus of extraordinary attention by European newcomers to the Americas.

Soon after their discovery, the Tortugas became home to pirates and wreckers and were prominently located on most charts of the New World. Even before it was clear that the Florida Peninsula was

not an island, navigators were advised explicitly on contemporary charts of the whereabouts and nature of the tiny landforms that were both natural hazard and haven.

By the end of the nineteenth century, the Tortugas's shifting sands were made to bear the weight of Fort Jefferson, arguably the largest masonry structure in the Western hemisphere. They attracted the attention of John James Audubon for their remarkable population of birds and served as a prison for Dr. Samuel Mudd and other convicted "conspirators" in the Lincoln assassination.

Due to their proximity, the Tortugas have always played a special role in America's traditionally volatile relationship with Cuba. This was the case before, during, and after the Spanish American War. They were the last place the USS *Maine* anchored before its fateful trip to Havana Harbor in 1898. During the 1960s they were reportedly a secret staging ground for the Bay of Pigs invasion and a listening station for the CIA during the Cuban missile crisis.

Given their dramatic history and strategic location, it is curious that the name "Tortugas" still rings only a faint bell in the minds of most Americans, if they've heard of them at all. Whether on land or underwater, the relics of human dramas that were played out in this unique place over the course of half a millennium are everywhere evident.

The natural ship trap formed by the atoll-like configuration of islands became the scene of more than 250 marine disasters from the early 1600s through the twentieth century. The mostly buried remains of Spanish galleons lie a stone's throw from the hulks of iron-hulled clippers and 1800s-era barges used to carry construction materials for the fort. An international heritage is protected on the submerged lands of this park.

In May 1974 (having safely arrived via backward engine seaplane), I was in the role of NPS observer on a project under the field direction of Larry Murphy, who was still working for the state of Florida as Sonny Cockrell's assistant.

It was difficult to fairly assess the project when for seven days of my ten-day stay, we were buffeted by gale-force winds. I could tell immediately, however, that the project was being run on a shoestring. Although legitimate, well-funded underwater archeology was being successfully conducted by Americans on classical sites in the Mediter-

ranean, archeologists such as George Fischer, Cal Cummings, and Sonny Cockrell were having a difficult time getting their agencies to seriously fund such work in the United States.

Commercial treasure hunters were making flashy discoveries that attracted media. Even organizations I had respected in the past, such as National Geographic, were celebrating the destruction of this aspect of the nation's resource base while they waxed sanctimonious on natural resource protection. Gold pendants, silver ingots, and pirate booty simply made more appealing stories than "Gov Archeocrats work on Protection and Preservation of Priceless Public Resources."

As the windy days wore on, the island grew smaller and smaller. We found ourselves imprisoned by the weather while bursting with the desire to explore. Eventually cabin fever had driven us to a point that we were prone to less than judicious behavior. When the wind died down one night Larry and I headed off at 1 A.M. on diver propulsion vehicles to see if there were any large sharks swimming in the entrance channel, a type of reasoning that has helped screen gene pools from time immemorial. During this escapade, I almost smashed my scooter headlight into the cascabel of an eighteenth-century cannon. At 2 A.M. we were setting buoys and taking measurements. The remarkable abundance of historic shipwrecks had conspired to make our early-morning joy ride into a working dive.

The next day or, more accurately, after sleeping the rest of the night of the same day, I recall seeing through painfully hung-over eyes, the red marker buoy we had left on the site. It was visible from one of the fort's casemates near our living quarters. We had found a shipwreck on a lark when nature had precluded serious survey. A marvelous site that we couldn't dive because the wind was up to gale force again. Eventually, the buoy blew away, we lost the coordinates blearily taken with compasses from the fort and never located the site again. I sometimes think it was a phantom site that reveals itself only to suicidal fools.

Thus far, this nation's record in caring for our own or other people's history in our waters, particularly in Florida, is less than enviable. Admittedly, Larry and I did nothing this particular day to improve that record—but, in truth, fools aren't as serious a threat to our maritime past as are greed and politicians. Bomb-crater–like holes are interspersed throughout huge areas of the shallows fringing the Florida

straits. They were dug by modern harvesters of antiquities using propwash deflectors in search of Spanish gold and other precious booty. The entire force of the search vessels' engines is directed toward the artifact-bearing sediments, completely destroying contextual associations but leaving gold and silver essentially unharmed.

Vandals? Illegal activities? No, for the most part the damage has been done by state-sanctioned treasure-salvage operations. A thin green line, the jurisdictional boundary of the national park, is all that protects the undersea historical treasures of the Tortugas from the fate of the rest of Florida's maritime heritage.

The wind rattled the shutters while we poured over the limited data that the group had been able to collect. I was becoming convinced that shipwrecks could be even more important archeological sites than I had originally suspected. Besides being the repository of many antiquities in a superior state of preservation than those found on land, their context is archeologically unique. A wreck site, studied properly, can offer a snapshot of a particular culture at a given moment in history—the time of the wreck event. Unless another wreck lies on top of it, the site is not "contaminated" with materials from other periods that in most terrestrial contexts would have to be painfully separated through stratigraphic analysis. In undisturbed sites, mundane artifacts that show the lifeways of the common seaman, rarely included in historical records, are subject only to the corrosive effects of seawater. They are less accessible to the more devastating effects of men.

Beyond their role as archeological objects, I was increasingly intrigued with shipwrecks as places. The context of working in a park was daily reminding us that shipwrecks are not just repositories of artifacts but special pleasuring grounds to be visited and enjoyed. For one dramatic site in the Tortugas, "The Windjammer," we eventually made a plastic underwater guide map for the use of visiting divers.

Fort Jefferson speaks eloquently about its colorful history to those who will listen. When Larry and I weren't clawing at the walls or making midnight attempts to dive, we walked the moat wall or clacked hollowly about the casemates at night. It was easy to dwell on the many historical vignettes that transpired therein. In places like this our separation from the past seems tenuous, just one dimension away.

The strategic usefulness of such a major fortress sixty five miles out in the Gulf is often questioned. Why couldn't an enemy fleet sail around it? Why did the American military establishment decide to defend forty acres of property with an enormous multimillion-brick edifice in the first place? Records suggest the rationale that the naval force that controlled the Tortugas effectively controlled trade throughout the Gulf of Mexico. More importantly, in time of war it was critical to deny any enemy maritime power access to the ideal staging area for a blockading fleet.

Larry felt the superior range afforded by the huge Rodman, smooth-bore cannons on the parapet were thought by military planners to be capable of keeping an attacking naval force at bay. Wooden ships weren't big enough to carry ordnance with sufficient range to threaten the fort. In fact, a shot was never fired by an enemy at this mother of all forts. Is that a sign of failure or success? Was the investment of billions of dollars in ICBMs that still sit in their silos failure or success?

The fort (all sixteen to twenty million bricks' worth by various estimates) was constructed primarily through the use of slave labor. Even during the Civil War, until the Emancipation Proclamation in 1863, the Union Army used slaves to construct the edifice to help suppress the confederacy and its secessionist and racist policies. While battles raged all through 1862, at places like Manassas, Shiloh, and Antietam, the Union Army was contracting with slaveowners to snap the whip over the backs of slaves at Fort Jefferson. Their "wages" went to the owners.

As we continued researching the history of the area, we found that the first natural color photographs from an underwater environment ever published came from the Tortugas. In 1927, *National Geographic* magazine published eight "autochromes" taken by Dr. W. H. Longley and Charles Martin, from the *Geographic*'s photographic laboratories.

The prize finds that helped Larry and me deal with our own frustrations about weather, logistics, and funding, however, came from moldy copies of official reports we discovered in a dank, windowless chamber of the fort. They were the monthly reports to the director of the Service from one of the "custodians," as park superintendents were then called.

About the time America entered into World War II, the National

Park Service had placed Robert Budlong as custodian of the fort and 75,000 acres of reefs and shallows that comprise the Tortugas. He brought with him both the protection ethic of the NPS and his own special flair for composing the requisite monthly reports to the agency's director.

In 1942, Superintendent Budlong dutifully reported on life at the fort: the heat, humidity, and mosquitoes "so large that when you swatted them you could hear their bones crack." With the advent of World War II, the fort was in the middle of the German U-boat mayhem for the first six months of 1942. Navy fliers dropped newspapers to Budlong and his wife and made practice bombing runs at the islets.

In his August 1943 missive to the director, Budlong happily reported that the sooty tern population had increased greatly over the year before. "The air is thick with them—this is especially noticeable when the immediate vicinity is bombed or machine-gunned by some passing plane." He also related, in his inimitable style, a run-in with poaching logic—something in which Murphy and I were particularly interested. Budlong had apparently begun a dialogue with the local eggers, who argued that their long-standing tradition of nest raiding indeed had conservation merit. Budlong reported in his August 1943 letter to the director:

> The devotees of the theories of the Second School of Thought agree that the birds will lay one egg, and that if the first one is taken from the nest the birds will lay a second one. Now, note carefully the difference: if you take the first egg, the birds will lay the second, and thereby live to lay more eggs another year; but if the first egg isn't taken the birds won't lay that second one, and the egg continues to grow and grow inside the parent bird until, swollen beyond recognition, it can't lay the egg no matter how anxious it may be to lay it, and the bird dies. Or else it finally actually bursts, when of course it dies anyhow. And then where is your bird colony? Just a lot of males flying around in a bewildered manner and not doing any good. But I have spent hours watching for birds bursting in air, and I have watched in vain. I have made very careful autopsies of dead birds during two seasons, and am greatly relieved to report that no birds were found that died of egg-strangulation either.

Superintendent Budlong considered the poachers' arguments and after due deliberation rejected them. The guilty individuals were put on warning of dire consequences should he apprehend them poaching eggs. He in fact made it known that "in the Dry Tortugas if you must eat eggs, fry them, boil them, or make them into an omelet or a cake, but don't poach 'em." Poaching abated dramatically during his tenure.

In many respects, things hadn't changed much in the Tortugas since Budlong's reign. One still had to rely on mechanical clocks or battery-driven wristwatches to tell time. One of the two generators ran too fast, the other too slow, so most of the government-issue, analog electric clocks sat in boxes. In the age of satellite navigation and radio transmissions to probes at the other end of the solar system, it was hard to finish most five-minute telephone conversations from the fort without the line going dead.

As for poachers, they still played a role in the Tortugas, but they tend to avoid the birds and turtle-crawls in favor of the underwater world—they knew the park couldn't keep a ranger behind every coral head. Too often, rangers found the mutilated carapaces of lobsters where they have been killed by poachers who simply rip the prized tail off the living animal, leaving it to an agonizing death.

But we were learning that the most endangered species of all in Florida waters were the shipwrecks. Just as the poachers had a stake in egging, treasure hunters have a stake in historic shipwrecks. The same thinking regarding cultural resources on public lands that happened to be dry would never be entertained.

Salvors play well on the old admiralty law concept of "imminent peril." The logic runs something like this: The wrecks aren't doing anybody any good out "there," and they will all soon be gone due to the pummeling of wind and wave. Hence, why not let adventurous entrepreneurs go find them and bring their sunken treasures back to the light of day where everybody can enjoy them? For their troubles the salvors should be rewarded with a lion's share of the artifacts.

Actually, shipwrecks tend to reach a chemical equilibrium with corrosive forces in the ocean by the time they become historic and are only in imminent peril from the incredibly destructive search processes that attend treasure hunting. Larry and I mused whether any salvor had proffered the notion that if you remove one artifact,

another will grow in its place—but if not, the site will eventually burst from internal pressure. As underwater archeologists, we had, in the spirit of Mr. Budlong, performed autopsies on many shipwrecks and could attest that we had never seen one that strangled on its own artifacts. It is also an undisputed fact that no one has yet succeeded in mating the surviving members of an archeological site in a museum and bred new ones.

The seeds of this antiquity-harvesting logic, transparent though it should be, find fertile soil in the miasma of state legislatures, some of which happily barter away history as long as the state can get a 25 percent split of the spoils. Thus, the protectors of the people's interest shrewdly hold out for 25 percent of that which is already owned 100 percent by the public. The fact that they had to create an expensive bureaucracy to facilitate giving our maritime heritage away to the highest bidder is apparently overlooked in the accounting process. So, too, is the fact that once in the hands of salvors they are off limits to recreational divers.

So, the wind blew, and finally the skies cleared for a few days, and I got to make a few dives during daylight hours before leaving. Cliff Green, captain of the NPS boat that ferried staff and supplies from Key West to the fort, befriended us. Crusty in 1974, he would be crustier when we returned two decades later in 1994 but he was always a real key to any success we enjoyed in that park.

Cliff took us to the few historic shipwrecks of which the park or state knew the location. We swam over patches of coral reef and turtle grass through which poked the remnants of old sailing ships—sea fans waving from their perch on deck cannon, piles of swivel guns scarcely hidden by stands of Elkhorn coral. We confirmed firsthand what we knew from the archives: The bottom out there held a vast storehouse in knowledge and beauty. Walking about the fort, listening to the waves crash on the moat, chatting for hours with Larry, and mulling over the hundred square miles of underwater park that was being rifled at will by treasure hunters helped me form a resolve.

It had become apparent that the antiquities market was well-funded. It had deep pockets, sharp lawyers, and a certain edge in the public eye. It could come off like folksy mom-and-pop enterprises being bullied by government bureaucracies. In fact, this was occasionally the truth. Some state governments actually were bullying down-

home locals who had found antiquities. And they were doing it simply for a take of the profit rather than any enlightened sense of how history should be cared for. However, this was rare; most treasure firms weren't financed by sunburned, leather-skinned men of the sea, but fat-cat investors seeing it as a lark—they'd have something to discuss over cappuccino if they scored or a tax break if, as was usually the case, they lost their investment.

Realists had already told me that it was impossible to fight these big-money interests, that the American public was too shortsighted to ever protect history under the sea. Maybe, but now I knew that one of the answers might be in the National Park Service. It was the only agency that nurtured Robert Budlongs, that was small and traditional and preservation-oriented enough to take real risks and might suffer idealists such as Larry Murphy and Dan Lenihan. Yes, we were going to return to the Dry Tortugas someday, but I swore it wouldn't be with a rubber boat and token funding. Larry swore with me.

Chapter Six

DAMMING THE PAST

~~~

Reservoirs. Water impounded by dams. Damn reservoirs. The Southwest is full of these creations. Improvements on nature, they tame indolent rivers, allow people to live in floodplains, make profitable farmlands from desert scrub, generate hydroelectric power for towns near and far, and ensure the supremacy of the outboard engine as the primary means of human transport. Shimmering, green reservoir waters have become the domain of a brave new breed of men and women. Feeling the surge of mega-horsepower, gasoline-fed energy under their thighs, and fortified with a six pack of desert courage, they career about the aquatic playgrounds, confident in their ability to control skittering hulls of souped-up boats and "personal watercraft."

Reservoir recreation areas can also be remarkably beautiful places, even if bastardized pieces of nature. I must admit succumbing to their charms myself. Particularly Glen Canyon, which captures the Colorado through stretches of Arizona and Utah. But the decision to sacrifice hundreds of square miles of pristine wilderness and red rock canyons to reap the benefits of electric power, flood control, and desert boating infuriates many environmentalists, particularly in the West. Eco-warrior Edward Abbey wrote a cult classic entitled *The Monkey Wrench Gang*, in which Glen Canyon Dam was the target of a plot to bomb the "abomination" out of existence.

It isn't only the aesthetics of reservoirs that causes significant ambivalence. Archeologists in the 1960s and 1970s couldn't agree on the effects of inundation on remnants of the human past. Were history

54

and prehistory destroyed when covered by impounded river waters or were they preserved forever in an underwater data bank for future generations? Environmental Impact Statements written by archeologists authoritatively maintained both convictions. Because these contradictory positions formed the basis of research assumptions for the most comprehensive and expensive archeological projects ever conducted using public funds, the federal bureaucracy wanted some definitive answers to the "inundation effects" question—fast.

One factor that made the effects of dam construction on archeology so severe was the very nature of reservoirs. River drainage systems are like arteries that provide life-giving water throughout a region. Human settlements from the earliest times to present cities tend to cluster around rivers and streams. This is dramatically evident in water-marginal places like the American Southwest. When dams back water up over the length of a river drainage, the most archeologically rich zone in the entire region is impacted.

To answer the effects-of-inundation-on-archeology question, the NPS was given the ball, and Cal Cummings wanted me to be quarterback. Cal had earned the confidence of the environmental offices in the Corp of Engineers, Bureau of Reclamation, and Soil Conservation Service. They wanted the NPS to conduct the study because it was an agency with no conflict of interest (it doesn't build dams) and is the nation's lead agency in historic preservation.

Cal had every intention of picking up that gauntlet and doing the job right, but he also had clear ulterior motives. He knew the construction agencies had more than a big need—they had funding levels for single dam projects that dwarfed the entire operating budget of the National Park Service. If the NPS was ever going to build a serious in-house capability for underwater archeology, it would be most feasible if it was first funded from the outside and given time to prove itself. Cal knew that underwater archeology isn't terribly more expensive than land archeology once you have an infrastructure in place. Gearing up and getting started was the trick. The deal he cut with the construction agencies was: We'll do the job and solve your problem— you fellas leave the equipment and personnel with us when the four-year job is over.

Although it was clear that his logic was sound, I had a strange ambivalence toward directing the inundation study. I knew it was going

to be an extremely long and difficult job and though I could see its importance and urgency, it would distract me from shipwrecks and caves. And four years—well, four years seemed like an awfully long time to pursue an intense study one wasn't wild about. I decided to level with Cal. He was eminently approachable, and we had communicated well ever since first meeting at Gulf Islands.

I told Cal I appreciated the opportunity to head a large program that could be the basis for a permanent NPS underwater cadre, but I didn't like reservoir research and would much rather work on maritime or submerged cave studies. He gave me a warm, sympathetic look and said, "Too bad, Lenihan. This is where the need is, this is where the money is—you can use this to build your dream or you can go back to Florida." Once I was provided such a clear set of alternatives, the merits of running the Inundation Study grew more apparent.

With green lights in all directions, it was time to start the recruiting process. Because the conclusions of our study would have so much effect on the decisions made by reservoir managers, and hence, the funding and careers of so many traditional land archeologists, I knew that our research design had to be impeccable. I settled on a strategy that would be carried on through the entire course of the reservoir study and two more decades running SCRU. First, I hired people who were smarter than me. Then, we worked hard together to lay a theoretical framework for our field studies that would be unassailable.

The last thing anyone expected from underwater archeologists in the 1970s was that they would take great pains with method and theory. The so-called New Archeology was in full momentum at the time. Proponents of this approach maintained that for archeology to qualify as science, it must work in a hypthetico-deductive framework.

While many established archeologists bridled against the scientific constructs being proposed by upstart young lions, they presented me no problem. I had nothing to lose in going along with these exacting protocols because I didn't have a significant history doing anything else. All that the New Archeologists were basically saying was: Don't dig then inductively provide conclusions; rather, lay out your problems, be clear about your assumptions, describe explicitly what it would take to solve your problems, then dig.

As clumsy as this procedure was for people trying to prove some

abstract aspect of human behavior, it was ideal for us. Our project asked what happened to potsherds, lithics, metal, and wood artifacts after inundation. These weren't soft, behavioral questions, these were hard physical problems that just happened to deal with archeological artifacts.

For eighteen months we searched the literature, laid out testable hypotheses, and developed an explicit 275-page research design that laid out step by step the scientific rationale for everything we were about to do. The only remarkable thing about this approach was that we actually did it. Many archeologists were preaching the necessity of explicit, problem-oriented research designs but we had one tucked under our arms.

During this year and a half, SCRU archeologists also learned advanced diving techniques in almost boot-camp conditions. I had the team take the disciplined mind-set of cave diving and apply it to this new environment. This meant: Practice total redundancy in life-support gear and train to meet each new variable in the underwater environment methodically and carefully. To help in this training process, I contracted with my longtime associates in cave and deep diving. There was even a heated pool on the premises that allowed our divers to keep in tiptop shape. During winter off-seasons the archeologists walked long distances at seven thousand foot elevation in Santa Fe with double tanks on their backs, followed by grueling pool exercises.

When the National Reservoir Inundation Study (NRIS), predecessor of the SCRU team, finally left its mountain hideaway and hit the field in the late spring of 1976 they were wearing NPS uniforms, were well disciplined, well equipped, and in superb diving condition. As luck would have it, three of the five archeologists I hired to commence the study were female. They were smart, ambitious, and highly motivated. One of them, Toni Carrell would end up staying through the transition into SCRU and work for the NPS for twelve years.

Even the crankiest, grizzled, blood-and-guts Chief Rangers had to admit that they were dealing with solid professionals—they began to take particular delight in showing off the females to peers in other agencies. None of the gals were over 5'5" in height and all were lady-like in demeanor, but when hauling tanks and diving, they seemed more like Navy SEALS than lady researchers.

And so began the process of building a permanent program from a four-year project. While we tackled the difficult scientific questions of reservoir inundation on a day-to-day basis, we built a reputation for diving and being park-friendly. By the fall of 1976 we organized and ran the first diving workshop for rangers in the Southwest Region. An indication of the seriousness of the demands we placed on the participants was the logo on the T-shirts the twenty-three trainees had purchased for those completing the course: "NPS Southwest Region Diving Workshop Survivor."

The first workshop was such a hit that it was funded for the next twenty-five years to the present, except for the odd year when the unit has been unavailable to run them. My mind during those first five years was focused on the inundation study but my heart was on a very different prize: a full-fledged permanent commitment by the Service to an underwater team.

So the National Reservoir Inundation Study archeologists visited many of these watery worlds in the desert where the dam builders had preceded. During the four-year study my team dived in most major water impoundment areas in the United States, particularly those in the arid Southwest.

Although we focused almost entirely on reservoirs, we still did some occasional work on shipwrecks and in caves. In October 1977, an instructive incident occurred when we set about obtaining samples of inundated wood for the NRIS. We were moving between impoundments in the Ozark area when Ervan Garrison, an archeologist from the University of Missouri, suggested we might be able to get some tightly dated wood samples by removing small plugs from the wreck *Queen City* sunk near Clarendon, Arkansas, in the White River.

We knew the date of the sinking to the day—couldn't get much tighter than that. It shouldn't be far from a bridge crossing the river and we could probably find it with our magnetometer. The *Queen City* was a Union "tin clad" (lightly armored vessel) that had been sunk by Shelby's raiders during what was known locally as the late great war of northern aggression.

Toni Carrell, Wayne Prokopetz (another NRIS archeologist), Erv, and Alan May from the university, and I headed down a stretch of dirt road next to the river for a quarter mile. We fired up a magnetometer, which located metal through detecting disturbances in the

earth's magnetic field. Then we hung the sensor on a pole and began doing sweeps right about where local lore had it that the gunboat should be. Within twenty minutes we got a hit that almost knocked us out of the boat—"must be it." We hurriedly suited up for the dive, figuring we would devote half a day to securing this plug of wood before moving on to nearby reservoirs.

We found the ship, tried unsuccessfully to video a bit of the wreckage in the murky water, and took our plug of wood for lab testing. The remarkable thing about this story is not that we found the *Queen City*. It appeared to us that anybody who felt like it and purchased a low-end mag could do that; the lesson came from the reaction of the populace. When I surfaced from the dive, I saw close to a hundred people lined up along the riverbank.

My first thought was, God, there's been an accident! Then, remembering we were in Arkansas, and seeing a couple people waving Confederate battle pennants, I thought it might be a lynching . . . mine. Natural reaction after spending years in the civil rights movement. We were in headlines in Memphis papers the next day, then national. We were absolutely flabbergasted by the intensity of the reaction to our "discovery."

Here we had arduously been conducting some first-rate underwater science for two years, visited numerous prehistoric and historic sites in reservoirs, and gotten not a glimmer of interest from the press. The lesson was shipwrecks hold a special place in the heart of the public, and Civil War shipwrecks are more compelling than even gold or silver. I put that lesson to good service in years to come. There was a natural sex appeal to what we were doing that, if packaged right, could generate support and dollars for our program.

But that was something to note for later. We were facing enough challenges in the inundation study—reservoir diving was a frontier of its own at the time. Besides low visibility and concerns over entanglement in barbed-wire fences, and the like, there was the problem of altitude diving, which was poorly understood at the time. The crux of the issue was that people diving from a lower ambient pressure were being exposed to a greater rate of pressure release when they surfaced, thereby intensifying decompression concerns. Because all reservoirs are backed-up rivers and rivers flow downhill, ergo all rivers are at some elevation above sea level.

So we developed one of the first manuals for diving at higher elevations. It was nothing fancy, but it became a staple in the Park Service and beyond. We ended up printing several hundred copies after receiving requests for the booklet from places as far afield as the Royal Australian Navy.

Then there was the major problem we were given to solve about the effects of flooding on archeological sites. It had as many facets as a bag of crystals. With more than a little dismay, we realized that we had to do no less than define the nature of archeological values before we could decide whether or not they had been destroyed.

It's basic philosophical questions like these that veteran practitioners of any science are usually wise enough to avoid, but they are heady fare for a handful of young archeologists selected for the job largely on the criteria that we could dive. We were delighted to rush in where angels feared to tread.

Is the stuff of archeology composed only of artifacts and bones and their relationships in space? What about the textures and colors of soils they occur in; how are they impacted by flooding? What of the chemistry of the soil that is used by archeologists to establish where humans performed different day-to-day functions? Did it become a homogenized soup useless as a cultural indicator? And what about thermoluminesence, radiocarbon, fluorine analyses, and other arcane laboratory tricks. Did those techniques work on materials that had been underwater for years?

Luckily, our systematic addressing of the issues through adhering to that laborious research design served us quite well. Five years later and a thousand-page report wiser, we were able to answer most of these questions with a respectable degree of certainty. The resultant document *Final Report of the National Reservoir Inundation Study* would affect archeology on large public works projects for many years to come.

The reservoirs had simultaneously become a convenient classroom for training, where the highly developed diving skills of the team could be transferred to rangers who were dealing with totally different concerns on a day-to-day basis. At the beginning of the NRIS, I was appointed regional dive officer for the Southwest Region, giving me direct responsibility for the training of rangers involved in underwater search and recovery and boating-related

accidents. Reservoir recreation areas were the scenes of a disproportionate number of drownings. A particular trouble zone was the boat ramps where people often accidentally launched their vehicles along with their boats.

I took a deep breath and looked around full circle. West Texas scenery just doesn't look the same when you're sinking into a lake in a '72 Chevy. Moments before, I had been at the top of the boat ramp, both hands on the steering wheel, thinking the car I was about to drive had seen better days. It had been confiscated by the Del Rio County sheriff from one of the less classy felons his deputies had recently apprehended. The clutch pad was kind of slushy, probably due to the lack of both an intact transmission and much of the engine.

I watched a half dozen park rangers donning their scuba gear on the loading dock at the bottom of the boat launching ramp. They were casting expectant looks back at me, sharing those nervous laughs that usually accompany a situation that isn't entirely funny. The year was 1977, and we were conducting one of the first experiments to determine what actually happened when people sank in cars. The NPS managed many large reservoir areas (such as Lake Mead, Glen Canyon, Bighorn Canyon, and Amistad) with boat ramps. People were ending up in the lakes inside their cars more often as use of these parks increased. As regional dive officer, it was only proper that I should be the first guinea pig. At the top of the ramp I cranked down the window and called to Larry. Since he was not yet working for the Service, I had shipped him in from Florida to help with the workshop on contract.

"Hey, Murphy."

"Yeah?"

"Pretty good experiment, don't ya think?"

"Yeah, brilliant."

I rolled the window back up. I was annoyed that Larry wasn't demonstrating a reassuring demeanor. He seemed nervous about this exercise, and it was becoming contagious. Leaning over toward the passenger seat, I checked for about the fifth time the status of the

scuba tank, regulator, and mask and fins that were wedged into a little pile on the floorboard. I rolled the window back down.

"Hey, Murphy."

"Yeah?"

"I mean, what could go wrong? Six safety divers, hell these old boys could easily get a door open even if I couldn't or, you know, break the glass out if nothing else."

"Yeah. 'Cept, maybe if you was to slide off the ramp and turn over in deep silt."

I rolled the window back up.

"Ready?" I could hear the voice of Warren Beitel, the district ranger, from behind me. I showed him a thumbs-up and heard a click. However the car had been secured to the tow truck, it wasn't anymore. It surprised me how fast I picked up speed just coasting down the ramp. The steering wheel worked well enough, and then I heard the "whump/splash" of impact with the water. Not really bad, but I was glad to have had the seat belt on. It was the old lap-type, nothing coming down across the shoulder.

I started monitoring everything that was happening to me, which was, of course, the point of the whole exercise. Rangers had been forever pulling people out of sinking cars and trucks at reservoir recreation areas. Usually the victims were trying to launch boats, and the trailer and vehicle would get away from them. Sometimes they were committing suicide or being murdered but usually they were just panicked folk being visited by disaster while on vacation.

Even after short periods of immersion, the occupants of the vehicles were in varying states of serious disrepair by the time the rangers got to them, often dead. It didn't seem that such an accident should have such a high fatality rate, and we were going to find out why. How? By going down in cars ourselves to see what was happening to those people—under controlled circumstances, of course. Anyway, it seemed logical at the time.

After the splash, I felt a giddy fishtailing effect for a while. Due to my momentum on impact, I actually was still making forward progress into the lake. What was most surprising, however, was the noise; it sounded like a couple of scuba tanks had had their valves knocked open around my feet. I glanced down several times at my safety tank and it was fine. The air was rushing in from below my feet,

around the foot pedals and from under the seats. Dirty water forced its way through the engine compartment. The weight of the lake compressed the air around me as it rose.

The car was still floating, although more of it was now under the surface. As the water reached my lap I pulled the tank up into the seat next to me and held the regulator mouthpiece in my hand. There were face masks peering in the windows. As we had suspected, it was not possible to open the doors at this point because of greater external pressure, but they were trying anyway. Then, came the water, up around my neck and over my face. Ugly, brown, and opaque, it was much grungier than normal lake water. I surmised that the reason victims seemed to be so inclined to panic in these situations was they were scared silly. For the first couple minutes, they could have exited easily enough by opening the windows, but the natural impulse is to stay put.

Here I had the cavalry at the door and a full scuba tank in the seat next to me, yet the quivery feeling in my innards told me none of the victims ever died of constipation. Okay, observation 1: Occupants who have not left car at this point, besides not being able to hear much from the outside because of all the infernal air hissing around them and grungy water climbing up their bodies, are petrified with fear. It explained some of the anecdotes rangers told me of victims just staring at them wide-eyed, not responding to their instructions to climb out the window.

I determined not to resort to scuba until the last moment. Instead I would try to breathe from the air pocket that forms at the highest point inside the car. As I strained to stretch my neck to the remaining puddle of air in the roof, it occurred to me that I was paralyzed. No, my seat belt was still on. On and jammed. Glurch! I put the regulator in my mouth and cleared it—forget the air pocket drill.

Then my ears started to hurt: I was on my way down. There was a light bounce on the pavement of the ramp, then the car leveled out on the bottom, probably less than twenty feet deep. No sign of my safety divers. The thought occurred that the reason there is no sign of the cavalry is that I was once again moving. Great. Okay, observation 2: When conducting such experiments, secure the frickin' car to something on the surface before riding it into the lake. On a reservoir ramp, it takes off again once it hits bottom.

I began hugging my tank like a long-lost lover, sucking deep on the regulator, suffering an episode of what one might characterize as self doubt. Well, at least that alarmist Murphy was wrong, I was still right-side up. Okay, guys, anytime now; I had to clear my ears again, which meant I was still descending and we'd taken the exercise about far enough.

Scrabble, scrabble, thunk. I heard the bugles blowing, the ranger corps had found me. I still couldn't see out the windows though, because the water in the car was filled with years of grime of human habitation. Then a squeaking sound as the door opened and light and visibility suddenly poured in from the left, a second later from the right. "Hey fellas."

I saw Mike Smith. Mike is big, strong, and . . . "Mike I know you can't hear me but I can't impress upon you how important it is that you help me out of this seat belt before you yank . . ." Too late. Mike had a hold of me and *was* going to pull me out of that car.

Somebody (Cal Myers?) had come in the passenger side and couldn't see a thing but *was* going to make sure my regulator stayed in place in my mouth. Rare are the rangers I have seen who can be faulted for lack of courage, but their zeal in rescue situations sometimes could be tempered by a moment's contemplation. Whatever happened, I knew the regulator wouldn't fall out of my mouth because it was being held in with an iron grip. The problem was no longer not being removed from the car, which I learned later was still slowly moving deeper into the lake. The new concern was being pulled apart by my rescuers.

I'm not really sure of the sequence of events after that—it's all a blur. Several moments later, however, I was being escorted by my rescuers to the surface.

By the end of the day we had learned a lot about getting people out of sinking and sunken cars, and everybody had a turn as driver or passenger. We found that cars could not be considered stable because they were on the bottom. Air pockets made them unpredictable; we had one ranger become trapped when the car settled on his foot after his partner bashed a hole in the rear window allowing air to escape that had been trapped in the roof. We found ways to secure a body in the car after inspecting the scene and have everything, victim and all, brought up as one. We learned that the electronic features, including

lights and windows, still worked under fresh water and many other things that came in handy during real incidents.

Years later, I saw a videotape of a similar but much more comprehensive experiment conducted by the Michigan State Police. Perhaps the most shocking results of the study involved school buses. As in our tests, cars spent enough time floating (usually around three minutes) that there was plenty of time for someone to bail out of the windows if they had their act together. School buses, however, have safety devices built into their large windshields designed to permit firemen easy access in the event of a traffic accident. This same structural improvement ensures that they sink somewhere on the order of thirteen seconds after they hit the water.

There were other reasons it had become important to improve our recovery time of victims of drowning accidents. Classic studies of cold-water drowning emerged during this time that indicated individuals who stopped breathing in an underwater environment under about seventy degrees in temperature might be revived without brain damage, even after periods of immersion approaching an hour.

This put a great deal of pressure on search-and-rescue agencies to improve recovery times. If you believe a victim will suffer brain death and probably cannot be revived after four minutes, you tend to think mobilizing scuba divers for rescue is not a viable option. They can just take their time and just do a methodical body recovery. Almost an hour, however, is a whole new ballgame. The element of urgency skyrocketed.

We ran many drills during our diving workshops, trying different methods for locating and entering vehicles underwater or finding individuals who had fallen off dam structures or boats and drowned. This resulted in dramatic stopwatch trials with a team of rangers racing down the highway in the back of a van, red lights flashing and divers madly suiting up while support personnel readied climbing ropes. We videotaped one of these exercises, and years later I felt the adrenaline coursing in my blood just watching it. The van screeched to a stop at the supposed scene of an accident where someone had fallen off the Amistad Dam (a realistic possibility). The doors flew open, one ranger secured a rope over the railing, and within seconds two rangers in full dive-gear were rappelling down to the water. We were amazed to find we were able to effect this operation, from simu-

lated call to actual diver-in-water at the scene in a little more than six-
teen minutes. One of the rappellers was Ron Kerbo who became
widely known in caving circles in the United States and internation-
ally. Ron became a good friend of mine and Larry's, and he trained us
in climbing techniques and supplied us with invaluable advice over
the years on caves.

Although these types of experiments conducted during the reser-
voir inundation study had little to do with underwater archeology,
they had a great deal to do with what would eventually become
SCRU. The yearly diving workshops our team ran for park rangers
emphasized staying in the forefront of rescue and recovery tech-
niques, not just refreshing our people in basic dive-survival skills.
These same rangers went on to become chief rangers and superinten-
dents, and they were people with whom we had developed a lasting
credibility. They worked with us in hazardous and life-threatening
situations. When the time came to speak of subjects such as sub-
merged sites preservation, the first reaction wasn't to think of us as
ivory tower researchers with thick glasses from the outside. We were
part of the fraternity, and protecting historic shipwrecks and other
underwater resources was *our* problem, not the eggheads'. This inter-
twining of the NRIS predecessor of SCRU with the mainstream of
NPS thinking was to prove invaluable. No budget increase, no dic-
tum from on high could have had the same effect.

In another sense, our close association with field rangers and su-
perintendents taught us a great deal. These people kept us grounded
and honest about our work and affected the core of our research ap-
proach. If what we did in our research didn't make sense to these
folks, there was probably something wrong with it. Scientists and his-
torians tend to become enamored of their own jargon—we had the
basics of our thinking challenged and honed by our gray-green appar-
eled associates who demanded explanations in clear English. Beyond
all that, it simply was a morale boost to be doing this work in the con-
text of an agency we could really feel a part of.

The written products of the inundation study provided us credi-
bility in the academic community that underwater archeology some-
times lacks. Four years of close association with field rangers in
dozens of park areas secured the small team of underwater archeolo-

gists a sense of acceptance and belonging in the mainstream of the NPS ranger ranks.

The time was right at the conclusion of the study to form a permanent NPS entity devoted to underwater archeology. In the spring of 1980, the personnel and assets of the National Reservoir Inundation Study became the NPS Submerged Cultural Resources Unit. We were to provide on-site assistance to all units of the national park system with underwater archeological needs. As the only team of underwater archeologists in the federal government, our services would be available to other agencies or nations at the pleasure of the director of the National Park Service.

I spent my thirty-fifth birthday fingering through the "Role and Function Statement" that would inextricably meld my destiny with that of the Park Service's underwater world for the next twenty years. Blindfolded figures marched in front of me on the TV, then broken helicopters in a desert after an attempt to rescue hostages from someone named Ayatollah Khomeini.

Larry Murphy, who had been working for me on loan for various assignments from the state of Florida had hired on full time in 1979 to the park service, and he and Toni were immediately phased into the newly formed SCRU in 1980. Larry Nordby and Jerry Livingston from another division were indefinitely assigned part-time to SCRU, Jerry, short, muscular, from a Nebraska farm family, was interested in drawing and hunting, and he became our underwater illustrator. Jim Bradford, another excellent NPS Southwestern dirt archeologist, had finished his dive training and was just beginning what would be two decades of distinguished seasonal service with the team.

Our first major assignments would include conducting underwater documentation of a shipwreck under litigation in Biscayne and the ten major shipwrecks of Isle Royale National Park in Lake Superior. However, before I jumped from the reservoir-inundation study headlong into running SCRU, the program that would be my life for the next twenty years, I needed something, a revitalization, a pilgrimage of sorts.

As if in answer to my inner voice, I answered a long-distance phone call and heard in a familiar Southern twang: "Lenihanski, whatcha been up to, man? Wanna stop fooling around in them old lakes and do some serious diving for a change?" Lenihanski indeed.

There was only one person who thought it necessary to condense my Irish/Polish heritage in one name.

"Yeah, Sheck, I think that might be just what the doctor ordered."

# CHAPTER SEVEN
# A RETURN TO XANADU

Heading south from Matamoros you're in honest-to-goodness Mexico real quick. At least that was the case in 1979, when I headed down there to explore the underground waterworld of Tamaulipas. My associates were primarily sons of the Confederacy; South Georgia and North Florida "boys," who comprised the hard core of American cave divers at the time. One female participant helped keep the testosterone level from bursting into the red zone.

Two of the group, Sheck Exley and Paul DeLoach, I had known well from my years in Florida. They were willing to forgive my indiscretion in moving to New Mexico and invite me along. They reasoned that if they could accept my being a Yankee (New Yorker, no less) when I first arrived in North Florida a decade earlier, anything else was comparatively easy to swallow. Sheck had ventured chez moi in 1975 to do a few dives in New Mexico caves, and didn't even ask if he needed a visa—a serious concern expressed by other cave-diving friends. Other expedition members included Frank Fogarty, Dale Sweete, Jamie Stone, Carol Velice, Steve Forman, and Ken Fulghum.

I suspected that there was a real possibility for some archeological discoveries in Mexico, but that was far from the prime motivation for my taking part in this expedition. I needed a break from the responsibility of running research projects. I wanted to dive with people I enjoyed in an environment I loved . . . for the pure hell of it. No scientifically redeeming factors, just exploration for exploration's sake. At least that's what I had in mind when we started. Sometimes

the most stunning archeological finds occur when you're only half looking for them.

An unexplored cave has the attraction of unpursued romance. Both have the potential to hurt you or transport you to levels of experience that make life truly worth living. For me, the risk of doing usually doesn't carry as much dread as the fear of missing out. After a quarter century running underwater research projects, I have come to find that I need this type of revitalization on a fairly regular basis.

We rendezvoused in Corpus Christi. Knowing most of my associates were strongly inclined to keep firearms in their vehicles—understandable when one considers how much time they spent camping beside sinkholes in the cypress swamps of north and central Florida—I thought it best to warn them it would not be wise to have them in Mexico. Their proclivity for guns was partly pragmatic, partly cultural. Backwoods Florida had its share of poisonous reptiles, both of the slithering and two-footed persuasion.

I once stood beside a cluster of cave-diving vans trading lies with my comrades, when we were all startled by the sudden hiss and rattle of a large snake coiled about ten feet away. Before I could form an opinion as to how threatened we were by the animal, a female cave diver, sitting in the side door of her van donning double tanks, produced a .38 revolver from nowhere and shot the snake twice. The approving comments of the men indicated her decisiveness and accuracy were expected in a "standup gal." Yes, it's partly a cultural thing—Southern, Southwestern; just not something you would expect from a Vassar girl.

I offered to stash their arms at a friend's house in Corpus for the duration of our time over the border. After grudging compliance (by most, I think), I squeezed myself into Paul's van and we trundled on toward the border.

The van was seriously overloaded, as were the three other vehicles in our caravan. We were carrying, among other things, eighty-seven diving cylinders. Most were hooked in double tank configurations; some carrying oxygen instead of air, for use at decompression. This created more than a little consternation with officials on the Mexican side of the border.

The border guards looked for their customary bribe while they questioned us about various items in our vehicles. My friends were

not thrilled about the shakedown and the easygoing, good-ole-boy smiles started to fade as the process continued. I negotiated with the increasingly irritable and pushy guards in my broken Spanish as the level of tension became tangible.

The Mexicans told me the unusual number of tanks required a greater financial blessing because only someone planning to illegally sell them in Mexico would carry such a quantity. We were not impressed with this line of reasoning and especially didn't like the manner in which the guards were poking through our life-support equipment.

The southern cave-diving fraternity of the 1970s was known for being fairly volatile when provoked. A cross-cultural incident of an ugly sort was brewing, so I moved quickly to secure a generous donation for the Border Guards' Ball. Hopefully, we could get on with the trip.

About the time I had collected what seemed from prior experience, a more-than-reasonable gratuity, one impatient guard grabbed a set of cave-diving cylinders and shoved it roughly aside. The double tank manifold banged loudly against the side of the vehicle. This was somewhat akin to driving a truck over a climber's rope. The failure of a manifold in cave diving approaches a worst-case scenario, much as failure of a rope in climbing. The owner of the tanks shoved past the official, examined the valve, and with the veins standing out on his forehead explained what would happen if another hand was laid onto his equipment. There seemed to be no language barrier in getting his point across.

Now, truly alarmed, I shoved the money I had collected into the hands of the lead Federale, bid him a series of *muchas gracias*, and helped Sheck herd our group back to their vehicles. Sheck was our nominal expedition leader and actually had a better command of Spanish than I did. He knew his associates well—they weren't the young, unsure-of-themselves-in-a-new-country college kids on holiday that the guards were used to dealing with. He was poised to insert himself if a melee broke out, and I was grateful for his calm, but assertive, demeanor. I had been feeling mellow, not psychologically prepared for the unpleasantness, and was more than a little rattled as we left the border behind.

Behind the wheel, Paul was still complaining vociferously about

the incident as he sped us down the road. Paul had curly, black hair and an avuncular disposition, so he was often called "Uncle Paul" by us. Sheck silently studied the map while I laid back, hat over my face, to collect my nerves. Paul briefly paused in his diatribe to ask Sheck, still gazing at the map, where the hell "Alto" was. He didn't like the fact that all the Mexicans in Alto's outskirts were standing around with automatic weapons staring at us. I sat up as if I had been jolted with an electric probe: "Stop Paul! Goddamn it, stop!"

The interior "frontier" checkpoints in those days had rectangular white signs that looked like those greeting the motorist entering a small town in the United States. The "alto" was in small black capital letters but meant "stop" nevertheless. Given the sociopolitical mood in Mexico at the time, it was wise to obey. Another series of apologetic explanations and we were on our way again. So much for collect-your-nerves snoozes; an auspicious beginning to what would prove to be an extremely event-filled eleven days.

The air in this part of Mexico was wet and thick. As we moved deeper into the Huatla range, the pungent essence de Méxique seemed stronger. I was more accustomed to the western portion of the Mexican "frontier" where the air is dry and crisp, even as you approach the Sea of Cortez. Physical similarities to Sonora and Sinaloa are few, but the feel of Mexico is similar.

There was a different ethic in Mexico regarding litter, which adorned the roadside with such consistency that a break in its presence startled the eye. A gap in the endless strip of roadside pampers, Agua Mineral cartons, cement bags, and broken glass would have seemed like a fault in an embroidered hemline. This fed the perception of Americanos del Norte that Mexico is "dirty." At the turn of the millennium this ethic seems to be transforming.

I'm old enough to recall the early fifties in the United States when the anti-litter campaign was just getting into full swing. The automobile window was God's own trash disposal until we Americans of the North decided littering was unwholesome. Concepts of dirt and disorder are largely cultural phenomena. Cultural anthropologists have written much on this subject. Some iconoclasts of the environmental-

ist persuasion, such as Edward Abbey, have even suggested the real environmental wound is the road, not the litter. He made a point of always throwing his drink cans out of his car window in symbolic protest to paved roads.

"*Bonjour,*" Paul greeted the man on the donkey-drawn cart. Cognizant his strong point wasn't language skills, he then leaned back in his seat to let Sheck continue the conversation.

"*Señor, ¿dónde está el nacimiento del Río Sabinas? ¿Allá? ¿Es Allá?*" Sheck was pointing through the mud-spattered windshield of the van as he finished his query about the birthplace of the Sabinas River.

"*Sí, allá*" from the man who pointed over his left shoulder with his right hand while never letting his gaze wander from the front seat of our van.

"*Cuántos kilometros?*" I piped in.

"Too many" he said in English, glancing down at our wheels, which were one-quarter buried in the mud. We had been following the dirt road for several miles after having noted clear water passing under the paved highway several miles back. In this area, clear water meant groundwater; groundwater meant springs; springs meant the possibility of underwater caves.

"*Gracias, buenos tardes, señor.*"

The man on the cart smiled, flicked the reins, and replied "*De nada.*" Glancing at Paul he waved and bid him "*Bonjour*" as he rolled on. We could roll nowhere ourselves until the other van and the four-wheel-drive vehicles showed up. All of us would push like crazy to get the vans going again and the remainder jump into their four-wheelers, as the procession pushed into the hills.

An hour later we located the artesian spring from which flowed clear subterranean waters that downstream merged with ordinary surface runoff to form the Río Sabinas. We couldn't care less about the river—it was the springs and the caves within, that is, the birthplaces of the rivers, that had drawn us so many miles.

We persevered until we found our spring in a rugged area with some flat heavily vegetated land around it. After a night's sleep in a meadow next to Río Sabinas, we were ready to begin our exploration.

The several-hundred-yard walk and stumble over river cobbles with full cave-diving gear were hard on my wet-suit–clad feet. The oversized double cylinders on my back weighed more than a hundred pounds, particularly since they had been stuffed with air well beyond any legal or prudent limit. The tanks were each capable of holding 102 cubic feet of compressed air when filled to their normal working pressure of 2,400 Pounds per Square Inch (PSI). These babies were supercharged to 3,400 PSI, their overpressure ports neutralized by our inserting two bursting disks where only one was indicated. Of course, this meant the tank would explode before the safety disks ruptured and harmlessly released the air. But we had weighed that possibility against the consequence of running out of air in a cave and made a choice.

The propriety of such treatment of diving cylinders is more than a little arguable, but to a team of divers about to push the envelope in cave exploration, the niceties of cylinder handling is far outweighed by a desire to carry a lot of air. With the steel pressing heavily on my back, the array of lighting systems pulling down heavily at my waist, and each step a challenge in balance, I began uttering silent prayers that I would make it to the spring where I could at least drown in comfort. Once there, it took a while to compose ourselves for the dive. A couple of our team members had managed to drag small oxygen cylinders along to aid in the decompression.

After recovering from the exertion of getting to the water, we slipped below the surface and were greeted by the familiar relief of the weight lifting from shoulder straps and waist. The myriad lights and gauges and hoses that encumber a fully equipped cavediver seemed to rearrange with a mind of their own into a much more logical configuration. Dive gear, particularly cave-diving gear, is meant for swimming, not for ambulatory humans.

A spelunker named Bill Stone had reported that there was a serious cave here, and from the size of entrance and the force of the outflow we had little doubt he was correct. Bill would, in later years, become a well-known cave diver in his own right, but, at this point, he was passing on his subaqueous finds to Sheck. There were five of us on this dive: an unusual number. We preferred diving in twos and threes and occasionally fours. Everyone was hoping to get a shot at

Sabinas before the thunderheads moved in. It had been hard enough driving into this place and we didn't want to push our luck.

At 180 feet deep the angle of repose of the bottom cobbles became even steeper, and the ceiling came down sharply to meet it. The cobbles had the disconcerting tendency to slide and roll if we touched them with our fins. This happened more often as we were forced closer to them by the converging ceiling. Presently we were faced with a major constriction. Where the ceiling met the floor of the spring, the water was emerging from a very wide aperture not high enough to enter.

We spent a couple minutes digging through the cobbles dog-style until we could make it through this tight point and were rewarded by the cave immediately opening up into a large tunnel with a more gentle slope. Jamie Stone, Carol Velice, and I kept to the ceiling while Sheck and Paul moved along the bottom twenty feet below us. We were now well over two hundred feet in depth and, after our digging exertion, were feeling no small amount of nitrogen narcosis.

The trick with narcosis is to know when you've had enough on any given day. For whatever reasons, about five hundred feet into the penetration I started to react adversely to the depth: I felt slightly nauseated and increasingly apprehensive as the nitrogen "high" started turning into a low. I checked my depth gauge, which was reading 250 feet, and signaled to my partners by waving my light beam ahead of them in a swift, erratic motion. All stop!

Had there been no further complications, I would have simply signaled my distress and indicated that I needed to "call" the dive. One of my nearest buddies would have accompanied me out while the others proceeded. I never had the chance to communicate further.

As the team members turned to check on why I had flashed them, two events occurred almost simultaneously. Sheck's sealed beam light imploded from the pressure with an ear-ringing "pow," and we could hear a rumble from the direction of the entrance.

It has always amazed me how things can go to hell so fast on a cave dive. One moment gliding through a new world, all receptors open to the excitement of the exploration, and the next, the distinctive feel of one's mortality rising in one's throat. My heart rate picked up perceptibly, and I took pains to calm my breathing before making a slow-motion turn and proceeding slowly back towards the entrance.

Exertion, excitement—anything that could result in overbreathing the regulator—could be fatal in our present position.

Air at this depth is very dense and harder to move through one's internal airways and mechanical appendages. Increased exertion generates carbon dioxide, which, in turn, aggravates the narcotic effects of nitrogen, and an unpleasant series of effects quickly takes over which usually result in one becoming a statistic. Sheck and Paul, who had been moving below us on the floor of the tunnel, tied off the guideline before joining us on the ceiling for the trip out. Their tie off was 290 feet deep.

Somehow, I wasn't surprised at what awaited us at the constriction. A cloud of silt hung ominously in the otherwise crystal-clear water; it surrounded the point we had burrowed through, our white line pointing precisely back into the heart of the murky puff of smoky-looking silt. I ran my hand along the line and felt it disappear into a pile of those damn river cobbles. Since I hadn't been in the best of shape before all this happened I decided to back out of the constriction and give my partners a shot at solving the puzzle. I settled back into the clear water and considered our situation.

I recall how strangely calm I felt as I coldly started assessing our chances. They were really rather marginal. Within minutes, which seemed several hours, Paul came out of the cloud and motioned me back to the line. I followed him back into the silt and through an exit he had dug several yards over from our entry point. I shot him an okay signal (kissing him would have been awkward) and proceeded back to the decompression stops in a business-like fashion, striving to preserve the false impression that none of this had shaken me up.

At the proper opportunity during the two hours we spent decompressing from the dive in the open part of the sink-hole, I swam discreetly over to the side of the spring. There, I vomited violently through my regulator. You can fool others, but it's harder to fool yourself. I knew exactly how close that reaper had come.

This was to become an extraordinarily thrill-packed week and a half. Each day brought a new cave and new discoveries. With the exception of the unpleasantness at the border we found the Mexican people very friendly and gracious to what must have been a bizarre-looking group. We would park our vehicles in fields or river washes on the edge of towns and bed down for the night, only to find in the

morning that we were usually in some thoroughfare. People, pigs, donkeys, and chickens would be parading between us in the morning, going about their business. They were more tolerant of the crazy gringos than I'm sure we would have been of them if the situations were reversed.

We found ourselves working in a karst system that was characterized by typically greater depth and greater temperature variation than the Florida caves. Some water was in the mid-60s Fahrenheit and in others it reached the low 80s. There were troglobitic creatures in some and amazing concentrations of prehistoric artifacts in others. The latter ranged from ceremonially "killed" ceramic vessels with telltale holes poked in the bottom, to ceramic figurines and alabaster "thunderbolts" cast by Aztec gods.

One of the springs called Mante was an extraordinary place, a geologic fault that seemed to drop forever. With hardly any lateral penetration we reached depths over 270 feet. Sheck and Paul tied a line off here at 330 feet deep, deeper than one is ever supposed to go on air. Over the next ten years, Sheck would return to this spot in a Mexican cow pasture and set the world's depth record for scuba diving and break it three times using a combination of helium and oxygen instead of air. He would eventually reach 860 feet deep and report a bottom still slanting down into some nameless underworld.

The future was not on our minds, however; we were too absorbed with the discoveries and obstacles each day brought. A major problem was a lack of a compressor with sufficient delivery to keep up with so many tanks. We finally decided we had to make a run to Tampico, several hours away, to fill our tanks. There were no dive shops there at the time, but there was a Coca-Cola plant that needed compressed gas services. The "planta," or drop place, for oxygen, carbon dioxide, and acetylene bottles in Tampico was called INFRA. The plant manager said it also had banks of compressed air to which he kindly provided us access. We prayed there was no breakdown in communication; a set of tanks mistakenly filled with oxygen would prove lethal at the depths we were diving.

The air we obtained at INFRA was indeed air, but it had a funny taste, and if we were anyplace but this wonderland of opportunities we wouldn't have dived with it. The biggest concern with contaminants in breathing air is the presence of carbon monoxide. It bonds

with the hemoglobin in red blood cells much more readily than oxygen and can create a situation in which the diver can't utilize the oxygen in the air being breathed. This happens even though there are more oxygen molecules actually available in the lungs because of the increased partial pressures at depth. The real irony is that if the diver gets deep enough, fast enough, the free molecules in the aqueous portions of the blood are so numerous that it can sustain the body's needs until the return to shallow water where blackout occurs.

Carbon monoxide is odorless and colorless but the by-products of combustion often give it away. It smells kind of like you were hanging around a bus station. This air didn't have that odor, it just smelled . . . weird. We headed back inland with full tanks and heightened spirits—we were ready for anything.

We arrived in Rio Verde, a small town on the way to San Luis Potosí. There were a series of springs there called Media Luna. We dived in the evening under a full moon in "half moon" spring. Unlike the other places we had been diving that were previously unexplored or "virgin" holes in cave diving's hopelessly phallic prose, this place had been heavily dived. Mexicans and Americans from Texas had frequently used this attractive and easily accessible open series of open sinks for sport dives. At the hundred-foot-deep bottom, there was a "boil," which is how cave divers refer to a strong outflow of water from a fissure in limestone. A tree trunk had fallen into the spring and was lodged into the crevice from which water was emerging with great force. The tree's branches were vibrating in the strong current.

We studied the situation for a few moments, and Sheck, Paul, and I tugged on the log until it pulled loose. Paul shined his light down to illuminate the fissure while Sheck and I pulled ourselves face first against the current through the restriction. It widened at about 130 feet deep, and the force of the water relented, allowing us to use our hands for things other than propulsion, such as switching on our primary lights.

Sheck immediately started scanning the craggy interior of the room for further leads to increase our penetration. Meanwhile I picked up a shiny object reflecting in my light and studied with disbelief a perfectly formed alabaster serpent (variously interpreted as a thunderbolt). Almost everywhere I looked there were ceramic Aztec figurines, bones, and other artifacts. Returning from his probing of

the chamber for more cave openings, Sheck stared wide-eyed at what I held in my hand. After several minutes staring at the treasures we returned them to the ledges where we had found them. Sheck took no convincing to do this; he respected the sanctity of caves. He has probably explored more underwater caves than anyone in the world but believed in leaving them the way he found them, natural and cultural wonders intact.

Paul couldn't tell from his vantage point at the top of the fissure what we were doing, but knew we were using precious air in a hole that obviously didn't go anywhere. He waved his light several times to remind us what we were here for, and we reluctantly made our way out. I can't account with confidence for the presence of those artifacts except to infer that they were ceremoniously tossed in the spring. Such a concentration of undamaged ornamental items in a small area suggests purposeful deposition for sacrificial purposes. The submerged spring would have appeared a mysterious dark blue spot during daylight hours—an inviting target. Also, there is an ethnographic and archeological analogy for this occurring other places in Mexico, even in other springs we located on this trip. Why no one had ever pushed into the fissure before us is beyond me. I would keep its existence secret even now except for the knowledge that this hole has since been excavated by the Mexican Institute for Anthropology and History. One of our group removed and photographed one of the serpents before returning it. A copy of the photo in hand, I reported the find to Pilar Luna, the head of the group's underwater program in 1980, and they took action by 1981.

A particularly strange series of events took place when we visited the Hotel Tanunil, a rather fancy establishment oddly situated on the road from Vittoria to Tampico. We had literally drawn straws to determine which teams had the honor of being first to "penetrate a virgin system." Although Sheck, Paul, and I had the first shot at Rio Verde, for some reason I can't remember, I was still owed one when we pulled up to the office of the hotel.

We weren't interested in rooms since we were all camping, but the fellow at the desk had some intelligence about entry into Río Choy, a magnificent spring that you could drive to if you had a key to the gate. It was on property owned by the distinguished gentleman who was also proprietor of the hotel, one Señor Gaston Santos. For a

reasonable consideration, we hoped the gate key might be obtainable from the desk clerk at the hotel.

Meanwhile another contingent of our group had made the discovery that the swimming pool of the hotel was spring-fed, and even more compelling, the shed that comprised the well-house had a pipe disappearing into what appeared to be a limestone fault. While the dickering went on at the desk over the gate key, I quickly donned a single tank and grabbed a small secondary light, while Paul maneuvered the van to block any view of the well-house door from the hotel.

I soon emerged from the side door of the van, slipped through the well-house door, and plunged into the crystal-clear pool. We were of the opinion that, in this case, asking forgiveness would be a more hopeful route than asking permission. I couldn't understand why I was always so lucky when it came to this short-straw thing and wondered whether being apprehended diving a well-house in Mexico was a felony. Paul assured me it didn't matter; they probably shot you for misdemeanors anyway.

The dive was brief but surprisingly interesting. There was no penetrable cave, but I spent awhile making sure, because it was real, real close. I could extend my light through the fissure at the bottom of the fault and see wide-open going, it was just not quite big enough to get through even with my tanks off. The group was intrigued with my report after they had safely closed the van doors around me on my return. They would do a night assault if there was any question in my mind, but there wasn't.

As I dried off, I could see that Paul and Sheck were still in buoyant moods, unusual after a negative report about a cave. "The key, you got it?" The smiles answered my question, and we were off down the road to Río Choy. The only downside was a sore throat—for some reason, that air from the planta didn't seem to have any other physiological effect on us except to leave several of us with whopping sore throats for several hours.

The hydrology involved in creating a place like Nacimiento Río Choy is understandable intellectually but hard to comprehend in its reality. The water is artesian, powered by gravity as it emerges fountain-like from the top of a mound of rocks several meters above the level of the surrounding land where it cascades down to become a small river. We could drive right up to the site but had to then clam-

ber up and over fifteen feet of steep rocks to get to the surface of the sinkhole, while carrying approximately 120 pounds of tanks and lights.

This climb occasioned the second time on this trip that I would be placed in a life-threatening situation, by far the most bizarre in my diving career. About midway up the waterfall slope my foot wedged between two of the large rocks. In trying to extricate myself I lost my balance and was pushed over on my side by the force of the water and the double 100s on my back. My extended arm was the only thing preventing me from going face-down, and it was holding a good portion of my upper body weight. Paul and Sheck at first thought this amusing until they realized that once my hand gave way, my face would be underwater.

I was in serious danger of drowning in water twenty inches deep. The gibes we usually shot at each other, in lieu of sympathy for minor injuries, stopped; both started quickly divesting themselves of their own gear so they would be able to reach me. They were suddenly in a high-stakes race against time. No words were exchanged, nor were they necessary.

I stared at them intently as I developed a case of "sewing-machine arm," an expression climbers and cavers use when an overstressed limb starts to go into spasmodic shaking before finally giving way. Paul reached me first, grabbed the tank straps where they crossed my chest, but by now I couldn't help push and he was only delaying the inevitable. Sheck then maneuvered to my right and somehow got a firm grasp on another strap. Between them, they were able to pull me forward. Once that happened, the crisis was over. I couldn't use my arm, but I was able to extract my foot and continue up the last few feet and roll into the pool of water at the top of the cascade.

Gasping for breath, we gathered at the top of the falls. My wrist was swollen to twice its normal size but I was okay otherwise. I was also the only one still fully dressed, equipment in place for the dive. I broke the silence with a question: "What the hell has been keeping you guys?" We lay in the pool on top of that silly Mexican waterfall and laughed insanely until our nervousness was discharged and my wrist had reattained some semblance of normalcy before we started our dive.

Río Choy was a hummer of a cave. Sheck ran the reel as we pro-

ceeded through this cavern that had a very irregular ceiling about 130 to 140 feet deep. We couldn't see the bottom most of the time, so we hovered high and ran our line between the lower ceiling projections. We decided to check one of the irregularities in the overhead and swam up a steep limestone projection.

We soon came to the surface inside the cave. We were in air, but the ceiling pocketed out a little way above us. The next projection resulted in the same finding; having dropped down to 130 again, we watched our depth gauges return to zero as we headed up to the next air-filled room chamber. There were portions of this cave above the water table, a very rare occurrence in the Florida caves. None of us had ever seen a formation like this—a series of what Sheck dubbed for lack of a better name "surge chambers," imagining a process of roiling surface water that might have formed them in eons past.

We couldn't keep ascending to check out the different overhead leads due to decompression complications, so we just continued at the 130-foot depth. At this point we had what might be termed a little quarrel in mime among friends. Sheck didn't want to loop the lines on the ceiling projections because it would complicate the mapping process on the way back out. We usually mapped our way on the return, noting depths, distances, and compass azimuths from the safety line, which was knotted every ten feet for this purpose. Paul and I were keen to map the place also but were even more keen to come out alive.

We kept visualizing what would happen if that line were to snap and recoil with no bottom reference. Sheck indicated considerable irritation when he noted Paul had looped the line behind him, ceremoniously undoing it and waving him off. We thought about that for a while and silently overruled his objection. At appropriate points Paul would pull some tension on the line emanating from the reel in Sheck's hand so he wouldn't feel the tugs, as I stretched the nylon cord over convenient limestone projections.

After about a quarter mile of penetration the cave suddenly dipped deeper, met a floor at about 160 feet, and became siltier. We had pushed about as far as we could anyway on this dive and it was a good time to call it. On our return to the entrance, Sheck accepted the discovery of our "wraps" with a resigned shake of his head.

On exiting Río Choy after a lengthy decompression stop, we

clambered back down the mini-waterfall in which I had almost met my demise and trekked wearily but happily back to Paul's van. The adrenaline was keeping us on a nervous high. Thinking that the day's adventures were over, we weren't prepared for the nature of our reception at the vehicle. Two jeeps were parked behind it, and five men were standing there eyeing us with what seemed a mix of curiosity and amusement. What struck me immediately about their apparel, aside from the fact that it looked decidedly more expensive than that worn by most Mexican field laborers we had been rubbing shoulders with, was the belt accouterments. They sported exceptionally large 45 automatic pistols. The desk clerk from the Hotel Tanunil was sitting in the back of one of the jeeps with a sheepish look on his face—so much for honor among conspirators.

"Hey, so, uh, *buenas tardes*," from me.

"*Bonj* . . . , uh, hi y'all," from Paul.

"Good afternoon," from the apparent leader of the Mexicans in pretty decent English.

"You know you are diving on property that is private to our boss, Señor Santos." This was not a question.

Sheck took over at this point and nodded. "*Si*." Then he gave them that Exley grin and offered his hand. I've never seen anyone turn down that offer from Sheck. His eyes conveyed a double-edged intensity that crossed language barriers. They seemed to say, "I'm a friendly fella, and I'm really enjoying meetin' ya, and you really wouldn't want to deal with me when I'm not feeling friendly no matter how big those *pistolas* are, and nice evening, eh?" It's true, Sheck really could say all that with a handshake and a grin.

"Mr. Santos wants to meet you."

Paul's eyes rolled in a circle as he glanced at me, and we both listened intently as Sheck responded, "Gee, that would be nice, figger we could drop by tomorrow?"

"No, he wants to see you now." This was not said with belligerence but firmness. The man then followed with a line that should rank in the top few I've heard in my life. "Mr. Santos wants you and your friends who were at the Tanunil [hotel] to join him for dinner . . . he said to tell you," the man paused here and his lips curved into the beginnings of a shy smile, "uh, . . . that he insists on meeting

you because he is glad to have finally found someone who may be as crazy as he is."

For a long moment we stood silent, mouths open and eyes dazed, reflecting our astonishment. Sheck, after glancing at Paul and me (no help there), turned back to the men and said, "Well, okay, sure we'll just get changed and . . ."

"And you will follow us." He then extended his own hand and added, "and I take the key from you now, okay?"

Sheck pulled the key to the gate from his pocket and handed it to them. We dressed quickly and our chastened little caravan of vehicles meekly followed the jeep full of private guards to Mr. Santos's hacienda.

Within moments we were ushered into an outdoor seating area, a very miniature amphitheater of sorts, and hesitantly took our seats. We had hardly settled onto the benches when ladies in colorful finery appeared and began serving us coffee and sweet rolls from platters they deftly balanced against their shoulders. These were well-trained servants, and some quite attractive. "Uncle Paul" was still not sure about the extraordinary developments of the last hour, and I saw him eye his sweet roll warily. More trusting, I was convinced something more was going on here than ritual preliminaries to an execution for trespassing. I downed my sweet roll with gusto.

Then we met Mr. Santos. He rode into the midst of what I realized was a private bull ring, in the full regalia of a matador. Mr. Santos's name, we learned later, carried about the same anonymity south of the Río Grande, as did John Wayne in the U.S.A. It was only our cultural ethnocentrism that left us in ignorance of the name of the most famous Portuguese-style bullfighter in all of Mexico.

This style of bullfighting is done from horseback, and Mr. Santos's name and face were plastered over walls surrounding bullrings throughout Mexico. He had apparently kept up on our antics at the Tanunil and other caves in the immediate area because he owned the hotel and most of the land one could drive to in ten minutes in any direction.

He entered the ring looking neither right nor left and proceeded to perform a series of extraordinarily deft maneuvers striking at and retreating from an imaginary bull. The fine nuances of technique were lost on us gringos, but we were thrilled to see the performance

and bask in what was now the firm conviction that we were truly guests and not prisoners.

There followed a fascinating evening of banter and storytelling. At the hacienda, we sat down to a lavishly prepared and served meal. A highly educated man, Santos rivaled us in both our command of English (somewhat surprising) and our ability to shamelessly embroider tales (very surprising).

When he told the story of his brush with death in Río Choy, however, I could sense he was sharing something that had deeply touched him. We were quiet as he recounted the episode in which he had, true to the nature of a bold man, decided to procure scuba equipment and dive in the mysterious water source located on his property. In the basin, or open part, he located and removed a mastodon tusk and then decided to experiment exploring the cave that led away from the basin.

It was a story, variations of which we had heard from other lips a hundred times. People take away memories from fearful experiences and close calls in various degrees of vividness—there is something about almost drowning in a cave, however, that causes the strongest soul to shudder and leaves an impression that doesn't dull with the passing of time. The nature of the incident was straightforward: He swam in through clear water, staying in sight of light, the silt came up, and, presto—his world shrank to within eighteen inches of his face. No matter how many times we hear stories like that, it hits home. All of us, at some point early in our association with caves, had dabbled at the brink of disaster. As he spoke, each of us seemed to quietly withdraw inside and consider our own early brushes with mortality. He saw in our eyes an empathy for the trauma he suffered that he probably would never find in anyone else.

Mr. Santos concluded the evening by touring us through his huge trophy collection: Exotic animals of every description, including a polar bear, were mounted in the hallways and antechambers of his home. As we departed, late that night, he insisted we take the tusk he had removed from Río Choy as a gift. After trying to refuse it many times, Jamie and Carol put it in their van. As we drove away from the rancho I wondered if Mr. Santos had insisted on us taking that memento of his dive because in some strange way, he felt we were the

only ones who could also take away the demon that lived within it . . . and within him.

This experience just added to the tempo and spirit of the expedition—we had been making one exciting discovery after another—some within the earth and, like Mr. Santos, some within ourselves. My revitalizing holiday had turned into an orgy of exploration. The archeological finds we had to report to Mexican authorities were, in themselves, stunning. We became tired and took even greater risks.

In the cow pasture of a field near the town of Mante, we found a spring that emerged from a shallow indentation in the side of a hill. Within hours we had dived the place to the limits of any semi-sane air diving. On the first dive, I watched my depth gauge edge over the mark at 270 feet when Jamie Stone, my partner, found a good tie-off point for our line. Before we had finished our decompression stops, Sheck and Paul passed by us on their way to extending our line. By the time we emerged from the water, it had been extended to a depth of 330 feet. Our dives at Mante brought our expedition to an end. We had fittingly ended with a spring that seemed to be going on forever.

Exhausted and sated with adventure, we made our way back to the border, and to Corpus. There I rearmed my friends, shook hands, and pointed my Volkswagen van back toward Santa Fe. We all returned to our respective lives, taking with us memories that could never be purchased by the richest of millionaires.

In later years, Sheck would return to Mante several times to further extend our exploration line to incredible depths that constituted consecutive world records for deep diving. Using gas mixtures that included helium to reduce narcosis, he achieved a depth of 680 feet. He then broke his own record when he took the line in Mante to 860 feet deep. I was preparing to visit him in Florida in the spring of 1994 with my family and some members of the SCRU team, when news reached us of the results of his latest and boldest attempt at securing the record.

He had mentioned weeks earlier that he was going to put an end to his deep-diving obsession. He told me that he wanted to tie a knot at 1,000 feet. "You know how I am about round numbers," he chuckled over the phone. I was a bit bothered because, in his most recent depth record in a sinkhole in South Africa, he had run into visual-distortion problems that made him terminate the dive at 860 feet. The fact that it happened to be where he chose to terminate in Mante made me uneasy.

There are no guidelines for diving to a 1,000 foot depth without use of sophisticated and expensive facilities and huge commercial or military commitment to support the dive. I hoped Sheck's own body wasn't trying to tell him something that gas laws and decompression theory could only suggest from studies with rats.

Sheck made his way back to Mexico and, with an associate from Austin, tried to execute the dive that would again break his own world deep diving record and allow him to quit at a "round number." It didn't work out that way. When Sheck surfaced, it was many days later and only because his body was entangled in the descent line. His gauge indicated he had been to 905 feet.

Sheck's book *Caverns Measureless to Man* was published posthumously. The title came from the lines in Coleridge's poem that he felt epitomized cave diving:

> *In Xanadu did Kubla Khan*
> *A stately pleasure-dome decree:*
> *Where Alph, the sacred river, ran*
> *Through caverns measureless to man*
> *Down to a sunless sea.*

I have never been able to think of Sheck, and the sunless seas we shared, or cave-diving without Xanadu popping into my mind. I hope he's there now, laughing that slow infectious laugh at Kubla Khan's jokes, laying line that never needs to be wrapped and setting records in perfectly round numbers.

In 1999, while representing the United States on an international committee related to UNESCO, I visited the Palacio de Bellas Artes, in Mexico City, where the Mexican Institute of Anthropology and History (INAH) had a display of underwater archeological finds from

their excavations. In one corner there was a fascinating array of ceramic figurines and alabaster serpents that had been scientifically removed from Media Luna. Sheck would have been happy to see that the artifacts he had treated with deference were twenty years later being enjoyed by the people of Mexico.

# PART II
# THE SCRU TEAM

The new team tackles the most difficult
shipwreck studies in the nation,
embodies an aggressive preservation ethic,
discovers and documents historic shipwrecks from
Florida to Alaska, and the Great Lakes,
maps the USS *Arizona* in Pearl Harbor, and
studies the haunts of pirates and prehistoric
cultures in Micronesia.

## CHAPTER EIGHT

# BISCAYNE: BAPTISM OF FIRE

—◦◦◦—

L arry Murphy is on fire. I am very tired, and full comprehension
of his predicament is slow to form in my bleary mind. His, too.
He casts a puzzled look at me from his position on the bounc-
ing bow of the twenty five-foot patrol boat as if waiting for orders.
Flames emerging from a small generator lashed to the deck lick up his
gasoline-spattered trousers and shirt, over the funnel in his hand, and
on up to his uniform baseball cap. I say, "Jump," and he steps back-
wards into the ocean, disappearing from view with a sharp sizzle.

Corky Farley, the ranger who has been steering us the past few
hours through survey lanes pre-plotted by our computer, grabs the
fire extinguisher as I take the helm. Hands on the wheel, I watch
Larry over my shoulder so we won't lose sight of him bobbing on the
waves. Still moving away at a slow, three-knot survey speed, we can't
turn back for him. We are towing a marine magnetometer, a cylinder-
shaped device at the end of fifty feet of cable, which would wrap in
our prop. Also, with the wind coming from behind us, flames would
wash over the boat if we came about.

The whoosh-whoosh of the fire extinguisher assures me Corky is
tending the blaze. "Got it," he yells. "Don't take your eyes off him."
Corky's feet pound over the fiberglass deck, and I feel him take the
wheel as he slips by me into the driver's seat. Then he tracks Larry as
I race to the stern to haul in the cable towing the magnetometer.
Within seconds, I toss the whole works on the deck, reacquire Larry's
position from Corky, and yell, "Hit it!" Adrenaline has cleared away
any remnants of my stupor. The boat's mega-horsepower engines

come alive as if happy to be finally doing what patrol boat engines are supposed to do: speed.

Good grief! Systematically, almost somnambulantly, searching for a historic shipwreck one minute; Keystone Kop fire drill the next. The fire resulted from gas spilling against the red-hot manifold of the generator. Poor form, filling a generator like that on a boat, but we finally had a complex array of high-tech hardware and software working. We weren't about to shut the system down because the generator's gas tank only holds a two-hour supply.

As Corky leans the craft into a tight turn to port, I keep my arm extended directly at Larry's bobbing head so Corky can use my extended limb as a compass rose and align the now-speeding boat with the direction I'm pointing. Within seconds we are bearing down on him. At the last minute, Corky cuts the engine and turns sharply to starboard, heeling the boat's left side into the marine version of a hockey stop. He lets the wind carry Murphy the last few yards to our port stern.

Larry is treading water, hat in place, sunglasses on, funnel still in hand; he hasn't even kicked off his deck shoes.

"Hi," he says.

"You all right?" Corky asks.

"Think so."

We help him in over the swim platform at the stern and sit him down. Amazingly, he is only burnt a bit along his right arm and hand, still clutching the funnel. Corky takes it from him. "Won't need that for a while."

"Why? Are we going in?"

Exasperated, Corky unfolds one finger at a time. "Well, Murphy, you just turned yourself into a flambeau, the front of my boat looks like it took a direct hit from an incendiary round . . ."

"Okay, okay," I interject. "Let's go in and regroup."

The treasure-hunting community in the Keys found it amusing that a bunch of Smokey Bears intended to find, in less than two weeks, a wreck in an area in which they had been successful only after years of searching. But that was our intent. The SCRU team had been offi-

cially in existence for less than a year when another in a series of gauntlets had been thrown down, this time by a federal district court in Miami. It was July 1980, a time when the eruption of Mount St. Helens was fresh in our memory, Reagan was running against Carter for president, and we started hearing about some scary new disease killing gay people in San Francisco.

Even at the time, it was illegal to search for antiquities in National Parks without an antiquities permit. But how to enforce it? On land there were explicit regulations against using metal detectors, but there was no such corollary on the water. Even if a looter removed items from the bottom and wasn't caught directly in the act, he could claim that the item came from outside the park in state waters where rules were much more lax. Treasure hunting was a time-honored tradition in the Keys with most locals willing to wink at transgressions.

But I didn't think the winking would apply to federal judges. When the park protested that a treasure permit could not be let on historic shipwrecks in a national park, the court said, in so many words, that the agency had to demonstrate its stewardship by finding the site. In the silly world of state politics and circuit courts, the NPS had been challenged Old West style to "slap leather."

The wreck in question was reputed to be a treasure-filled Spanish galleon brimming with gold doubloons and silver pieces-of-eight. In fact, all wrecks in Florida were reputed to be treasure-laden Spanish galleons, even the ones in which people had to push aside boiler tubes and steam fittings to get to a good digging spot.

The irony of it all was that most of the greed-driven damage was concentrated on maritime archeological sites that carried nothing but a treasure of knowledge: priceless information on the lifeways of seamen, insights into a maritime past that was quickly decimated by the frenzied bottom clawing of treasure-seekers.

Most destructive were the commercial operations that had invested in propwash deflectors. Elbow-shaped metal tubes, lowered by winch over the stern deflected the full force of the vessels' propwash downward. These powerful devices could blow huge holes in the bottom sands, destroying any context of the artifacts and much of the remaining structure of buried ships. Where necessary because of deep sand overburden, they could be carefully used by archeologists to make contact with the first layer of cultural remains. In the hands of

treasure salvors they were used to blow the wreck and associated coral into a soup of encrusted wood, concreted metal fastenings, and hunks of live coral. The one thing that survived this punishment quite well was gold and silver. These deflectors were called "mailboxes" in the Keys and attributed to treasure hunter Mel Fisher. They had actually been in existence for other marine applications for decades.

Early reports regarding the wreck we were looking for was that it was definitely wooden and fairly early; the rest was probably wishful thinking by the salvors. But that was immaterial to us; an ancient wreck in park waters is sacrosanct regardless of what treasures it might hold. Biscayne National Monument (now Biscayne National Park) almost entirely comprises submerged lands located south of Key Biscayne. They were/are owned by the people of the United States. We had been given three weeks by the court to find the remains of a two to three-hundred-year-old wooden vessel embedded in the coral and sand of Biscayne National Park within a nine-square-mile search area. What this decision had to do with the time-honored and, to all appearances, legal principle of not screwing over antiquity in national parks escaped us, but the court is the court. If we hoped to keep our tenuous hold on heritage sites in parks with submerged bottoms, we had to win this case.

We and our associates at the NPS Archeological Center in Tallahassee agreed the only way to succeed at such a task was with state-of-the-art electronic positioning. A week flitted by before we could convince the suits in the regional office that we couldn't do the job by towing a magnetometer and using sextants to position the boat. We were left with a grand total of eleven days of project time. Our operation using the electronics would cost a thousand dollars a day, not counting our normal salaries. The suits finally capitulated, and there we were, with the electronics we had insisted on and under a lot of pressure.

The key to winning resource protection battles in the parks is largely a function of getting the local park staff on your side. When we pulled into the government dock at Biscayne, with Murphy's burnt forearm soaking in our ice cooler, and told the chief ranger what had transpired, we were at a critical juncture. He could have curled into an ass-covering ball of green and gray and lectured everybody on boat safety. Instead, he listened carefully to his rangers offering to take us

back out all night without pay, and said: "I don't want anybody hurt. Paint that smudge off before morning and take these lunatics [us] back out if you really think you can do it without bloodshed."

The fact that the NPS has the oldest nonmilitary diving program in the country, consisting of 150 collateral duty divers spread throughout the park system, was one of the elements in the equation that made the rather remarkable accomplishments of the SCRU team over the next two decades a reality. It should also help one understand the level of intensity that attended our operations in the parks and why Chief Ranger Tim Setnicka let me and a freshly bandaged, just-returned-from-the-emergency-room Larry Murphy and a still smoking generator back out on the waters of Biscayne that night, even though he knew we were turning his park into a war zone.

The SCRU team could only succeed by working at a fanatical level of intensity and the NPS was perhaps the only civilian agency that had the collective personality to nurture such a group. Steeped in almost a century of "rangering" tradition, the folks in the parks understood SCRU and took it under wing. The unit was absurdly tiny for its mission but during the NRIS it had built a support network that was still growing in many of the 300-plus units of the national park system. Biscayne had just become one of them.

Nine square miles is a very big piece of underwater real estate to survey comprehensively in the time allotted, especially with the technology available in 1980. With less than a week to prepare for the work at Biscayne, Larry and I stopped off at an ocean engineering firm in Houston to learn how a Del Norte positioning system worked. To someone using a PC today it doesn't sound daunting, but in those days it was like deciding to take a two-day course in astrophysics before blasting off for the moon. In later years Larry would swear that the computer that formed the base of the technology had a hole in the side for a crank-starter.

"Crap, it went down again."

The patter of the rain on the tarp draped over our heads was slow but relentless. The tarp kept the rain off us and the computer, but it also blocked the breeze. Sweat poured off of Murphy's brow as if he were still in the rain. His uniform was soaked through with perspiration, and mine wasn't much better.

"Damn!" This erupted from underneath a neighboring plastic cocoon where George Fischer was monitoring the output of a Geometrics 806 magnetometer.

Crammed in the stern of the 25-foot white patrol boat (with a freshly painted bow) was roughly a hundred thousand dollars worth of electronics, including a magnetometer to find iron—a component of all shipwrecks—and an electronic positioning system that tells you where you are when you find it. The onboard computer stored the boat's location within several meters of accuracy every second.

It was the first time we had used such sophisticated technology, and it was horribly demanding and frustrating, yet crucial. If we were to find this site in such a large area in such a short time, it is critical to know exactly where we had, and had not, been while towing the magnetometer. Treasure hunters didn't use precise positioning systems at the time, but a model for covering large blocks of submerged bottomlands for shipwrecks scientifically had been demonstrated by the aforementioned Carl Clausen, working with a young marine archeologist in Texas named Barto Arnold.

We learned early on that Larry has a much greater proclivity for dealing with computers and recalcitrant electronics. George, from the Tallahassee office, who had originally hired me years before, likewise had more patience in this area. I returned to the dive boat to supervise in-water examination of magnetic anomalies. On this day I had as one of my divers, Jack Morehead, the superintendent of Everglades National Park. It was July 4th, a national holiday, but he couldn't stand all this happening several miles away at Biscayne without getting involved.

Jack Morehead was the living epitome of the park ranger tenacity that suffuses the agency. Although his background was forged on the

climbing walls of Yosemite and Canyon de Chelly and as a ski instructor for mountain troops, he had learned to dive as early as 1959. He conducted many working dives when he was superintendent of Isle Royale. At fifty years old, he had wavy white hair, a ready smile, and was in great physical shape. Jack had lobbied for the creation of SCRU and was here to make damn sure we succeeded, even if it meant taking his turn on the endless dives checking out anomalies. Each day he called for a progress report, checked in by phone, or, if he could spare the time, was waiting on the dock with his neat pile of dive gear and a little insulated cooler bag he carried each time he boarded our boat.

A high-ranking Park Service official, Jack would never have needed to get his feet wet in the field. Two years earlier he had attended one of the intense training programs we ran for NPS divers at Amistad. His presence at the course, designed for down-and-dirty, find-the-body, fix-the-buoys field rangers helped generate support for our fledgling group.

As we headed the dive boat for a set of marker buoys dropped by the mag boat, I heard the characteristic click and lowering of radio static that meant someone had keyed their transmitter. Larry's voice crackled a recommendation to bypass the next several targets we were slated to "ground truth," in favor of one close to where he had just made a pass. He had broken the pattern of survey lanes that they had been tirelessly following and were now running the mag back over the same area from a different direction. I knew he had a hunch.

I radioed back, "Roger . . . switch to direct." The allusion to "direct" meant we were now transmitting only line-of-sight and could not be monitored by any but nearby craft, and we seemed to be alone on the ocean that day. All the usual holiday mayhem common to water parks was probably occurring nearer to shore.

I turned to Jack and said, "You don't mind getting on the troll-line again, do you?"

We were moving over clear water less than thirty feet deep so we could visually cover the area best by dragging divers from lines suspended from the stern. They held a Danforth anchor, which could be tilted in such a way that water rushing over its surface depressed or raised the diver like a poor-man's dive sled. They usually used their snorkels but wore scuba in case they needed to descend for a longer

time. The "trolling" reference was to the timeworn gallows humor that this technique was reminiscent of trolling for sharks, with the diver as bait.

Jack, though recently returned from an hour on the towline, had no complaints about getting back in. He and our assigned boat operator were soon in the water while I joggled the throttles to diver-towing speed—around one-and-a-half to two knots. The radio crackled back to life, and I heard Larry's voice.

"Head toward red buoy after lining up from due east, bear eleven o'clock after passing buoy, pattern back from thirty yards north."

"Roger."

I watched Jack slide over the surface, methodically turning his head left to right as we approached the red marker. It looked like a lobster buoy the park had confiscated from an illegal trap.

Suddenly, Jack was gone. A ranger sitting in the stern monitoring the person being trolled, noted it as soon as I did. "What the . . . ?" It was okay to depress the line, but against our protocol to leave the line without giving a signal to the monitor, who, in turn, would tell the boat operator to put the engines in neutral. Running boat props anywhere near a diver has to be done with extreme caution.

Within ten seconds Jack was back at the surface sputtering. He switched from snorkel to his regulator mouthpiece, yelled something incomprehensible, and darted down again. A minute later he was on the surface and with our engines now cut we could hear him plainly.

"Dan, there are cannons all over the bottom, artifacts, ballast, ship structure . . . get the hell in here!"

I radioed the survey boat that we were deploying an anchor and that they should "raft off" alongside. They should come in from the north and stay clear of divers in the water to our south. Our helmsman had already joined Jack on the bottom.

The exhaustion from the past ten days wrapped around me like a damp blanket. Emotionally as well as physically depleted, I sat alone on the gunnel, bouncing in the gentle swells, and watched the survey boat approach. Soon everyone from both boats was in the water except Larry and me.

"You knew, eh?"

"No way to know, but I damn well felt it. Long, continuous anomaly, multiple spikes. It smelled right."

Within minutes we had our tanks on and were splashing over the side. There was still the chance it was a different wreck from the one the salvors had found.

Our "dive suits" in these climes were not especially trendy. We found the most practical apparel was a pair of blue jeans and an old neoprene wet suit top, loose fitting, with the forearm zippers ripped out. This provided plenty of protection against coral, jagged metal, and stinging hydroids on the bottom and sun on the surface. If one was going to dive all day, it also precluded ever having to change one's garb.

As I pushed away from the boat and broke the surface, I noticed sea fans and turtle grass bending steadily in a moderate bottom current running in a different direction than the lay of the boat from its anchor. The next thing I took in were the irregular shapes on the bottom; man had indeed intruded into this world at some time in the past. Lastly, I noted my growing sense of calm and well-being; away from the frantic surface activity and blaring radios, for the first time in days I could melt back into the world in which I feel the most at home.

I came down near what appeared to be a large coral head, but as I drew nearer it was obviously something man-made, encrusted with coral. My mind starting putting the shapes into some semblance of order and searching for an explanation. Under the encrustation was a hodgepodge of . . . junior bowling balls? Not likely. A shot locker? Yes. Apparently, there was once a stowage area for cannon balls. The wood had long ago decomposed, but the iron shot concreted in a manner that kept the shape of the old container.

Wooden vessels from the sixteenth or twentieth centuries—or any time in between—seem to share certain similarities in the way they break up. They tend to disarticulate along the turn of the bilge, that curved area where the ship's sides seem as if they are taking a sharp curve toward the keel. The end product of that process is that they all get flattened out into about five or more pieces representing sides, bottom, stern, and bow. The light superstructure is often broken off and separated by ocean dynamics from the rest.

I knew there was structure under me, beneath the sand, because of the way the coral, grass, and marl had dispersed; but I had no idea what part of the ship it was. The first clues I looked for were usually

features such as ports or scuppers which would tell you the structure was from a part of the ship above the water line. Then, I check for frames or ceiling planks which means you were looking at the inboard rather than outside planking of the hull. But no such evidence yet.

The most visible feature beyond the pile of shot was the line of ballast rock. If the wood ran under it, we could reasonably assume we were looking at ship bottom rather than side, but still nothing solid enough to start putting the puzzle together. I tried not to guess and to wait to see something definitive. Once a half-baked interpretation of a site is begun, I find it tends to build on itself—the mind starts arranging the evidence to fit the preconception.

I followed along the bottom, seeing now the first of the cannon Jack had noted, then another and then ... then the signs of the vandals that had preceded us. Rebar, the modern gnarly steel rods used to reinforce concrete, were driven into the bottom at set intervals every few yards. Not far from each rod was a "doggyhole," as we called those places where divers had kneeled forward on the bottom and paddled sand back between their legs like a mutt trying to dig for a T-bone. Usually, I had mixed feelings on finding these: part of me wanting to slap the cuffs on the greedy dullards; then that part that was kind of curious about what might be just a little deeper in the hole. But this time, I had no such conflicting emotions. It was rapidly becoming clear that this was a serious archeological site and these folks had begun systematic plundering. The holes reminded me of prehistoric Mimbres sites in the Southwest worked by pot hunters, except the physics of working in air made the latter more likely to use shovels and rakes than to dig dog-style.

To my left was another cannon, this one wound multiple times with nylon rope. There were chunks of black, with the look and texture of badly burnt bread, laying about in the white sand. It was apparent that the salvors didn't like where the cannon was and had moved it, paying little heed to what it bounced against on the bottom. The black "junk" that had chipped off the gun tube could easily have concreted artifacts which were now separated from their provenience and probably destroyed. Obviously the treasure hunters knew the concretions had potential—some of the larger ones were smashed open. Any chance of x-raying the globs and retrieving delicate arti-

facts, or even using the concretions as forms to make wax molds of what they once held, was lost.

I glanced at the trunnion of the gun facing me. It was shiny where black concretion had broken off. I felt what was becoming an all too familiar sense of sadness in the pit of my stomach—the one that comes over me when I see mindless destruction like this. That trunnion could have had an intact maker's stamp or have left an imprint of a trademark in one of the pieces of black scattered hopelessly about the site.

Swimming further, I noticed green-stained wood and slivers of green and black concretion again in pieces. Cuprous. Anything visible they thought was copper or brass had been ripped from the site. Murphy passed by me absorbing the signs of pillage—he raised his arms in a frustrated gesture—why? I shrugged.

He motioned to me to look at something, and I swam to where he pointed at a pile of ingots that had been chipped at. I looked closer and felt slightly bemused—it was iron, pig iron. Bet that was a disappointment when they finally muscled one to the surface and found it wasn't silver. But this find had additional significance. The reason the stone ballast pile was comparatively small was this ship also had pig-iron ballast, something we associated with British—not Spanish—vessels.

Then we both came on another cannon, this one with the cascabel or iron bulb at the back extruding from the sand. We looked closer. The gun wasn't buried so far that we couldn't see the outline of what appeared to be a Tudor rose engraved on the top. This Spanish galleon had English faience pottery, pig-iron ballast, and a goddamn Tudor rose on its guns. Any one of those things is not enough in itself to judge nationality because people captured other people's ships and traded for goods. In fact, there was some Spanish olive jar pottery on this site, but given the range of material culture we had observed on this dive, it already was becoming apparent to both Larry and me that this ship was no more Spanish than Queen Elizabeth. Before we ever laid eyes on the site, George Fischer had been suspicious of its supposed origins just from what he knew of the reports from the treasure hunters and the local record of ship disasters. Indeed, Spanish ships were known to be down in the area, but so were vessels of other nationalities of the same period.

We climbed back on board. The good news was that the damage to the archeology, though significant, was not severe. With the documentation we would be able to present the court, it was doubtful that the pillage would be allowed to continue. Jack Morehead came back up at that moment and we helped him over the transom.

Knowing full well our frequency was being monitored and it would be like making an announcement to the entire Florida Keys, I picked up the radio, switched from "direct" to the long-distance repeater channel, and sent a terse message back to headquarters.

"NPS dispatch, this is park patrol boat Survey Two, 10-20 Legare Anchorage . . . eagle has landed." It might have been silly, maybe a little melodramatic, but damn, it felt good. Larry smiled. Jack shook his head chuckling.

"Eagle has . . . indeed." Then, more serious, "You know they're never again going to find it quite so funny that people in Smokey-bear hats are protecting historic shipwrecks in the Keys."

Within a half hour, most of the park patrol boats in south Florida were rafted off or anchored in the area. We had obtained a tight electronic coordinate with the transponders. But the boat rangers, having little trust for gizmos they had seen malfunction and short-out for the better part of a week, took a host of ranges and bearings and even backtracked through the reefs holding out their hands, two or three fingers extended, "taking visuals." With their ubiquitous brown briefcases open, handles of 357 magnum pistols exposed, notepads flapping in the breeze, they wrote things like: "48 degree bearing from Caesar Creek, wait til Turkey Point stacks equidistant, then hard right until patch coral breaks up and three fingers separates Rhodes Key light from E. shoreline." I knew better than to take lightly what they were doing. It never ceased to amaze me how they could return precisely to a spot on the reef flats miles from shore using those arcane methods.

Still dripping from our dive, we let our boat drift a ways from the throng, Larry and I conversing with Jack. Suddenly, Jack glanced around conspiratorially and reached into the little cooler bag he had been bringing aboard each time he visited the operation during the last week. I had been curious what was in it; now I knew as I heard the pop-tops spritz open and smelled the odor of beer mix with the salt breeze.

"Been carrying this damn thing for a week, never had a doubt it would get opened."

*Postscript*

Along with Florida State students George had shipped in from Tallahassee over the next few days, we documented the extensive remains of what we were becoming convinced was an English vessel, probably naval. It had been heavily vandalized by treasure hunters but was luckily large enough a site and hard enough to locate that most of it was still intact. It holds a wealth of information on early eighteenth century naval and shipboard life, and we had gotten it a reprieve from destruction, so that it could be properly excavated and displayed. After several more preliminary studies, the HMS *Fowey* is, at this writing, being prepared for major excavation by the Park Service.

The courts, owing largely to our passing the judge's curious find-the-wreck test, deemed the remains property of the American people. Florida State University archeologists, working for George, continued archival research and analysis of artifacts in the lab. On some of the latter, they soon noted English "broad arrow" markings. They determined that the wreck was that of a British man-o'-war, probably the HMS *Fowey*, recorded lost in the vicinity in 1748.

In frustration, the head of the local group of salvors passed out place mats at his restaurant identifying the coordinates of the wreck to attract looters and spite the Park Service. His claim to the site died in court and in a final twist of dramatic irony he too died—gunned down in his own restaurant for reasons unknown.

As to searching in parks for antiquities: Several years later SCRU had the opportunity to help in the rewrite of CFR 36, the Code of Federal Regulations that applies to managing national parks. There is now a stipulation in that code that anybody carrying a magnetometer or side-scan sonar into the waters under the jurisdiction of a national park must have the instruments broken down, crated, and stowed while in park boundaries.

Rather than accompany us to Biscayne, Toni Carrell had been putting the final touches on the Inundation Study Report and readying us for our departure for Lake Superior. She was helped in those preparations by scientific illustrator Jerry Livingston, who would help us face the difficult challenges we anticipated to the north.

One event did occur during this rushed period that, minor in importance for SCRU, would have long-range implications for me personally. Larry and I were busy for a while filling out the accident forms that God and the bureaucracy demanded be filled out in full when mishaps happened. Having burnt and trashed more than our usual quota of boats and people, there was a lot to fill out. The lady who reviewed such forms in the regional office at the time was intrigued by the creative irreverence we employed in such paperwork and asked to meet us. A pleasant, attractive woman, just moved to Santa Fe from being a fisherwoman in Alaska, she was shown around our facility and promised to keep in touch. She and I did stay in touch—her name is now Barbara Lenihan.

# BULLY HAYES AND OTHER SHARKS

—◦◦◦—

Talk in the South Seas is all upon one pattern; it is a wide
ocean, indeed, but a narrow world: you shall never talk long
and not hear the name of Bully Hayes, a naval hero whose
exploits and deserved extinction left Europe cold . . .

—*The Wrecker* by Robert Louis Stevenson

Not long after SCRU became a going concern, the Pacific
Isles seemed to become inextricably involved in our destiny.
Within a year of becoming a permanent team, we received
the first request for assistance in promoting underwater preservation
in the South Pacific. After dealing with the problems of Biscayne and
a brief reconnaissance trip to Isle Royale earlier that year, the thought
of moving on to the Pacific Isles in the Santa Fe winter seemed pretty
enticing. As January 1981 rolled around, we were ready for a South
Seas adventure. The hostages had been freed in Iran but too late for
Carter—we had already elected Reagan. And some fool had shot John
Lennon to death . . . after first making sure he had obtained his auto-
graph.

The request for our services came from the former Trust Terri-
tory of Kosrae. Although we had plenty to keep us busy in the Na-
tional Parks, the Department of the Interior (including NPS) has
special obligations to provide assistance to present and former trust
territories. From that came our mandate. From the Pacific itself,
came the crying need and the romantic attraction.

Over the years, I never had trouble recruiting divers from other
NPS divisions to help SCRU on projects in that part of the world;
and they were always ready to return, apparently suffering mass am-
nesia regarding how burnt-out and exhausted they were from their
last assignment to paradise. As a point of accuracy, all but one of the
projects that SCRU tackled in the far Pacific (far west of Hawaii, that

is) took place in Micronesia, which is actually north of the equator. I
refer to the area herein as "the south seas" in conformance with pop-
ular American parlance that dates from Robert Louis Stevenson and
continues through *Victory at Sea* and *South Pacific*.

Actually, the word Micronesia says it all. It is a place of tiny land
and great water. It takes several hours to cross Micronesia in a com-
mercial airliner but you could fit its entire land mass into Vermont.

I eventually developed a love/hate relationship with projects in
this part of the world. The logistical challenges of working in the far
Pacific were staggering, but so, too, were the rewards. Micronesian
people have all the same variability between individuals as anywhere
else but the people of Oceania seem to share a oneness with the sea
surpassing anything I have witnessed, even among island folk in the
rest of world.

The natural diversity in the marine environment in the western
Pacific is stunning. Single harbors contain a greater range of life
forms in the coral mazes fringing boat channels than can be found in
the entire Caribbean Basin. The only downside for a small research
team like ours, is that "Micro"nesia (the place of tiny lands) is so
damn big.

When Larry, Toni, and I first arrived in Kosrae in 1981, the only
way to fly there was to take the Air Micronesia "milk run" from Hon-
olulu to Guam. It made five stops over a thirteen-hour period. Pon-
ape was about two thirds of the way to Guam. One disembarked
there, then secured a charter flight via propeller plane three hundred
miles to Kosrae.

Our introduction to a more relaxed style of life began minutes
after arriving in Ponape. There was no airport except for a small
wooden kiosk bordering a gravel pullout adjacent to the landing strip.
We stood in a milling crowd of people who were coming/going, on-
looking, whatever, it was incomprehensible to us. We watched our
signature, large, orange, fiberglass boxes taken from the plane and
loaded on the back of a pickup by three fellows, who then joined the
luggage in the truck bed. They held on for life as the vehicle made a

sharp racing curve and headed for the kiosk. One of our boxes did a complete back flip off the back of the truck and slammed down on the hard runway with a sickening crack. Naturally, it was the one containing our video system. The driver sheepishly got out and helped the others load it back on, very gently.

I heard Larry mutter to Toni, standing next to him as they surveyed the scene, "glad the buggers are being careful now." Uniformed, briefcases in hands, we stood out from the crowd anyway; all of a sudden, we stand out more because, well, we're the only ones standing. On some signal we didn't catch the entire crowd hit the deck, crowding around the kiosk, faces covered with hands, hats, whatever was available.

Larry just managed to get a "what the . . . ?" out of his mouth before the jet blast hit us. With no push-back vehicles, the standard procedure for the "Air Mike" pilots was to goose it on one engine and burn out in a cloud of gravel and hot air. As we extracted ourselves from where we had joined the rest of the crowd in a heap behind the kiosk I heard Toni remark half to herself that "Toto, I've a feeling we're not in Kansas anymore."

From Ponape we boarded our chartered prop plane for Kosrae, as we mulled over the observation made by bystanders at the kiosk that the latter didn't have the developed amenities of their island. The whole distance, we passed over every shade of blue and green imaginable, the water surface hinting changes in depth and nature of the coral and sands below.

The exotic, roughshod beauty of Kosrae is not confined to below the water's surface. The island is dominated by a volcano that looks from a distance like a sleeping lady. Unlike Pacific atolls, Kosrae has only a fringing reef rather than a lagoon surrounded by a strip of land. We found ourselves quickly caught up in the pace of life of the islanders, who shared their customs and lifestyle easily and graciously with outsiders.

It seemed the exclusive domain of Japanese pickup trucks. In the humid, tropical air filled with salt spray, rust is a blight that takes an incredibly quick toll on even comparatively modern steel alloys. People traveled standing up in the pickup beds, feet splayed, to ensure they rested on cross-struts that wouldn't collapse beneath their weight. We soon found ourselves in the same feet-splayed stance,

hanging on for dear life as we and our equipment were hauled from the airstrip to the village of Utwa.

Our mission in Kosrae was to evaluate some ship remains reported to reside in a cove where a river entered the ocean near Utwa. The Historic Preservation Officer of the Trust Territories of the Pacific Islands (TTPI) had requested the Department of the Interior to send its underwater archeology team to ascertain if the wreckage might be that of the *Leonora*, a ship owned and mastered by the notorious Bully Hayes.

Hayes had made quite an impression in these parts. Many islanders bear the Anglo-Irish family names of the rogue's men. He also made an impression on American folklore of the sea. "Blow the man down—blow that Bully man down," this is the Bully referred to in that popular sea chanty. James Michener immortalized this seaman's outrageous, often violent antics in his book *Rascals in Paradise*. He was a notorious blackbirder, thief, woman-abductor, swindler, brawler, and all-around badass.

Not long after losing the *Leonora* during a storm while anchored in Utwa Harbor, he liberated another vessel from its rightful owner. It is not clear, in some instances, whether the women he abducted were also liberated, as their level of resistance to being taken often seemed arguable. He simply removed them and their husbands' ships from their husbands' oversight. Historical accounts indicate that some of the ladies actually got into the spirit of it all and showed some reluctance at being ransomed. Considering the oppressive elements of traditional European and American society toward their gender in the 1870s, perhaps there was a certain attraction to a gentle abduction for a life of exotic travel. There is no indication Hayes abused the women. As various hearings and court cases showed, kidnapping and piracy were hard charges to make stick with old Bully.

The colorful Mr. Hayes hailed from Cleveland and learned his seamanship on the Great Lakes. After an extraordinary career in the Pacific during which he was variously labeled in American newspapers pirate, slave trader, womanizer, thief, murderer, charming gent, and a praying man, he managed to become stranded when he lost the *Leonora* on March 15, 1874. At storm's end, knowing his reputation for borrowing the ships and belongings of others, two whaling vessels immediately fled Kosrae when they learned the fate of the *Leonora*.

Among the items lost with the ship were several copper-clad wooden water tanks and large amounts of ship's apparel and trade goods. Through some twisted logic Hayes decided that the natives must have stolen some of his goods and demanded they pay him 48,000 coconuts as he settled in to wait for a potential rescuer or someone who owned a ship to his liking. Some missionary ships arrived several months later, and he managed to con one ship's master into taking him on to Ponape, then Guam. He was arrested by the Spanish and moved to a Spanish prison in Manila. Here, he underwent one of his conversions or metamorphoses of convenience, this time to a convincing Catholic, and was released.

In 1877, returning to Kosrae from Jaluit on the good ship *Lotus*, which he had stolen along with, as was his custom, the owner's wife, Hayes ran into stormy seas—in more ways than one. He had a dispute with the cook, Dutch Pete, which was settled out of court. When Bully headed below to obtain a pistol to enforce his stated decision to throw the cook overboard for "poor steering during rough weather," the man sneaked up and bashed him on the head with a boomcrutch. Being struck with this doubled piece of seasoned hickory had a similar effect to a full swing with a weighted baseball bat. Pete and the first mate tossed Bully overboard, thus ending with a splash one of the more interesting maritime entrepreneurial careers in the Pacific.

Jim Stewart, dive officer of Scripps Institution of Oceanography, confirmed that divers from a Scripps research vessel had seen signs of wreckage in the harbor some years past. They had given the artifacts they had retrieved to the curator of the *Star of India*, a clipper ship converted to a floating museum in San Diego. After the curator of the museum let me examine the artifacts I knew we were definitely in the right ballpark. The ceramics, bottles, bronze gudgeon—all would have been appropriate for a ship the vintage and size of the 1874 brigantine *Leonora*.

When we accepted the invitation of the Trust Territories of the Pacific Islands to evaluate the site, they gave us the name of a native Kosraen who was working at the time in Ponape. Our liaison was an energetic, intense young man named Teddy John. Newly drafted into historic preservation from baggage handling for Air Micronesia, he coordinated the considerable logistics for us to conduct research diving in the remote village. He also joined us in all-night spearfishing

expeditions to secure food for traditional Kosraen feasts and soon be-
came as much friend as liaison.

The living conditions in Utwa were indeed rustic. We three
shared a block house with a tin roof with a Peace Corp volunteer
named Paul Ehrlich, who was also a diver and had written a historical
treatise on Bully Hayes. We slept on frond palettes and shared an out-
house, which featured a hole in the cement floor as the commode. A
rubber hose provided a gravity feed from a river for the shower. We
had to squat or lie down and hold the hose over targeted anatomy no
higher than two feet to get a steady flow. There was a small screened
area outside where villagers brought us breadfruit, fish heads, rice,
and the like for breakfast. It wasn't fancy but actually quite pleasant,
once one adjusted.

We soon learned that Kosraen feasts were called at the drop of a
hat but were nothing to take lightly. When Larry and I offered to help
in hunting the fish that would invariably be a major course in addition
to the slaughtered pig, we found ourselves spearing fish in the moon-
light until 4 A.M. The wake-up call for our day of research diving was
6 A.M.

Toni Carrell, though not expected to take part in hunting due to
Kosraen custom, was not summoned with the rest of the women on
our return to cook the fish. But she voluntarily engaged in a fair
amount of food preparation. Larry and I wore uniforms or shorts and
T-shirts while on the island. Toni, when not wearing her NPS uni-
form, in deference to Kosraen custom, wore a skirt, the hem of which
extended well below her knees. Oddly enough, there probably would
have been only minor adverse reaction from the most Christianized
islanders if she went topless. However, Toni seemed disinclined to ex-
periment with that theory—she figured that was a question for eth-
nologists not archeologists.

The *Leonora*, situated at the mouth of a river, is covered by silt and
tons of dead coral, mud, and marl, concealing most of its features.
The village of Utwa is also subject to significant tidal changes. Al-
though the tidal level only changes a few feet, the harbor is shallow
and we found we had to walk a hundred yards offshore to enter the
boat during low tide.

Our first visit to the site of the wreck thought to be *Leonora* was
via motorized outrigger canoe and catamaran-style fishing boat. We

pulled into the shallows so we could stand up with enough room to put our tanks on without tipping over the outrigger. I couldn't wait to see what was below us. Kosraens piled aboard the catamaran fishing boat to watch the action. They speared fish, any fish at any size it seemed, to marinate on deck for meals between dives. To the question "What kind of fish is that?" the answer was invariably, "Sashimi."

We studied the bottom carefully as we entered the warm, clear water. Most of the wreck remains were covered in thick coral and deep silt. It was, after all, the mouth of a river. The depth is not much more than thirty feet anywhere on the site. A swim of about a hundred yards would have taken us out of the harbor and over the fringing reef. The depth there dropped away to the deep blue abyss.

As our eyes became accustomed to the bottom life on the site, the cultural anomalies began to take recognizable shape. There was very little wood but there were many metal fittings including iron and brass pins and a number of sheets of copper sheathing. Because copper sheathing was used typically below the waterline only to protect against marine borers (wood-eating teredo worms), it appeared we had found some lower section of hull where the wood had not lasted but the articulated sheathing kept the shape of a small portion of hull. Then, there was what appeared to be the remains of a bilge pump and a large coffin-shaped container clad in copper that was the most visually dominant artifact on the bottom. It extruded from the side of a deep silt-covered coral channel.

We puzzled over the latter, because the shape of it made no sense for sheathed hull or rudder assembly. Then we recalled the historical record that listed water tanks. Swimming back to look over the "coffin," we noted how the seams of the copper sheets tightly overlapped and how well made it was. Larry did some quick calculations and the volume would fit in the range of the *Leonora's* water tanks.

Combined with the precise location where the *Leonora* was indicated to have sunk, the total lack of artifacts that would have proved contradictory to the period or function of the *Leonora*, and the presence of the water tank, we concluded that it could be reasonably assumed that the vessel purported to be the *Leonora*, was just that. We worked with Kosraen divers to create a photo mosaic of the site and mapped in all the significant features. From the look of the silt deposition and the nature of the material we were finding, we came to an-

other conclusion: The major part of the ship was probably intact and buried under the coral-silt cap, which provided an excellent environment for organic preservation. During the entire operation we had been using our video system to gather additional site documentation. It was never quite the same after doing a half-gainer off the Air Mike pickup truck, but we managed to make it work most of the time in Kosrae.

After completing a series of dives on the remains of the *Leonora*, I decided to show our underwater video footage to the villagers. In those days we had only the crudest black-and-white reel-to-reel video technology; color home videocams were still a few years from hitting the market. Isaiah Kan, the chief of Utwa, ordered the village generator cranked up that evening as people gathered expectantly around the nine inch black-and-white screen.

Behind the village elders there were no less than two hundred schoolchildren and parents entranced with the half-tone images flickering across the screen: divers, fish, artifacts, and hopelessly inadequate representations of brilliantly colored coral, all in living gray.

We had placed a "mug board" near one of the artifacts. This metal plate, with magnetic letters, identified the site and number of the feature being documented, the date, and had the words "Kosrae State, FSM" along the bottom. We never could have imagined the impact those words would have on our viewers. They gasped when they saw their newly established nation state's status acknowledged through the authoritative electronic magic of television. After the show, the children, to all appearances without direction from the elders, broke into their new national anthem. I was curiously touched by this unself-conscious display of pride in one's homeland.

After completing the modest research operation, which took little more than a week, we held a meeting with Chief Teddy John and the elders from several villages on Kosrae. We discussed the attraction of historic shipwrecks to visiting divers and commercial treasure hunters, who might be visiting their island in much greater force if and when air travel became more direct. The elders agreed that history was easy to pluck from the bottom but then was gone forever.

I asked if they felt the *Leonora* was part of their history or only a remnant of European and American intrusion—that is, What did it mean to them? After some discussion among themselves, they came

to the conclusion that this intrusion, good or bad, was indeed a key part of their heritage and they should protect it. I asked if they had a marine police organization of some sort. When translated, there was general laughter. Teddy John explained that if a Kosraen chief decided there would be no taking of artifacts from their village waters, people were well-advised to take heed. In short, their answer was reminiscent of a line in a famous American movie: "We don't need no stinking badges."

SCRU, beyond the dubious distinction of having introduced the Kosraens to their first experience with television, had established a foothold for no-nonsense underwater preservation in Micronesia. We packed our bags and grabbed a charter flight back to Ponape. After a couple days' layover, we made brief stops to familiarize ourselves with the wrecks of Truk Lagoon and the waters of War in the Pacific National Historical Park in Guam. In all of these places we found a wealth of underwater history, and a dizzying array of threats to same, in the context of a very complex cultural arena.

During that brief layover in Ponape, however, we had an incident with local fauna, the implications of which would only become apparent many years later.

I learned on that brief stopover that sharks can make you think it's a long, long, way back to the boat. The day before flying out, I swam using scuba gear a fair distance from our boat at a depth of sixty feet. I was near the top of a drop-off or "wall," as divers call it, accompanied by Bob Adair, a Peace Corps volunteer who had been working with us in Kosrae.

The wall was covered with various forms of coral; the water was clear, warm, and generally appealing. If we looked seaward, the water faded quickly from light blue to dark blue. Similar to outside the harbor at Utwa, straight below the little shelf we were following, the wall made a dizzying pitch to easily a thousand feet—Empire State Building class of depth.

Large pelagic critters swam by going about their business. I was particularly fascinated with the gray reef sharks and the white-tips that would bustle by every few moments headed for some destination as if a few moments late for work. The latter are sleek guys with a splash of white on the tip of their dorsal fin. Eventually, one of the grays decided that I was worth his attention. One moment, I was on my knees lean-

ing over a crown-of-thorns starfish with a camera and strobe flashing pictures, my back to the dropoff. Seconds later, I was trying to ram the camera down the shark's throat. For no apparent reason, the animal had taken a serious dislike to me. Though only six or seven feet in length, he was trying to fit his jaws around my head.

I was almost more perplexed than scared. Almost. Though I was truly curious why this one shark should suddenly react in such a belligerent manner, I became considerably more focused on the problem of how to get back to the boat, which was about a hundred yards away. Bob shared my enthusiasm for a quick return, though he could also see that hurrying seemed to agitate the shark more. By this time, the animal had adopted what has become known as a classic attack posture, with pectoral fins down, back arched, and teeth flashing.

I couldn't help but think of Jim Stewart's arm while this was going on. Jim, the Scripps Institution diving officer, to my knowledge, was the first person to report this behavior. In Jim's case, the attacking shark, which was very similar to the one antagonizing me, succeeded in almost tearing his arm off. I had seen the old warrior's scars from that incident and had no desire to have my own illustrated story to tell.

As we finally neared the boat, with the shark still following and jabbing at us, we had to decide how to make that last several yards and pull our feet in behind us, while retaining all our toes. The psychology of the situation was perverse. Although being in the boat was safe as being in a cradle, there was that short period when we would have to take our eyes off this ill-tempered fish and mess around handing our tanks up, with our feet kicking like fishing lures.

We solved the problem with a strategy that seems simple in hindsight but appeared the essence of creative genius at the time. We had Larry throw a rope into the water so we could detach our scuba rigs and tie them off to the line while watching and parrying with the shark. Then we swam within a few yards of the boat and one after the other, turned, lunged for the gunnel, and hauled our considerably lightened bodies into the craft. With Larry tugging from above, this process took about three seconds.

We ended up going home with all our appendages, but I remained very curious about that incident and why it occurred. It wasn't until we were working on the Bikini Atoll project almost a decade

later that the question was answered to my satisfaction, but more on that later.

We had made our first inroads into the Pacific. Over the years, it called us back again and again. We would eventually return to work on many sites in Micronesia, from Yankee whalers to World War II casualties to sites that derived from the nuclear age. But the "South Seas" had worked their magic that first year. Bully Hayes, gray reef sharks, a thousand exotic sights and smells, and a charming people were too much. We knew the tyranny of size and the commonsense advice that it was "a black hole for energy" would never be enough to keep us from our mandate in the Trust Territories.

## CHAPTER TEN

# IN OUR GLORY

W hile spending the spring of 1982 writing up our survey work at Biscayne and reconnaissance trip to Micronesia, and planning full-blown mapping projects for the coming field season at Isle Royale, we were called unexpectedly back to Amistad—the reservoir that had been the scene of some of our earliest endeavors to train park rangers. We were ready to be finished with reservoirs but they weren't finished with us. This time we would be wearing not our research hats but our ranger hats.

We had, during the course of the Inundation Study, performed occasional recoveries of drowning victims in reservoirs, but they had been fairly low-key and easy. Fate had saved for us a real walk on the reservoir dark side for a couple years after we had completed the Inundation Study.

❖ ❖ ❖ ❖ ❖

The young man in the government green chair at the ranger station rambled in answer to our questions. He alternately cried, laughed, looked for our approval, and faded away to some secret place deep inside.

"So, the last time you saw your buddy he was at the window."

"No, I was ... he was gone ... I was at the window. We were in our glory, man, it was beautiful."

I caught pointed glances from three other rangers who had dived to the point on the powerhouse the distraught man was describing. It

would take an incredible stretch of the imagination to see the place as beautiful. Visibility, before stirring up the silt, was about two to three horizontal feet. The water temperature, a bone-chilling 48 degrees Fahrenheit.

"He went back inside for another cruise through the building and I waited for him. After five minutes I knew something must be wrong ... so I took after him."

"No line?" This was the first Larry Murphy had spoken.

"Naw, we could see on our way in, but it was a brown cloud on the way out, couldn't see a thing."

"I thought you said ... " Larry Nordby saw Murphy and me looking down at our feet and caught a slight shake of my head. He took a deep breath and motioned to the chief ranger that we were finished with the questions.

We'll never know what really happened on the dive during which this man lost his friend; he'd just recounted a hopelessly confused version of a trip to the lower rings of hell, something that he will sort out in nightmares for the rest of his life.

When he departed, we were momentarily silent. Six men and one woman dressed in green and gray, four rangers from the park and three of us just arrived from the regional office.

"In our glory! Beautiful, sweet Christ! He's off his rocker." The powerhouse of the dam where the accident occurred was a very nasty place. The chief ranger from Amistad had called us in from Santa Fe after the park dive team had attempted a recovery dive, succeeding in locating the entrance point to the structure, and assessing all the conditions. The search would involve an under-ceiling dive in very low visibility, cold water almost a hundred feet deep. They had made the right decision not to push any farther on their own.

The Amistad Dam is just a few miles from Del Rio, Texas, not far from Langtry, of Judge Roy Bean fame. The dam had backed up the waters of the Rio Grande, the Pecos, and the Devil's River to form a large reservoir. In so doing, it had covered tens of thousands of acres of west Texas mesquite-covered badlands, and along with it, hundreds of prehistoric archeological sites, historic structures like ranch houses, and even old reservoirs upstream of the present lake. Cannibalistic by nature, as are all dams, the Amistad Reservoir had swal-

lowed an earlier impoundment built decades before on the Devil's Arm of the lake.

Nordby, having been sponsored to a NAUI instructor institute by SCRU was newly serving in 1982 as the NPS Southwest Region diving officer, a position I had vacated due to time constraints after a five-year appointment. He had been handed a doozy of a first body recovery to manage. He was an accomplished southwestern archeologist, from another division in our Santa Fe office; Nordby had been trained to dive by us, and we regularly liberated him from chores in the desert to join our projects in the Pacific isles and Great Lakes. The mapping skills he had honed drawing three-dimensional Anasazi structures translated nicely to shipwreck sites. Now a diving instructor and veteran of several NRIS expeditions, he was getting a taste of the grim side of park service diving.

The man we had been interviewing had a military diving background. Along with his friend, he had just finished an intensive training program in commercial salvage diving, including hardhat, surface-supplied, and the like. They had picked the marina area in Rough Canyon for their "celebration dive" because they thought it would be exciting to find the remains of the old dam structure reputed to be there.

They asked a park maintenance man where they could dive to the powerhouse of the old dam. He told them it was at the bottom of the buoy he was servicing but recommended they keep clear of it because diving conditions were lousy this far uplake. The water near the Rough Canyon marina was still in the zone where the moving river slowed to a halt as it hit the man-made lake and dropped its sediment load. The preferred diving locations are much farther downstream and have been duly marked by the park service for easy access by recreational divers. These fellows felt they could handle the adverse conditions because they weren't trained as sport divers but professionals. They were half right; two went in and one came out.

The water was cold but clearer than we expected for the first forty or fifty feet. As we approached the structure to which the down-line was attached, the clarity degraded, and we found the park's divers were accurate in their visibility assessment. We wore wet suits that didn't afford as much thermal protection as the dry suits we usually opted for in water this cold. Wet suits, however, are less bulky and

more streamlined for swimming through confined spaces. We had jettisoned our snorkels because they snag on things under ceilings, and we eliminated any other unessential gear that might catch on projections. For air, we carried a set of twin hundred-cubic foot cylinders. We also carried backup lights and a cave reel. Essentially we were diving in a man-made cave.

Murphy's 230-pound form loomed next to me in the dim glow of the powerhouse window. My depth gauge read ninety-two feet, and it was supposedly compensated to read correctly at altitude. As long as rivers keep flowing downhill to oceans, dams will be found at some elevation above sea level. This altitude factor has certain implications for divers' physiology and instruments, less so here in West Texas than in the higher-altitude lakes of the Rockies. Given the length and seriousness of the dive in which we were about to engage, however, we were taking no chances. As we checked decompression charts and bottom-timers before entering the building, Nordby and two rangers from the park brushed by us, giving a cursory salute. Their job was to check the outside of the structure along the bottom in case the victim had made it out and drowned before being able to ascend.

I let the butterflies find some place to rest in my innards and focused my dive light on an okay sign formed by my thumb and forefinger. It was a query that Larry immediately returned. Yeah, I'm okay, you're okay, let's get it on. Not having any good excuse for further delay I undid the drag-button on the line reel and played out several feet of #18 braided. It was standard cave-diving line, one-sixteenth-inch diameter, stronger than the garden-variety twisted nylon, yet compact and stretchy when necessary. "Necessary" is when you get fouled in it and need your buddy to untangle you without having to cut it.

I looped the line over a concrete projection in the outer wall, adjusted my buoyancy compensator to neutral and started to walk on my fingers into the room. My knees were bent and my fins were up away from the silt. They would receive little use during this dive. Due to the stillness of the interior, visibility actually picked up some as I inched forward. I could probably see three plus feet; enough to note rebar and wires sticking from the ceiling. I shuddered, only partly from the cold.

It was clear to me now what had been the first mistake of the un-

fortunate young men. As they had penetrated they mistook the slightly clearer dead spaces for some indication of what they would encounter during the whole dive. I did not need to look back to know that Larry was probably encountering less than eighteen inches of visibility because of my bubbles percolating silt off the ceiling. On our return I also knew that we would be lucky to find six to eight inches of visibility in front of our face masks. I had no way to communicate it but I wished I could ask Larry if he was in his glory yet.

I felt Larry's presence through the nylon line as we started a pendulum-like sweep from where the line was fixed, feeling ahead of us in the gloom for obstructions and some mother's son. I had dived with Larry often enough in tight situations that just his finger tension on the line and the movement I occasionally caught through the silt of the glow of his light told me all I needed to know of his mental state and how well he was progressing through the concrete maze. A familiar contradiction in desires overcame me: partly wanting to find the victim and partly hoping like hell somebody else would. After sweeping the first room I reeled in the slack and felt my way to the doorway we had encountered almost opposite our point of entry through the window. Finger pressure and gentle nudges from his elbow told me Larry had guessed my intention and was positioning directly behind me instead of side by side to negotiate the narrow opening.

I checked my air gauge, which still read comfortably high, and could tell that Larry was doing the same. Through the cloud of silt behind me, I could see his light reflecting off something shiny. It took about thirty seconds for him to make out the numbers in the brown soup. He tapped twice on my leg—we were go for room two.

I slipped through the opening and brushed by what seemed to be a wall of iron mesh like a small-gauge cyclone fence to my right—a switch cage. My light could only penetrate a short way in the gloom, but I could see no sign of a diver behind the mesh. I did pass a man-sized opening into the cage, however, and knew it was possible for someone to have gone in there.

Hoping Larry would understand, I continued past the opening where I found enough room to turn around so I could come back and kneel face to face with him. As usual, he anticipated the move and was waiting for me when I inched back. He had his left hand on the line

and his right was probing the entry through the mesh wall. We put our face masks together, and I shined my light down over our heads. Thus, even in the thick haze, we could make momentary eye contact. I pointed my finger into his face plate and then toward the cage opening. You go in there; that was the message.

Without hesitation, he pushed the line away to make sure he didn't entangle himself and backed his legs through the opening. Then he clanged and scratched his tanks and torso through. I pulled tight the line, which now extended past him to the window we had originally entered someplace back there in the world. I wrapped the string twice around my right palm and wrist and passed the reel to his hand, which now extended back into the hallway. Using my wrist for a convenient tie-off he turned and felt his way through the mesh chamber until he was absolutely satisfied no diver could be crammed in any corner. He made sure there wasn't even a nook in which a body without tanks could fit. We both knew from our experiences in Florida caves that it was not unusual for panicked divers to ditch their equipment in some last desperate attempt at escape.

In less than a minute he had reeled back to my hand which still extended from my kneeling form. He handed me the reel and grabbed the line with his left hand, chucking his right thumb in front of my mask to urge me to keep on penetrating. My Larry-sixth-sense was telling me that his brusque motion meant "Let's finish this, I'm getting to seriously dislike this place."

As I turned to continue, I ran into a wall that forced me left and down. Down? I was already on the damn floor! It was a staircase. I found the top of the banister, took a loop, and started headfirst feeling my way down the flight of stairs. Behind me I thought I could hear curses gurgle through a regulator mouthpiece when Larry found the wrap and realized he was heading down to a lower level. Probably just my imagination, because it's hard to hear something said underwater from several yards away.

At least the stairway was fast going, and I was at the lower level in a few seconds. I turned to reposition the reel and banged my head into the edge of some container or closet. I know I took the Lord's name in vain in the midst of a number of four-letter words. No one's imagination this time. I was pissed and getting a bit stressed; I too wanted this dive over.

As I progressed, the wall on my left turned out to be a closet door of some sort. When it opened to my touch, I reached in, looking for our victim. Instead I found a porcelain bowl. "That's it, goddamn it! I'm somewhere here in surreal hell and I'm hugging a commode. Murphy, we're in the goddamn bathroom." Of course, he couldn't hear a word I was saying. I turned and put my fist in his face, meaning stop, freeze. He held tight to the line and watched my fins for the next several minutes as I inspected, felt through, and otherwise spiritually connected with three drowned toilet stalls.

The room dead-ended. It contained no deceased diver or any sign of him—no dive light, piece of equipment, or anything. I managed to turn and was again face to face with my partner. We once again spent the better part of a minute examining our instrument gauges before we could decipher them in the thick murk. I found I could only read mine if I pressed the gauge against my faceplate and held my light over my right ear. Enough light filtered through a side panel in the mask to illuminate the dials.

We noted that we were still reasonably okay on air in our double hundreds. Also, we were slightly below a hundred feet deep, and our timers indicated we had left the surface almost thirty minutes ago. We were bone-cold, knew we would have to spend extra time in the water decompressing, and were thoroughly disenchanted with our cozy new dive site. We were by no means in our glory.

The trip out was ugly and slower than coming in. It seemed that long ago, idiots had extended iron bars from the ceiling in such a manner that they hung up on every piece of equipment we owned during our slow crawl back upstairs and out of the building. As we emerged from the glass window, unwrapped our reel, and headed up the rope to the surface buoy, we both dearly hoped that Larry Nordby and the other team had found the victim. As we approached the twenty-foot decompression stop, we could see the other team hanging there—they had no deceased diver in tow.

As the thirty-one foot Bertram pounded its way back through a wind chop, we lay on the back deck discussing what we hadn't found. "Well, he ain't in the building and he ain't outside the building near the old dam outlets," remarked Nordby.

Murphy added that we had learned something else.

"What?"

"That fella didn't go back in there lookin' for his buddy."

"How do ya know?"

"He's alive."

I nodded my agreement. He might have gone in once and stumbled out by luck, but there is no way in hell he could have survived going in after the silt was up.

"The damnedest thing is we can't even comfort the kid without contradicting his story. He would have been insane to return to the interior—we'd just be after two bodies but we're going to have to let him beat himself up over it." The irony of the situation was that the fate of the drowned diver had been sealed when he took the lead in penetrating the building without a line; what anyone did afterwards was irrelevant. But the survivor clutched his attempted-rescue fantasy like it was his last chance at self respect.

We did have some good news when we got back to the ranger station. An enterprising park employee had traced down a copy of the plans of the old powerhouse from God knows where.

"There, that wire mesh . . . that was the switch cage," Murphy noted. The drawings were actually quite helpful as we mentally retraced our dive. Nordby asked us every way he knew how, without offending us, if we were absolutely sure we covered the entire structure.

We were stumped and irritable. Frankly, purported experts at diving under ceilings or not, we had no desire to go back in that building. "I'm telling you we felt through every miserable corner of that dump," muttered Larry. "Unless that dumbass flushed himself down the commode he ain't in there."

It is easy for divers to identify with drowned compatriots and the degrading of the lost diver's status from victim to "dumbass" was a sign I had noted before in recovery operations. We were reaching a temporary point in our personal psychology where devaluing the victim helped us suppress our own risk-taking proclivities. We could justify not taking actions that might result in our own demise. He would regain the status of "unfortunate young man" to us once we found him but, at this point, Larry's assessment seemed right-on.

Nordby knew we weren't going to plumb that building again unless they could give us an ironclad guarantee that he hadn't fallen to the old riverbed. The next day Murphy and I watched the "outside team" led by Nordby descend for a final sweep of the base of the dam.

If they found no sign of the man, we would repeat our examination of the powerhouse.

After they disappeared from view, I sat in the boat cabin absently staring at the plans of the building. It was just not that complicated a place: a first room with a grated hole in the floor for some engineering purpose, a long wall with internal glass windows separating it from the back room, and the staircase that led to the lower level. We had seen, or rather felt, all of this and we had inspected from floor to ceiling knowing the body could be buoyant. Suddenly, a chill went up my spine.

"Larry, c'mere, look at this." He was on the back deck already suiting up while engaging in some of the gallows humor with the other rangers that typify most high-stress recoveries once out of the public's sight.

"Find 'im, did ya? Great, we don't have to go down now. We could get some beer, have a service on the boat, put the fun back in funeral. We ..."

"I know where he is." Silence from everybody. I definitely had the floor.

"Remember we kept running into these windows at the end of our passes in the first room?"

"Yeah."

"When did we see the back of them in the second room?"

"What? The damn switch cage is right there and I felt all through it ... the glass is probably right beyond it." As his second remark trailed off he sat down heavily, staring at the drawing; he no longer was certain. "Damn, look at the cross-hatching they drew between the cage and the glass ... could that be indicating a manway? Hell, the damn space isn't twenty inches wide."

I just stared at him, as did the others. Murphy turned, kept pulling on his wet suit jacket and grumbled resignedly as he stepped back into the sunlight, "may as well get ready partner, he's in there. That's the only place he can be."

Armed with our new insight, we plunged back in. Larry stood back and tended the line as I swam with my face pressed against the long panels of glass in the first room, my dive light held even with my faceplate. I dearly hoped I would not find an agonized face pressed up to mine on the other side of a quarter-inch glass panel. I didn't. As I

passed back and forth, peering through the glass working from the top down, the first visual contact came with his fin.

His dark wet suit was invisible even inches away through the murk, but I noted a piece of blue reflective tape on one of my lower passes. As I stared at it, I gradually was able to discern the shape of a diver's fin with a foot buckled inside. Why in God's name he had wedged himself into that narrow confine only a panicked mind could surmise, but he was there.

Knowing where he was, I had only one option for extricating him. I handed the reel to Larry and, double tanks and all, forced myself into the manway. I didn't need the reel because there was no way in hell I could get lost; it was getting stuck that was the concern now. Suddenly I was on him, upright in front of me. I had the unsettling feeling that I was standing behind him in line.

Dutifully, I ran my light down his torso, gathering information we needed for the report. Regulator hanging free, face mask on, eyes open . . . eyes open, good Lord, I wished the still compartment wasn't affording such good visibility. I had a good two and a half feet of seeing room, enough to emblazon the scene in some compartment of my brain I don't like to visit.

Enough, forget the paperwork. I grabbed the corpse by his tank valve and lurched backward. I felt my own tanks break free of the confinement with a degree of relief that informed me how much I must have been worrying about being able to back out. My hand was still extended into the slot; with a final wrench I pulled him out. Rigor mortis was still evident (lasts longer underwater) so it was a mannequin I handed to Larry. He wrapped his right arm around the diver's waist and, looping a finger over the guideline, made his way back to our entrance window. Ambient light was coming through from the outside; we could switch off our lights, slow our breathing, and collect ourselves.

I could tell from the way Larry was holding him that the predicted transition from dumbass to tragic figure had indeed occurred. He was gentle and respectful with his ward. He was a handsome young man, and he had lost everything he ever was and was ever going to be. As we ascended I watched the physiological process occur that I had seen on other such occasions. The face mask on the pale face was filling with blood and other bodily fluids from his nose as the

pressure of the water gradually lessened and the gas in his lungs embolized.

There wasn't supposed to be any family up there, but we were taking no chances. I removed his mask and Murphy stopped every ten feet so he could squeeze the victim's chest and vent the fluids. In the green gloom of the reservoir water, he appeared to be exhaling a black smoke. We knew its true color would be dark red at the surface and nobody needed to see that.

So we brought him home. We were right to prepare him for the surface because though his family wasn't allowed near our boat, they were five minutes away at the marina. You think you can steel yourself for a father and brother's grief, but you can't.

"Jesus, he's laying there like a big stiff mackerel, can't we do something about that?" Nordby was upset that we couldn't make him more presentable but the law enforcement specialists just shook their heads.

"Can't move anything till the coroner examines him." I was glad we had taken the steps we had underwater, he could have looked a lot worse.

When the flurry of ambulance sounds, death bureaucracy, and grief-stricken moans of the bereaved were behind us, we began to process the experience ourselves, each in our own way. The good news is that our efforts brought closure to a family's trauma. They could begin grieving without the added stress of not having the mortal shell of their loved one to grieve over. This, I have come to learn, is very important.

The young diver is a rubber-suited symbol to me, a sad statement about man entangled in the web of his own dreams. But as divers aren't made to last forever, neither are dams. As some unfortunates living downstream of older dams in the United States have found out, the river always wins eventually. Until then, we ply over water on fiberglass hulls where once, had we wings, we would have ridden the wind.

# ISLE ROYALE: MISSION IMPOSSIBLE

Isle Royale National Park is an island wilderness area forty-five miles long and two to six miles wide. It's known for its wolf and moose and rugged backpacking trails and for being one of the most visually striking, yet least visited, areas of the national park system. Though its original founders were not thinking of shipwrecks when it was set aside as a park, they could not have designed a better underwater museum had they tried.

Ten major shipwrecks lay sprinkled around the island dating from some of the earliest steam navigation on the lake to as late as the 1940s. They include wooden and metal passenger/package freighters, bulk haulers, and passenger vessels. There are also the remains of a dozen or so small boats built by local craftsman—a sort of vernacular version of naval architecture as interesting to archeologists and historians as some of the larger vessels.

The fresh, frigid water acts like a deep freeze, ensuring spectacular preservation of organic remains. The wooden vessels at Isle Royale have been disarticulated from storm, ice heaving, and salvage tugs. Some of the metal steamers are almost totally intact. The water below fifty feet down never varies in temperature. It's 34 degrees Fahrenheit—two degrees above freezing in midsummer as well as under the ice during the long winter. Along much of the shoreline of the archipelago the ice shelves up in noisy, crusty piles, grinding against the rocks until spring. This causes ice gouging as deep as forty feet on some of the sites.

As we began to focus on the Isle Royale expedition I felt both in-

creasing excitement and anxiety. Jack Morehead had been superinten-
dent of Isle Royale for several years, including 1978, when he came to
take part in one of our dive workshops in Texas. He regaled us with
photographs of the Isle's extraordinary shipwrecks and impressed
upon us their value as both historic and recreational resources. He
made it plain the park staff knew too little about them and intrigued
us with how challenging it would be to document them fully.

He showed us slides taken by sport divers and park staff of intact
vessels in deep, cold water—other wreck sites seemed like hopelessly
confused piles of ship structure where more than one vessel had come
to grief. "The intact shallower ones will take a lot of work . . . . The
deep ones and these jumbles of timbers here, I expect they will be im-
possible."

Larry and I, entwined in Jack's silver-tongued web, studied the
images and flinched in concert on hearing the word "impossible."
Jack smiled and went on. At breakfast the next morning he asked what
we thought. While Murphy quietly poked eggs and grits around his
plate, I mulled his question for a while and replied, "You get the
money, Jack, and we'll not only do the doable ones, we'll take a closer
look at them there 'impossible' ones."

Jack left Isle Royale shortly after his visit to Texas to become su-
perintendent of the Everglades but not before he had secured the
funding for a full-scale submerged cultural resources survey. It was to
be a multiyear core project for the newly christened SCRU. Shorter,
one-time commitments like Kosrae and Biscayne could be fit around
work at Isle Royale. Doug Scovill, NPS chief anthropologist and our
chief Washington office supporter, agreed with the choice. It would
involve a resource that was recognized in the diving community as
world class; the job was a high priority to the park manager and it
couldn't be mistaken for a summer vacation. No one would question
the seriousness of a park research team that cut its teeth on the ships
of Isle Royale.

The complexity of the science and the problem of depth were is-
sues with which we already had considerable experience. But then,
there was the numbing cold, to be endured for long working dives.
This park closed for six months of the year because it was too ice-
bound to reasonably support visitation. I had dealt with cold water
before in deep reservoirs, even worked diving for oysters under ice in

Maryland, but one taste of Great Lakes cold and I knew it was going to be a major factor in everything we did at Isle Royale.

On my first visit I dived in Lake Michigan with my friend Jim Quinn. We explored the remains of some wooden schooners, but I had little recollection of the wreck sites—my overriding memory was the bone-piercing chill. Wearing a standard quarter-inch-inch thick wet suit with hood and gloves, I had the impression I was swimming in a huge punch bowl full of crushed ice with an icicle thrust through my nose into my brain—a condition that compromises the quality of one's concentration.

Consequently, I resolved to look closely at the use of the latest dry suits available in the industry. By the time the Isle Royale project began in 1980, I had my entire team fitted with "unisuits," the state of the art in underwater thermal protection, manufactured in Sweden. These were bulky, neoprene dive suits that permitted wearing of thermal underwear. They had neck and wrist seals, which kept water out, and a hose from the regulator first stage was fitted to the suit, allowing the diver to inject air in as the depth increased and the ambient air in the suit compressed.

Aside from cold and depth, many of these wrecks were intact, which would mean there would be a significant call for under-ceiling diving. The reason for the presence of these more recent vessels is the special nature of navigation problems on the Lakes.

Called "inland seas," the Great Lakes can be particularly treacherous. Lake Superior is known for violent storms that create short-period waves highly stressful to ship hulls. The water is cold enough year round that survival time for an unprotected swimmer is usually measured in minutes. Much of the coastline, if reached by a desperate survivor, would be too steep to allow egress from the water.

The size of Superior is another problem, both too large and too small for safe navigation—large enough to permit great wave height and compound the difficulty of finding vessels in distress, yet too small to provide adequate sea room for vessels to maneuver against high seas and ride out a storm's fury. Bitter cold accompanies most Great Lakes storms and freshwater spray freezes faster than salt water, permitting buildup of huge ice castles on the superstructure of ships. This makes them topheavy and more subject to capsizing.

Even after the advent of radar and various other ship-positioning

and navigation aides, Lake Superior was considered by knowledge-able skippers one of the most dangerous bodies of water anywhere. I recall reading a reference to the Great Lakes while perusing the log of a ship captain in the Aleutian Islands in Alaska. The coast pilot refers to the Aleutians as having the worst weather in the world, so it interested me when this man wrote he had "never seen anything worse than the Aleutians except, perhaps, for my years in Lake Superior."

We first put our heads underwater at Isle Royale on the site of the *Monarch*, an 1890-built wooden freighter that slammed into an area called the Palisades during a snowstorm in 1906. The perfectly preserved wreck timbers were spread out below us as if they were part of a giant ship-building kit some kid had finally lost patience with and had walked away from.

It was a good place to start because some portions of the wreck were very shallow. Near the surface in this area, the temperature shot up to almost 50 degrees Fahrenheit in late summer. Larry gasped when he hit the water. "This is the warm one, eh?"

"Roger."

Toni, already swimming around on the surface, looking down at the spread of massive ship timbers disappearing below her into the depths, heard Larry's comment, and added, "This is the easy one, eh?"

"Roger." She didn't look convinced. "Ole Uncle Jack says this is only one wreck. It gets real complicated on Rock of Ages reef where there's two intermingled."

"Could of fooled me. Looks like about twelve wrecks here."

We found this to be the reaction of many visiting archeologists over the years. They usually had experienced only much smaller, older vessels in saltwater with significantly less surviving structure. I splashed in beside her, and the three of us began to descend, following the filet-of-ship, its apparent backbone leading us on a forty-five-degree angle toward the bottom. It's a good thing we had the bottom to orient us; flattened pieces of ship disappearing on each side of us in fifty-foot visibility seemed to have no rhyme or reason. The good news was that we could see everything—it wasn't covered with silt. But that was also the bad news—these conditions made the huge site seem overwhelming.

Weightless but bulky in our canvas and neoprene dry suits, we

moved with little effort as long as our movements were slow and deliberate. As we cruised down to the apparent remains of the fantail, or stern of the ship, we were hitting seventy feet on the depth gauge where the water temperature had that classic 34-degree Lake Superior nip. Such cold greatly limits the useful bottom time of divers. The same factors of cold and depth that defined our limitations also, however, enhanced the archeological potential of the sites. Wood-boring teredo worms and most of the bacteria that attack the fabric of shipwrecks in warmer, saltwater environments are absent in these inland seas. Lack of light penetration at depth enhances preservation even more.

The oaken ribs or frames of the *Monarch* have so much structural integrity, I bent a ten-penny nail pounding it into a timber for a survey datum point. Larry wanted to remove a wood core and brought along a device we used for that purpose on land sites in the southwest. Within minutes, his vigorous efforts resulted in a bent, and then broken, tool. I showed my partners leather boots in Vincent de Pauw store condition except for the cotton thread that had rotted even in this deep freeze. The shoes, seemingly sound, disarticulated in our hands when we lifted them from the bottom for inspection. Each section of leather was pliable and intact but the stitching that gave the shoe form was gone.

We surfaced from the dive and began reconnoitering other wreck sites around the island. One particularly mangled metal vessel was the *Algoma*, on which forty-five people died in 1885, the greatest tragedy on record for Lake Superior. In shallower portions of the site we found long stretches of scoured granite bottom. Toni swam below me, tracing her finger over streaks of red iron-oxide staining the rock where metal ship structure had been dragged along the bottom by the heaving ice, and rudely deposited as twisted piles of debris in deeper water.

Bolts and rivets torn from tortured metal were wedged in cracks in the basaltic lake bed. As Jerry Livingston and I swam over the *Glenlyon*, he clutched his everpresent slate, trailing a mechanical pencil held by a piece of surgical tubing. I felt as if we were medical examiners visiting the scene of a violent crime.

Then, in stark contrast to the mechanical mayhem caused by the Lake's dynamics on the shallower sites, there was the pristine condi-

tion of those ghosts of a maritime past that lay a few feet deeper. A
light rain of particles suspended in the fresh, cold water slowly but re-
lentlessly rained down on what seemed a fantastical underwater
theme park. Here the massive anchors of a bulk freighter hung heav-
ily from their hawse pipes, there we saw a ship's telegraph and binna-
cle on the bridge. On the most modern vessel, the 1947 bulk freighter
*Emperor*, Larry Murphy and I swam past staterooms. Mattresses in
bunks 130 feet below the surface would never know the warmth and
weight of another tired voyager. This really was swimming into his-
tory; Jack Morehead hadn't exaggerated a bit.

Most of our work at Isle Royale involved mapping and photo-
documenting the sites, not excavation. Our intent was to inventory
what was on the sites, then make them even more accessible to recre-
ational divers. We created maps for diving visitors and installed
mooring systems so they could safely dive without damaging the ves-
sels with anchors. You can't be a good steward of a resource you don't
understand. Jack acknowledged he had as much responsibility to care
for these shipwrecks as he did the moose and wolves of Isle Royale.
He already had a major research program in place to monitor the
predator-prey relationships of the latter.

Sometimes, mapping was necessary at Isle Royale simply to tell
apart the remains of different ships. A case in point is the site where
the wooden bulk freighter *Chisholm*, in 1898, joined the wooden side-
wheeler *Cumberland*, which had been there since 1871. The wreckage
of the later screw vessel seemed hopelessly intermixed with similar
wooden features of the earlier ship. Over a quarter mile of wreck-
age—this was the site Jack had specifically referred to as "impossible"
to map and interpret.

Also in the impossible category for systematic recording and doc-
umentation were ships like the *Kamloops* because of their extreme
depth. We had our first run-in with the *Kamloops's* site only several
days into that first field season in 1980, and we didn't even have to get
wet for the experience.

We leased a tugboat, the *LL Smith* from the University of Wis-
consin, to ensure we had plenty of vessel under us in case things got
rough. After reconnoitering a number of sites underwater, we decided
to do some side-scan sonar imaging of several of these deeper wrecks.
After scanning vessels on the north side, including *Monarch* and *Em-*

*peror*, we headed for Kamloops Point. Many think a shallow reef in the area was the cause of the *Kamloops*'s demise.

Our plan was to find the wreck and the reef and do a brief assessment dive. We succeeded nicely at imaging the wreck. But the problem with towed instruments that tell you clearly about the bottom where you've been is that they are mute regarding the bottom where you are heading. Mesmerized with watching the sonar image of the ship take dramatic form on the maroon and white paper, emerging still damp from its birth in the sonar console, we felt ourselves come to a grinding halt.

Larry, Toni, side-scan operator Gary Kozak, and I, all in an aft cabin with the console, looked up, mouths agape. We could hear yelling in the pilot house and Jerry Livingston's feet pounding up the deck from the stern where he had been monitoring the cable to the towfish. Murphy remarked matter-of-factly, "Uh, I believe that would be the reef."

At midnight, under a full moon, we were sitting hard aground on Kamloops Reef. But we were not preparing for a dive; we were preparing to abandon ship. The lake was absolutely flat but famous for changing moods in minutes. While we waited for a park tug to scramble in response to our radio call and come to our aid, we had plenty of time to reflect on the fate of those who, over the past 150 years, grounded their vessels and didn't have access to niceties such as park radios.

Soon the park maintenance staff stationed at Amygdaloid Ranger Station came chugging to the rescue. The skipper of the *LL Smith* only thought he was distraught before this merry band showed up. We had obviously roused them from their hard-earned rest after they had indulged their prerogative for some off-duty consumption of alcohol. It wasn't that they weren't competent and in control of their faculties, it was just that they were enjoying the occasion far too much. They couldn't get into a spirit appropriate to the gravity of the situation. The hooting and hollering and thick Upper Peninsula accents had an unnerving effect on the captain.

About 2 A.M. our heroes succeeded in securing a line to our stern and, with the *Osprey*, their "little tug that could," were hauling for all they were worth to free us. The helmsman and his deckhand were sober as judges, but they brought the Amygdaloid cheering squad that

definitely wasn't. Truthfully, by this time, the SCRU Team had bene-fitted from the generosity of the Amygdaloid lads. A case of Moose-head lager helped us grow considerably more relaxed about our plight.

The hull beneath us scraped about for quite some time on the rock reef from the efforts of the tug. Occasionally we heeled over at a crazy angle, and our research instruments came tumbling out of lipped shelves that were designed not to let things tumble out in heavy seas. "Geee whiz," said Jerry Livingston. "We're gonna go over if they tip us broadside anymore!"

Quickly strapping down the most expensive and delicate of our gear and letting the remainder of our equipment fend for itself, Jerry and I ran to the back deck. There, the skipper and Larry and Toni were helping reset the heavy hawser line for another burst of power from the little tug. The latter was backing off from the last pull and drifting towards our bow for some reason. I saw ranger Ken Vrana, mumbling under his breath, walk to the side of the *Smith* that was op-posite the towline and lower the Moosehead into our rubber dinghy. While my mind was processing all this, I heard a new series of war whoops from the direction of the *Osprey* and here they came out of the dark, engine whining, revved to the max. Now, we all knew what the new strategy was, and I could see Jerry Livingston heading to join Vrana while Murphy laid out flat on the deck. Our skipper could only say, "Lord, they're gonna try to jerk..." and he crouched into a stoop as the tug roared by on its way to try the last resort maneuver: using sheer momentum, to jerk a sixty-foot tug off the rocks.

I had time enough to see the hawser, thick as my ankle, begin to stretch like a nylon rubber band. Then, I too was on a headlong run for the coward's boat on the other side. If the hawser snapped, anyone standing around would probably have been cut in half on the recoil. I would like to say that I gallantly looked out for Toni at this moment, but, being an equal-opportunity survivor, I crashed into her in the process of diving into the dinghy.

In quick succession, I heard the oomphs from my impact, an unla-dylike curse from Toni, a loud scraping sound as the *Smith* broke free from the reef—and after a few seconds of silence, a cheer from the skipper and his assistant, who were the only ones left standing on deck. Disentangling myself from the rest of the gray-and-green ap-

pareled cowards in the boat, I heard a concerned protest from Vrana: "Watch the Moosehead, you're standing on the beer."

So, we were rescued, and by the time we were hauled into the harbor at Amygdaloid, it was daylight. There is not much to do on the north side of Isle Royale except meditate and libate and this group was definitely not the meditating type. Our rescuers decided not to bother sleeping as it was already light. Instead, they declared a holiday in honor of our being snapped from the jaws of icy death. They drank all day long, occasionally jumping into the frigid waters. This combination they assured me helped them avoid the ferocious price to be paid in hangovers.

The next day I sat across from Chief Ranger Stu Croll, explaining why his North Shore ranger station had closed down for the day. He was also curious about what I was planning to do now that we were here with our equipment, all dressed for a party, and no boat to get there. The *Smith* was finished for this operation; it was undergoing makeshift repairs and would soon be removed.

This boat karma was starting to bother me. As great a record as we had for dive safety, we were developing a terrible reputation for attrition to boats. It wasn't just the Biscayne fire, there was a flipped jon boat at Biscayne from a 1975 project, an incident in the Tortugas and . . . anyway, it was getting to be a sore spot. I told Stu that we were indeed at a loss, and hadn't expected to lose a boat so early in a project. I was about to tell him it usually took a few weeks longer but thought better of it.

Once again, it was the park that saved the day. Stu wasn't going to see us knocked out over a boat when they had patrol craft and rangers to operate them. He offered a solution that paralleled others that came from parks over the years. "I'll give you the *Lorelei* (a thirty-two foot Bertram) and Ken Vrana for the rest of the time, but if there are visitor emergencies on the north side, you have to break down your ops and respond with the boat." We were back in business. This sort of arrangement had worked well before and would again. Sometimes we found ourselves doing odd things for archeologists: conducting rescues, boarding boats for searches, and helping wrestle down drunks in marinas. But, all in all, it was a great trade-off.

An added benefit to this arrangement was that Ken was a good diver, and he knew the north-shore waters like only rangers get to

know them. There was no room for living on the patrol boat, but we could use ranger stations and trail crews' quarters that were interspersed around the island. This wouldn't have been feasible in the *Smith* but this boat had three times the cruising speed of the eight knot *Smith* and could get us to quarters somewhere each night.

Vrana introduced us to Larry Sand, the young boat owner/operator of the *Superior Diver*, a thirty-eight-foot craft designed for dive charters. His craft was much smaller than the *Smith* but slept six and was very well equipped for diving. We were impressed with his knowledge of local conditions and soon arranged to hire him next year.

We also met Ken Merryman and other very accomplished Lakes divers who shared much with us about what they knew of the wrecks and how to deal with the cold. Joe Strykowski, an excellent photographer and cold-water diver, helped us obtain images in the challenging environment. Scott McWilliam, Jerry Buchanan, and other Canadian divers also readily volunteered to help on our projects. We learned a host of little things about how to modify off-the-shelf equipment that made it more comfortable or functional for frigid water dives—things simple and obvious to them but instructive to us.

Also we learned much through trial and error. For example, once in the water, even in the mildest breeze, you didn't take your regulator out to speak. The air hitting any exposed skin around the face caused convection cooling. This made the regulator feel like an ice cube when it was replaced in your mouth. Removing a glove for even a few seconds would incapacitate that hand. The moment ice water hit your fingers, they were useless. Getting the hand back in the glove was a difficult feat.

With many such lessons under our belt, we concluded our first few weeks at Isle Royale and came back a year older and wiser in 1981.

In the 1981 and 1982 field sessions, we perfected our mapping and documentation techniques on "the difficult" and then started dabbling with the "impossible."

On the *Cumberland/Chisholm* we took pride in finding key diag-

nostic attributes of the two ships that allowed us to quickly distinguish the pieces of the underwater jigsaw puzzle and create a map that clearly assigned each section of the remains to the proper disaster. This was not only critical to the archeological evaluation of the sites but a great aid to park visitors: Sport divers saw the site as hopelessly confusing. We were helped immensely in this task by Patrick Labadie, the director of a maritime museum in Duluth, who joined us on site and shared his intimate knowledge of the architecture of Great Lakes vessels.

We learned that the quarter-mile-long stretch of intermingled wreckage was perfectly decipherable once we determined diagnostic elements of each ship and laid our magical baselines. The taut, thin white cords clipped every ten feet with a Plexiglas tag became a trademark of SCRU. They gave chaotic fields of wreckage straight, measured streaks of sanity. When scaled down and replicated on paper, they became the backbone on which we built our maps. Everything else on the sites could be "trilaterated in." Measurements from two points on the line to any object formed sides of a triangle. The length of the section of baseline between the two points became the third side. Once we knew those numbers, nothing could escape our illustrators. We called the technique trilateration, rather than triangulation, because it employed three distances rather than three angles as normally done on land. It probably is no surprise that the line we settled on for this purpose was #18 nylon. Cave-diving techniques seemed to have relevance everywhere.

Using primitive reel-to-reel, black-and-white video that required helmets and a surface-supplied diving operation, we recorded hours of video on the sites. We taught ourselves to carefully reference where the video was taken so that, months later, our illustrators could pick details from the tape for inclusion in the final drawings. One by one, the confusing jumbles of timbers started to take meaningful shape. We could then add the sizes of the ship pieces and determine what portions of the wrecks were missing. In some cases, we inferred where the missing components should be, searched for, and found them.

The other impossible sites, due to extreme depth, were the *Kamloops* and the stern of the *Congdon*. Here, progress was not as gratifying. Our second run-in with the *Kamloops* came in the 1982 season.

Among the basic physical realities of deep diving is that underwa-

ter, every thirty-four foot depth of fresh water duplicates the entire atmospheric pressure of the earth. At 170 feet, six times the volume of air at sea level is compressed into the same available space—one's lungs. This means the air is six times as dense, and its chief components (nitrogen and oxygen) have six times the biochemical effect on the diver that they had on the surface. The body tissues suck up the rich supply of oxygen while the brain is dulled by the narcotic properties of the nitrogen. Over-exposure to high-pressure oxygen could make your nervous system blow a fuse while the nitrogen could put you to sleep. Any exertion seriously compounds the problem. In addition, problems with life-support equipment are aggravated when the deep water happens to be freezing cold.

Frenetic movements or exertion in deep, cold water can cause the mouthpiece to freeze, resulting in a wild rush of air known to divers as a "free flow." Not particularly ominous in milder waters, this was a serious problem at Isle Royale. With a regulator frozen open, the rushing air can't be breathed and the physical properties of convection render the oral cavity numb within seconds. Fumbling with rubber mittens over deadened lips, mouth filled with slush, the diver can't feel when the backup regulator has been inserted. It's like trying to siphon gasoline from a car by sucking on a hose after receiving a shot of novocaine in all four sectors of the jaw.

Our first dive to the *Kamloops* was a humbling reminder of how much can go wrong in water that is both cold and deep. Larry and I were the only ones on the team really experienced enough to take on the exceptional demands of the *Kamloops*. Its shallowest point is on the stern, 180 feet below. At the deepest point of the bow, the diver's gauge is jogging past 260 feet. Because the wreck is several hours running time from the other sites we are working, we can only afford to dive it as a target of convenience, en route to wrecks on which we can bring to bear the energies of the whole team.

We were accustomed to very deep air diving (approaching 300 feet) in warmer climes and had been as deep as 150 feet at Isle Royale. We descended the line of an anchor we had set in the wreck at a depth of 180 feet. The *Kamloops* came into focus as an amorphous form extending deeper into the gloom.

It was a ship that had gone missing in 1927 and had been found only recently by a group of very proficient sport divers including Ken

Merryman and Ken Englebrecht. The legend of the ship and its demise is one we had pored over in the archives. Now we were about to finally set down on its hull ... and Larry's regulator began a violent free flow. I helped him insert his backup mouthpiece and shut off the malfunctioning unit as we ascended up the line to 140 feet.

Shaken, but willing to try again, Larry again opened the valve to the regulator that had malfunctioned—it seemed to be working okay. We were so near that we had to try again. We passed 170 feet, and I was inches from placing my fin on the deck when I could hear Larry's regulator blow off again, this time popping right out of his mouth, spewing a wild torrent of bubbles. I grabbed him and shoved his spare regulator into his mouth, knowing there was no way he could feel it after what had just happened. He looked at me tentatively, afraid to take that first breath, having to trust me that it would be mainly air, not water. Gagging and coughing down there with a mouth full of slush could be fatal. I could see the relief in his face as precious air began entering his lungs.

We both held his mouthpiece in place for a full minute as we headed slowly upward. He eventually regained confidence in his equipment, pushed my hand away, and continued at a normal ascent rate. I watched Larry cut his eyes ruefully at the *Kamloops*, knowing that she had beat us on this attempt. It would be a full year before we could venture to the wreck again for a brief inspection. I finally decided it was too dangerous for normal survey operations but I was loathe to give up. The solution presented itself some years later, but we'll tell that story when we get to it.

During these first couple of years at Isle Royale, there was one other issue that we had to address that most archeologists don't: the obligation to make the park a safer experience for recreational divers where possible. One ship, the *America*, had claimed the life of a diver, and the park had received frequent reports of "near-misses." The problem was a door; divers were penetrating deep into the ship, squeezing through a partially open iron door separating the galley from what became known as the "forbidden room." The door had multiple "dogs" or latches that caught up regulator hoses. As people struggled to get free, the silt rose, panic set in, and the dive could stretch into an eternity.

We didn't prohibit divers from exploring the *America* or any other

wreck in the park because of safety reasons, even the *Kamloops*, at depths well over two hundred feet and already the scene of one fatality and one crippling injury. The park service might discourage diving there but doesn't prohibit it. The same held for climbing El Capitan at Yosemite; there is no law that says you can't take risks in national parks.

This is something about which I feel strongly. I believe sport divers should be expected to treat historic wrecks respectfully. But when it comes to their own safety, they should be treated as responsible adults until proven otherwise. In other words, I believe managing agencies should stay out of their faces regarding how deep and long they can dive. It would have inhibited my being able to work for the Park Service if there were disagreement on that philosophy. We decided to take special action on the *America* because we could fix the problem with minimal consequences for the historical or recreational integrity of the site.

Chief Ranger Croll discussed the matter with Superintendent Don Brown and decided we should "get that damn door off or blow a hole in the side of the sonofabitch." Stu and Don were sensitive to cultural resources but they were even more sensitive to visitors drowning in their park. Although blasting is usually the quickest and safest way to remove obstacles underwater, this was a historic site. We opted for the less destructive if more labor-intensive method. It proved to be an interesting dive.

I decided to videotape the effort because it would be a first in park resources management. Self-contained video housings were still a year from being marketed, so we had to lug a camera trailing a wire umbilical back to the surface. Four of us, laden with crowbars, camera, and cable, descended through the emerald-green water along the side of the ship. I wore a Superlight 17 commercial diving helmet, with the communication wire and video lead attached to my harness. All of us used double tanks for air supply, although I had the option of running a surface-supply air hose to my helmet with this rig. But that would have necessitated a much heavier, more unwieldy umbilical.

The *America* leans against an underwater cliff at about a seventy-degree angle from horizontal. We dropped for sixty feet until we came to a side-loading hatch that permitted access to the interior of the old passenger/package freighter. Adding bursts of pressurized air

from our tanks into our dry suits slowed our descent until we could level out at the open hatch. Two divers positioned themselves at the top of a staircase to tend the video cable as Larry Murphy and I began our descent into the bowels of the *America*. Toni Carrell followed us in and scurried back and forth tending my cable back to the surface.

The problem with further descent once we entered the ship was the angle at which it rested. It was so steep that it made it very difficult to orient to up and down. A diver, for all intents and purposes weightless, usually depends on visual cues to orient to an enclosed underwater environment. Descending down the tilted stairs, gravity took over as our suits compressed and we found ourselves falling someplace—not down, but sideways.

We banged and cursed our way down the stairway to a lower deck, turned the corner, and headed down another flight. Larry, at 230 pounds inside the bulky "unisuit," plowed ahead of me, seemingly larger than the passage he was negotiating. He dragged a nine-foot pinch bar down the stairs behind him.

My progress was slowed by the cable trailing from the video camera in one hand and a five-foot crowbar in the other. The low-intensity lights of the video camera were all I used for illumination; stronger light scarred the vidicon tube of the old unit.

Within minutes we reached the ship's galley, with Murphy still ahead of me. He was staring accusingly at the large door with the tell-tale latches. I proceeded toward him and spilled awkwardly over a stainless-steel table to end up in a heap against the door. Having exited the staircase I forgot we were still Alices in a half-inverted Wonderland. Silt rose about us, making it increasingly difficult to see or videotape our activities. Our depth was about seventy feet.

After glancing through the door at the forbidden room, I laid the camera down and pushed inside. Dry goods, cups, plates: It was a damn pantry. This is what drew one young man to his death and six others close enough to feel the rush of the sickle's sweep. Withdrawing from the slot I felt the "dogs," or latches, grab my hoses. I stopped to experiment disentangling myself. Larry's reassuring presence made this feel more like a pool exercise than an emergency. I disengaged and backed away from the vicious piece of metalwork.

My glove snagged briefly on something. The seal was pulled far enough back on my wrist to let a small rivulet of water down the side

of my hand. Curiously, the icy cold felt as if someone had rolled a red-hot marble along my flesh; the broken seal would limit our dive time. I withdrew to a corner of the galley and tried to position myself for filming the door removal. A scraping and banging of metal began as Larry tried to find a purchase with his feet so he could throw all of his strength into the door. The problem with heavy work underwater is leverage—an astronaut trying to press a button will push his whole body away unless properly braced against something—the problem is similar for aquanauts.

Straining to see Larry through the cloud of sediment our activities had stirred, I was startled by what felt like a direct hit from a torpedo. Another deafening crash, then a scuffling sound. Adrenaline in ample supply, I turned to see that Toni, tending cables, had come into the room. A glance into her face mask told me she mirrored my wide-eyed visage.

The door was very heavy, a couple hundred pounds. Larry was levering the damn thing up (sideways?) to spring it from its hinges. It kept slipping from the end of his pry-bar and falling several inches to the metal deck below. We felt we were swimming in a steel drum while someone pounded it with a sledge hammer. Sound travels faster underwater than on land, so it is very hard to tell where it is coming from, but it loses nothing in intensity. I wedged myself into a corner of the ceiling and pointed the camera at Larry's herculean efforts. The crashing was mind-numbing and the cold in my right glove, hand-numbing. As I hung from the ceiling like a bat with various parts of my anatomy losing feeling, the absurdity of the situation struck home. I started to laugh.

Murphy, due to his exertion, generated a lot of carbon dioxide, which greatly aggravates the effects of nitrogen narcosis. During a pause, he noticed my shoulders moving and came closer where he could faintly hear my hysterical laughter. He gave me a concerned okay query with his circled thumb and forefinger, to which I nodded affirmatively since my hands were encumbered. His okay sign changed slowly to an obscenely extended middle finger, after which he returned to the door. Even at eighty feet, a depth not normally associated with nitrogen narcosis, heavy exertion, cold, the tricks played by visual distortion from silt, and the angle of the ship, all took their

toll. Minutes later, there came the most enormous crash of all, and the door fell heavily to the silty floor. The job was done.

Archival records tell us the *America* went down with no fatalities except for an Irish setter chained to the fantail. Hopefully it will claim no more than it already has since its sinking. On our return scuffle up the stairway I noted the purser's cabin. There are mail slots in the wall of his booth that are partially filled with silt. The slots have collected underwater dust, which shows from the angle it has settled and filled the box, the direction true "up" really is. We emerged from the port hull of the ship into a shower of sunlight. Then we headed to our decompression stop, leaving a place where time and even the rules of physics have only tenuous hold.

At the ten-foot stop we had our only real brush with danger. A bull moose swimming past our boat to a nearby island saw our bubbles and came over to investigate. Luckily, the hooves of a swimming moose don't quite reach ten feet below the surface. It would have been a terrible irony to have exited unscathed from a risky working penetration of a wreck in freezing water only to be brained by a moose.

During the six years that we spent a part of each summer working on the shipwrecks of Isle Royale we learned not only of the richness of a special collection of maritime relics but that they were special places where those with the will and stamina could find touchstones to the past rarely equaled on land. It was the place where I and most other members of the team solidified a real sense of mission. If Isle Royale was an awakening, our next assignment would cement the revelation as nothing else could.

Cocooned on a bunk in the V-berth of our research boat in a remote cove on the north shore of the island, I heard the high-speed whine of a park patrol craft. Soon I was handed an official looking letter to be opened only by Dan Lenihan, c/o Chief Ranger, Isle Royale National Park. As usual, the seal was broken. Stu Croll admitted he couldn't stand the suspense of not knowing what was in these occasional missives I received from Washington. That evening, I assembled members of the SCRU team after dinner. I told them that next

year, after their hitch at Isle Royale, they would be diving the rest of the summer in very different waters. They would be working on the USS *Arizona* in Pearl Harbor.

CHAPTER TWELVE

# PEARL HARBOR: USS *ARIZONA*

—————◦◦◦◦—————

A s we entered the water from the *Arizona* Memorial's floating dock, the Navy raised pennants to warn boats that diving operations were commencing. A red-and-white "diver down" flag and a blue-and-white "alpha" were soon flapping toward the southwest. From the mast on the memorial flew the same colors in a more familiar form: Old Glory, the wind keeping her parallel to the others.

On a similar bright morning on December 7, 1941, flags were just being raised on the ships when sailors, standing at attention on deck, were distracted by a group of show-off fly-boys buzzing the fleet. Even when the first bombs tore into the ships, most thought there had been some sort of accident. Only when the red "meatball" insignias on the planes became visible did there come full realization of what was happening. Flight commander Mitsuo Fuchida had moments before radioed "*Tora, Tora, Tora,*" and watched, with what must have been great relief and satisfaction, the initiation of a complete surprise attack on the American Pacific fleet.

The Japanese had gambled the whole pot on one winning hand. They were trusting that a surprise attack on the home port of the Pacific Fleet would break the spirit of the American people and bring the United States to the negotiating table while Japan commanded a position of strength. It was a terrible miscalculation.

The underlying motivations were nationalism and racial pride; the immediate source of provocation to the Japanese was oil. A crippling embargo initiated by the United States would crush any hopes for the Japanese dream of a Greater East Asia Co-Prosperity Sphere.

In this vision, Japan would be at the apex of a new Asian Empire of the Sun.

The decision to attack Pearl Harbor to achieve these ends was tactically wise but strategically disastrous. A U.S. populace, which suffered a deep ambivalence over becoming engaged directly in yet another punishing war in Europe, was united literally overnight. The Japanese, their German and Italian allies, and anyone or anything associated with them were immediately the focus of a sweeping and violent reaction. America, the industrial giant, which entered World War I with great reluctance, was playing out the same isolationist instincts during World War II, after three years of conflict had transpired. But on December 8th, after the attack, the United States entered the war with a vengeance.

Although it may be argued that Germany would have eventually capitulated to the Soviet Union and Great Britain, the Pacific was primarily an American battlefield. The single act that precipitated changing the face of nationalism in Asia and hastened the end of the war in Europe took place in this harbor. The *Arizona* was at the heart of the storm. Half of the deaths from the Pearl Harbor raid occurred on this vessel, and the remains of almost a thousand of the 1,177 men that died on the *Arizona* that day are still here.

Superintendent Gary Cummins's words ran through my head as Jerry Livingston, Larry Murphy, and I swam slowly on the surface toward *Arizona*'s sunken bow. The depth of water over the wreck varied from eight to thirty-eight feet. We breathed through our snorkels, intending to switch to scuba when we reached the bow and reconnoiter the ship from stem to stern.

Gary had said, "I need a map of this thing, pictures, and an idea of what's happening to it down there." Like many park managers, Gary had an eclectic background. He had graduate degrees in archeology and history, and many ranger skills including diving. As soon as he took over as first superintendent of the Memorial in 1980, he knew the quality of information about the major American shrine he was responsible for was sorely deficient and totally unacceptable.

The biggest problem facing him in initiating a survey of the hulk was resistance from the Pearl Harbor military establishment. A mythology had grown about the ship that caused most admirals to believe it was too dangerous to dive. It took two years of discussion and

negotiation to gain all the clearances necessary to begin surveying the ship.

There wasn't much question about what had been there in 1941 before the attack. Historic photos, ship plans, and even movie footage of the ship in its death throes tell that story. But what was left after more than a million pounds of explosives in the forward magazine and a load of aviation fuel were ignited by a Japanese bomb—that wasn't so clear. The Navy had also spent a year removing the tall masts and superstructure, further altering the remains.

By 1980, there was a Memorial straddling the ship to which five thousand visitors a day were transported by Navy launches for a brief visit. But what were the rusted metal features that extruded from the water? What was still down there aside from what could be discerned from aerial photographs sold in the visitor center as postcards? No one had a clue. We were about to find out.

As we switched from snorkels to our regulators and began our descent, some strong association emerged from my subconscious. Diesel fuel. That's what it reminded me of: diesel fuel like I smelled as a volunteer fireman—overturned eighteen wheelers and diesel fumes, masculine, harsh, intrusive. Scents are powerful stimuli and distinct odors underwater are rare, so when they occur, it leaves an impression.

Was it coming through my airtight face mask? No, I was probably smelling it through my regulator. Droplets of water, making their way through the one-way exhaust valve as vapor then into my throat—I was tasting the wreck. And feeling it. The ship has a unique texture: rough, unforgiving, jagged metal. Most of it was coated with a crust of barnacles and tube worms—a strong contrast to the smooth, sometimes slippery-with-algae, surface of the iron-hulled wrecks at Isle Royale. If we weren't clothed head to toe with neoprene and denim, we would have been scraped raw every time we touched the ship.

And the eye. The *Arizona* plays on the eyes in tune with its taste and feel. Stark, as if it had been there for eons—a force of nature not the work of man. When the silt wasn't disturbed, we could see clearly for only five to seven feet. Past that distance, objects became shapes, and beyond; the shapes blurred into indistinct forms, eventually merging into a greenish-gray metallic mass. Something here was the ultimate expression of profound finality.

We were swimming the site to assess the problems we would face in our research. Biofouling, marine organisms mixed with products of corrosion, covered the *Arizona* like a thick scab. Studying the composition of the crust would tell much about the structural integrity of the ship and also the environmental history of Pearl Harbor.

We had descended at the "bullnose," near the very stem or prow of the ship. From this perspective, two holes cut into the hull above us for accommodating mooring lines appear much like the flaring nostrils of a bull. The *Arizona* is amazingly narrow at the bow; I find I can wrap my gloved hand over the stem as if it were the edge of a door. Hawse pipes through which chains for the four huge anchors used to descend are carpeted with sponges, mollusks, and other colorful organisms. But sunlight still makes its way through from the deck. Rays of light from the midmorning sun pierce the gloom.

We move on to the area of major blast damage. The thick metal plates and beams are radically ripped and folded here reminiscent of crumpled paper. This is where the huge ammunition magazine was struck by an armor-piercing Japanese bomb. Its delay mechanism allowed it the necessary fraction of a second to penetrate several decks before detonating in the heart of the ship. Such an explosion begins to compare with nuclear detonations—equivalent to approximately five hundred tons of TNT, which amounts to a one-half kiloton blast. By comparison, the bomb that destroyed the federal building in Oklahoma City was about four tons.

The stories of survivors are often jumbled and conflicting, as one might expect of people witnessing such a traumatic event. Particularly interesting are eyewitness accounts provided by men standing on the stern of the *Vestal*, a ship moored outboard of the *Arizona* on the morning of the attack. They swear that a torpedo traveled directly under them and struck the deeper-draught battleship, causing the massive explosion. One survivor visited me in Santa Fe to adamantly make this point. We veered off toward the starboard side to check for ourselves. We found a crack that begins at the top of the torpedo blister and followed it to the mud line. Larry looked back at me and shook his head. There simply is no torpedo entry hole where they say it should be. It is possible one exists below the silt line, but we would expect to see "washboarding," a rippling effect on the hull, or some other sign of the hull being compromised below. This interplay of

Submerged Cultural Resources Unit

*Left:* An early version of SCRU logo.

*Below:* Little River cave, Florida 1972. Tex Chalkley and the author. *(Photo by Greg Fight)*

*Bottom left:* Author working in tight space in a cave in an Arkansas park, 1974. *(NPS photo by Larry Murphy)*

*Bottom right:* Exploring Rio Coy cave in Mexico, 1979. Standing: left, author; right, Paul DeLoach. *(Photo by Sheck Exley)*

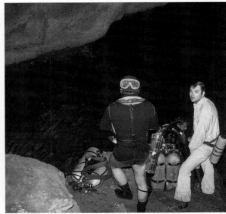

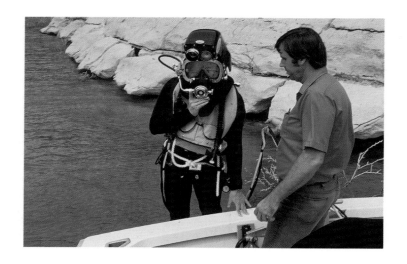

## Amistad Lake, Texas

*Above:* Inundation study, author in video helmet, 1976.

*Right and below:* Rescue-recovery exercises for park rangers, 1979.

*(NPS photos by Eric Reubin and Toni Carrell)*

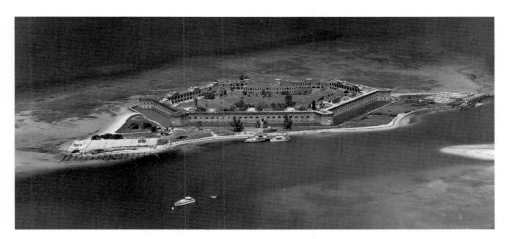

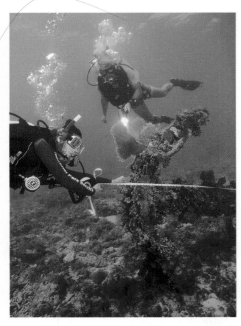

## Dry Tortugas

*Top:* Fort Jefferson aerial view, 1960s.
(*NPS photo by Jack Boucher*)

*Above left:* Anchor from 1800s. (*NPS photo by John Brooks*)

*Above right:* Mapping operations, 1993. (*NPS photo by John Brooks*)

*Bottom:* Larry Murphy reading survey instruments in patrol boat, 1993. (*NPS photo by Tim Smith*)

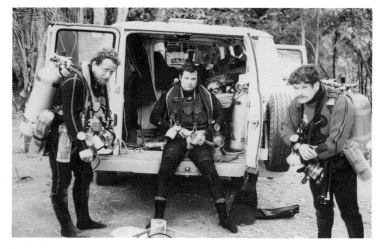

## Mexico

Rio Choy, 1979. Left to right: author, Paul DeLoach, Sheck Exley.

## Biscayne

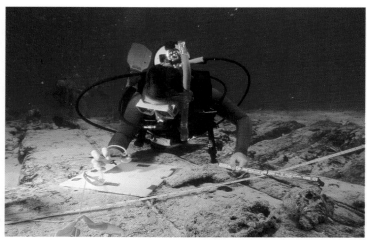

*Right:* Mapping, 1990s. *(NPS photo by John Brooks)*

*Below left:* Author monitoring the magnetometer, 1980.

*Below right:* Larry Murphy back-filling excavation with dredge, 1990s. *(NPS photo by John Brooks)*

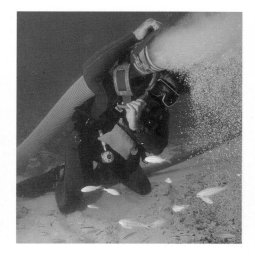

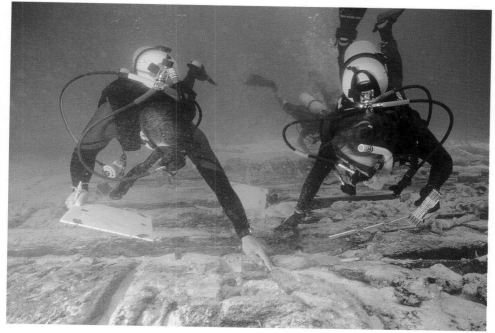

## Biscayne

*Top and below right:* Mapping the HMS *Fowey*, 1990s.

*Bottom:* HMS *Fowey* shot locker. *(NPS photos by John Brooks)*

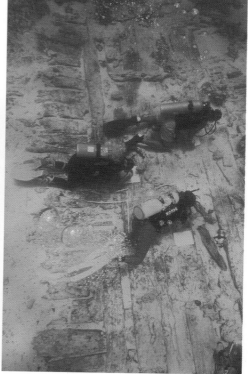

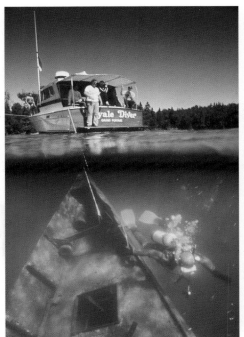

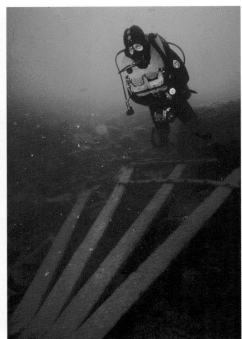

## Isle Royale, 1980

*Above left:* Diver and wreck below *Royale Diver*. *(Photo by Mitch Kezar)*

*Above right:* Toni Carrell above the remains of the paddle wheel from the *Cumberland*. *(NPS photo by John Brooks)*

*Below:* Inside the *Emperor* shipwreck at Isle Royale. *(NPS photo by Larry Murphy)*

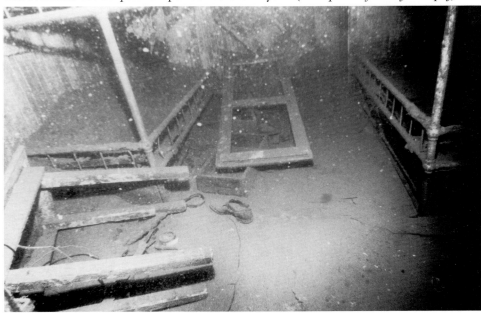

## Isle Royale

*Top:* Surveying the *Kamloops* in excess of 200 feet with robotics, 1986. *(ROV photo of second ROV courtesy of Emory Kristof,* National Geographic *magazine)*

*Middle:* Larry Murphy videotapes (black-and-white, reel-to-reel) the aft cabins of the *Emperor*, 1981.

*Bottom:* The wheel of the *Kamloops*, 1986. *(ROV photo courtesy of Emory Kristof,* National Geographic *magazine)*

Kalaupapa, *Above:* Kauhako Crater, Marine Corps helicopter retrieving survey gear. Author at center of concentric swirl in water, 1988. *(Courtesy of Emory Kristof, National Geographic magazine)*

Bikini Atoll, *Below:* Larry Murphy at propeller of upside-down Japanese battleship *Nagato*, 1989. *(NPS photo by Daniel Lenihan)*

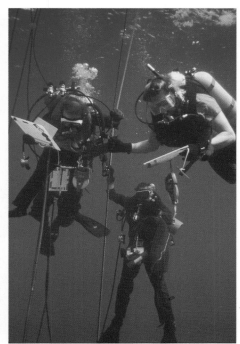

Bikini Atoll, *Above left*: Jerry Livingston sketches over the submarine *Pilotfish*, resting 180-feet deep, 1989. *(NPS photo by Larry Murphy)*

*Above right:* Decompressing, Jerry Livingston, Jim Delgado (obscured), author, Larry Nordby, 1989. *(NPS photo by Larry Murphy)*

*Below:* Author examining bombs inside hangar deck of USS *Saratoga*. *(NPS photo by Larry Murphy)*

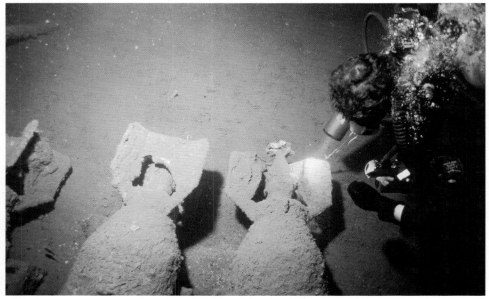

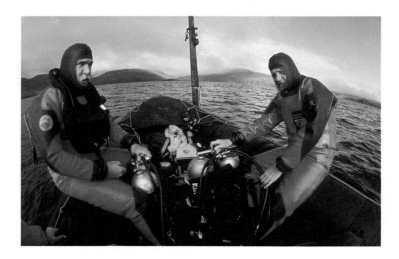

## Aleutian Islands
(Kiska Harbor)

*Top:* Larry Murphy and author, 1989.

*Middle:* Midget sub, Murphy and author.

*Bottom:* Author enters Japanese submarine. *(NPS photos by Michael Eng)*

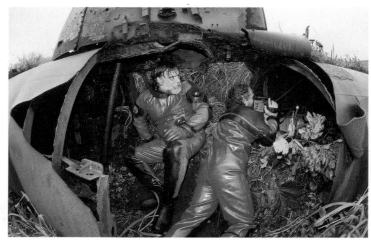

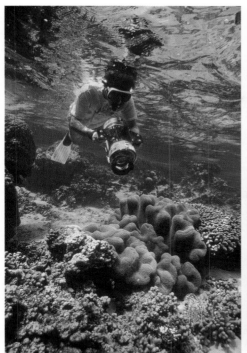

*Top left:* Doug Cuillard, Superintendent of the National Park of American Samoa, making photo inventory of coral, 1992. *(NPS photo by John Brooks)*

*Top Right:* Pohnpei, coral column, Nan Madol, 1992. *(NPS photo by John Brooks)*

*Below:* In American Samoa, author examining coral killed by discarded disposable diaper, 1992. *(NPS photo by John Brooks)*

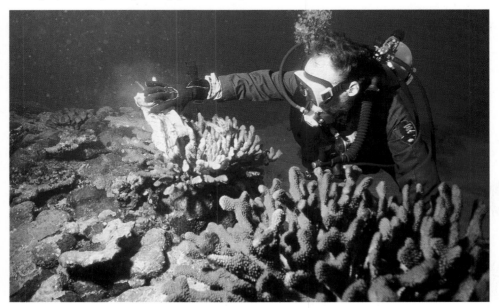

Kosrae, preparing for videotaping of *Leonora*, 1981. Left to right: Toni Carrell, Larry Murphy, Julian Jonah, Teddy John. *(NPS photo by Paul Ehrlich)*

Kosrae, survey of Bully Hayes' *Leonora*, copperclad water tank, 1981. *(NPS photo by Bob Adair)*

Guam, Ranger Jim Miculka videotaping turret on invasion beach at War in the Pacific National Historical Park, 1983. *(NPS photo by Daniel Lenihan)*

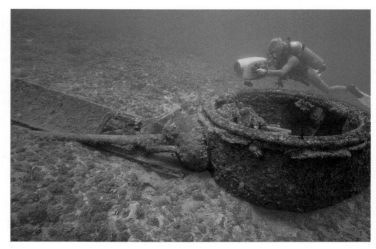

*Above:* Kosrae, Larry Murphy and author doing photo mosaic on *Leonora*, 1981. *(NPS photo by Bob Adair)*

*Below:* Author and Larry Nordby mapping lava cave, Kaloko-Honokohau National Historical Park, Hawaii, 1992. *(NPS photo by John Brooks)*

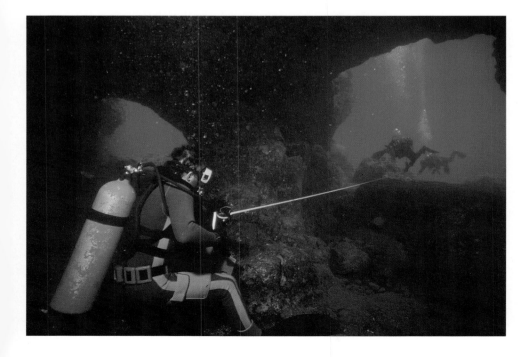

Forward hatch of Civil War submarine *HL Hunley*, Charleston Harbor, 1996. *(NPS photo by Chris Amer, South Carolina Institute of Archaeology and Anthropology)*

Author over wreckage of CSS *Alabama*, off Cherbourg, France, 1993. *(NPS photo by John Brooks)*

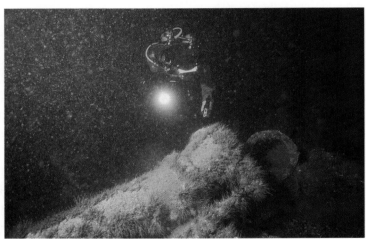

Pearl Harbor, 2000. SCRU and friends pay tribute to Cal Cummings, senior NPS archeologist, on hearing of his death, from left to right: Dan Lenihan, Matt Russell, Deb King, Larry Murphy, Jim Adams, Jim Bradford, Kathy Billings, Art Ireland, Brett Seymour.

Pearl Harbor, 2001 (*NPS photos by Brett Seymour*)

*Top left:* USS *Arizona* Memorial. *Top right:* Deb King mapping artifacts on deck of USS *Arizona*. *Below:* Oil samples being taken for analysis by Larry Murphy.

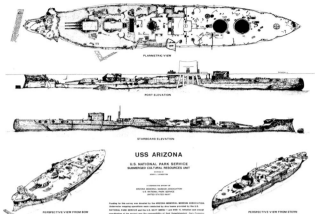

## Pearl Harbor

SCRU five-part drawing of USS *Arizona*, by Jerry Livingston and Larry Nordby, won awards for graphic display in 1985. Project was funded by Arizona Memorial Museum Association.

*Right:* No. 1 turret 14-inch guns of USS *Arizona*.

*Below:* Looking up at the Arizona Memorial through oil splotches. (*NPS photos by Brett Seymour*)

documents, people's memories, and physical evidence comprises historical archeology, its answers, and mysteries.

The cavernous muzzles of three fourteen-inch-diameter guns began to take shape in the murk ahead of me. They weren't supposed to be there. Park Service and Navy officials in charge of the site told us the forward turret had been removed along with the other three during salvage operations. The presence of the huge turret underscored Gary's point—how ignorant we were of the present state of the ship. Earlier in the week, other discoveries were made by park divers, such as live ordnance for the five-inch guns decomposing under the busiest part of the memorial. We called the Navy Explosive Ordnance Disposal teams in to remove the shells.

I followed the dim shape of the sixty-foot barrels—they appeared incongruously large. Everything around them is amorphous in the cloudy water, except for these encrusted steel tubes: guns capable of heaving a projectile the weight of a small automobile twenty miles. Only battleships had guns like these. Although the importance of these huge sluggers in naval warfare was soon to be overshadowed by the aircraft carrier, in 1941 they were still the symbolic pride of the world's navies.

The knowledge that the majority of the battleships in the Pacific fleet were on the bottom after only a few hours of fighting one Sunday morning—before war was even declared—had an extraordinary effect on the American public. That the Pearl Harbor attack was flawed, because it emphasized the wrong targets and was ended too quickly, is easier to understand from a historical perspective. In 1942, after news of the full damage leaked out, the attack seemed apocalyptic. Matters weren't helped by the fact that German U-boats were then pounding merchant shipping in sight of U.S. beaches in places like New York, New Jersey, and North Carolina.

I shined my light down the barrel of the port fourteen-inch gun and spied a puffer fish. His choice of a home was ironic. What might have been the most inhospitable place in the world for anything to live on December 6, 1941, became ideal fish habitat a day later.

We caught up to Larry, his swimming pace slow, subdued. He pointed at an intact porthole, then gestured there were more ahead. We cleared a mat of sponges and other organisms covering the glass. Faces glued to the port as the silt cleared, we saw blackout covers

closed tight from the inside—evidence of the state of readiness the ships were supposed to observe with clouds of war gathering to the west. As we checked other portholes, we found some in which air remained in the spaces between the glass and the cover, air dating from 1941.

Jerry elbowed me and pointed down at shiny teak decking exposed where the silt seemed to have been fanned away. It is rare to see wood preserved so well in a warm, saltwater environment because of the insatiable appetites of teredos, marine-boring worms. The silt covering the deck apparently helped by creating an anaerobic environment. Then the mystery of how the decking became exposed was solved when we observed Tilapia wallowing to clean an area to deposit their eggs.

As we passed over the top of the ship in shallow water in front of the Memorial, a crowd of spectators watched over the rail. We entered the remains of the ship's galley, where coffee cups and forks used by the crew in 1941 still lay. Intermingled with them was modern detritus from millions of visitors who have been to the Memorial over the years. Camera lenses, sunglasses, and hairbrushes accidentally dropped, plus hundreds of coins, purposely thrown on the ship.

We found something else amid the other offerings and lost items: photographs. They seemed to be mainly of children or the very old. I wondered if they were mementos from the living to the dead. Photographs of the siblings, children, and grandchildren of the men who lie here; perhaps a way of sharing the joys and sorrows of unknown offspring. An image flashes through my mind of the black stone wall in Washington, D.C., on which more than 50,000 names are inscribed. Men and women wearing the Park Service uniform stand silently by each day as flowers and photographs accumulate. The Vietnam Wall commemorates the death of the sons of the generation entombed in the *Arizona*. I wonder how many of the men on this ship never saw their sons, who, in their turn, never saw . . . we move on.

The water around us turns dark as we pass under the Memorial structure. Aft of the Memorial, the barbette for the number-three turret extrudes from the water, the largest single visible feature at the wreck site. Reminiscent of a huge cylindrical well casing, it was the support structure for one of the huge turrets holding the triple set of fourteen-inch guns.

Next to this turret is an area where people standing on the Memorial reported seeing the most consistent presence of oil. We found a hatch from which shiny black globules emerged every few seconds. Like lazy liquid marbles they rose gently to the surface. When they hit the air a few feet above our heads, they changed character, losing form to become part of the omnipresent rainbow slick bobbing on the waves under the gaze of onlookers standing in the Memorial.

The size of the slick seemed disproportionately large compared to the black drops that created it. There was a sense that the *Arizona*, easy to anthropomorphize anyway, was still bleeding.

We reached the stern of the ship where the base of the crane used for hauling aboard the reconnaissance planes had been removed. Larry ran his finger over the scalloped metal edges of the hole—the work of cutting torches, not the ragged tears associated with blast damage. The Navy and civilian salvage community accomplished a feat after the bombing of Pearl Harbor almost as dramatic, and easily as portentous, as the attack itself. Within several frenzied months, they raised and sent back into action the majority of ships that on December 7th were considered total losses.

What must the architects of that attack have thought when their enemy displayed the ability to rebuild ships faster than they could be destroyed? Among the flaws of the Pearl Harbor attack, besides missing the aircraft carriers, the Japanese neglected the ship-repair facilities and aviation fuel depots in favor of the more immediate gratification of seeing battleships in flames.

Hardly six months passed before the reconstituted American Pacific fleet delivered a blow at Midway that eliminated any serious chance of the Japanese Imperial Navy launching a major offensive ever again. Most of the Japanese aircraft carriers, and their crews, the backbone of the attack on Pearl, took their turn on the seabed in 14,000 feet of water, far beyond any hope of salvage or any vision of a new world order in the Pacific.

We arrived at the fantail, the very stern, where the *Arizona* narrows radically and again becomes identifiable as a ship, even in low visibility. We noted the empty flagstaff hole—the flag had been removed, spattered with oil, water, and blood, by two *Arizona* survivors

in the aftermath of the attack. An orange buoy marking the stern bobbed only a few feet above our heads.

I separated from the others and swam on the surface back under the Memorial to a place where the twisted steel is only a few feet underwater. Waves slapped the concrete supports that straddle the ship; there was a steady staccato of splashing from a light chop stirred by the northeasterly breeze. I let the regulator fall from my mouth and breathed fresh air as the waters parted around me. Again, there was that pungent odor of fuel oil mixed with sea salt. I ran my fingers over the mask strap on the back of my head, and noted a slightly viscous feeling to my hair.

Standing on the tips of my fins in chest-deep water and leaning against the jagged remains of a bulkhead that used to be part of the ship's galley, I heard voices in the Memorial. I imagined 1,177 young men exchanging jokes, flexing their muscles, feeling immortal at 8 A.M. on a sunny Hawaiian morning. Ten minutes later, they were consumed in an inferno, transformed instantly into the stuff of history.

The latest visitors from the tour boat are orienting themselves to the spectacle of rusted metal stretching below them. From my vantage point in the shadow of the white arching Memorial, I observed them strolling along the promenade over my head, but I was visible only from a few points on the walkway. A child looking through the railing at knee height spied me and tried to convince his mother he saw a man amidst the tangle of wreckage in the water beneath them. She knew better and, never glancing in my direction, explained away another figment of her son's overactive imagination. Yellow and purple flower leis, tossed onto the ship by a group of Japanese, floated by me in the current, their brilliant colors only slightly subdued by the effects of the oily water.

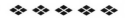

During those first few weeks we dived the USS *Arizona*, I tried hard to see it as just a job. We were going to measure and photo-document the largest object ever mapped underwater—three times the size of the Statue of Liberty—nothing but twisted metal and the unfeeling remains of a long-ago tragedy.

We made dive after dive. I sent mapping teams and photo teams around the ship, setting reference points, running our mapping line (#18 braided cave-diving line—a habit from my misspent youth). Gradually, we figured out what worked in mapping and photographing a 608-foot-long battleship on the bottom of a murky harbor. Our strategy was to run nylon strings down the deck, carefully mark them in ten-foot increments, and send team after team of Park Service and Navy divers to measure distances from the known lines to features of the ship.

The lines had previously been marked with numbered clothespins by the project archeologists and illustrators, and miniature versions of them plotted on graph paper. Tape measures stretched between any two known points on the line and any object of interest on the ship formed a triangle. Reduced in scale, the taped distances are transferred to our base map, where they accurately reflect the location of the object in the real world. We made thousands of ephemeral triangles that lasted but a few seconds, two sides of measuring tape and one side of string. A combination of fifth-grade geometry, several hundred clothespins, and almost a half mile of string made up our technological portfolio.

We worked out the planimetric or bird's-eye view with variations of the system we had perfected at Isle Royale. But we ran into additional problems with the *Arizona* on the elevations or profile views. In a word, it was curves—steep curves in low visibility. I had our divers drape our white lines over the vessel at ten points approximately sixty feet apart. We mapped the relation of all the straight lines to each other—then using our mystic triangles, mapped in all the features within these areas on each side of the hull as if they were separate flat panels.

Larry Nordby, who was in charge of the elevations, came up to me as the process started and pointed out an "issue," as he called it.

"Dan."

"Yeah."

"Uh, I should point out that the ship varies in beam, or width, from about four inches at the stem, to one-hundred-four feet." That means from an imaginary straight line running parallel to the center-line axis of the ship, the hull varied from two inches to fifty-two feet deep on each side.

"So?"

"Well . . . , " He had crossed his arms in front of him and was snorting his exhalations through his nose; a sure sign of trouble. "If we map all the flat panels between the string accurately, you do understand that we are going to end up with a six-hundred-eight-foot ship that will scale out more than six-hundred-twenty feet long."

After a long pause, where I cogitated his meaning, the implications of what he was saying started to sink in . . . along with the embarrassment. Of course! Damn! In low visibility we were not going to be able to compensate for the ship's very sheer lines. Welcome to another "Hail Mary" moment.

Nordby smiled and added, "Just poking ya, boss, it's a problem but I can fix it. A little trigonometry, a little fudging, we won't have an error factor more than a few inches in each panel—and it won't be cumulative." Always, always recruit people smarter than you!

The mapping progressed beautifully. Nordby concentrated on the port elevation and provided oversight to Mark Senning, a ranger from the park who supervised work on the starboard. Jerry Livingston supervised the plan view but spent as much time assimilating the results of the other teams—he would be responsible for the final rendering of all the drawings. Dave McLean, Chief Ranger from Lake Mead and diving officer from the Western Region, served as project dive officer and liaison with the Navy. I found that, even given a cadre of archeologists made up of diving instructors, it was a great advantage to have a person who could concentrate on dive safety without being distracted by the scientific goals.

The drawings coming together in the anteroom of the Memorial captivated visitors. Rather than avoid the time-sink involved in satisfying their curiosity, Cummins and I decided the public deserved to have their myriad questions answered. They, after all, were paying for the work with their taxes. So, we had each participant take a shift during the day playing host and interpreter to the visitors. The people were thrilled with the courtesy shown them, and things were going generally well. I started to relax.

There was only one other component of the project that I needed to tend to; the acquisition of video-imaging of the ship underwater. As I started to come down from the panic of uncertainty about being able to accomplish the job, I noticed that my attempts at distancing

from the emotional load of the *Arizona* started to weaken. The place was starting to get to me. The thing that finally did it was the video footage.

In 1983, they had just begun coming out with the home color video cameras, and several months later some enterprising folks in California had designed an underwater housing for them. I chose one mounted in a big fat housing, which handled quite well underwater. The housing even had room for a three-inch color monitor that gave me instant feedback of what was being recorded on the VHS tape.

I loved the practicality of this new self-contained system. No umbilicals to the surface, no one yelling into the coms unit in my helmet: "Pan right, twenty degrees left, come in closer here." I could see it all real-time on the monitor and, best of all, use an ordinary scuba mask, not the neck-crunching, massive Plexiglas and iron helmets that were our weapons of choice for videotape operations at Isle Royale and the reservoir inundation study.

I started focusing on the things that I thought might interest people—poignant things. Poignant, that is, to people who weren't here doing a job. True, 1,177 men had died here, and the remains of over a thousand men were intermingled with the silt. But I was determined not to let that distract me from a job that demanded all my attention. In a sense, I tried to treat it like body recoveries and keep my distance. This all had happened a long time ago. I had a job to do; keep my distance.

Slow pan of the fourteen-inch gun muzzles, portholes with the blackout covers shut, forks and knives in the galley, firehoses; yeah, that'll make good footage—melted couplings where the survivors had made futile efforts to . . . Lord, this place must have been hell: keep my distance.

I took the camera to the surface and handed up the housing. Before changing tanks I toweled down the Plexiglas back of the housing, opened it, and removed the first color video ever shot on the ship. Gary Cummins had placated the media by allowing one representative of all the stations to dub the tape onto a broadcast-quality recorder and share it with the others.

I was soon back down on another dive. Returning an hour and a half later, I was surprised to find news cameramen still there—I had

already given them a twenty-minute cassette of tape. "Anything wrong with that first tape, Gary?"

Gary said under his breath, "Wrong? Hell no. These guys viewed the first stuff and want to dub every damn inch of tape we bring back." So I got carried away for a while. That big clumsy rig on the surface was incredibly easy to pan underwater and as long as I kept moving slowly and surely, the harbor water acted like a giant fluid tripod—none of the jumpy, jerky moves you saw in home video footage.

I felt good by the end of the day. We had obtained decent video documentation, and we were getting excellent measurements with good closure. After shampooing as much of the oil out of my hair as I could, I hopscotched over the roaches at the Pagoda Hotel to fall exhausted into bed beside a very pregnant Barbara Lenihan.

"Switch on the TV, let's see if they used any of that videotape."

The screen came to life just as an anchorwoman with a solemn expression finished her lead-in discussing what they were about to show.

"Wow," Barb said, "I didn't think it would look so good."

For the next four minutes, an enormously long time for a newscast, I watched the footage I had shot earlier that day. Beautifully edited, it was a moving montage of twisted steel, eerie hatch openings, ghostly portholes all in vivid contrast to the colorful fish swimming by. They finished with an oil globule I had filmed, working its way slowly to the surface, and ended with a cutaway shot from the Memorial, where the oil burst into a rainbow slick and the camera panned over the names of those killed on the ship, the American flag fluttering above, and Honolulu in the background. The newswoman said simply, "All of us in Hawaii thank the National Park Service for sharing these images with us."

The ship was never the same for me again. As silly as it might sound, this was the one place, in my motel room, lying next to my wife, that my defenses were down. The images were absolutely haunting. For the next two weeks we repeated the ritual of handing over our new footage, and all the Honolulu stations played it religiously every night. I could flick from one channel to the other and review footage I shot that day and was too tired to review at the Memorial before coming back to the motel.

It is a most curious thing that television, the "cool medium" Mar-

shall McLuhan and others have argued distances people from reality, had this effect. It was that very medium that provided me with an oddly personal connection to what I had seen firsthand for weeks.

As time went by, my connection with the ship increased. My attempts at keeping a distance from the carnage in the forced intimacy of the underwater environment was doomed from the start—but I'm glad it happened early. It would have been a shame to have made hundreds of dives on the *Arizona* and never really have been there. I increasingly came to terms with the ship and its history over the years. We understand each other; I even found myself talking to the young men, the thousand or so still there, through the portholes—never in words but in feelings.

I spoke to them as I laid mapping lines, pulled tape measures around the ship. I told them they hadn't missed much; music's gone to hell, the Dodgers and Giants have left New York, overpopulation, etc. They welcomed me like a familiar custodian, made me feel comfortable, like I was really doing something when I worked to honor them. Yes, the crew of *Arizona* and I are on good terms; we really do have an understanding.

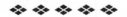

*Postscript:* The Navy became increasingly intrigued with the methods SCRU had developed to map things underwater. The techniques we employed were homespun, simple, and very effective. Jerry Livingston, our illustrator, assembled the line drawings we had generated in our early work into a five-part rendering of the ship from different perspectives that won a national award for historic display. The video footage we obtained helped finalize the drawings and provided the teaser that inspired an excellent documentary on our work by the BBC in 1986.

The Navy's interest in our approach to surveying things underwater and the fact that we generally worked well together provided the basis for a long cooperative relationship in a program called Project Seamark. For the ten years after our first dives with them, the Navy increasingly joined us on projects throughout the Pacific and through much of the lower forty-eight and Alaska.

# CONTEMPLATION VS. ACTION

[On exploring the tide pools near La Paz for scientific specimens:]

"What did you lose?" they ask.
"Nothing."
"Then what do you search for?" And this is an embarrassing question. We search for something that will seem like truth to us; we search for that principle which keys us deeply into the pattern of all life; we search for the relations of things, one to another, as this young man searches for a warm light in his wife's eyes and that one for the hot warmth of fighting.

*The Log from the Sea of Cortez*
John Steinbeck

The Submerged Cultural Resources Unit, as seen from the outside and written about in the popular press, is usually portrayed as the sum of its actions—its projects. There was also an intellectual growth process that reflected the constant stimuli we received from dealing with so many diverse forces in our diving and research world. Some of these considerations were on the theoretical level, some on the methodological. It would be an incomplete story not to pause in our recount of adventures and reflect for a moment on the Yin that, in the early 1980s, accompanied the SCRU Yang.

SCRU was in operation for only a year before Larry, Toni, and I felt that we were operating in a theoretical vacuum. In the NRIS, we addressed the issue by creating a comprehensive research design to face the unique problems of reservoir research. But SCRU's issues were different, in that there were several competent organizations, academic and otherwise, working on shipwrecks, but they operated completely disassociated from the broader, anthropologically ori-

ented discipline of American archeology. We felt a compulsion to address what we felt to be total lack of convergence of shipwreck archeology with the fundamental body of anthropological theory.

In its most extreme form, leading archeologists had asserted that "archeology is anthropology or it is nothing." Although we by no means felt that to be the case, we did feel that anthropological issues had been disregarded by the largely classical and historically oriented groups that were engaged in serious shipwreck studies.

As we sifted through data from Biscayne and Tortugas and *Leonora* and considered the wrecks of Isle Royale with which we had only brief acquaintance at this point, we sensed something missing in our approach—a theoretical underpinning. We were finding, describing, and waxing prosaic about shipwrecks, but there seemed to be no precedent for logical linkage with our mother field of anthropology. The more we attended conferences, the more this became apparent; even excavations conducted by first-rate underwater archeologists were isolated scientific events without the unifying connection to the social sciences offered by anthropology. Information gleaned from the sites fed little back into the comparative study of man and human cultures.

The fact that a pewter cup was found on a shipwreck site engraved with a name, and the name could be traced through the archives to identify a particular sailor was indeed interesting. It helped history come alive and demonstrated the link between the material record and the written. But this sort of link seemed to be the ultimate triumph of historians doing underwater archeology. What was lacking was demonstrated relevance to broad patterns of human behavior. What commonalities existed between shipboard life on a seventeenth century French man-o'-war, a World War II German cruiser, and a Phoenician trading vessel from 600 B.C.? How did humans cope with the act of shipwrecking as evidenced in items they selected when abandoning ship? Were they practical, religious, or strangely unpredictable in making those choices under stress? There were hundreds of existing areas of behavioral inquiry that anthropologically oriented archeologists were addressing on land sites. But there seemed to be no attempt by underwater archeologists to feed into those social scientific issues. As a result, the traditional archeological community tended to take underwater endeavors less seriously.

Other maritime archeologists noted this problem, but most were overseas, including a fellow named Keith Muckelroy, who was writing some very compelling articles and books on maritime archeology, trying to provide the very theoretical grounding we were missing.

Shortly after returning from Kosrae in 1981, I walked into the office of Doug Schwartz, the president of the School of American Research in Santa Fe and asked him if he could help. He had been running highly respected seminars in different areas of archeological theory for many years and tackling widely disparate theoretical issues in all areas of anthropology and archeology.

I laid out our concern, telling him the Park Service would help fund a seminar to address the problem but it must be a joint venture. I asked Doug to absorb some of the costs at the school and lend his expertise in running highly effective seminars. We'd provide the names of a few practitioners we wanted to see involved, including ourselves. But I made it clear we were not interested in hearing a lot of underwater people fumble about trying to be theoreticians; we wanted the best minds that the discipline of archeology had to offer, the people most conversant in theory, to dominate the session. And...we wanted hard results in the form of a publication in his seminar series.

Doug said nothing during my presentation, just sat there with his hands behind his head, listening. When I finished, he broke into a smile. "You've really surprised me, I didn't at all think that was what you were going to suggest."

"Yeah, I expect you thought I was going to ask you to set up some seminar on underwater techniques where we could all impress each other with how technically competent we were and go home."

"I expect you thought right."

"Well, what do you think?"

"Who comes to mind?"

"What do you mean?"

"Who do we get to chair the seminar?" Doug pulled his chair around and started in as if we already had a signed contract. Who should be invited, when should it be held, who would lead it? By the time I left his office I not only had a commitment to joint-venture the seminar but we had settled on most of the participants and decided on a tentative date. No wonder Doug was so successful at running the

school; he didn't let grass grow under his feet once he had made a decision.

Before I left that morning, Doug had also left a message with Dick Gould, who was leaving as chair of anthropology at the University of Hawaii to teach at Brown. Doug convinced me that he would be a good person to run the seminar. He was a highly regarded theoretician and had an interest in underwater archeology. We were soon to find he personally knew and respected Keith Muckelroy, one of the key people we had identified from abroad.

The seminar ran later that year. *Shipwreck Anthropology*, the book that resulted from the session, was published by the University of New Mexico Press in 1982. Written by eleven participants, including six top people in archeological theory (Dick Gould, Pat Watson, Peter Schmidt, Stephen Mrowzowski, Mark Leone, and Cheryl Classen) and five practitioners (Murphy, myself, Cockrell, George Bass, and Gary Stickel), the combined papers comprised an articulate statement of the potential and the limitations of applying anthropological paradigms to underwater archeology. Most comprehensive works in maritime archeology cite this work, either agreeing or taking issue with the authors on points of theory, both about the nature of shipwrecks and about their studies in an anthropological framework.

In addition to taking an important step toward gaining a firm footing in theory, this distinguished group of primarily land archeologists all signed a "Statement by Seminar Participants on the Present Looting of Shipwrecks in Florida and Texas." This statement, prominent in the front material of *Shipwreck Anthropology*, was a powerful endorsement of shipwrecks as "an irreplaceable resource for archaeology and anthropology," and it also included a pointed indictment of any archeologists working in collusion with treasure hunters. Any areas of gray that had shaded the subdiscipline of underwater archeology as the domain of treasure hunters, or suggested that less stringent standards be applied underwater than on land, were firmly laid to rest: "Scientific, legal and ethical standards that apply to archaeology on land should also apply to archaeology under water. Archaeology for gain, by selling gold and other materials taken from wrecks for personal or corporate profit, is not acceptable. Nor is any indirect involvement by archaeologists in activities that foster a market in such antiquities."

Satisfied that we had set the stage in theory for what we would do in practice, we were ready to return to the field with renewed energy. The only aspect of the seminar that dampened our spirits was the absence of Keith Muckelroy from the list of participants. He was instead listed in the dedication—he had drowned in a freak diving accident before being able to take part in the seminar. I never met him but one only had to read his work or speak to his many friends to know that maritime archeology was diminished through his passing.

About the time that *Shipwreck Anthropology* hit the streets in 1983, another issue arose that deserved serious contemplation. This was more a methodological concern and should serve as an example of many that came up in the history of SCRU, an organization that blended cutting-edge diving with underwater science and exploration. It was brought to my attention in the inimitable style of Jim Stewart, dive officer from Scripps Institution of Oceanography.

Jim Stewart, longtime dive officer at Scripps, was a great supporter and mentor of the NPS diving program from well before I was in the Service. Jim is opinionated, irascible, and often dogmatic regarding diving protocols. Naturally, I immediately liked him and took to arguing with him every chance that presented itself. The following is my best recollection of a phone call I received from Jim after our 1983 field session.

"Well, Lenihan, have you killed anyone at Isle Royale yet?"

"No, not yet. Nice to hear from you, anyway, Jim."

"Well, it's just a matter of time."

"Why's that?"

"You're diving them too hard for too long."

"Ya think?" I didn't even bother pointing out that Jim had never been within miles of our Isle Royale operations. The Service diving community is small and intense, and everybody pretty much knows what everybody else is doing several minutes after it's done. Jim was the one external diving expert privy to the NPS internal grapevine. I knew his information about our procedures was probably accurate enough—I was really curious what was on his mind.

"Stays light up there, so you dive all day long into the night."

"We're real conservative with the tables, Jim."

"Doesn't matter, your divers are too tired and cold."

"Hell, we're substituting oxygen for air on the decompression stops but using air tables, that's a huge safety factor." Jim could have blown the whistle on us using oxygen for in-water decompression of scuba divers because it was frowned on by most institutions at the time. But Jim was a diver's diver, he wasn't hung up on what books said or laws decreed about doling out oxygen. He knew that it was a good thing and had defended my using it during policy meetings.

"Right, my friend. And that's why you haven't bent anybody up there yet. The only reason."

"Ya think?"

"I know. Dan, you're not paying enough attention to the 'Safari Syndrome.'"

"The who?"

"The decompression tables weren't meant to be used in those damn twenty-one-day diving marathons of yours up there. You've got to let them clean out their systems every few days. . . . Bet a lot of your folks are going home sick or going to bed overly tired every day."

"Nope, can't say that I've noticed any trend like that." I lied. As a point of honor (or dishonor), I couldn't let Jim know that he'd nailed me. For the remainder of the conversation, I basically implied that he was overreacting and shouldn't read any more books about syndromes and the like.

After the call, I immediately pulled out the dive logs from Isle Royale and, while I went over them, considered carefully everything Jim had said. In the past, we had disagreements on many little things and a few big ones but I had a great deal of respect for his diving savvy. Most diving physiologists and medical doctors were a mixed bag of help to people in the business of running serious research diving operations. Jim was in constant contact with all of these specialists, and, unlike most dive officers, he could separate the kernels of really useful information from the chaff. Whether or not I agreed with Jim I always took his opinions very seriously and never rejected them out of hand.

I mulled over the conversation for weeks. The reason we were pushing so hard is that every day of the boat charter snapped about $750 out of our meager budget, and the work ethic of the group of in-

dividuals was extreme. The team took great pride in its accomplishments, and its members were dedicated to the point of fanaticism. Our people were often exiting the water and climbing into sleeping bags to regenerate core temperature for their next dive. We made jokes about pouring peanut butter and jelly and hardtack into one end of the sleeping bag until the divers re-emerged from the other to use the facilities or suit up for another plunge. They were often unnaturally tired (which is a subtle symptom of borderline decompression sickness), and they indeed were being sent home on a frequent basis for injuries and respiratory infections.

Beneath any surface bravado, all of us in SCRU took diving safety very seriously. We spent much time debriefing minor incidents and discussing ways to avoid problems before we had to deal with them. Larry was particularly important in this regard. He had run many hundreds of exceptional exposure dives on air (over 190 feet deep) at Warm Mineral Springs with no accidents. He had great instincts for rooting out problems before they occurred. But one weakness that Jim had pointed out before was that our team was tremendously goal-oriented and had a blind spot regarding fatigue—a weakness Larry and I shared in gauging its effect on ourselves and others.

Jim had me. Of course, the tables, even with our safety factors added, just weren't made for such use. Also, the fact that people are willing to work themselves to death isn't sufficient reason for a good supervisor to let them.

As a direct result of Jim's call, I changed our procedure. We instituted a twenty-four-hour "flush" period for decompression purposes on every fourth day if we were involved in deep diving or moderate-depth repetitive diving. I also cut the sessions at Isle Royale to two weeks unless we could get someone physically off the boat and into a house or hotel facility for two days' rest. This was not easy to do there or in many of the remote places we worked without planning. In many parks the running time of our vessels from the wreck sites to enclaves of civilization was measured in days depending on weather conditions.

Being a good sport, a fellow who could admit he was wrong, and secure in my leadership skills, I thought it only fair to tell Jim how much his criticism had affected our dive protocols, not only at Isle

Royale but in general. It was sixteen years later, but I did eventually tell him.

This conversation with Jim was one of many. I was fortunate to meet and befriend people in my career who contributed immensely to the success and safety of our operations by just being willing to share their knowledge. People such as Al Behnke, George Bond, Art Bachrach and Dud Crosson, and Paul Cianci in the diving sciences, and Tom Mount, Jim Corry, Jeff Bozanic, Paul DeLoach, Scott McWilliam, and many others in the technical diving community.

Any significant, successful action is surrounded by periods of intense contemplation and discussion. Neither in our science nor our diving activity were there many models or recipes already in existence. SCRU was as much a cerebral as a physical endeavor, and without the active contribution of these people it would have failed in one of the critical aspects—either the science or the safety.

CHAPTER FOURTEEN

# ISLE ROYALE: THE FINAL CHALLENGE

W e had overcome some of our greatest challenges at Isle Royale from 1980 to 1984. We learned to map and systematically photo-document very large ships. For perspective, the wreckage fields of some of the sites at Isle Royale involved areas hundreds of times larger than our colleagues tackled on ancient wrecks in the Mediterranean. It's the difference between mapping a tennis racquet and a tennis court. We had set a standard for mapping large shipwrecks that others tried hard to match or surpass; in essence we'd raised the bar in a friendly competition among professionals. This experience also came in very handy on the USS *Arizona*, and indeed probably made it feasible for us to take on that project. Our work in the waters off the rugged island also taught us invaluable lessons about dealing with the combination of extreme cold and depth, which would serve us well on future projects in Alaska, Yellowstone, and Glacier.

Although we had a gratifying level of success at Isle Royale in documenting most of the shipwrecks, and land-related underwater sites such as fishing camps, dock sites, etc., I knew by 1984 that we would never have full closure with the park's submerged resource base. The problem was the extreme depth on the passenger-package freighter *Kamloops* and the bulk freighter *Congdon*.

The stern of the latter and the entire *Kamloops* were just too deep for us to work responsibly. The stern of the *Congdon* stretched down a steep incline to 180 feet. The *Kamloops* lay on its starboard side on a slope; the shallowest portion was approximately 200 feet deep and the

166

deepest, 260 feet. In water 34 degrees Fahrenheit, this was too deep for air scuba. I would make excursions to the *Kamloops* to scope it out for planning or setting mooring lines, but I simply wasn't going to have people work in those conditions on air, even if it meant that we would have to admit that there was an element to our mission that indeed was "impossible," at least for us.

The use of mixed gases such as heliox (helium and oxygen) or trimix (a combination of helium, nitrogen, and oxygen) would have mitigated the serious narcosis and decompression problems presented by these sites, but it wasn't the appropriate place for us to use them. They necessitated employing either expensive support facilities beyond our means or technical diving rigs that had not evolved sufficiently in the mid-1980s for me to feel comfortable using them on a government project. Sheck and others I knew in the cave- and wreck-diving world were using such systems successfully, but I wasn't ready to take a chance on them. Many thought we worked excessively deep on air and should switch to these systems. But when given the choice, I always opt for the simple, tried and true, regardless of apparent advantages of newer technology.

In short, I would rather leave blanks in the report than risk lives on the *Kamloops*, but I hated giving up. I let it be known that we were in the market for solutions to that problem, and in 1985 an opportunity presented itself.

The oceanographic research vessel *Seward Johnson* from Harbor Branch was going to be in Lake Superior in the summer of 1985, and its scientific director wanted to take certain natural resource–related samples in park waters. This ship carried the Johnson Sea-Link, a deep-diving manned submersible, and the large remote operated vehicle (ROV), *Deep Drone*. I forwarded our request through the proper channels and received a commitment for two days of ship time without charge. This was very encouraging, because such time is extremely expensive—my memory is that it sold for $13,000 per day. I headed up to Isle Royale in 1985 with high hopes. I was in for a less than satisfying experience.

At a brief orientation with the project leaders I began hearing the phrase "evaluating the possibility of checking out those wrecks." I hadn't taken two weeks out of my schedule and paid the expenses of

flying to Isle Royale for any "potential" project. I bit my tongue, but I was starting to have premonitions of disappointment.

On the sort of cruises the *Seward Johnson* regularly undertook, the ultimate decisions as to whether or not a particular vehicle would dive on a certain day was made by the chief of operations. I had no basic problem with that; we often left final decisions about safety to a diving officer on our projects. Even the best-laid plans might see something unforeseen arise that made them unfeasible to put into effect. The man was disinclined to allow the Sea-Link or the *Deep Drone* to work around *Kamloops* because of the potential of being hung up by extraneous lines or cables. Curiously, the sub pilot was perfectly willing to undertake the dive. I didn't know enough about manned submersible operations to evaluate the wisdom of the operation officer's conviction, but I *did* know that all of the information necessary to making that decision had been in front of this fellow for months before we rendezvoused at Isle Royale.

Still refraining from doing anything confrontational that could have jeopardized the project, I kept my own counsel until the night of a planning meeting on board the ship. I had a local wreck diver, Scott McWilliam, give a briefing to the research crew. Scott and the local members of the extreme wreck-diving community, which paralleled the Florida cave-diving community in intensity and skill, had made numerous forays to the ship. Scott was willing to share a sketch they had put together and a fair amount of firsthand knowledge related to potential obstacles or hangup points for the submergence vehicles.

The reaction of the chief of operations and several "marine scientists" was to make wisecracks about Scott's choice to dive that deep on air. I was mortified. Scott was not being paid a dime to be there or share his firsthand observations. He also, I would wager, had more deep diving experience than all of the assembled scientists put together. I grabbed Scott, turned to the assembled audience, and said, "This meeting is over," and left. I was concerned he would suffocate under the blanket of smugness in the room.

This was not the first, or last, time we dabbled with interfacing with projects run from large oceanographic research vessels. Invariably the experiences were not productive. Something about big ship culture did not make for good chemistry with SCRU, unless the ships happened to be big Navy ships. For some reason we blended

well with the Navy, police, and commercial operations but had poor karma with oceanographic cruises.

We agreed eventually to have the *Johnson* run ROV pattern searches in the area where the lost bow of the *Algoma* was said to rest. It was a token effort. We found little of interest, and pretty soon our high-dollar visitors left to pursue more lofty goals. Beneath the immediate, personal dynamics at play here is a larger issue—the unfortunate fact that in the United States, most deep submergence systems are controlled by oceanographic institutions and agencies that have little understanding of, or appreciation for, archeology.

In vivid contrast to this snobbish display, we received assistance in 1986 that brought the project to a most satisfying conclusion. Emory Kristof from *National Geographic* magazine felt he could solve the last of our "impossible" problems with some newly developed LCROVs. The acronym stood for "low-cost remote operated vehicles." These were tiny versions of the crane-deployed *Deep Drone* that were being developed by a young electronics wizard named Chris Nicholson. The advantage was they could be deployed from a twenty-eight foot park patrol boat by simply picking them up and tossing them over the side, and they were more maneuverable in tight quarters. In addition, Emory and his technical assistants were bringing two of these vehicles to deploy at the same time so they could monitor each other as they attempted a penetration of the wrecks. The imaging capabilities exceeded anything produced by the larger *Deep Drone*.

Coincidentally, a BBC film crew was going to join us on the project. At the time, the BBC maintained an excellent underwater film unit and hadn't yet succumbed to the fit of spasmodic downsizing and contracting-out of most corporations seduced by the latest management fads of the 1980s.

We had a helluva project. Emory was still fresh from his considerable involvement with the discovery of the *Titanic*. He had some serious hard feelings about that project, and he raved the better part of the first night about the ugly clash of egos and the credit mongering by the project directors. I was not sure what to make of the several-hours-duration display of temper, but any misgiving I might have had about Emory vanished the next day when our operation started in earnest. He and his assistant Keith Moorehead and Wayne Bywater of

Northeastern Underwater Services were field people of the first caliber.

We dropped those swimming eyeballs overboard, and they worked like magic. I thought Emory's constant reference to the devices being FM had something to do with the frequency of the return of the data stream to the boat—in fact, he meant they were Fucking Magic. We moored directly to the *Kamloops*. Ken Vrana, who was then a law-enforcement ranger working for SCRU, and I made a couple of dives to the ship to attach chains for mooring the patrol boat and providing descent lines for the robots. Back on board, warming up, I watched as the slick little robots were joy-sticked around the wreck that had eluded our best attempts at documentation for so long. We systematically surveyed the entire exterior of the *Kamloops* hovering on spots that needed special attention for fifteen minutes at a time. Depth and cold were irrelevant. We drank coffee in the boat cabin watching the progress of the two robots slaving away for us in the frigid water 200 to 270 feet below. Then came the real magic . . . the little buggers could penetrate.

"Think you can slip through the engine room skylight?" Emory queried Wayne as we bounced gently at anchor, glued to the video screen of ROV1.

I was about to remind Emory that the radio above us was droning warnings from Canadian Coast Guard Thunder Bay in that curious three-speak—"Security, security, security, all stations, all stations, all stations"—that there was a fast-moving front bearing down on us, when I realized that ROV2's screen was now looking back at ROV1 from inside the engine room! Emory looked over at me with a demented smile he puts on when he's doing something particularly outrageous. He arched his bushy eyebrows up and down Groucho Marx style and announced in his best hospital intern voice, "We're in, doc."

Pat Labadie, whose vast knowledge of Great Lakes material culture was being put to good use narrating observations onto the videotape, was momentarily speechless. He was looking at the *Kamloops* from the inside out. Then, things started happening really fast. The boat shuddered as the first gust of wind from the approaching gale gave us a warning kiss. District Ranger Jay Wells stepped down from the bridge and announced, "Time to wrap it up folks. We're sitting ducks out here."

This is when the project director earns the big bucks, usually needed to pay for treating those ulcers later in life. If we had several days of access to the equipment remaining, I would have just thrown in the towel, but these opportunities always seem to present themselves in the eleventh hour.

"Jay, look, man, I'm not asking you to put us at risk of life or limb, but can we hold out for a bit?" Jay glanced down at the screens and whistled. He didn't need any explanation why I was so desirous of hanging on a bit longer.

As Jay mulled my question, I said, "Emory, that's over $100,000 worth of *National Geographic* equipment in that engine room. You know, if we start taking this wind broadside, we're going to leave it there before we endanger the crew...What's your call?" Jay was nodding as I spoke so I knew he was willing to stick it out if he could dump the equipment and motor clear of the shoreline should the wind come up with the ferocity it often does on the Lakes. I didn't know it then, but this wouldn't be the last time that Emory and I would be standing someplace on the razor's edge of a tough decision.

Emory sighed, did a few more eyebrow arches, and muttered, "Let's go for it, Lenihan, if it was easy everybody would be doing it."

The BBC crew was rafted off to us in another boat. I told them things were going to get real intense real soon and they would have to pull clear of us. They sensed the building drama, and Russ England, the producer of this segment, asked if he could leave his camera team, John Beck and Brian Marden-Jones, to catch the action. I said, "Sure, if you think they're expendable." These Brits were great to work with, but my humor sometimes eluded them. I could tell from Russ's face that this was one of those times.

"Just kidding, Russ. Sure, leave John and Brian, and we'll return what's left of them and the cameras later." He knew then I was really giving him a crack at a great scene. He clapped his hands, gave a "Righto," and started getting all of his folks except the camera team to their own boat.

Emory sat down and started directing his robot flyers. Technically, I was supposed to be the one making the decisions about where the ROV went for archeological purposes, but I wasn't about to stand on formalities. I quickly deferred my prerogatives to Emory and Patrick. Emory knew the capability of the machines and his operators,

and Patrick knew the inside of an old Laker's engine room far better than I did. I could feel the BBC tug depart and watched Ken Vrana prepare the thirty-two-foot patrol boat *Lorelei* so it could immediately cast loose from where it was moored to the stern of the *Beaver*. Pretty soon we had only our mooring and the robot cables to contend with should things get rough quick. We knew from the rapid increase in frequency of wind gusts, it was no longer a matter of if, but when.

Almost as if the gods of the Lake knew what would entice us to stay too long, the footage from ROV1 became breathtaking. The engine room telegraph and binnacle came into view. Though we couldn't position to read the setting to confirm the report that it read "finished with engines," the water in the engine room was clear as air. Emory pushed his control link to the vehicle's camera and the flash went off, then the video image went still, as he backed up his photo with an electronic freeze frame. We could feel the boat shift slightly and start rolling; we were now in the troughs of the still small but building waves rolling in from the northwest.

Then Keith said, "Hey, what's this?" As everyone glanced at ROV2 a hush fell over the cabin. Just the wind blowing and all of us staring at "this." The human form was like something out of a grade-B horror film: a feathery white-looking corpse with soft tissues the consistency of soap where the overalls kept the shape normal. The head had fallen to the floor, and leg bones were sticking out of the overalls cuffs. We knew there were supposed to be human remains in this room, but the reports had come from the nitrogen-fogged memories of a few technical divers who had made it to this point at the risk of life and limb, and their recollections were highly contradictory. No contradictions here, just a very accurate, gruesome testimony to a tragedy. The other ROV monitored the cables of ROV2 as it moved up to and carefully examined the remains. Then another and another.

In addition to the emotional tension in the room, the pitching boat was getting to the ROV operators. Every few minutes they would have to hand someone the joystick while they bolted for the companion way and ran to the rail to vomit. Motion sickness is a real problem for people controlling a joystick on a boat. They are seeing through the eye of the robot a very still, controllable world. In direct contradiction to their sense of sight, the chair they are sitting in is rolling and bouncing with the building seas. The contradictory cues

to the balance organs are too much. You can tell much about people when the pressure is on; these guys were good. They took their orders while green in the face, made for the rail, and came back—time after time, without protest.

There was another irony to the whole thing: As we were in the process of obtaining the incredible footage of the bodies, I felt obliged to whisper to Emory, "You know my friend, I can't let you use this tape." He just gave me a green-faced nod in reply. We had achieved our research goal and were now getting extremely useful information for the use of the Park Service in managing the wreck, but the superdramatic scenes of the human tragedy were too much for a television audience. In any context except forensics and law enforcement, this was sheer gruesome spectacle that would be inappropriate for us to release.

Suddenly, the boat pitched to the side, and Patrick was sitting in the lap of the BBC cameraman. "Th, th, that's all folks." Emory's Porky Pig imitation was a cue to his robot operators to get those machines out and back to the surface. Jay jumped down again from the bridge to make sure we had come to our senses and to be reassured that we were in the process of disengaging. He knew he didn't need to add to the pressure, so he just said in a soft but firm tone, "Got about five, fellas, five minutes and we're out of here, robots or not." Nods all around followed by a sigh of relief as ROV1 made its way without incident out of the engine room. Two of the seated men rushed to the back deck to begin hauling it aboard, no tidy cable laying, just the "flap flap" of armored wire hitting the aluminum deck and the "Come here sweet baby of Keith," as it was pulled aboard.

After helping on deck, I jumped back down the three steps to the main cabin where I could tell by the grim expressions that things weren't going as smoothly with ROV2. "Okay," Emory's very even, forced-calm voice said, "let's edge back toward the engine again and see if we can't find where we're hung." I figured we now had a potential loss of only about $50,000 because the other ROV and the consoles were all safe. Also, two minutes, give or take a minute. We were now pitching regularly, and the poor operator was deathly nauseated. Even with the clock ticking so ominously, he had to ditch for several seconds for one final retch over the side. He took back the joystick and tried a last-ditch effort to run the vehicle the full length of the

engine room and see if it could jerk loose from whatever was hanging it up. The screen filled with rust and silt as some small projection gave way somewhere in the room and, somehow, he was untangled. "Make for the skylight! Even if you can't free it, just bugger for the surface. We have enough cable so if we throw it loose, you can still get the vehicle back up and we'll just lose the cable."

Jay popped in and said, "Sorry, fellas, game's over. I'm cutting us loose as soon as both engines are going." We could hear the diesels turning over a few seconds later. No arguments here; everyone knew Jay was right; the damn robot wasn't worth dying for but . . . damn near. Then a cheer, as someone yelled in from the back deck, "She's free and on the surface." From there, it was up to Jay's seamanship. With engines running and free of our mooring, he had to make sure we didn't get closer to the rocks while we gathered in the second swimming eyeball and several hundred feet of cable. We did it . . . and departed, in haste.

The Lakes get your attention when they get riled. Halfway back to Blake Point on the northeast end of the island, we knew it was time to quit playing the odds. "I'm heading for Amygdaloid," Jay yelled down through the roar of the engines. No surprise. Jay would gamble with equipment but not lives. He knew we could always pull into the deep cove where the park service maintained the ranger station we had been hauled to in the *LL Smith* several years earlier. The *Lorelei* and the BBC tugboat were already there. We pulled in and exchanged high fives on the dock, speculating that it would be hours before things calmed down enough to make it around Blake. It took hours all right, thirty-six of them, during which we all crashed on the floor of ranger Ellen Maurer's cabin.

"Hey, Russ, you got your camera back, and," pointing to John and Brian, "we even have your film team intact."

When things calmed down the tug made a run for it the next day. His cameraman might have made it home intact, but Russ didn't, he was thrown out of his bunk even during the "lull" and gashed his forehead. No one in the group that limped back to Rock Harbor a day later would ever have any reason to wonder why the Lakes had the reputation they were famous for. We were a battered but happy lot. We had managed to complete the Mission Impossible that we had been handed six years earlier by Jack Morehead. National Geographic

had perfected its use of ROVs in the toughest test they would ever face and the lads from London had a heck of a story in the bag.

## Postscript

The work we conducted at Isle Royale and the USS *Arizona* and reconnaissance work in Micronesia were the subject of a one-hour PBS documentary (BBC/WCET) entitled "Shipwrecks, Science, Salvage or Scrap," produced by Derek Towers. This was #8 in what was probably the best series on underwater archeology ever produced. Older hands at the BBC, like Bruce Norman, Ray Sutcliff, and Derek, with some very talented young lions like Russ, represented what to me has always seemed a 1980s golden age in BBC underwater filmmaking. Discovery Channel bought the series eventually and showed it for two years running. Our segment, the most popular in the series, eventually aired to a cumulative audience estimated by the BBC at more than a billion people worldwide.

# CHAPTER FIFTEEN
## *ISABELLA*

—◦◦◦—

I listened intently. Crouched in a sandy depression full of old ship timber, a mangy sort of kelp, and torn swatches of fishnet waving in the current, I could hear it. The brown-green water of the Columbia River swirling over the bar, bouncing off of incoming tides, playing havoc with predictability of any kind, and humming a tune all the while. It reminded me of the wind whistling through the subway tunnels in New York City before you actually hear the train coming.

Sure, we had tide tables and were trying to make our dives correspond to slack periods. On the Columbia Bar, however, where the river separating the states of Washington and Oregon meets the Pacific Ocean, the current seemed to largely ignore any rules of order imposed by man. Slack tide there meant the current simply changed direction and dropped in velocity enough to coax us in, when prudence suggested otherwise.

The dive boat with our support crew was thirty-five feet above us, anchored on a fore-and-aft moor. This meant the boat would remain stationary, whereas it would dramatically shift location if allowed to pendulum on a single-point moor. But this arrangement had problems of its own. When we surfaced, the current forced incoming divers against the water-entry step with crushing force.

We'd chosen this fixed-platform approach because we were using an experimental instrument to map the remains of a very important old wooden sailing ship. The instrument is called a SHARPS, Sonic Highly Accurate Range Positioning System. To use this tool required placing and retrieving sonar transducers (about the size and shape of a

flashlight) on the bottom during each tidal window. Because they were "hardlined," wired back to the boat, we couldn't allow the vessel to swing around, twisting up cables at the whim of the river.

I listened to the river because I found the sound to be my best clue for when we should round up our divers and get on board before we were dealing with current velocities that were simply imprudent. As Larry Nordby continued to draw in the murky glow of an underwater lamp held by Jim Delgado, I scurried about, checking the transducers for the SHARPS. I popped up the line every few minutes to ensure my ears hadn't deceived me. At no time did I dare release my grip on sturdy pieces of wreckage or the heavy guidelines we had installed running down to and along the bottom. About ten feet up the descent line is where I could best feel, as well as hear, the full force of the current.

With all this effort we were trying to confirm whether or not we were diving on the remains of one of the oldest shipwrecks on America's west coast. There had been exploration and even the wrecking of a Spanish "Manila galleon" in California waters as early as the sixteenth century. But, with the exception of small Indian craft, there had been minimal organized maritime activity until the Hudson Bay fur trade, two hundred years later. We believed we were diving on the mortal remains of the *Isabella*, which sank in 1830 carrying a full hold of trade wares for Fort Vancouver.

Jim Thomson, Park Service Northwest Region Archeologist, had asked us to investigate the site. In addition to Delgado and Thomson we had a third "Jim" with us: Jim White had contributed his boat and local diving knowledge to the project. Thomson had called SCRU in to help the director of the Columbia River Maritime Museum in Astoria, Oregon. The site would have great historical significance if confirmed to be *Isabella*, and we had a mandate to help state and local agencies on National Historic Landmark–quality sites.

Suddenly I could tell the river's mood was changing. I pulled myself hand over hand back down the line to Delgado and Nordby. Engrossed in their documentation, they had no clue that the river was picking up faster than the tide tables predicted. I gave them firm "Up now!" signs and moved on to find Mike Monteith. Mike was commanding officer of the Cape Disappointment Coast Guard Station located near Ilwaco, Washington, only scant minutes away by boat. He

was a seasoned diver and knew the river well. I wasn't surprised to see he had sensed the pickup in current and had already plucked one of the transducers. Hands full, he nodded to me, indicating he was heading for the nearest of the remaining two instruments. I turned and headed for the farthest, deployed perhaps twenty yards away.

The instrument is a story in itself. It was developed by the Wilcox brothers, the same siblings who brought the world ultrasound as a prenatal examination device. These "ducers" actually work on the same principle. Sound waves move through seawater much as they do the fluid of the womb, although the comparison seemed a bit strained to me at the moment.

The speed of sound in water is a known, so the time it takes to get from point to point can be measured in order to provide distance. Three of these ducers on the bottom could be used to reference a fourth, which we called the "mouse," in the hand of a diver. As the diver moved from point to point on the wreck, holding the mouse up to objects of significance and tracing the outline of the hull, an electronic matching image would be generated on the computer screen in the boat cabin. Accurate to within a few centimeters, this device could send back reams of data which let one post-process the shape of ship structure and location of artifacts in x-y-z coordinates—that is, not only where they would be located on a planimetric, or bird's-eye map, but also their height above bottom.

I swam past the ascent line, just as Jim and Larry finished their preparations to take the ride up. They knew the drill. Slates and lights secured by clips to metal D-rings on their vests, they pulled any dangling straps in tight and gave one sharp kick up from the relatively calm bottom. The current did the rest; with their arms looped over the line, it slid them toward the surface—their only concern was to exhale fast enough to release the rapidly expanding air in their lungs.

I gave them a moment to regroup on the surface, arranged my burden of transducers and wires for the ride, then followed. On the surface I found Larry pinned to the swim platform of the larger boat at chest level. Monteith was already out of the water and helping the surface crew free Nordby from the river. They augmented Larry's own strength, by pushing him away from the wooden step and upwards, until his waist reached the edge. From there, it was easy. People bend at the waist, not at the rib cage.

Larry was past the danger point. I positioned myself so that I could, on signal, let go of the line from which I flapped like a flag in a stiff breeze. I would be slamming into the platform next. I watched Larry being pulled to his knees, his regulator still in his mouth and his fins on, in the event he should slip back overboard. Next they pulled him over the transom and dumped him on the deck safely inside the gunnels. They motioned me to release the safety line so I could follow through the same ordeal.

As I flew toward the platform of the main boat, I took in with a sideways glance that Jim Delgado had been helped up the ladder of the small double-ender, Montieth's personal boat, which was rafted off to the cabin cruiser, owned by a helpful volunteer diver named Jim White. Delgado was standing out of the water with, I was alarmed to note, his fins off and his regulator dangling free. I didn't have the energy to yell a warning to him but resolved I would give him a talking-to once we were all back on board. Jim was a valuable new adjunct member of the team who had been helping from afar with maritime history and archeology issues, but he was also the least experienced diver.

It's always instructive how fast things can go to hell in diving. Also, how relatively mundane a near-death experience can be when there is little time to anticipate it, or savor its closeness afterwards. Once adrenaline stops pumping, you go to work, get embroiled in the hassles of the day, and forget about it. In the next five minutes we experienced an event like that on the Columbia. It happened so fast, was over so quickly with no serious consequences, that we hardly talked about it a few hours later—although many years afterwards we still discuss it over beer.

As I was being extricated, I heard a splash next to me and an exclamation from one of the Coast Guardsmen. Exhausted from climbing onto my own platform, I couldn't tell what the commotion was about except that the fellow helping me said, "Somebody fell in."

By the time I disengaged myself from my equipment and sat up on the deck to take stock of things, I could see Jim Delgado staring at me from inside Monteiths's double-ender. All his equipment was now off, and he was pale, looking at me with glazed eyes. What happened to him was simple, quick, and horrifying, at least in retrospect.

He had slipped off the ladder of the small boat, without his fins,

into what had probably built to a three-knot current and almost drowned. His heavy weight belt took him thirty feet to the bottom, where he managed to release it, fill his buoyancy compensator, and lunge back for the surface. If he had gotten the regulator back into his mouth and taken a deep breath of compressed air during that time, the wild ascent might well have killed him. His instinct, *in extremis*, would have been to hold madly to that breath of life-giving air, which could have easily ruptured his lung, causing an embolism.

As it was, he hit the bottom of the boat and clawed at the hull as he was dragged along by the current. Jim Thomson, working with the surface crew, heard Delgado scratching the boat below his feet. With the aid of a strong "Coastie," he grabbed him just as he popped to the surface at the bow. They managed to pull him back in, shaken but unhurt. Jim now was the subject of a "close-call" war story and not a corpse. Within fifteen minutes he was cracking jokes about the incident. How close had he really come? I don't really know, but I suspect very. I can't help but think back to the death of Keith Muckelroy in conditions much more benign; falling over in four feet of still water with a similar assortment of gear.

We confirmed the ship to be the *Isabella*. A number of characteristics of the ship hypothesized in our research design would provide proof-positive identity if they were present. We found them all, including a sawn hole in the hull remains which fit the story of its salvage in historic times. The work on the *Isabella* represented an important extension of our work to National Historic Landmark–quality sites in state waters that were not associated with parks or Trust Territories. We turned information and artifacts over to the Columbia River Maritime Museum, and Jim Delgado published the results of the work in several journals.

Although we had known Jim since he joined us looking for the Manila galleon *San Agustín* at Point Reyes in 1982, this was the first time he officially participated in a SCRU operation. He worked for the Chief Historian in Washington, D.C., and provided a valuable source of assistance both in the archives and in the field for many more years. He was also in an excellent location to help with the increasing workload that was developing at the time in the area of shipwreck-protection legislation and in the growing initiative to extend

our protection over wrecks of importance to American heritage in foreign waters.

In some ways he reminded me of that other young man, so full of promise to the discipline, who only a few years earlier had met his demise in similar, but less dangerous circumstances. Jim was lucky, Keith wasn't. It's always hard for me to have to admit how large a role plain luck plays in this business.

# REACHING OUT

The SCRU Team expands its influence to
U.S. Naval shipwrecks in foreign waters,
the atomic bomb test ships of Bikini Atoll,
and Confederate raiders and submarines,
and sets a new standard for scientific shipwreck
surveys of large areas in the Tortugas.
The team returns to Pearl Harbor with a new
mission, and passes the torch of leadership in 2001.

CHAPTER SIXTEEN

# PROJECT SEAMARK

~~~~~~~~

In 1988, the growing relationship SCRU had with the U.S. Navy
since our work in Pearl Harbor reached a zenith in scope and ef-
fect. The year before we had support from Navy diving com-
mands in our underwater research operations in Guam, Cape Cod
National Seashore, and the San Francisco area, including Alcatraz. In
1988 however, while we arranged for the East Coast Navy Mobile
Diving and Salvage Unit (MDSU 2) to work on a problem salvaging
ship remains from a landing slip at Ellis Island, we engaged in a series
of far-flung projects in the Pacific with MDSU 1.

The Navy, realizing the benefits of deploying their reservists on
real-world deployment problems as opposed to make-work tasks, was
adding a great deal of clout to Park Service preservation endeavors.
We had a classic symbiotic relationship going, with the key propo-
nents on their side being two commanders: Otto Orzech of a Long
Beach Reserve Unit and David McCampbell, the active duty head of
MDSU 1 in Pearl Harbor. In 1988 two projects in the Pacific dramat-
ically underscored how much Seamark helped SCRU extend its influ-
ence to remote places and demanding tasks we could never have
accomplished on our own. One was the massive survey operation in
Belau and the second an exploration of a water-filled crater in
Molokai. Happily as SCRU became increasingly engaged in far-flung
field assignments, many involving complicated interagency logistics, I
was lucky enough to recruit a crackerjack new administrative assistant
named Fran Day. Fran would become SCRU's anchor to reality, the
calm, competent voice on the other end of the phone in Santa Fe
when things had gone to hell on some remote island.

It was a year when Americans would obsess over fires in Yellowstone National Park, we would be talking about movies like *Mississippi Burning* and *Rain Man*, and even shipwrecks would be making the news.

The Abandoned Shipwreck Act had finally been enacted. In short, the United States asserted title to historic shipwrecks in its territorial waters and simultaneously passed it to the states except in the case of national parks and Indian lands. This took most shipwrecks out of the realm of admiralty courts but left them where the least responsible state legislatures could still make fools of themselves by giving them away to commercial antiquity traffickers. The park service was cracking down on shipwreck vandalism, including a massive undercover operation at Channel Islands National Park. *Skin Diver* magazine ran shrill editorials warning sport divers that big government would be taking away all the wrecks and giving them to bureaucrats.

Some firms started looking abroad to pursue treasure hunting interests—I even had a long, rather thorny phone conversation with a fellow named John Erhlichman who, having run into some difficult times in his public life, was now "representing the interests of American investors" in a treasure-hunting scheme in Colombia. He was incredulous that I, as a civil servant, seemed unwilling to help in this endeavor and made thinly veiled threats to use his influence with the new administration to darken my future in civil service. I was even having problems with a park superintendent who seemed to be willing to dispose of a shipwreck in national park waters at Ellis Island because some political appointees in Interior told him it was a "done deal." I pointed out to him perhaps with less discretion than the moment deserved that "this is an election year and all those blowhards in Interior are going to be gone in November anyway." All in all, it was an excellent time to depart for the far Pacific.

The huge quartz monolith gleams with quiet power from beneath a dull surface patina. Scattered light filtering through the thick jungle canopy flickered over the pensive faces of my three companions as they gazed at a ring of stone dominating the center of the clearing. A

hand-hewn lithic presence, it appeared to have not yet fully emerged from the island bedrock in some mysterious birthing process.

I turned my attention back to the camera and clicked the shutter; the built-in strobe flashed in a vain attempt to get enough light on the nine-foot diameter object to do it justice. In the midday Micronesian heat, the camera lens had fogged from the intense humidity, and I couldn't find a piece of clothing dry enough to wipe it clean. "What you think, Don?" Belauans, for some reason, do not find it easy to say Dan. Either that, or they just prefer the sound of the other.

We were looking at a coin, a piece of "Yap money." Many like it had been quarried from here in the Rock Islands of Belau (formerly Palau) in years past and transported through great trials and tribulations by oceangoing canoe to the island of Yap. In fact, the more trials and tribulations, the more the coin is worth. What did I think? Hell, it was the *Pietà* of currency is what I thought.

"Reminds me of Michelangelo," I told him. "You know, one of those statues he never finished, emerging from the granite." Vince smiled, and there was the sound of betel-nut juice being ejected through his front teeth expertly onto the forest mat beside him.

Vince Blaiyok was Palauan, or "Belauan," as many natives of the new republic now prefer being called. He enjoyed showing me treasures like this on frequent detours we made during our boat transits between islands where our dive operations were in progress. A trilling exchange of syllables with the speedboat operator usually preceded a sharp turn through the mangroves and mushroom-shaped coral and limestone islets to another hidden wonder. This one was special to Vince because it was of Belau not of the outside world. Most of the heritage sites that we had been documenting on this expedition relate to World War II, not ancient Micronesian folkways. I had no way of knowing at the time, but this concentration on megalithic coins and structures would become much more dramatically apparent in our work in Micronesia several years later.

Round of face and body, Vince is razor sharp of mind. Like many natives of this archipelago, humble clothing, quiet demeanor, and stumbling use of English as a second language belie a sophisticated intelligence. Walter and Thomas, also employees of the Belau Historic Preservation Office, have found detached pieces of other rocks

hewn from the old quarry and returned them to the earth after examining them.

As we left the clearing and made our way down a steep talus of loose rock interwoven with vines, I could hear the voices of children from the boat. They were my children. It was a weekend; although our recording work didn't stop, I allowed myself the privilege of taking the family along when the excursions were to places I expected they would enjoy. Barb had returned from a climb to see the Yap coin and was playing with our youngest, the two-year-old, in the shallows. His four-year-old brother dangled his legs over the side of the boat as he absorbed some nameless wisdom from a Belauan man, who spoke to him in a low, intent voice while pointing toward the water.

I came to learn during several trips to Micronesia that having my family along, if anything, facilitated SCRU breaking the ice with the native peoples of each island. Belauans, Kosraens, and Guamanians seemed to warm up to outsiders more quickly if there was family along. Perhaps it was because we were showing some vulnerability and trust in putting our children into the equation.

There was no strategy or design in my bringing family, just practical concerns for long periods of separation from growing children. But in this particular huge venture with the Navy, it proved very important. Months earlier there had been some altercations between Belauans and Navy personnel, unrelated to our operation. These incidents had resulted in seriously injured sailors (SEALs, actually) and Belauans. I was warned not to bring family by some of our Navy contacts. I replied that, from what I knew of Micronesians, if it wasn't safe for my kids, it really wasn't safe for anybody and we should go elsewhere. As it turned out, the Belauans were terrific hosts to our entire contingent for the full three months of our operation.

I found it hard to live fast enough in Belau. There only six weeks, during the heart of a ten-week project to assess submerged cultural resources, the richness of the natural and human history of the area had me dazed. We were emphasizing the larger World War II sites in the harbor, mainly due to the nature of Seamark, the financial support system that enabled SCRU to be here.

As marvelous as it was in some respects, it could also be constraining. The World War II sites were certainly worthy of attention, but it frustrated us being tied to cumbersome surface-supplied protocols.

The Navy needed to emphasize helmet diving on this project to meet training goals. The hard-hat divers required a large surface platform, and the necessity of dragging heavy hoses on the bottom was inappropriate for sites where delicate coral growth or ship fabric could be damaged. Although we couldn't move the bulk of the operation far from the large harbor area, we were able to make many exploratory forays to distant parts of the islands with small contingents of volunteers or with family on weekends, such as the one on this day.

The "Pelew Islands," as they were once called, were first brought into contact with the modern world through the occurrence of a shipwreck. In 1783, Captain Henry Wilson wrecked the British East India Company packet *Antelope* on the western reef off of Babelthaup. The story of the wreck and the subsequent treatment of the survivors by the natives of Belau is a classic in the lore of the South Seas. It involves a sea captain, a native prince and kings, disaster at sea, and their eventual triumphant return to England.

More significant for the anthropologists and social historians is what happened to the cultural history of the archipelago as a result of the infusion of European weapons into a society in which a balance of power was all that ensured a shaky peace. It was as if an alien spaceship from some futuristic society had crashed in the Soviet Union at the height of the McCarthy era in the United States. A Belauan arms race of unprecedented magnitude ensued after the wreck of the *Antelope*.

Shipwrecks and survival, warfare and reprisal—these seem to be recurring themes in Belauan history: Captain Wilson facing his captors in the 1700s and then the successive waves of European domination in the Pacific, culminating in the conversion of all of Micronesia to a battlefield in World War II.

Most of the sunken wrecks we documented in Belau were "*Marus,*" the Japanese name for a "pretty" or merchant ship—these were fitted with gun mounts fore and aft. The majority of warships, as in the case of Operation Hailstorm at Truk Lagoon, were able to flee before the American air strikes. The *Marus* were capable of contributing to a coordinated antiaircraft defense in a convoy or slugging it out with a surfaced submarine, but during a concerted air strike like Operation Desecrate in 1944, their armament was largely ornamental. American Avengers bombed and torpedoed them while P40s strafed them on

the run. The beautiful Rock Islands and the turquoise-colored water surrounding them and Malakal Harbor turned into an inferno of black smoke, oily water, and sinking ships.

 Barb and I and Dave Orak, another Belauan who worked for the Historic Preservation Office, descended through a shimmering cloud of snapper, which parted at our approach, enveloped us briefly, then suddenly disappeared. This wreck had wispy stands of black coral, which looked anything but black in its natural state. We had no authority or desire to remove any, but I cleaned a couple inches of the fuzzy covering of one strand with my knife to let Barb admire the hard ebony core.

 A bright-colored lion fish moved lazily in front of us. Many eons of evolution taught it not to waste energy rushing from threats. Its array of imposing barbs could cause severe pain, and worse if one's body is particularly reactive to the toxin. It was smaller but the same species as the individual that a couple years later would give one of our divers something to reflect upon for the rest of his life. We passed a Navy diver holding one end of a measuring tape, while gingerly avoiding contact with the deceptively beautiful animal.

 Otto Orzech reported that one of his men saw a book extruding from the silt in a room aft of the ship's bridge. I recruited Barb to hold a video light for me and drafted her into the project for a few dives—everyone else was spread among three other tasks and I needed her as a diver this day, not a mom.

 I was hoping Otto could come along, but he was working with Toni Carrell and Jim Bradford topside, where they monitored a large surface-supplied, hard-hat diving operation on another ship. But Otto's directions were good. We soon found the compartment he described, the mound of silt, and what appeared to be the outline of a book beneath it. I settled down in a kneeling position on the deck after making sure my knees wouldn't land on something fragile. Then I hand fanned the silt away enough to get a good sense of the size and state of preservation of the book. With extended forefingers I carefully tested to see if it could take the burden of its own weight if lifted. It seemed sturdy enough, so I moved the volume carefully several feet

out from the room into the open, where there was ambient light and the silt hadn't been disturbed.

Barb held the video light as Dave Orak videotaped the book, and I took several still photographs. As we found it partially open, I made the decision to open it the rest of the way and film the actual printed characters. It held up well to our disturbance, and I decided to leave it on deck, but covered with canvas, until the next day. My command of Japanese is approximately the same as my Chinese and Phoenician, so I resolved to find a Japanese tourist to help interpret the find. The book was in astounding condition, considering that it had lain under salt water and silt for forty-four years.

The next day I assigned Toni to lead a team in removing one of the loose pages, then return the book to its original resting place and rebury it with silt. The point here was to remove what was diagnostic and could be preserved and leave the remainder in a stable environment until the Belau preservation office could find funding to excavate and fully conserve it. She did an excellent job of recovery and brought the page unscathed to the surface clamped between two pieces of Plexiglas. Japanese tourists, plentiful on the island, interpreted the characters, revealing that we had discovered a complete operating manual for a Japanese transport from 1944.

Somehow, the document put a face on the crew of this vessel that wasn't there before. They had their day-to-day problems with machinery, and they had manuals to cope with it. Revelation? No, but somehow the mundane things that come from the underwater world of ships and men provide a connection beyond the intellectual. That artifact, literally a page out of history, joined the records of our survey in the museum at Koror, the capital of the republic.

Belau, or Palau, as it is known so much better to the generation that fought in World War II, left an indelible mark on the SCRU team. Belau has a marine environment second to none in the world, where there was a wealth of history underwater and where we perfected our dealings with the military. The relationship we started with the Navy at Pearl Harbor, had enabled us here to field over 250 men and women to solidify Project Seamark as an institution. After the work in Belau, Seamark became the foundation for projects ranging over half the globe. It resulted in tens of thousands of logged dives where underwater historic preservation goals were pursued by the

Navy in what one admiral characterized as "the best real-world dive training ever."

Several days after returning to Santa Fe from our Belauan adventures, I had the pleasure of receiving our first correspondence from a head of state. I tacked an appreciative letter from the President of the Republic of Belau on the office bulletin board. Two weeks later, in a very different mood, I tacked under the letter a newspaper article about his death by suicide. The island state had two presidents in its short history, both of whom left office at the behest of a bullet: in the first case at the hands of an assassin and, in the second, by his own hand.

I recall the sad looks on the field-hardened faces of my team members when they read that article. As in most cases, they bond with the people they work closely with—the Belauans had been especially gracious toward them. We were rooting for these folks and hated to see them suffer a setback. There were more to come, and the people of that beautiful archipelago are still trying to sort out a national identity from a confusing and turbulent past.

Seamark was the springboard for a very different but equally compelling expedition that same spring in the Hawaiian Islands. On the Kalaupapa Peninsula of Molokai is a facility dedicated to treating Hansen's disease, better known as leprosy. Because this complex was begun by Father Damien in the nineteenth century and was known far and wide for its early efforts at treatment of the disease, it had been designated Kalaupapa National Historical Park in 1980.

"They made a park out of a leper colony?" It seemed an innocuous enough question, but Pacific Area Archeologist Gary Somers blanched at its utterance. I quickly learned from the folks at the Pacific Area Office that it was one of the more politically incorrect statements I have ever made, which, considering my natural affinity for faux pas, was truly remarkable. I had made the comment a year earlier when stopping off in Molokai on a flight back from the Big Island to scout out potential for underwater archeology.

The trip via small prop plane along the coast of Molokai to the Kalaupapa Peninsula was magnificent, skirting some of the tallest sea

cliffs in the world. Gary met me with a four-wheel-drive truck at the dirt landing strip and whisked me off to a dorm, where we could outfit ourselves for hiking. After checking out the crater, we planned to spend the night on Molokai before getting a flight back to Oahu the next day.

The object of our interest was Kauhako Crater, a volcanic feature which was dramatically obvious from the air, but much less so when approaching it on foot through the thick jungle foliage. Gary had done archeological surveys all around the crater and discovered many rich remnants of early Hawaiian culture. I found out the next day that this was no mean feat on Gary's part. The place was covered with Christmas berry, an exotic vegetation that was not as benign as the name implied—as one made thorny contact with the omnipresent shrub, it tended to flay you alive.

We macheted our way through the hateful stuff until we gained access to the lip of the crater. I was pretty proud of the accomplishment until Gary informed me I had been following a "path;" we had just been tidying up our access trail with the machetes. It was hot under the low, thick canopy, and we were bleeding from numerous scratches from the thorny flora anywhere we didn't have at least two layers of clothes protecting us.

Gary pointed out many vestiges of Hawaiian prehistory that ringed the crater's top. The entire peninsula had seen an extraordinary amount of human activity for the past thousand years, with the crater being the possible focus of the activity, perhaps ceremonial. Gary wasn't about to make a bunch of unfounded assertions about the obvious question—was the water-filled crater, so similar in form and appearance (if not geology) to the cenotes of Mexico, the focus of human sacrifice? Regardless of that tantalizing possibility, the archeological potential of the crater was great.

Some years earlier, hydrologists had dropped a weighted line in the hole and determined that it was extremely deep and that indications from crude water chemistry gave them reason to believe the depths of the crater were anaerobic. This was extremely compelling information.

Gary's analysis of the archeology around the rim of the crater indicated a long period of occupation starting from very early in known Hawaiian prehistory. Organic materials don't survive well over time

in the soils of Hawaii, leaving huge gaps in our knowledge of the early inhabitants. Imagine if the native peoples who had played out their lives around the rim of this crater had deposited in the water, purposefully or unintentionally, the whole spectrum of mundane items used to subsist from day to day—in other words, a cross section of the material remains that comprise a foundation for archeologists to reconstruct prior cultures.

Assuming the water was anaerobic past a certain depth, containing no oxygen to support the myriad creatures that destroy organic remains, the potential was staggering. Then, we wondered, what if the muddy pea-soup appearance of the water from the surface was due only to algae and oxygen-dependent life forms; the water below the aerated surface level might be clear.

As we slipped and stumbled down the steep slope inside the crater toward the water surface, I was increasingly impressed with both the difficulty of access and the startling scientific potential of the place. Gary muttered between falls and curses that even though he figured "it's impossible to ever dive the place, it's worth your seeing it anyway." As we reached a ledge of horizontal rock near the water surface and found a place several yards in width where we could walk without holding on to something, I already knew I would be coming back.

I told Gary that we had a motto in SCRU that went "show us a place that can't be dived and we'll show you a place that has no water." I didn't tell him that the motto was two minutes old. In 1988, Seamark gave me the wherewithal to back up the boast. I had returned with "big brother" in the form of the Navy and a squadron of CH46 twin-rotor Marine Corps helicopters out of Kaneohe. To provide the documentation punch, I talked Emory Kristof into bringing the same robots that had been so successful at Isle Royale—this time with Chris Nicholson, the young man who had invented the marvelous little machines.

The story of Kauhako Crater is one more of logistics, and nail-biting, nerve-wracking deployment of instruments through feats of courage by the military rather than diving. But it demonstrates as no other expedition, except perhaps one that would soon to occur in the Aleutians, the increase in SCRU's effective domain, which came from partnering with the Navy.

Our research goal was simple—to find out what the conditions

were in Kauhako crater for future diving operations. We knew the potential for archeological remains was great from Gary's work, but did that brackish foul-looking lake of brown water at the bottom of that very steep crater really have the depth reported? Might it clear up several feet down, allowing practical survey? Were there projections of rock that might hang up cultural material? Could we, without disturbing the native vegetation along the crater walls, access the place with heavy diving equipment. We had a week to find out.

The first CH46 arrived at the airstrip on the Kalaupapa Peninsula. A contingent of MDSU divers led by Dave McCampbell and Emory and I spent several hours discussing a strategy for getting Chris's ROVs into the crater. They had circled it several times on the way in from Oahu and had some sense of what they were dealing with. They understood now why the Army and Air Force had opted out after their flyovers of the crater weeks before. They said they had the best machines for doing the job, but it was still going to be hairy. The skipper, a Vietnam vet with countless missions under his belt, said, "That, my friends, is a serious drop." Their helicopters were capable of dropping into the hold of a moving ship at sea; although Kauhako wasn't moving and probably hadn't moved for several million years, it was a tight drop. Also there was a problem that we could never really grasp while looking up from the bottom or down from the rim—the drop was not straight. To access the water, the chopper would have to drop straight down most of the way, then back up twenty or thirty yards under jungle canopy, essentially flying under a ceiling! I knew what I thought of diving under ceilings, I could only imagine what it would be like to fly under one, then hover there, no less.

I pulled Emory aside, and we talked a bit. Both of us were tense about this. As important a step as this was to understanding Kauhako Crater, it wasn't worth risking these men's lives. But they were in the business, as we were, of assessing risks, so we just put it straight— "Fellas, if you don't think this is reasonable, we don't want you to feel pressured to do it."

The pilot thanked us for the concern but said he felt they could handle it and was game for a try. We spent the next few hours rigging small rubber boats with harnesses to hold a load of sonar and robotic gear. We would have the chopper lower two of these thirteen-foot

boats, one at a time, into the crater, and MDSU would unhook them from below. We surveyors would climb down the side of the crater each day to join the equipment; two rangers and Navy personnel were sent down to rig a safety line we could hold on to on the slippery descent.

Watching on different descents and lifts, from the water and from the rim, I witnessed flying I didn't think was possible. The helicopters took up the entire area over the water and literally had to wend their way back out. Due to equipment problems, they had to bring over more helicopters with spare parts until we eventually had four sitting at the remote Kalaupapa airstrip.

Somehow, the equipment all made it down, and we spent three days sending the robots down to explore Kauhako Crater. The first discovery occurred within moments of starting the robot's descent. After twenty feet, the water went from about six inches visibility to unlimited. As far as the lights could shine, the robot could see, which often meant across the entire crater. The materials lying on ledges, primarily leaves and other vegetation, looked like they fell in yesterday. The significance of that was the water was probably anaerobic in addition to being crystal-clear. There appeared to be tufa growths down the walls and the dropoff was precipitous, but craggy with plenty of places to catch up cultural material. The only reason we stopped at 540 feet is that we ran out of cable!

In short, we had the makings of an extraordinary archeological site on our hands. Our mission was complete, now we just needed to get everything out and everyone home safe. This is when the Kauhako expedition turned into a nightmare for Emory and me. The removal of the equipment on the fifth and last day of operation was a hand-wringing nail-biter. Getting the stuff out was considerably harder than putting it in.

At this point, of course, the Marines had ultimate authority to simply declare it was too dangerous and halt the operation. The problem was we knew damn well these guys, along with their skill and common sense and normal good judgment, had pride. Each time one of the birds dropped down into that crater, Emory and I stood there at the rim muttering to ourselves the same obscenities intertwined with prayers again and again. "Come on, come on, come on . . . can't

see the fuckers, Lenihan, I can't see 'em, damn, damn, get the hell out of there!"

On the last attempt after five failures to get the second rubber boat up, I joined MDSU in the water. Much of the problem was attaching the hook to the boat under the winds of the dual props. If the rotors touched one of the trees in the crater (sometimes less than ten feet away), the chopper would disintegrate, killing everyone on board and probably everybody on the ledge at the bottom of the crater. It was tense.

In the water with three MDSU divers, all of us wearing just mask, fins, and snorkel, we waited for the last attempt. The CH46 was like a huge flying ant, making an unworldly sound in the crater, blowing everything around like a mini-tornado and causing three-foot waves in water that had probably never seen more than a one-inch ripple in geologic time. To add to the excitement, it began raining. MDSU had strung a heavy line across the lake, and we held onto it as tightly as we could while sitting on the cargo netting in the boat. As soon as the hook came into range, one Navy diver would grab it, and we would all try to hold the boat steady enough for him to get the hook through the ring. Somehow, a second later, we were all blown out of the boat, and I came up next to the hook. I held the damn thing up and swam for all I was worth toward the boat and the big Hawaiian Navy diver who would have the strength to clamp it to the ring. I thought I would go under when the hook suddenly got lighter and my arm stronger. Both of the other MDSU divers had found me and were holding my arm up with the hook. Thank God for the tradition of muscles among those guys; it came in real handy that day.

I don't know if I was helping at this point or simply had the hook in a death grip (they nicely assured me later I had helped), but we got the hook to the diver in the boat. He hooked it to the ring and threw himself out. Off the rubber boat went like magic, then several yards forward to clear the bend, then out to a sky that had suddenly turned blue. Three MDSU warriors and I swam to the side and lay there in a heap for at least twenty minutes without moving.

"Hey, Lenihan." It was Emory, who had come down the crater from where he had been praying in obscenities on the rim. "Want to try that again? Don't think I got the best picture." Real comedian, that Emory.

Our job at Kauhako was done, and we would soon be off for new places, but we all made our way to the airstrip to bid our adieus to the Marine chopper crews. We felt a real closeness with these guys after spending the better part of two days grinding our teeth with concerns over their safety. They had really put out for us, and we were grateful.

The crew would not accept any sort of gratuity, which was not a surprise to me: We in NPS were under the same sort of restrictions. The imaginative Emory did, however, write a check eventually to the base exchange or club or some such, which sold beer. He specified on the bottom of the check "Not to be used for any purpose but the consumption of alcoholic beverages." Legal enough, I suppose, but I would have loved to have seen that check being cleared through the Finance Department at National Geographic.

As it turned out, the men of the lead helicopter probably never had the opportunity to enjoy the libations supplied by Emory's check. The entire crew was killed less than two weeks later when their helicopter crashed in a routine flight out of Kaneohe. The news made all of us who had worked with these men absolutely sick. You don't have to know people a long time under the conditions we worked with these fellows to form opinions. We had really taken a liking to this exceptional group of men. Knowing how bad we felt when we heard about this accident when we had nothing to do with it just reinforces how difficult it would have been to deal with if they had bought it doing a marginal task at our request.

At this writing, I have learned that the native vegetation we were so concerned about harming turned out to be exotic. I'd love to pursue our archeological assessment. But I must say, even twelve years later, the excitement and triumph I feel over conquering that crater that couldn't be dived is tinged with a bit of sadness.

BIKINI: OPERATION CROSSROADS

L arry Murphy, who grew up during the 1950s, remembers being an avid young philatelist—until one day, during the heyday of thermonuclear testing, he suddenly lost interest in his hobby. What was the point maintaining a long-term project like a stamp collection, when each day found him huddled under his desk at school, bracing for nuclear annihilation?

With the end of the Cold War, we are no longer forced to take comfort in dubious deterrents such as Mutually Assured Destruction (affectionately known as MAD). Yet Earth's surface remains scarred from years of playing with nuclear fire—scars etched in the landscape of Siberia and our own Nevada test site. More recently, names like Chernobyl, Three Mile Island, and Rocky Flats resonate in a dark corner of our psyche. Instead of convincing ourselves we might survive atomic holocaust, we're now charged with figuring out how to live with the residue of nuclear trial and error. If any place on the globe symbolizes both these challenges, it is the area in the Western Pacific that comprises the atolls of Bikini and Kwajalein.

In 1989, SCRU was asked by the Department of Energy and the Bikini Council to undertake the first systematic underwater recording of sites where the United States conducted a series of nuclear tests that forever changed our world. Larry Murphy, Jerry Livingston, Larry Nordby, Jim Delgado, and I composed the NPS team. We were accompanied by Department of Energy personnel, an ABC television crew, and members of the Navy MDSU 1 detachment that had worked with us at Pearl Harbor. It was two months after a briefcase-

toting student faced off with a tank in Tianamen Square and two months before the fall of the Berlin Wall.

The first ship we surveyed was the *Prinz Eugen*, a heavily armed German cruiser that had been made an example of during the heady days of nuclear tests immediately following the end of World War II. Once a member of the commerce-raiding fleet built by the Germans to enforce their vision of a Third Reich, the *Prinz Eugen* had become a household name on May 24, 1941, when she joined the *Bismarck* in making a break from the protected waters of Norway and engaging the HMS *Hood* in the North Atlantic. Fourteen hundred British sailors went down with the *Hood*, but the *Bismarck* paid dearly—she was tracked down and sunk by torpedo planes and warships three days later with more than twenty-two hundred sailors dying. The *Prinz Eugen* slipped off to the Azores, where it escaped the wrath of the British Navy and managed to survive through numerous scrapes until war's end, when it was handed over to the British at Copenhagen.

A half century later, the huge propellers of the *Prinz Eugen* jut pathetically from the waters of Kwajalein Atoll lagoon. The turrets holding its eight-inch-diameter guns have fallen from their barbettes to the lagoon bottom, several feet below the deck of the inverted ship. Wire and cable entrails from the guns extend back into the vacant barbettes like rubber and steel umbilical cords. My team members and I include it as part of our exploration of the Bikini graveyard—the fleet of ships sacrificed to U.S. nuclear tests in 1946.

The *Prinz Eugen*, part of the detritus of atomic bomb tests conducted at Bikini under the rubric Operation Crossroads, was towed to Kwajalein laden with radiation and punch-drunk from two atomic haymakers. But the bombs didn't sink this ship—in the case of the *Eugen*, it was a slight leak and mishandling by its post-test caretakers that did her in.

We were on an unscheduled layover for our short hop to Bikini from Kwajalein. This delay, we came to learn was the rule, not the exception. We could reach Kwajalein in the Marshall Islands, 5,000 miles from Santa Fe, in two days. But we never did make it the 200 miles, to or from Bikini, without a two-or three-day delay.

While stranded, however, we could easily access the *Eugen*, as much a part of the Bikini story as any of the ships still at the test site. She just happened to sink somewhere else. We scraped together air

tanks and other gear from the "Kwaj" Scuba Club because our own equipment was still crated for the trip to Bikini.

As Larry Nordby started sketching, I began to poke around under the ship. Ships like the *Arizona* and *Prinz Eugen* evoke for me black-and-white "memories" of World War II, probably a product of Movietone News and *Victory at Sea* propaganda films with which we war babies were inundated.

It took all my concentration to orient to the topsy-turvy world of the overturned ship. Keeping bearings was especially difficult on a steeply sloping sea bottom. I lightly sculled my fins to keep sediment from rising as I moved through the tangle of steel and cables. My light flashed on a tubular contraption that seemed attached to the deck above but almost completely buried in the silt with the weight of the ship. Tubular? My mind reached for something—then it occurred to me: a "Christmas tree."

I rolled on my back on the sand bottom of the lagoon and crawled underneath the wreck to see the world correctly from the point of view of someone on deck. Then I was sure, this was indeed a Christmas tree; a peculiar structure designed by Operation Crossroads engineers to hold blast gauges and other instruments to measure the force of atomic explosions. The *Eugen*, turned over to the United States by the British as a war prize, had been fitted with this special hardware by American scientists before being chained in place as a sacrificial lamb in the Bikini test array.

I waved my light at Larry Nordby to get his attention in the aqueous gloom under the shadow of the ship. He recognized the tower for what it was and noted its location on his slate. I then motioned one of the media crew to follow me back under the ship with his camera. The strobe blinded me temporarily, so I lay there listening to my bubbles working their way along the inclined hull while my retinas recovered from the insult. The *Prinz Eugen* was not the only upside-down warship we would dive during that project. At Bikini, the Japanese battleship *Nagato* and the U.S. battleship *Arkansas* both lay keel to the sun.

The decision to work in Bikini was not something anyone on the team took lightly. Indeed, several members opted not to go. They weren't sure they could trust assurances from the Department of Energy that participating in the survey of ships once deemed "too hot to

dive" was in the best interest of themselves or their future offspring. I didn't question their decision; the government has far from a spotless record in that regard.

My own decision was based on having made a career of assessing risks to doing research. At the time SCRU was asked to assess Bikini, we had conducted some of the deepest and most dangerous diving operations ever undertaken in underwater archeology. I felt the stakes were high enough in this operation that it was worth sweating out solutions to a few manageable risks. The issue of living with low-level radiation and working in places "polluted" from nuclear fallout had importance beyond historic preservation.

The first atomic bomb was detonated in 1945 at the Trinity Site in New Mexico, about a three-hour drive from my home. Hiroshima followed a few months later and Nagasaki shortly thereafter. Bikini played host to numbers four and five, all part of Operation Crossroads, a gargantuan experiment to test the effects of the Bomb on ships.

The first of the Crossroads bombs, "Able," was an air blast at an altitude of five hundred feet; the second, dubbed "Baker," was an underwater detonation of a nuclear device suspended from a landing craft anchored in the lagoon. These were all atomic bombs, magnitudes smaller in effect than the fusion devices that would replace them. Years later at Bikini, thermonuclear devices (hydrogen bombs) replaced the fission bombs. Names like "Mike" and "Bravo" belied the otherworldliness of the power unleashed in those later explosions.

I read closely the assessment of radiological doses at Bikini prepared by Lawrence Livermore Labs. The down-to-earth, intelligent demeanor of Bill Robison, the man from the lab who had run most of the radiological studies at Bikini, helped immensely in my understanding the charts and numbers. He patiently answered the same questions posed in many different ways. It was critical that I understood the rationale for it being safe to dive at Bikini from a layman's perspective, not only because I had to decide if my team would take on the job but because I would be the one to write recommendations for future use of the site by visiting divers.

Bill and I spoke for hours regarding different types of radiation, from gamma rays to tiny particles called alpha-emitters that could in microscopic amounts cause serious damage to humans if ingested—

say through a regulator mouthpiece. Although Bill's articulate discussion of the properties of radiation threats inspired confidence, I was a firm believer in the old Soviet dictum "Trust . . . then verify." I took all of the information Bill had given me to a friend at Los Alamos who worked in the field of radiological health.

Jim Sprinkle carefully reviewed the data and spent an evening discussing it with me up on "the hill." Something handy about living in Santa Fe, is the proximity of the heart of the Manhattan Project when you're planning to dive in potentially radioactive environments. I wanted a second opinion from Jim as a friend, not an "official" opinion from Los Alamos.

After weighing carefully the evidence from the studies and the advice of these two men, I decided to commit to the Bikini project. I reserved judgment on any position paper regarding wider use by sport divers until we could see the area first hand and conduct additional spot checks of radiation levels. Thus, in August 1989, I found myself lying beneath the *Prinz Eugen* at Kwajalein studying Christmas trees. As fascinating as we found the *Eugen*, we were happy to receive a radio transmission that we would be able to depart for Bikini next day. We terminated our diving and headed back to Kwaj.

After the long buildup and so many delays, I was extremely excited to get my first glance of Bikini Island. In 1989 Holmes and Narver Company represented the Department of Energy in the Pacific. Their field station on Bikini was small and well-managed. In fact, the whole island was small and well-managed. Trees grew in straight rows on Bikini and the houses had no people in them, the occupants having been displaced because of the tests. It weighs heavily to see land in Micronesia not lived on, not used; it's illogical. So much water, so little land.

The delay in obtaining transport to Bikini underscored another concern I had discussed with our team members before leaving Santa Fe. A major problem in risk management is allowing one dramatic issue to override more mundane concerns. Radiation worries could dull our edge regarding the more traditional problems of deep diving in remote areas. Bikini is two hundred miles from the nearest recompression chamber at Kwaj—not necessarily troublesome in Hometown, USA. A medical evacuation to Kwajalein, however, could take days, depending on the vagaries of boats and planes that might be

available to us. We planned to make long dives on air as deep as 180 feet—twice each day for two weeks. As Jimmy Stewart had pointed out to me so forcefully regarding our work at Isle Royale, the U.S. Navy decompression tables weren't devised for that kind of use without accepting some incidence of bends. I wasn't about to accept anything of the sort.

As insurance against bends, we had a ton of oxygen available, literally. Before leaving Santa Fe, I called Kent Hiner, the Holmes and Narver manager, and told him I wanted a dozen large bottles of industrial oxygen shipped from Kwaj. He thought that was an odd request for a diving operation that used compressed air for underwater life support but relented when I explained its role in preventing bends. Kent, knowing well the risk of being penny-wise in remote operations, ordered twenty-four bottles to make sure I hadn't underestimated. I also instituted a policy that all divers would stay off compressed air for a twenty-four-hour period after every three days of operation. This was no game; a miscalculation meant someone might never walk again.

The other risks at Bikini included unexploded live bombs and torpedoes, a heavy shark population on the outside reef, and some nagging doubts about radiation. The hard data we collected during our project had to dispel even the ghosts of that issue. If not, they would haunt attempts at using the ships as the focus of a tourist-based economy in a resettled Bikini.

Slam! The peculiar little pontoon barge, with the big six-by truck on it, crunched into the beach sand. With a great straining of gears, the six-wheel-drive train tried to gain traction, but failed. A D9 Cat on the beach was chained to the truck's towing eye, and soon a load of our equipment made its way ponderously to the field station. The same bulldozers were used to launch our dive boats through the surf.

Finally, after a series of coordination meetings, we were doing it: diving at Bikini. Heading out to the site in a fast Boston Whaler piloted by a Bikinian, we looked incongruously overdressed in our Park Service coveralls. We wore the coveralls for protection: On the surface, they shielded us from the withering, melanomic rays of the sun

that burned through lotions and flimsy T-shirts; on the seabed they provided a thick skin to take the edge off our contact with jagged metal and the stinging sea creatures that covered the wrecks.

The photographers and television types working with us hated these dark green uniforms. They complained we looked like "underwater janitors," and worse, they "suck up all the damn light," making filming us a real chore. We commiserated with them on these problems as we zipped up our coveralls. Jean Lajuan, our assigned boat operator, traded banter regarding our pale complexions and the gobs of sunscreen with which we painted our faces and ears, the only exposed parts of our anatomies.

Jean was in his twenties, another sharp contrast to we Santa Feans, all in our forties at the time, except for Jerry Livingston, who was fifty-six. We were an unusually old bunch to be doing this kind of diving so Jean missed few chances to prod us about our feebleness, pending impotence, and imminent departure from this life. We, in turn, assured him that being older and wiser had only increased our competence and sexual prowess, etc., etc. This sort of banter seems to be a required ritual among males that crosses all cultural boundaries.

Soon, with the boat stopped and no cooling breeze, the heat caught up to us. The joking was put aside while we went through the process of getting from the wave-tossed boat into the water. It was a race against time—once we'd committed to the heavy tanks, buoyancy gear, and weight belts, the coolest and safest place to be is over the side. Overheating is nothing to take lightly before a deep dive, nor is dehydration, which we deterred by drinking deeply from the Styrofoam cups of ice water Jean passed to us frequently.

Demeanors changed quickly and Jean listened intently to my last-minute instructions about deploying the oxygen hoses as we prepared to do a back roll into the lagoon. My eyes burned inside my face mask as perspiration poured over them. I gave a last look at my dive partners arranged around the edge of the whaler, poised to flip backward on the signal to begin the dive. "Everybody happy?" I received four sardonic "Yo's" in return. "Vamanos," and we were over the side, as water closed over our heads and we entered a cool, blue world. From

this point all of our actions became disciplined, focused, intense. As with cave diving, the teamwork is so much of what appeals to me about diving as a member of SCRU. Communication is the key to success in a world where speech is impossible without elaborate electronic accessories.

A good team of divers develops a body language that overcomes communication handicaps. They nurture a sixth sense about their partners that allows them to detect a problem before it grows into an incident. Larry Murphy turned quickly and came to me when I had a minor problem with my gear after entering the water. It was remarkable only because no conscious signal passed between us, just some inadvertent, slightly erratic movement on my part. We turned back to our descent and to the sharing of a mind-boggling experience.

The *Saratoga* loomed beneath like the ruins of a steel city—a fortress with five-inch-diameter guns and many smaller ones bristling along the perimeter of its flight deck which was dotted with thousands of fittings that once held teak decking in place. The decking is gone now, having provided a nourishing meal for millions of marine worms, ugly little swimming intestines that eat wood. The metal on *Saratoga* was also being eaten by a different, slower process called corrosion.

As we passed the command bridge, or "island," which stood on the starboard side of this aircraft carrier, the visual impact of the site was electrifying. This had been the nerve center of the great warship. The huge elevator for passing planes up to the flight deck had collapsed; a black square hole with rounded edges outlined where it had been. We moved past that access to the ship's bowels in favor of a blast damage hole further aft. At least three of us did—I motioned for the illustrators, Jerry Livingston and Larry Nordby, to break off and head to a vantage point for drawing as we passed the dark square hole. The resemblance of our descending team to a formation of planes was not lost on the ABC camera team that joined us from their own boat to film this first dive. The producer and cameraman, Lee McEachern and George Lang, respectively, were known to us from 1982 when they first covered our underwater work at Point Reyes and Alcatraz for the San Francisco ABC affiliate.

Bubbles from our mouthpieces rose in long, ever-expanding, reverse cascades as we swept along the deck a short way and spiraled

gently into the hole. We were intent on penetrating as far back into the hangar deck as we could get. Jim Delgado's search in the National Archives indicated live ordnance was placed throughout the hangar at certain frame numbers. We meant to find if it was still there and intact. This would tell us something about the A-bomb's effect, and more importantly for our park assessment, what sorts of hazards might greet recreational divers who would inevitably be drawn to make exploratory penetrations into this eerily beckoning portion of the ship.

The ABC crew followed, intent on documenting our progress as the site revealed its secrets. Their presence was welcome because they carried huge movie lights that helped illuminate the hangar. We swam the forward part of the hangar through the elevator shaft, noting intact Hell-Divers, a type of naval dive bomber, and racks of 500- and 250-pound bombs.

The largely intact vintage warplanes, wings folded for stowage below decks, would have a great appeal to the diving community. Jim said his work in the archives led him to believe that some bombs were dummies, with plaster having been substituted for the primary explosive charge. Supposedly, the architects of Operation Crossroads were concerned that exploding conventional ordnance on the battle-ready ships might mask the effects of the A-bombs, so they filled some of the test ordnance with inert material instead of real explosives.

The problem was inconsistency in the application of this logic. It is next to impossible to tell if a given bomb is filled with plaster or high explosive without breaking it open. We were concerned the attrition factor for the "breakers" might be unacceptably high, especially because the fuse and initiating charge of even the inert bombs were powerful enough to kill a diver.

As we pushed farther aft in the hangar, there was no "plaster-filled" designation on the archival documents, so we had to assume the rack of rockets in our light beams were live, fused, and armed. We moved gingerly by the weapons, which look stark and lethal in their cradles. We would discuss our finds with Navy explosive ordnance

disposal experts later—we had no desire to field-test the latest theories on the stability of immersed World War II ordnance.

Then the sun seemed to shine around me as the ABC megalights caught up. Their appearance made me particularly happy I was "running a reel." As in cave diving, the strand of nylon line ensured some physical link to the hole through which we entered. As we passed more rockets and torpedoes along the walls of the hangar, it became clear we were coming to some sort of termination point. A chaotic array of pipes and nondescript material on the floor, and a bulkhead in front of us barred further progress. A glance behind me vindicated my decision to run the line. The tiny patch of blue that would have pointed our way out was totally obscured by silt raised from the swift fin kicks of the camera team holding the heavy lights.

The feeling of being in a large space was eliminated as the silt rose in reddish brown clouds. Our perceptual world compressed into a few feet of thick brown water that the most powerful lights couldn't penetrate. No up, no down, just confusion, save one piece of clear white sanity, that straight unmoving nylon line, pointing to light and air. The *Saratoga* is a cultural cave of ceiling and walls. Steel passageways formed by man are so different, yet so very much the same as natural ones; both as unforgiving as they are intriguing.

We made our way out along the far wall of the hangar as I slowly wound line back onto the reel; the rest of the group kept ahead or beside me. We were soon out of the hangar and heading up the island to our decompression stop under the dive boat.

Our time on the bottom at 130 feet in the hangar was considerable, so we required almost a half hour of staged decompression using hoses suspended from the bobbing Boston Whalers on the surface. During stops at twenty and ten feet we nursed contentedly from the hoses, listening to the reassuring rush of oxygen moving thickly, at half again its surface density, through the rubber umbilicals.

Hanging from a rope bouncing up and down with the swells is not my idea of fun, but it has its purpose in the scheme of things. The glazed expressions of my compadres yo-yoing around me made me ponder the market for a text on Zen and the art of contemplation on decompression lines.

"Bikini base, Bikini base, all divers are up," Jean Lajuan confided to a hand radio and received a quick acknowledgment. On the way

back to the field station, with the whaler slapping the waves smartly, our spirits still soared from the dive. There are few things in life that can clear the cobwebs from the brain and put things in perspective so well as an exploration dive. Perhaps it is because you put aside anything not immediately relevant to the tasks at hand: finding, learning, surviving. We already had learned the answer to the first question posed by the Departments of Energy and the Interior: Are the sites visually and historically compelling? Hell, if there was nothing else but the *Saratoga* at Bikini, it would rate as a world-class dive destination.

Later that day we made a shallower dive on *Saratoga*, concentrating on the bridge, command center, and admiral's cabin. Instead of cameras and slates, we carried a modern version of a Geiger counter in a Plexiglas housing. Kitty Agegian, a researcher and diver for the Department of Energy, showed us how to monitor the device as we checked enclosed areas deep in the ship. We also carried plastic bags and sponges. These were for gathering samples of silt from the overheads and decks at random points. These sediment samples would be sent to Lawrence Livermore labs to be analyzed for alpha emitters and other signs of radiation residues. The point of all this was to verify empirically what analogous studies on land and inference told us should be the case—that the ships were safe. Trust, then verify.

A deep dive Larry Murphy and I conducted the next day to check for radionucleides on the *Saratoga* was educational in a different sense. It suggested an explanation for a puzzling incident that had occurred almost ten years earlier. As I carried the radiation meter and several plastic bags full of silt back toward the surface, from a 180-foot dive to the mud-line, Larry and I were approached by a gray reef shark. This individual was probably less than five feet in length, certainly not grist for an awesome shark tale of the *Jaws*—dum-dum-dum-dum—Roy Scheider-save-the-town ilk.

Encumbered with bags of silt and instruments and wishing to return to the decompression stop without delay, I was in no mood to be distracted. I ignored the animal even though he was circling us closer than usual for these grays at Bikini. He didn't seem agitated or aggressive, just curious.

Larry, coming up behind me with a camera, had a few shots held in reserve, as was his habit for situations just like this. "Whap," the strobe startled me as much as it did the shark. But what happened af-

terward really captured my attention. The strobe hooked to Larry's camera started that whining, high-pitched sound they make when recycling for another shot. The shark went looney—this half-pint went into a classic aggressive display!

Murphy thought it was amusing and immediately burned off two more shots. If I wasn't so encumbered, I would have done him violence. There is no such thing as a small shark when it's in the water near you, teeth flashing, back arched, and pectorals down. But when I knew I should be totally engrossed in the moment, I felt something drawing my thoughts to the past. My memory took me back almost a decade to this shark's great-grandfather off that reef on Pohnpei in 1981. The one that became so inexplicably aggressive and chased me from the water. It occurred to me that when I was taking those pictures of the crown of thorns starfish and this shark's ancestor began harassing me, there was something else in the water with me—the granddaddy of Larry's strobe. I watched Larry fire off one more picture as we made our way to the decompression stop—from the fish's reaction, I was certain.

We determined from immediate feedback instruments, such as the detector, that most of our assumptions about the lack of radiation danger on the *Saratoga* were correct. The meter would react sometimes, pegging out the needle, but in those instances the settings were so low that it probably would have acted similarly if carried out of my home into direct sunlight. The background radiation at Bikini was, in fact, significantly less than commonly found in Denver or Santa Fe or anyplace in the Rocky Mountains for that matter. Analyses of sediment in the bags would eventually yield similar negative results.

Meanwhile, Nordby and Livingston's work was progressing on a map of the great aircraft carrier. They shared my conviction that just by itself the *Saratoga* comprised a world-class recreational dive site.

Although I knew that in our limited time we could develop a really comprehensive map of only the most dramatic site, the *Saratoga*, and perhaps devote several dives to the *Nagato*, we were loathe to leave without some level of documentation of the other wrecks. It was this necessity that mothered the invention of a new technique that worked so well for us at Bikini. We later employed it in many other projects requiring high returns from limited bottom time. We called it the "Blitz."

The first place we tried it was the site of the submarine *Pilotfish*, one of the vessels in the Bikini test array that would be a draw for many people on its own but was cast in a supporting role due to the proximity of the superstar wrecks *Saratoga* and *Nagato*. All we knew about the sub was that it was nearby, Balao Class (about three-hundred-feet long), and reported to be sitting upright by the Navy MDSU divers who had buoyed it for our convenience.

After a lengthy huddle discussing how we could milk all the data possible from one dive, we were ready to try our plan next morning. All five members of SCRU strapped a small strobe light to their left shoulder. We descended simultaneously, planning to be back at the decompression stop under the boat in less than thirty minutes. As the submarine started to take form below us in the eighty-foot-plus visibility, I took the lead while the others broke into pairs behind me. I leveled us out at 155 feet deep and started making a slow pass down the centerline of the submarine. The other four spread apart, until they were forty to fifty feet from each other, keeping me and the centerline of the sub between them.

I flipped over and swam backward. To my right Murphy was slowly following, strobe light flashing at regular intervals. On my left, Jim Delgado, most familiar with the archival information on the vessels, proceeded at the same pace as Murphy. He was shooting video with a small 8-mm camera from which we had fixed a wire attached to a microphone in the oral-nasal area of his full face mask. This allowed Jim to make verbal observations directly onto the videotape—much quicker and more accurate than trying to reconstruct what he had seen. Trailing twenty feet behind both of them were the illustrators, Livingston on the right, Nordby on the left.

My job was to set the pace, control the depth, watch the time, and query through hand signals those I thought might need to check their air. The only concentration-breaking requirement they had was to keep my flashing armband in the corner of their eyes for reference. If I were to bang on my tank with my knife blade, it meant all-stop, something was wrong, or somebody in trouble.

It was a dreamy twenty minutes on the bottom for me. I swam slowly backward with my gauge console held just under my chin. I kept my depth precisely at 155 feet as I passed over the hull of the sub resting in 175 feet of water. On both sides of the vessel, I monitored

the trailing four divers, their strobes making them easy to track. I could tell from a glance behind that the *Pilotfish* was coming up to reach me. The sub's sail, or con, rose close to my height off the bottom, and I was soon brushing by soft corals adhering to the top of the periscope tubes. A cloud of tiny fish hovered around the twin 20-mm Oerlikon machine guns, barrels canted upward at a crazy angle.

Check time, check depth, check position of divers—all well. Murphy slowed for a shot too long; I rapped my tank once. He glanced, saw me spin my index finger in a "keep rollin' " gesture, proceeded— all well. Check time, check depth, one rap of knife, motioned Delgado "up three feet"—all well. Check time, two minutes to turnaround but we were almost at the stern so we continued.

When we reached the stern of the sub, I motioned Murphy and Delgado to check air and switch sides. As planned, Nordby and Livingston reversed directions but stayed on the same side they had started on. The logic was that the illustrators needed more time on each side to draw than the others for photo and video acquisition.

The benefits of this approach were dramatic. As long as I remained steady at the helm, the time divers usually spent worrying about their buddies—elapsed time, pacing, and depth variation—was greatly diminished. The results were sweet. We arrived back at the decompression stop in twenty-nine minutes. We had in hand: two rolls of film, a twenty-minute narrated video pan, and a sketched oblique perspective of both sides of the vessel. We used the technique on two more sites at Bikini, and it worked well in all cases. Besides information for the report we had a new word for the arcane SCRU vocabulary: Blitz.

Except for the Blitz dives, Larry and Jerry continued mapping *Saratoga*, as Murphy, Delgado, and I completed assessment dives on other vessels, including *Nagato*. Eventually, it would be dives on this ship that stirred the deepest feelings on my part. They took place a year later when we completed our survey of Bikini.

In 1990, we returned to finish our work, much of the report was written, and the ABC television people thought they had the makings of a great documentary, so they funded much of the operation. This time, *National Geographic* magazine writer John Eliot and photographer Bill Curtsinger were added to the brew. On this expedition, ABC

television had changed producers—ABC Kane Productions had relegated Lee McEachern to an assistant role. From my point of view this was a mistake—the replacement producer had none of Lee's savvy with the people or appreciation of the nuances of the underwater park story at Bikini that to me seemed so compelling.

His Imperial Japanese Majesty's Ship, *Nagato* had enforced the Japanese vison of a new Pacific. The flagship of the Japanese Navy at the time of the raid on Pearl Harbor—this is where Admiral Yamamoto sat out the attack, waiting word from the strike force far to the east.

We decided to do a modified Blitz on the *Nagato's* deck and guns, which were probably crunched under the weight of the overturned monster in 180 feet of water. The same Blitz rules would apply, including the shoulder strobes, which were even more important now that four others from the TV team would be joining us in the water. We couldn't swim the centerline, but I would still steer the dive and monitor the progress as on the *Pilotfish*. We wouldn't have agreed to so many people in the water at once, except for the fact that Nick Caloyianis would be leading the ABC underwater camera team and we knew from past experience he was a highly competent diver. Also we had the strobes. As long as I could monitor the well-being of my four divers, distinguishable by their flashers, the dive would continue. If confusion became too great under the ship, we would call the dive short.

As we passed beneath the upturned edge of the ship, the massive sixteen-inch-muzzles stared us in the face. Armor-piercing projectiles designed for these guns were modified into the bombs used to wreak havoc at Pearl Harbor. I thought of the USS *Arizona* and the time I had spent swimming around her wreckage. Not at all like the feeling of *Nagato*, for death is tangible on the *Arizona*: 1,177 lives cut short before their time. The *Arizona* lies heavy on the harbor bottom, weighed down with silt, and the bones and crushed dreams of nineteen-year-olds.

The *Nagato* is different. It lies upside down, smashed with an atomic fist; no lives lost because it was just an "experiment." They took the last capital ship of the Japanese Imperial Navy, the enforcer of the Greater East Asia Co-Prosperity Sphere, and made sure it was dead. Most of the other ships at Bikini were present to carry out a test of atomic warfare at sea. Journalists who accompanied the sailors to Operation Crossroads reported battle-hardened veterans weeping as the *Saratoga* sank beneath the quiet waters of the lagoon. They spat

on the water over *Nagato*. The memory of *USS Arizona* was too fresh in these men's minds for any thought of forgiveness; they wanted *Nagato* in hell—a twenty-kiloton flash granted them their wish.

The sixteen-inch muzzles still have tampions in them. I rolled over on my back and sculled my fins, gently propelling myself underneath the ship but far enough off the sediment to keep from stirring up a cloud of silt. We were as far from the surface as an eighteen-story building is high, where nitrogen narcosis makes strong impressions even stronger.

Lacy white whip coral strung down from the deck like thousands of long, soft pipe cleaners. The light in my hand played over these strands bringing out their crystal whiteness and appealing texture. It is remarkable the colors artificial lights can elicit in a deep-water environment. Almost all surface light is filtered out at these depths so the eye normally sees only blues and grays. It would be similar to watching a black-and-white TV and having it suddenly change to Technicolor. A captivating scene in fifty feet of water, it is positively enrapturing at one hundred-eighty feet.

Larry Murphy came behind me, flashing the strobe on a still camera. One was in his hand, another hung from his waist straps. Larry used these same cameras on USS *Arizona* years before. He moved with his usual grace, thousands of hours of diving experience evident in his parsimonious use of energy; almost imperceptible twitches of his fins propelled him fluidly under the ship.

Suddenly we were both bathed in light as the ABC camera team found us. I could tell they were surprised how striking the scene was they had happened upon. I heard the whirring of $40,000 worth of sixteen-mm camera over my left ear. It's a strange feeling, being alone with your thoughts as several million people look over your shoulder.

I had assumed the superstructure, or lighter upper works, would be all collapsed under the tremendous weight of the warship, but a stirring sight greeted us. On the periphery of my vision, Murphy's strong, even fin kicks slowed, and he no longer worked the film advance of his camera. He had seen it too. The bridge of the *Nagato* had somehow escaped destruction and lay intact on the bottom of the lagoon, miraculously preserved from the crushing weight of the hull.

The film crew was confused because we had stopped swimming and were staring into the gloom ahead of us. They were yet to understand the significance of the twisted metal with the vertical rectangu-

lar ports. Then Nick realized what we'd found. He began a staccato kick of his fins, holding the camera with one arm extended and motioning wildly with the other to his light men.

"*Tora, Tora, Tora.*" This is where Yamamoto stood when the coded message transmitted by flight commander Mitsuo Fuchida reached him in Japan's Inland Sea, thousands of miles from its origin in Pearl Harbor, December 7, 1941. Tiger, Tiger, Tiger: The fleet is at anchor in Pearl Harbor, surprise is achieved, attack to begin.

The ABC producer wanted to use excerpts from our small video camera in his film to show the diver's "point of view." Jim Delgado, wearing the mask with microphone to video, didn't disappoint him. "Unbelievable," he yelled on seeing the bridge. I could hear his excited voice, muted through eighteen inches or so of water.

Shipwrecks always have much to tell us as artifacts, but they can also be shrines to the past that focus us spatially and temporally. To us, the *Nagato* was more than a source of archeological information, it was the very fabric of the past, of a pivotal moment in history. Part of what we are came to be on the bridge of this ship fifty years ago.

Shucking our gear off in the boat we were still buzzed from what we'd just seen. "Dives like this make me remember why I'm in this business," Murphy murmured. We talked about how powerful an experience it will be for people lucky enough to see the place.

"Why's that, Dan?" The producer/cameraman turned his infernal machine back on, but this time I was up for it and my standard camera shyness dissolved. During the impromptu interview, I expressed my feelings about the remarkable nature of the monuments we had just visited under the sea. Creating opportunities for people to experience submerged history in the raw: "That's what excites me, that's what parks are about . . . it's what we're about." I expanded on this by developing a vision of sport divers visiting the sites and perhaps a tourist submarine for nondivers.

I had already come to a conclusion about what I was going to write in the eagerly awaited "recommendations" section of our monograph. The ships were spectacular visually and historically. Even considering how remote they were, they would eventually attract the most devoted of the world's advanced divers. There was no credible evidence that they presented any problem to the health and safety of visitors due to radioactivity. The live ordnance on the ships did pre-

sent a potential danger to the incorrigibly stupid. It was easily avoided by leaving the stuff alone. The real risks at Bikini, in my opinion, were the normal ones associated with remote, deep diving. Our report, with a foreword by the Secretary of the Interior, recommended treatment of the ships in a manner consistent with their being historic resources in a park: Visit, enjoy, and leave unspoiled for others.

That night we talked about what really went on at Bikini in 1946. Why did the U.S. military really blow these ships up? Robert Oppenheimer, the orchestrator of the Manhattan Project that built the bomb in our home state of New Mexico, had drily opined that if you drop an atomic bomb on ships, the ships will sink—an indication of his opinion of the Crossroads Project.

Much was learned at Bikini, despite Oppenheimer's skepticism, about what happens to ships when they are nuked. For example, they don't all sink. In fact, only a small percentage sank after two tests, but they sure went through hell. Radiation was discovered to be a more complex problem to deal with than expected and revelations about its effects would continue for decades. But few modern-day miscalculations will ever rival the spectacle of Navy sailors a few hours after the blasts at Bikini swabbing down the decks of the *Saratoga* in short-sleeve shirts. They were "cleaning" the ship of radiation.

Whatever other reasons there were for the tests, we figured the target audience was really Moscow. The Able and Baker blasts, the first shots in the Cold War, were a sort of ritual combat in which goats and pigs were killed instead of men. The atomic bomb was replicated by the Russians in 1949 as were the hydrogen bombs tested in Bikini in the early 1950s.

And why not? Ritual combat is a time-honored mammalian tradition, as I recalled discussing in introductory anthropology classes I taught at Florida State. Lions and wolves rarely fight to the death when it's clear they can easily cause irreparable damage to one another. As mammalian predators maneuver for territory, they shove and display their teeth to convince the other how awful will be the outcome if their domain has to be defended. For decades the United States and the Soviet Union bared their technological fangs at each other—Operation Crossroads was the first serious snarl.

Through the earpieces of my Walkman, the Drifters sang of "Magic Moments" against the steady drone of the Air Micronesia jet whisking me back to the desert Southwest. I tried to sort through a jumble of emotions, as reefs in the lagoon below asserted themselves in brilliant greens and turquoise—bold slashes in a navy-blue ocean.

We had seen the destruction of great warships by a scientific trick I really couldn't comprehend. Splitting atoms. Fission bombs, nukes. Toys! These things that sunk and irradiated the fleet at Crossroads were toys compared to what came later. I thought of the Bravo crater from the 1954 thermonuclear blast that became the largest detonation ever set off by America. It wasn't intended that way, but it was at least 300 percent bigger than anticipated—a fifteen megaton monster that vaporized three small islands and doused radioactive fallout over a good part of the Marshalls.

One pop of fifteen megatons equals fifteen million tons of TNT, more than all the explosive detonations of all the wars in history compressed into a second. The crater was still visible from the small planes we took from Bikini to Kwajalein.

The Bikini flag is a variation of the American stars and stripes. It has three stars provocatively separated from the others in the upper right corner, a memorial to the islets that disappeared in a mushroom cloud. This symbolizes the loss of land, a precious commodity in Micronesia.

"Men otemjej rej ilo bein anij" is inscribed along the lower half of the flag. These were the words spoken by the Bikinian leader when asked if his people (all 150 of them) would agree to leave their homes to accommodate the Crossroads tests. The tests were, after all, for the "ultimate good of mankind." The English translation of the man's response after looking around him at the assembled military might of the most powerful nation on earth was "All things are in God's hands."

A few weeks after my return I was driving to my Santa Fe office in the early morning. In the distance were the flickering lights of White Rock, the bedroom community for Los Alamos where the Crossroads bombs were born. My next-door neighbor was picketing the entrance of our subdivision. Dressed in attire reminiscent of lab technicians' protective clothing, she waved a sign, "WIPP Route," her way of reminding her neighbors that the trucks carrying nuclear waste to the new Waste Isolation Pilot Project in Carlsbad were going to drive right past our homes.

Disposing of radioactive waste was and is a "hot" issue in my hometown. Fear and anger about the subject are intense. I waved to her and mouthed some words through the closed window. She nodded as if in comprehension and waved back, although I don't think she really understood what I'd said: *"Men otemjej rej ilo bein anij."*

THE ALEUTIAN AFFAIR

———— ~~~ ————

I felt the Aleutian cold reach through my Thinsulate and down garments right into my bone marrow, even in early September. As Larry Murphy and I conversed on the fantail, rolling North Pacific swells made the deck of the Navy salvage ship seesaw beneath our feet. We spoke in loud voices to overpower the noise of the engines and, in unconscious synch, sidestepped a few feet to the right, then the left, to match the ship's roll.

Puffs of breath visibly punctuating his words in the cold, Larry briefed me on what had transpired so far on this expedition to locate and document remains of the only fighting on North American soil during World War II. We were heading for Kiska, hoping to finish survey work there, and then we were to move on briefly to Attu, at the very western end of the chain.

Larry had hitched a ride up to Alaska from Pearl Harbor on the USS *Safeguard*, a 250-foot Navy rescue/salvage ship. It was September of 1989. We were on the way back from Bikini, when we parted in Hawaii: he to head north and get the survey started, while I headed back to Santa Fe for a few days with family before flying up to join him in Adak.

In 1942, the occupation of these two islands, Kiska and Attu, off the coast of Alaska by the Japanese was seen as an ominous development by the American public.

Many now feel the Japanese assault on Alaska was a diversion to distract the American Pacific Fleet from the real focus of the Japanese Navy's next major offensive: Midway. The Imperial Navy had been

riding high since the attack on Pearl Harbor. Their victories in the Philippines, Guam, Hong Kong, Burma, the battle of the Coral Sea, and the sinking of the two largest British warships in the Pacific off Indochina—all made it easy enough to believe that the destiny of East Asia would lie under a rising sun. Indeed, in the spring of 1942, a Greater East Asia Co-Prosperity Sphere under the aegis of Japan seemed an attainable dream, with Hawaii and the Western Aleutians not necessarily excluded from this vision.

Six months of glory and the prospect of a final showdown with the U.S. Navy made for heady moments, a sense of purpose, and belonging for a generation of Japanese who felt their nation was finally coming into its own. The more cautious among their leaders were, however, driven by a different force, the knowledge that anything less than quick destruction of the U.S. Pacific fleet would spell eventual disaster for Japan.

Admiral Isokuro Yamamoto had spent enough time in America to understand the overwhelming industrial capability of the United States and to be less than certain of the prevailing conviction in Japanese military circles that Americans lacked the will to fight. A particularly disquieting event had occurred during these months of headlong victory, which gave him additional pause in this regard. On April 18, 1942, about lunchtime, sixteen American B-25 bombers appeared, seemingly from nowhere, and bombed Tokyo. Although the tactical effect of the "Doolittle raid" was negligible, it was symbolically stunning. It was a daring attack, difficult to reconcile with a spineless enemy.

Yamamoto and his staff knew that the twin-engine B-25s were long-range, land-based bombers; where did they come from? It would be weeks before the Japanese became fully convinced of the truth—that the raiders had been specially trained to fly these planes from an aircraft carrier and that the USS *Hornet* was their origin. Not being clear where these planes came from raised the frightening possibility: that the United States had managed to build long-range bomber bases in the Aleutians. Suddenly, scant weeks before the Japanese made the curious decision to divide their forces between Midway and Alaska, the Doolittle raiders had given the Japanese additional reason to strike north besides simply presenting a diversion for their assault to the south.

Regardless of motive, the Aleutian campaign became one of the most compelling events in American military history. It was the first time enemy troops had occupied U.S. soil in North America since the War of 1812, so when the drumroll began to evict the invaders, it derived as much from national pride as strategic decision making.

The NPS divers aboard the ship included Larry, Mike Eng (SCRU law enforcement specialist who had replaced Ken Vrana), Jay Wells (formerly of Isle Royale, now chief ranger at Wrangell St. Elias in Alaska), and me. Susan Morton, a land archeologist from our Alaska Office, and representatives of the U.S. Fish and Wildlife Service and U.S. Air Force rounded out the primarily Navy complement of shipboard personnel. The *Safeguard* had a crew of approximately eighty men and women.

The Navy divers on this mission included several permanently assigned to the ship, with the remainder from Mobile Diving and Salvage Unit 1 in Pearl Harbor. The latter were men and women we had worked with before in similar Seamark ventures from Pearl Harbor to Palau. With the tough diving conditions we faced on this project, their presence was particularly welcome. The water temperature hovered around 36 degrees, and the weather, for maritime purposes, is some of the most treacherous in the world.

In most theaters of World War II, the chief antagonist was the enemy; in the Aleutians, it was the elements. Even winter on the Russian front couldn't match the Aleutians for nature playing havoc with the technology of war. Entire air and sea engagements took place in this West Alaskan archipelago with the opposing sides never seeing each other. In some phases of the campaign more faith was placed on blips on radar screens than ever before in military history.

There were instances in the conflict in which whole squadrons of planes were decimated without ever contacting the enemy; fog and 100-mile-per-hour winds caused them to miss not only the enemy, but the way home. Lost, returning stragglers, out of fuel, crashed into treeless hilltops, leaving stark testimony on the Aleutian landscape of the human costs of war.

The Japanese Pacific juggernaut, which began with the raid on Pearl Harbor, ended within a day of their opening attack on the Aleutians scarcely six months later. As their planes came in for a second raid on Dutch Harbor on June 4, 1942, several thousand miles to the

south, two squadrons of American dive bombers engaged in the battle of Midway would happen upon the main carrier force of the Japanese combined fleet . . . with their planes refueling on the decks. Within minutes the fortunes of war would shift, and any dreams of a Greater East Asia Co-Prosperity Sphere would be in flames along with the cream of Japan's naval air power. Would the result have been the same if Japan's two remaining fleet carriers had been at Midway rather than wrestling fog banks in the Aleutians? Hard to say, but one may rest assured that this question was asked many times in the smoke-filled meeting rooms of the Japanese high command.

Alaska was purchased by the United States from the Russians in 1867 through an agreement that became known as Seward's Folly. At roughly fifty acres per dollar, this folly ranks with the "purchase" of Manhattan Island from the Indians for $24 as one of the more inspired transactions in the history of real estate speculation in the New World.

The native Aleuts were almost killed off by the Russians before the war. The Japanese and Americans deported them during the conflict, and the latter effectively diluted the remains of their culture afterwards. The Aleuts were themselves latecomers in the eyes of the otters, seals, birds, and other inhabitants of an archipelago left blessedly undisturbed by human intrusion for all the preceding millenniums.

I felt that I'd long had some special connection with the Aleutians. Even though this was the first time I had actually been in the archipelago, the mental images painted by my wife, who had spent most of a decade there, made it seem familiar to me. During her years as a fisherwoman in the 1970s, Barb and her friends had spent considerable time scrounging through World War II detritus for materials to build their cabins around Dutch Harbor. All this occurred before the broken-down buildings were declared historic, or worse, declared junk by the Corp of Engineers and "cleaned up."

My expectations from my "wife's tales" were fulfilled immediately on arrival at Adak. I had no sooner left the legendary Reeves Aleutian airplane in the mandatory Aleutian rainstorm and started to drag my bags through the doorway to my quarters when the whole building began shaking from the by now expected Aleutians earthquake. I

phoned Barb in Santa Fe to assure her that everything was pretty much the way she had left it.

Even with the tough conditions, Larry informed me he had successfully surveyed much of Kiska harbor with side-scan sonar with exciting results. He and our Navy comrades found several sunken vessels, including one submarine. The strategic bombing survey and other archival reports indicated these sites should be there somewhere, but now we knew where "somewhere" was.

The use of a Navy ship for three weeks was one of the more remarkable benefits of Project Seamark. The Navy was helping us expand our reach into places we couldn't ordinarily touch. The NPS is technically responsible for helping to preserve National Historic Landmark Sites (such as Kiska and Attu) regardless of where they are located. No one, however, thought we could actually field an operation somewhere so remote. Except for C-130 flights to maintain a Coast Guard Loran Station (navigational aide) in Attu, these islands were only visited once every few years by an occasional fisherman or a Fish and Wildlife vessel. Not only had we gotten ourselves here through our Navy collaboration but a number of land archeologists and historians had taken advantage of the opportunity to pursue their own preservation responsibilities in this remote part of Alaska.

The landlubbers in the team had made excellent progress also, making good use of the brief window of opportunity afforded by the Navy ship to explore and document the remains of the war. They reported that the landscape of Kiska harbor was totally dominated by the almost fifty-year-old residues of the conflict. The next morning, with the ship moored in the comparatively calm waters of the harbor, I had a chance to confirm this for myself.

Standing alone on a walkway on the ship's bridge I gazed at the shoreline, where the morning fog moved up to join the normal overcast and form a thick ceiling of clouds only a few hundred feet above us. Before the hillsides disappeared into the mist I could see they were heavily fortified and pockmarked with bomb craters. The tundra has preserved, in sharp relief, the cumulative results of many American air raids on the Japanese fortifications.

There are no trees in the Aleutians; severe rock outcrops contrast with the soft greens and rich browns, and reds of soil and tundra. Someone's crab pots on the dock were the only sign that anybody had

been there since the Japanese departed. Ships of the same gray color as the *Safeguard*, but carrying guns many magnitudes larger than the fifty-calibers that rested silent under the tarps on our vessel had bombarded the island for weeks. They supplemented the bombing runs by U.S. and Canadian planes from Adak.

In an effort to avoid the heavy losses and hardships encountered by Allied forces during the retaking of Attu, the American military spared no expense in air raids, or naval bombardments, to soften Japanese resistance on Kiska. On some of the raids an intense bearded man, a maker of propaganda films with some Hollywood experience, rode in the belly of one of the B-17s. That was how John Huston first set eyes on the rolling green and brown hills of Kiska.

On Attu, the last of the Japanese soldiers held hand grenades to their chest and pulled the pins rather than suffer the dishonor of being captured. Five hundred young men soaked several acres of the noncommittal tundra with their blood and body parts. They were successful in escaping dishonor as well as a future, taxes, old age, and death by natural causes. The defenders of Kiska were using a different manual.

One may recall the peace slogan from the sixties. "What if they started a war and no one came?" Battle was declared on Kiska, and the Japanese just weren't there—none, not one. While the U.S. fleet headed north to intercept a series of radar blips that turned out to be an electromagnetic Aleutian fantasy, the Japanese defenders boarded destroyers that had slipped through the fog to take them home.

It would rank as one of the more spectacular no-shows of World War II. The lack of enemy forces wouldn't prevent twenty-eight fatalities from accident, booby traps, and "friendly fire" when American and Canadian troops stormed the island and confirmed the growing suspicion of their officers that there was no one there to fight.

Briefly, the sun won out in its struggle with the fog, and I had a glimpse of a smoking volcano in the distance. I expected next to see a prehistoric creature stick its head up from the shallows, but instead a sailor summoned me to the back deck. The fantail was alive with activity—a break in the weather and all were in a frenzy to get mobilized. The two thirty-five-foot launches were lowered and Larry, or "Griz," as he was referred to by the sailors, arranged boat assignments with the Navy chiefs.

The larger launches began towing sonar gear and deploying shore parties while we readied rubber boats for the diving operations. I was soon bouncing my way out to my first dive with Mike Eng. Our bright red dry suits, designed for cold-water diving operations, contrasted wildly with the drab black boats and subdued tones of the Aleutian hillsides, especially since the overcast was already beginning to make up for its minor setback. Perhaps having just returned from a month diving in Bikini made the chill more tolerable.

It's amazing how cold-water diving makes one aware of parts of the anatomy usually taken for granted. Sinuses, for example, are like donut holes: empty spaces, significant only because of their location. One is not likely to forget them, however, when diving in 36-degree water. It seems like they are linked to the eyes, inner ear, and teeth through some kind of icy bond of pain. I grabbed the video camera handed down to me from the rubber dive boat and began to come to terms with the cold water as I waited for my diving partner.

I began my usual soliloquy that preceded cold-water dives. Mike, with SCRU at this point for two years, paid no attention to my muttering as I confided to my regulator profane observations on the teeth-cracking cold, the slothful nature of my companions, and the general injustice of the human condition. As our descent began, my body adjusted to all the insults it had received, purpose came back to life, and my companions magically became competent and the salt of the earth once again.

We followed a white nylon buoy line that was set by a Navy team near one of our sonar contacts, a Japanese submarine. Soon we were filming and sketching the remains of what archival documents told us should be "RO 65," in about one-hundred feet of water—a "Vickers Class" medium sub, noted in the Japanese records as an accidental loss, which conflicts with the U.S. Strategic Bombing Survey listing it as sunk by U.S. bombers out of Adak. We immediately noted that whatever "accident" sank RO 65 blew the entire conning tower off the vessel and left it (periscopes, snorkels, and all) several feet away from the upright, otherwise intact sub.

Northern Pacific anemones adorned the hull in splashes of white, red, and purple. Even some wood decking had survived but most of it was in poor condition. We passed the torpedo tubes through which swimming bombs were helped on their way toward their targets by a

burst of high-pressure air. The greatly superior quality of the Japanese torpedoes that emerged from these tubes became a major military scandal for the United States during the early part of World War II. American sub skippers and their crews who had risked weeks of privation and danger waiting for the opportunity to launch torpedoes had to watch helplessly as their defective "fish" bounced harmlessly off their targets.

Next we passed the transducer for the upward-looking sonar: a sign of one of the inevitable technological turnabouts of war. The submariners had adapted one of their worst nightmares from the surface forces tool kit, sonar, to track its own prey from below. Suddenly, another feature of the sub immediately absorbed all my interest: the torpedo-loading hatch. It would hardly be remarkable but for the fact that it was wide open. I glanced at my air-pressure gauge, which assured me I still had over two-thirds of my air supply remaining in the double eighty-cubic foot tanks strapped to my back. The hatch was large enough to enter without removing any equipment and, like all openings into shipwrecks, it seemed to be beckoning frantically to be entered.

I looked over at Mike, my glance conveying much in the language of divers. He shrugged and nodded. Translation: "Yeah, I see it, okay by me if you go for it." When we are accompanied underwater by a single partner, it's our unwritten rule to get consent before doing anything that takes attention from your partner for more than a few seconds. In the forced silence, Mike had just momentarily absolved me of my responsibility to be an attentive buddy.

I pointed the video light down the hole. There were no entanglements that couldn't be negotiated, so I pulled myself down the hatchway headfirst with my free hand. My movement dislodged a slight flurry of silt; then, my tanks scraped against the top edge of the entryway and made a dull clank when I settled myself in a sitting position on a smooth surface.

I was mesmerized by what appeared in the beam of my light inside the sub. The water visibility in the still void was startling in its clarity. To my right was exposed wiring covered in shiny insulation, to which the omnipresent silt that collects in shipwrecks didn't seem to adhere. Arrays of circuit breakers and electrical switches were interspersed along the overhead, along with valves the functions of which I hadn't

a clue. Small signs on electrical panels were at the fringe of my vision; they appeared to be in English, although I couldn't quite make out specific words. As the case with much Japanese military hardware, this submarine derived from factories in the British Isles.

Japan, a nation limited in natural resources, had no such limits in imagination and cultural resourcefulness. Gazing at the British technology kluged together in the sub, I wondered how often American and British soldiers were torn apart by shrapnel recycled from old bicycles shipped to Japan before the war clouds had gathered or torpedoes from hybrid subs guided by British instruments.

I knew my movements, no matter how careful—even the air bubbles escaping from my regulator—would soon stir the sediment to mar the crystalline clarity of the water. Quickly I extended my hand back through the hatch, where Mike, anticipating me, was already handing down one of our small, self-contained video cameras. Leaning forward, I began to "film" with one hand whatever was caught by the beam of the light held in my other hand. I slid along the ramp I was straddling to see if I could find and film a torpedo. Steadying the camera against my cheek, I panned it down slowly, in synch with my eyes, following the light beam.

My eyes and the camera lens simultaneously recorded an important fact: I was not straddling a ramp—it was a torpedo, warhead in place. This made for exciting video. Luckily, the camera had no sound track to record the muffled exclamations from my regulator mouthpiece. I froze in place, afraid to move, and began to assess my situation using logic, since my knowledge of torpedoes is limited. I had been around a lot of munitions underwater (indeed weeks earlier at Bikini, they were everywhere), but, no ordnance expert, I firmly ascribed to the no-touch rule. My Navy EOD (Explosive Ordnance Disposal) compadres say most of it is harmless, but the stuff that isn't will turn you, in their words, into "red soup" very quickly. Charming imagery, but the humor was lost on me at the moment.

I reasoned the torpedo was probably not armed and that I really shouldn't be as nervous about sitting on it as my gut reactions dictated, but there were many things I would rather be straddling. Although I couldn't tell for sure, it made no sense to me that the Japanese would have had an armed torpedo sitting around . . . unless they were about to place it in a tube. Hell, maybe it was set to go, but

then, I had read that they usually had to travel so many rotations of the propeller before arming themselves and a contact pin would provide the final push of the button. Then again, the EOD fellows had stressed to me that the inhibiting mechanisms in bombs and torpedoes tended to corrode faster than the detonating devices. In other words, it was time to slowly and gently leave. But since it hadn't gone off yet, I decided it should make no difference to sit there quietly and finish my crude video sweep of the interior.

A moment more filming and I gingerly extricated my legs from around the lethal tube intended to sink U.S. warships and exited the compartment. Mike reached down for the camera and light and I was soon back on the sub's deck. He was showing signs of interest in having a look himself until I put my finger in front of his mask and wagged it back and forth a couple times in a "no-go" signal.

As we moved toward the stern, further examination revealed that the sub had a large diameter chain stretched underneath the propellers and rudder assembly. It was obviously not part of the ship, and a Navy salvage diver later pointed out that this is a common step in the procedure to salvage a submarine. It seemed plausible that a Navy salvage diver would have a better sense for that than an archeologist, but it raised the question of who the would-be salvors were: Japanese or American? That question would take more time to answer.

We were at a point that we would have to stage-decompress already so we headed back toward our boat. A few minutes dangling on a line to clear excess nitrogen, a rush of bubbles and surface sounds, and I found myself bobbing on the surface in front of our black rubber boat. I couldn't return the okay sign from the Navy divemaster because my hands were too full of cameras and other recording paraphernalia, so I nodded vigorously in answer to his signaled "Okay?" query. That seemed to satisfy him, so while the support crew bustled around getting Mike into the boat, I did a slow pirouette in the water by sculling my feet and scanned the brooding Aleutian landscape.

On our last day Larry and I opted to join the land crew. We were making our way back to the launch that would take us to the *Safeguard*, having witnessed the detritus of Japanese occupation forces spread over the entire harbor: artillery emplacements, flattened buildings, complex caves dug into hillsides with machine guns still lying in

them, a midget sub still in its pen on land, and even a complete water system and fire hydrant with Japanese characters included.

I was most intrigued at this moment, however, by one of the bald eagles that had been circling our little party as we bounced back down the last green slope of springy tundra. He settled on a remaining communications pole and stared down at us, wings remaining out-stretched as if he had forgotten to withdraw them in fascination with the scurrying humans below. He finally pulled in his wings, solemnly turned his back, and pointedly ignored us—apparently bored with the panorama of human destruction with which we were so fascinated.

Places like the Aleutians that stay preserved in remote splendor, these outdoor museums of our past conflicts, are precious—not just because they keep for posterity dramatic residues of old killing fields but because they provide a context for viewing them that compels re-flection and offers perspective.

Back on board *Safeguard*, Larry and I resumed the chill-inspired, hands-in-pockets, hunched-over position on the fantail. We discussed with Susan Morton and Mike Boylan our project goals and accom-plishments. Mike, manager of this area for the Fish and Wildlife Ser-vice, had a "what'd I tell ya" look on his face. He knew we were overwhelmed with the scenic splendor and archeological richness of his island domain.

We had used up all of our ship time on Kiska and didn't have a chance to touch Attu. Perhaps the Navy could be persuaded to help us again. A slow deep rumble began in the bowels of *Safeguard* as the en-gines warmed up for our imminent departure. I looked back to where we had been last standing on shore, and that haughty old eagle still had his back to us.

CHAPTER NINETEEN
THE MICRONESIAN SWEEP

———⟋⟍⟋———

While many in America in 1992 were celebrating the five hundredth anniversary of Columbus's first voyage to America, the SCRU team was engaging in what we knew would be our last voyage to Micronesia, at least for a long time.

Accepting the assignment had been a difficult choice for me. Recent increases in the Park Service research budget, coupled with availability of technologies perfected during the Gulf War, made it feasible for us to develop the survey system that we had dreamt of for so long—a system that would enable us to carry through on the "We shall return" oath Larry Murphy and I had sworn eighteen years earlier in the Tortugas. But, as often happens with opportunities, they come in bunches. We simultaneously had an offer to work in Micronesia that was hard to resist. Funding came available in the National Register programs, run by the Park Service, to conduct training of historic preservation officers in the former trust territories of the Pacific. When we asked about priorities, training in underwater preservation was identified at the top of their list.

What made this so compelling was the implication this held for submerged-sites preservation in such a huge and important marine environment. The fact that local preservation officials saw the training as a priority was extremely promising. The notoriety of SCRU had also been increasing in the Pacific. We had been getting extensive coverage in documentary films at the time, both on major network and PBS channels, including work we had conducted at Pearl Harbor, Palau, and Bikini. Hence, our credibility was especially high, which

230

increased the potential for having a constructive influence in these developing island nations.

We had a chance of actually winning here, of getting ahead of the preservation power curve, not having to go in and reeducate people to basic principles of caring for heritage underwater. But if we did it at all, we'd have to throw everything we had at it. If our prior efforts in the far Pacific told us anything, it was, don't go half-committed.

Larry, in particular, was concerned about taking energy from the survey system design. So, I let him present the pros and cons in our team strategy meeting.

"The Pacific eats us up every time," Larry said. "Lord, it's tempting but . . . I don't know. We've got to get rolling on the GIS [Geographic Information Systems] package and the GPS [Global Positioning Systems] base station . . . damn, maybe I should stay."

"The problem with you staying here, Larry, is those folks put a lot of stock in personal trust. You've got a lot of currency out there because you're you. They asked for us by name, compadre, they believe in people, not programs and agencies."

We had lost Toni Carrell to the private sector and Jerry Livingston to retirement, but Jim Bradford had experience in Micronesia and Larry Nordby had been on both of our operations in Bikini. Murphy, like me, had eleven years of establishing himself in that corner of the planet, and he had a charisma that Micronesians were as susceptible to as anyone else. Because much of our objective was to solidify an ethic along with the skills, Larry Murphy would be sorely missed if left behind. Larry knew that who you were, in Micronesia, stood for a great deal. Your history there was your reputation and your reputation was everything.

I decided to end Murphy's agonizing. I had a trump card that I decided it was time to play. During the meeting I had become convinced myself that we should do the mission and I knew how to remove the doubt in Larry's mind.

"The Federated States of Micronesia [FSM] has a new historic preservation officer now who is over the officers from all the individual states."

"Really, who's that?"

"Teddy John."

Murphy sighed resignedly. "Game, set, match. Let's start plan-

ning." The way things work in FSM, as in many developing traditional societies, is that seniority is very important. A person who has both competence and personal presence, in addition to seniority, can be tremendously influential. Larry knew Teddy had all of these, and he was as well a staunch preservationist. The ex-baggage handler for Air Micronesia had come a long way since our 1981 work in Kosrae. He had written us every year or two about exciting new sites he was finding in the islands, ending each letter with the question, "When are you coming back?" Money and the press of obligations in the parks is all that held us back, and one of those problems had just evaporated.

The next day we had him on the phone to sketch out our operation. I would stop in Guam to handle some affairs with War in the Pacific National Historical Park. The rest would head to Chuuk to help with some specific preservation issues, then we would all meet in Pohnpei to start the training. After that, we would head to Kosrae, Majuro, and Hawaii. Then, Jim Bradford, John Brooks, and I would split for American Samoa while Larry Murphy and Larry Nordby headed back to Santa Fe. We figured the whole operation would take three months. I could probably get Larry Murphy back in a little over two; the rest were in for a long ride. Barb and I decided to foot the bill for taking the family on the whole trip.

To understand the very complicated sociopolitical world we were about to enter, it may be helpful to consider the following: The islands comprising the geographical entity known as Micronesia were almost all trust territories of some European entity at one point. But by the beginning of World War II, the possession of most of these islands had shifted to Japan. The typical sequence of outside influences for Micronesia followed this pattern: whalers, then missionaries, then copra trade, then foreign occupation. After World War II, most islands came under U.S. jurisdiction as Trust Territories until 1980. At that time, most entered various forms of free association with America. Some, such as Kosrae, Pohnpei (formerly Ponape), Chuuk (formerly Truk), and Yap, formed the Federated States of Micronesia (FSM). Others, such as Belau (formerly Palau) and the Marshalls opted to become republics. Although submerged cultural resources exist from all periods, certain historical themes including prehistory,

whaling, and World War II have left the most compelling underwater archeology.

Pohnpei: Ancient Temples in Nan Madol

Somehow our boat operator managed to keep his cigarette lit through the salty spray pulsing over the bow. The sleek, open skiff slapped its way over choppy water as we coursed south along the inside of the fringing reef. We turned sharply through a break in the living wall of coral and precariously negotiated huge rollers that were ending their own journey through thousands of miles of open Pacific. Here, the boatman must skillfully slide over the large waves at an angle, then jog, to avoid a painful impact at the bottom of each trough.

This was a moderate sea for the east side of Pohnpei in June. Our excursion outside the reef was necessary if we wished to reach the ancient city of Nan Madol during low tide. Our driver slowed almost to a stop regularly to check on three other craft in our little flotilla. We could only see our companions if we happened to crest waves simultaneously. If one of the small craft lost power, it would only be a matter of time before the occupants were washed over the reef back toward the island—like so much cheese over a grater. Because of that danger, each boat had two outboards; a "buddy system" was used for additional backup.

Nan Madol is one of the special places on this planet. Built about a thousand years ago, intricate structures fashioned from large basaltic columns have intrigued many a visitor to the Eastern Carolines. Much in the fashion of Egyptian pyramids, the method employed in their construction eludes, equally, modern Micronesians and experts from abroad. Where were the five-to fifteen-ton elongated building blocks of basalt quarried? How were they transported and arranged in such tight, artful architectural arrangements?

Wedged between a pile of life vests and bags of dive gear to avoid pounding my vertebrae into mush, I could see the walls of the temple complex take form in the distance. At least we assume a "temple" or ceremonial function for Nan Madol, since it's hard to imagine a creation like this would have only a secular purpose.

We rode the surf through the fringing reef toward a stadium-size

area of shallows built of coral rubble to accommodate the placement of buildings. Now the ancient ruins have a tangible air of mystery. Their remote location has kept the worst impacts of modern intrusion from disturbing the site. Even the Japanese occupation and military buildup leading up to World War II had comparatively little effect on this part of the island.

"Cheated death again, Thomas," I yelled over the engine roar to our boatman. He smiled, said nothing, but began to relax. He still straddled the tillers of two outboards he had deftly worked in synch throughout the trip. Torn T-shirt flapping in the wind, baseball hat slightly askew on his head, and still puffing through a mentholated coffin nail—our boatman was the very model of a modern Micronesian workingman. He seemed somehow a refreshing contrast to his jogging, assets-leveraging, fiber-eating American counterparts.

Quantity had not yet superseded quality as the major objective in life management here; in Micronesia people still expected to die someday. Neither were the Japanese burdened with absorption in self-preservation when they fortified these islands for the impending confrontation with the allies in the 1940s. A long life without the prospect of honor and glory held little attraction.

Our boat speed and heart rates slowed perceptibly as we entered calm water and came into full view of the ruins. Much of the suffocating tangle of mangroves had been cleared, leaving the intricate faces of the basalt walls to capture any wandering gazes or temporary flights of imagination. When you are fully confronted with Nan Madol, it is hard to think of anything else.

Our boats deftly rode remnant waves from outside the reef, now reduced to two-foot swells, through an entrance in the ancient sea wall. It was quiet in the tiny boat harbor, the air still and immediately hot.

The occupants of the boats disembarked in waist-deep water to stretch and partake of a newly appreciated luxury: sipping water from plastic jugs without fear of a sudden jolt knocking their teeth out. I look about me at my companions; most were dark-skinned natives of Pohnpei or other islands in Micronesia. In contrast, the blond shocks of hair of my two children bounced energetically among the rest of the group, as we slowly gathered ourselves to begin our explorations. The children soon scurried off to look for papaya, while the Park Ser-

vice dive team and the Micronesians we recently trained to use scuba began to assemble tanks and underwater mapping and recording gear.

I smiled to myself at the appearance of the Park Service divers, a grizzled looking group of men with many expeditions under their belts. It intrigues me that this contingent of ranger/archeologists hailing from the high desert country of New Mexico, several of whom originally plied their trade of discovering the past in the American Southwest, had taken so well to the demands of underwater archeology.

The drab green Park Service coveralls they wore on the surface and underwater, Aussie hats, and other improvised headgear selected for protection from the tropical sun gave the team a quasi-military appearance. I had come to know these men well over the preceding fifteen years and felt extremely fortunate they had chosen to follow this path. I would be lost without them.

The objective of the day's dive operation was to examine several submarine features reported just seaward of the entrance channel. They had been variously described to us as basaltic columns placed upright, possibly indicating some form of ancient engineering, and by more skeptical observers, as coral features of unknown origin. One nationally broadcast television documentary we had seen before departing Santa Fe referred to them, without qualification, as manmade. The narrator also mentioned that an underwater tunnel of ancient construction had been discovered nearby.

If the columns were purposely placed basalt, it would indeed amount to an extraordinary feat of underwater engineering for any civilization a thousand years ago, let alone one in the sparsely populated islands of the Pacific. Having the legend conclusively confirmed or debunked by native preservation officers would be a symbolically important accomplishment, regardless of the outcome.

Treasure hunters and antiquarians often mystified the marine archeological process to people in developing nations, making it appear as if their sophisticated knowhow and technology were necessary to working on underwater sites. If, as part of their diving certification checkout dives, this group could solve an ancient riddle about their origins, it would be a great boost to their morale and confidence.

Still, the group presented some challenges we didn't usually have to deal with in training divers. One was simply linguistic. It is neces-

sary to understand certain concepts of physics and physiology to dive safely, particularly at the depths demanded to accomplish preservation tasks in these islands. Intelligence of the trainees wasn't the problem, it was conveying the nuances of some fairly complicated physiological processes to students who spoke English as a second language. I could imagine trying to learn some of these concepts in my stumbling French; it wouldn't be a pretty sight.

In addition, there were other cultural issues besides language that made the training more challenging, particularly the islanders' dependence on betel nuts. Some natives of FSM are rarely seen without a frond pouch in their hands or belly pack that contains betel nut. When chewed with powdered lime rock and mashed-up cigarettes, it provides a buzz that "gives us energy for the day."

It is similar in ways to the American analogue of a farmer with a mouth full of Red Man, but the effect is considerably stronger and more immediate. It is this betel nut that also gives many Micronesians the appearance that they have been chewing gum mixed with cordovan shoe polish. Some say the betel-nut mash is bad for the teeth; others contend that it prevents cavities.

Whatever the truth in that regard, the fact that it altered the diver's mental acuity in some way was not met with enthusiasm by us diving instructors. Then, there was the problem of choking on the stuff underwater, not to mention the aesthetic issue of having to buddy breathe or share regulator mouthpieces with a chewer. The fact that these men had a sense of humor about as irreverent and twisted as ours provided the basis for development of an interesting cat-and-mouse game, which involved the NPS instructors forbidding use of the substance and the islanders playfully hiding a chaw in their mouths.

I watched during one underwater exercise as Larry Nordby signaled a trainee to approach him. The heavyset black man moved cautiously up to Larry Nordby and returned an okay signal. Larry then leaned forward and gently prodded his ward's cheek with his forefinger. To the great delight of the others, a brown cloud emerged reminiscent of an octopus squirting a protective cloud of ink. Larry shook his head, signaled him to spit out the nut, and continued with the lesson.

But the training had progressed well. Betel nuts aside, these men

knew the stakes were high and worked hard to overcome any language barriers. The significance of this training was that these individuals all had serious responsibilities for protecting the heritage of their respective islands. After finishing their training here, they would be on to Kosrae, where we would run them through intense drills in the mapping of shipwreck sites.

Swimming out the entrance channel through the sea wall involved a fancy bit of maneuvering this day. The same moderate surge that forced the boats to surf into the protected harbor was still washing through the shallow channel. Whichever hand wasn't committed to grasping equipment was devoted to holding onto the bottom while the surf rolled overhead. One had to kick strongly with the outwash to make several yards' progress, an operation made trickier by plentiful stands of fire coral that delivered painful penalties for any miscalculations in underwater navigation.

Within a few minutes we cleared the shallow entrance and were in deep water. We regrouped to ensure no one was too banged up or heavily chastised by the fire coral, then headed off to execute our dive plan. Before long, we were staring back toward the entrance from a sloping bottom about fifty feet deep. Directly in front of us were the much-discussed pillars. Two seemed to align with the entrance channel, where they stood in stark contrast to the sand-and-silt bottom from which they emerged. My usual cynicism about ancient underwater engineering feats was admittedly shaken in the presence of the columns.

Larry Nordby led a team, hammer and probe in hand, to core one of the columns while John Brooks, our team photographer, and I headed for the other. John swam ahead of me, camera in hand, positioning his strobe for a forelit silhouette shot. Hands full, he motioned with his chin for me to pose on the column for scale. I moved in close and shined my light in a way I hoped would look pleasing in a lecture slide while he flashed away. As I repositioned myself for another shot, I noticed that there was a place in the lettuce-leaf-like coral growth on the column through which I could insert my dive light.

After checking for morays and other creatures that punish divers for rude intrusions into their living rooms, I forced my head and shoulder into the declivity. On a whim, I turned off the light, held my

breath, and let my eyes adjust. In the next thirty seconds, well before our team had finished sinking the first core, I learned, without a shadow of a doubt, the true nature of the mysterious underwater columns of Nan Madol.

What convinced me so quickly were the cracks of blue light that appeared as soon as the silt had settled in front of my face mask. I was looking straight through the densest portion of the column. If it was basalt, I would have seen a black impenetrable mass of rock with coral growth at the edges. Instead, I was seeing streaks of blue light, overlapping in places. I was seeing through the column. One simply cannot see light through volcanic rock. By metaphorically sticking my head into the horse's mouth (not to count the teeth, but to take a picture), I had proved to my satisfaction the natural derivation of the columns. They were what the skeptics had suggested: natural coral formations.

Moments later, John and I swam by Larry and his team laboring with the probe. Our Micronesian trainees were busily absorbed in pounding a metal shaft through the column. These men, non-divers a week ago, were performing like they had been doing it all their lives.

Reaching the surface after the dive and mandatory bodysurf through the entrance channel, we regrouped to discuss our findings. The mystery of the columns had unlocked itself far quicker than we would have guessed. Larry Nordby, probe still in hand, tank on, sitting on rocks in shallow water, announced, "Coral! That stuff isn't coral-covered basalt, it's coral-covered coral." I agreed, telling him about my experiment with the light in the crevice.

The columns at Nan Madol aren't manmade, but their location defies easy explanation. Earlier in the week, John Brooks and Jim Bradford had found and photographed similar-looking coral features at a location far from Nan Madol. We knew from that experience that column formations occurred naturally in the area, but weren't sure if that's what the features were at the archeological site. Now that we had determined they were indeed coral, it was still intriguing that two of the comparatively rare features should just happen to line up with the entrance channel to one of the greatest marvels of prehistoric architecture in the Pacific.

Nan Madol is no less intriguing than ever, simply a little better understood. Archeologists are still making progress mapping the

complex and seem to be closer to providing explanations for many of the most compelling questions about the site: why, how, and where from? A similar architectural tradition exists in the island of Kosrae and seems to have preceded Nan Madol but is located in downtown Leluh (the island's principal village). This makes it more accessible yet visually harder to appreciate.

Our group was rightly proud of their accomplishment. They had cleared up a standing controversy on their first dives. We now knew that the columns were not man-made, but they are uniquely located. We wondered if they might be unintentional artifacts of human activity. Perhaps the building of the walls of Nan Madol caused brackish water to vent from inside the complex over a particular point where they stimulated abnormal coral growth. Regardless, our colleagues now understood that there was nothing a bit mystical about taking their archeological and historic preservation training underwater. No one would be selling them a bill of goods about their submerged heritage sites being incomprehensible and useless without the expertise of salvors—entrepreneurs who would be glad to harvest antiquities for them, and maybe even give them a percentage of what they already owned in payment.

Teddy John and Berlin Sigrah from Kosrae pointed out that the earliest human activity in the Carolines often seemed to involve gravitating toward megalithic architecture and some extraordinary feats of engineering. They reminded me of the clearing I had stood in with Vince Blaiyok in Palau studying the huge piece of Yap money. There is an apparent affinity for peoples of this part of Micronesia for large-scale construction that involves movement of massive, worked stone objects over many miles of ocean.

It was clear that these were the right men to be in charge of cultural resources on their islands. One successful dive was followed by hours of discussion about the nature and behavior of their ancestors. Soon there was even some heated debate. As Nordby helped me load one of the boats, he whispered out of the side of his mouth, "Betel nuts be damned, these guys are archeologists all right, they can't agree on anything."

My sons returned with a load of papayas purloined from the surrounding jungle, and the younger six-year-old was anxious to show me a technique he had been taught by his Micronesian hosts for start-

ing fire with hibiscus wood. His brother was too intrigued with the sketching done by Margaret Pepin-Donat, one of the Park Service team, to pay any mind to his sibling. Teddy John meanwhile bubbled with pride over the day's accomplishments. He was ready to finish in Pohnpei and take the team on to his home island of Kosrae to complete their training.

On the two-hour trip back to town I was the only casualty. I suffered a mild black eye from a stray flying fish that didn't quite clear our boat on his winged leap. We met up with Murphy and Bradford at the dock where they had returned from an even further haul down-island. They, and several Micronesian trainees, had been mapping in a remote harbor where oral and written history indicated the CSS *Shenandoah* had burned some Yankee whalers. This Confederate raider successfully terrorized the Pacific from the South Seas to Alaska. It was particularly notorious, however, for carrying the raiding not only to the end of the war but past it. Communications being what they were at the time, the raiders didn't know and, when told, refused to believe, that the Confederacy had surrendered at Appomatox.

In short, our team had been successful. They had located and mapped one and possibly part of another whaler that had been burned to the waterline. Teddy and the contingent from Pohnpei were ecstatic. They had indeed geometrically increased their knowledge of their island's submerged resource base with the day's work. After a day of breaking down equipment, we were off for Kosrae.

Some seven years later, we passed the information about the whalers to archeologists from the University of Hawaii. In association with the Pohnpei preservation office, they continued surveying the area of our find and located and documented the remaining whalers.

Kosrae

In Kosrae, we kept the momentum achieved in Pohnpei and at times surpassed it. The Micronesian officials had been trained to the point that they could seriously concentrate on performing tasks beyond simply surviving underwater. We trained them in our trilateration techniques and had them take the lead in mapping and photo-documenting a cluster of World War II wrecks in Lelu Harbor.

One need not search for too long in Lelu Harbor for traces of the war. Teddy John easily found the *Sunsang Maru*, a Japanese armed

transport in sixty feet of water that was taken out by American carrier-based bombers as they began their relentless sweep through the Carolines in 1943. The visibility was not much better than ten feet horizontally, but these conditions served well as a training site for our newly trained Micronesian dive team.

While part of the group set about mapping and videotaping the transport, others ventured out into the gloom with Teddy and me on search patterns to relocate other sites Teddy and his associates had stumbled upon since our 1981 visit. Utilizing search-line and compass patterns, we soon located another transport and a landing craft. Within two more days, we had a road map of white lines which could be followed from various points on the *Sunsang Maru* to the new sites—a silent testimony to the daily peril the Japanese lived under from U.S. air power as the war progressed. Included in the collection of World War II relics on the harbor murky bottom are two planes, reportedly casualties after the American occupation.

Although few Americans have ever heard of Kosrae, a 1959 film entitled *Up Periscope*, with James Garner took place there. *Up Periscope* centers on a commando raid from a submarine on a radio facility, remains of which are still on the island. The island was bypassed by the Allies in terms of any serious amphibious landing, but the raids on the radio tower and the constant harassment from air strikes that accounts for the wreckage in the harbor kept the Japanese guessing.

In the midst of searching various harbors and coves of the island, Teddy took us to a site that was truly mind-boggling. At one spot, which shall be left unnamed, was the remarkable remains of an early whaler. In stark contrast to the remnants of twentieth-century warfare this was a low-profile spread of fired bricks, copper sheathing, and cast iron try-pots. They are the unmistakable imprint of a wooden sailing ship engaged in the whaling trade. While half of the Santa Fe team worked with the Micronesians on documenting the larger World War II sites, the rest concentrated on the newly discovered whaler, which was an archeological gem.

The hull of the unknown whaler, although burned to the water-line, carried ballast and an entire complement of period artifacts. A rendering pot for whale blubber dominated the bow section, and keel pins from the stern deadrise marked the end of the after-part of the vessel. We realized that what we had first taken to be coiled hawser of some sort was actually a pile of iron hoops for making whale casks.

They had melted from the fire, which apparently sank the ship into a shape that resembled coils of rope.

Besides kiln bricks, animal bones, and wood, there were many brass fittings, some imprinted with the English "broad arrow." Did this ship in an earlier life have some connection with the British Admiralty? Why British naval markings on an obviously nonmilitary vessel? The historical records seemed to make a poor match—none of the known whaler losses at Kosrae fit the location and type of what we had found. When considered in concert with our finds at places like Biscayne, the ubiquitous broad arrows bring home the omnipresent nature of the former British Empire, upon which "the sun never set." Indeed, the evening we first found the whaler I recall watching the sun fall into the sea while pondering my realization that it was probably just then rising over the site of the HMS *Fowey* in Florida.

Among all the mystery and fascinating vestiges of the past that lay in the ever-present gloom of the harbors lurked a very different type of presence that had me more than a little bit concerned. Lion fish are common in this part of the Pacific, and they are known to inflict very serious wounds with their venomous spines. Usually, they are only a minor consideration because they are not aggressive. Also, they're highly visible and—as they swim imperiously about, never rushing, secure that their armament allows them to be contemptuous of the larger members of the food chain—they are easily avoided.

It was different on this wreck. The fish were unusually abundant, large, and hard to see in the silty water. My divers were running tape measures, drawing on slates, and generally doing things that took a lot of concentration. The slow-moving fish were curious, wanting to explore the areas disturbed by the mapping team.

At one point Jim Bradford looked up in time to see his partner, Joe Canepa, holding the dumb end of the measuring tape while Jim recorded distances, in a most precarious situation. He was floating head down and motionless, to avoid disturbing the silt—oblivious to the huge lion fish swimming between his legs. Jim did nothing to startle Joe into a reflexive movement that might have caused him to impale himself on the vicious spines. Instead, he slowly swam into Joe's range of vision, motioned him to freeze with a fist-extended gesture we heed religiously, and pointed to the source of danger. Keeping his torso motionless, Joe craned his neck to watch the large swimming

pincushion pass with maddening slowness, its jagged, venomous spikes mere centimeters from the vital area where Joe's legs joined. Joe then relaxed his rigid form, released a large column of bubbles from his lungs, and backed off to collect himself before continuing the dive.

Like an approaching car suddenly swerving into your lane, then correcting itself, some of the most serious brushes with serious injury and death come with no fanfare. A momentary shot of adrenaline, a distraction from the car radio for a few seconds, and a muttered curse—as if nothing really eventful has happened at all. With Joe, there had been no *Jaws*-like beating of drums, no rush of a predator; he would probably see the same fish many more times during the day and pay it no heed. Just a curious critter uncomfortably close that might have made him unequivocally dead.

Kosrae was still as magical as on our earlier visit. I was delighted to share this part of the world with my compatriots and family. We visited the site of Bully Hayes's ship and found it had changed little in twelve years. The outer reefs still teemed with fish and dropped off into deep blue depths where we could see giant groupers and sharks going about their predatory business a hundred feet below us. Air Micronesia now flew directly to the island. There were some paved roads and, we understood, satellite TV, although we never saw any. But Kosrae was luckily still not the Riviera.

We stayed at some of the best accommodations on the island, but even these were still quite humble by most U.S. standards. The hotel had a primitive charm, like everything else on this island. Our room even had an air conditioner. Unfortunately, the electricity was so tenuous that the machine surged all night. The constant revving and surging of the motor made us turn it off as a nuisance. We read by flashlights because the AC light bulbs were constantly dimming and flashing like Christmas lights. The boys played a game of leaving the outside walkway dark and flicking the lights on to startle the rats.

But, for the few inconveniences, the island was coming along reasonably well to our way of thinking. We couldn't pretend to understand what "progress" meant to the native Kosraen, but the trap of losing one's heritage to the pressing demands of the present didn't seem to be an issue there. They had a strong preservation office built by Teddy John that was growing in size and prestige and they lived in

a society that still had a sense of the past as being the foundation of the present.

Majuro

Teddy joined us as we left the island for the last part of our sweep, this time to the Republic of the Marshall Islands. SCRU had been here before, of course, but Bikini and Kwajalein were worlds unto themselves. We were headed for Majuro, which held the civilian capital of the Marshalls, and was the center for the workings of real Micronesian people, not military constructs.

Majuro is still heavily marked with the residues of war. We were hosted in Majuro by Dirk Spenneman, a professional archeologist from Australia working for the Marshall Islands government. His training was primarily on land sites, but he understood perfectly the importance of underwater resources for island nations. Surprisingly, this is not always the case with traditional land archeologists.

Majuro, like Bikini and Kwajalein, and unlike Pohnpei and Kosrae, is an atoll. Many miles long, it is extremely narrow. In many places you can throw a baseball the width of Majuro. On one side of the road it would fall in the protected lagoon and on the other, head to dark blue depths.

Beyond seeing the importance of the underwater sites, Spenneman had produced some excellent archeological treatises on aviation sites in the Republic, some of them underwater. He showed us the remains of a B-24, which we photographed and about which we heard an amazing oral history from Carmen Bigler, the Marshallese woman who was the Republic's historic preservation officer. Her family had tried to help the American crew of the plane, but they were captured by the Japanese, who occupied the island, and all were executed. These war sites were as intimately a part of these people's heritage as any prehistoric artifact, just a bit more recent. It reminded me of the story of Ralph Reyes, the superintendent of War in the Pacific NHP in Guam. The war was not so distant that he had forgotten the day his brother was beheaded by the Japanese.

Perhaps the most interesting site we explored and documented on Guam was not so much poignant as simply bizarre. We call it the Ejit Truck Dump. It is just that, a place where, like oddly shaped coral

heads, antique vehicles emerge from the white sand bottom in forty to sixty feet of water.

As the entire team swam by tow trucks, ambulances, cars, and general-purpose truck bodies, we felt we were in one of the strangest places we had ever seen. The vehicles were mainly of Japanese manufacture and had the headlights, shape, and general ambience of a prewar time warp. Nothing modern is on the bottom, just World War II rolling stock.

Nordby, who said nothing surprises him anymore after so many years with SCRU, just tied off to one truck on his way by and started running out #18 line. I wrote on my slate, "What are you doing?"

He wrote back, "Laying baseline."

"What for?"

"Aren't we going to map these suckers."

"Guess so."

"That's what for." He handed me back my slate, and we all resumed swimming to the next vehicle.

By the time we were back on shore, the team, with no prompting by me, had photographed and sketched about a third of the site. When we showed the results of our recon swim to Teddy and Dirk, I responded to the amazement in their faces. "What can I say? These guys are animals, mapping machines. Don't leave any women around, that's the only other thing that obsesses them." Teddy stamped his feet as he laughed. I believe that if I have ever seen anyone "in his glory," it was Teddy on this trip.

A few days later we said our goodbyes to Teddy. He headed back on the milk run to Kosrae, and we made our way back to Pearl Harbor.

As predicted, at the turn of the millennium, we have yet to return to Micronesia. The press of the huge survey mission in the parks and nationally significant sites in state and foreign waters combined with limited personnel have kept it high on our wish list, yet under the cut line of priorities. But we hope the effects of our last big sweep through the chain will hold, and the seeds of preservation we planted with Teddy and his colleagues will germinate and take root.

Teddy dreamed of a day that his fellow islanders would truly be able to take over the reins of protection for their own heritage and recognized, since we first met in 1981, how important the underwater part of that equation would be. He accompanied us through all of our 1992 expedition in Micronesia and personally dived on every site he could. His vision of a bright future for historic preservation in these islands was a living thing that spurred us on each day. This chapter is, in fact, dedicated to Teddy and the hope that his vision survives because Teddy has not. Teddy John died at 44 of a heart attack a few months after our return to Santa Fe.

CHAPTER TWENTY

SUNKEN LEGACY OF THE CONFEDERACY

A s the sea closed over the battered remnants of the Confederate raider CSS *Alabama* on June 19, 1864, the victorious federal warship USS *Kearsarge* and several civilian craft began to pick up survivors. The rescuers in some of the small boats spoke halting English but excellent French—not surprising since the battle took place within several miles of Cherbourg, France.

The not so "civil" war between the North and the South left a well-known trail of carnage across the Southern and border states and lesser-known skirmishes in the American West. Few except period historians are aware, however, of the saga of the Confederate commerce raiders that wreaked havoc on Union shipping from the Americas to Africa, Europe, and the western Pacific—the *Florida*, the *Shenandoah* (which kept on raiding even after war's end), and, the most successful of all, the *Alabama*.

Like many naval engagements, the dramatic episode off Cherbourg left a rich archeological record of an important period in American maritime history—in this case two-hundred feet under the treacherous waters of what the French refer to as *La Manche* and we call the English Channel. During the summer of 1993, three members of SCRU (Larry Murphy, John Brooks, and I) broke away from field projects at Dry Tortugas and Biscayne National Parks to spend several weeks diving with a French team on the *Alabama* site.

This followed three years after SCRU's involvement in another site in foreign waters that was high on the list of historic shipwrecks targeted by American preservationists: the U.S. Brig *Somers* sunk in

1846 during the Mexican-American War off Vera Cruz. In 1842, the *Somers* achieved special notoriety when, on a training cruise, the son of the incumbent Secretary of War was hanged for mutiny. Herman Melville's short novel *Billy Budd* was largely modeled on this incident. In command of the *Somers* at the time of its sinking was one Raphael Semmes. Eighteen years later, in an ironic twist of fate, he commanded another warship when it sank in foreign waters . . . the CSS *Alabama* off Cherbourg.

This special aspect of SCRU's mission, the recovery of U.S. heritage in foreign waters, had been greatly enhanced through a cooperative association we developed with the Naval Historical Center (NHC) in Washington, D.C. The center, under the leadership of Dean Allard and later Bill Dudley, had a specific mandate from the Navy and State Department to establish protocols with foreign nations aimed at reciprocal protection of sovereign vessels.

The U.S. Navy rarely relinquishes title to its own ships or those of the former Confederate States of America, regardless of where they may lie. The NHC has worked hard to locate and seek protection for the U.S. Naval heritage in foreign waters and offer the same protection to sovereign vessels of other nations in U.S. waters. SCRU, as the lead underwater archeological team in the federal government, was a natural ally to the NHC. The outreach we had already been pursuing to reclaim U.S. maritime heritage in the South Seas and remote territories had been kicked further into the international realm.

On the personal level, I had been chosen the year earlier as the U.S. representative to the International Committee of the Underwater Cultural Heritage of ICOMOS. This was and is a UNESCO-affiliated committee composed of professionals from around the world that developed standards of practice for underwater archeology. For SCRU it meant we had an excellent network to air NPS preservation philosophy in an international venue and to discuss ideas and strategies with a very impressive group of people committed to the same principles.

What a maritime spectacle the battle between the *Alabama* and *Kearsarge* had been. All of Cherbourg had turned out for the show. The bluffs above the shore were lined with carriages, women with umbrellas, gentlemen, gentlewomen, and spectators of all classes and

walks of life. A gauntlet had figuratively been thrown down by Semmes: You stay three miles out there, beyond French territorial waters, let me reprovision, and, in a few days, I'll come out and do battle. Captain Winslow of the USS *Kearsarge* just silently waited.

The French were impressed with the romance and gallantry of the whole episode, evident even now in the streets of Cherbourg, where some taverns still commemorate the battle. A painter by the name of Edouard Manet showed up and rested his easel, waiting to immortalize the confrontation. The *Kearsarge* had relentlessly tracked the Confederate raider so that, when it came time for the engagement, Winslow had a few surprises of his own for the wily Semmes. The disciplined Federals had prepared carefully for battle, with guns serviced and powder dry. Winslow even had them drape chain over the hull at midships and conceal this primitive armor coat with a wooden frame. The idea, and it proved to be a good one, was to absorb the impact of the *Alabama*'s iron shot. With the makeshift armor concealed behind wood, this was the equivalent of showing up for a sword fight while failing to mention you wore chain mail under your blouse.

The battle itself was worth the price of admission. Finally, with the Confederate ship experiencing some problems with the state of its ordnance, the fight went to the Union vessel. The raider sunk stern-first beneath the waves, and survivors were picked up by the *Kearsarge* and some privately owned French and English vessels.

Semmes and a number of others were snatched by a fellow named Lancaster, an Englishman, and not turned over to Winslow, the victor in the battle. This act became the basis of a major legal controversy that would rage for years.

The saga of Confederate commerce raiders was not entirely new to us because during our operations in Micronesia in 1992, we had located at least one of four Yankee whaling ships that the *Shenandoah* had reportedly captured and burned while terrorizing American shipping in the area. We knew of Semmes because of our work on the *Somers*, and we were interested in commerce raiding because of its historical and anthropological significance. Many naval historians maintain that the U.S. shipping industry never fully recovered the prominence it once held internationally after the years of devastating

raids on its commerce by the handful of raiders commissioned by the Confederacy.

We were interested also in commerce raiding because it was the core naval strategy opted for by the Germans in World War II, using submarines and pocket battleships and cruisers. When working at Bikini Atoll, we had stopped off each year at Kwajalein to conduct documentation dives on the *Prinz Eugen*, which had been the consort of the *Bismarck* and took part in sinking the revered HMS *Hood*.

So, beyond helping the Naval Historical Center assess the archeology being conducted on the *Alabama* site, we felt privileged to see firsthand a vessel that exemplified the whole concept of commerce raiding, a cultural behavior that we felt had been understudied. And the *Alabama* was perhaps the most successful raider in history; she took sixty-two prizes before she was sent to her own grave by the *Kearsarge*.

The French divers working on the site were from a well-established dive club, ASAM, that engaged in serious wreck diving. The archeologist in charge was Max Guerout, whose work we were there to assess for the Naval Historical Center in Washington. This was part of an arrangement the State Department and Navy had worked out with the French to protect American warships in foreign waters. Confederate ships had reverted to the U.S. Navy after the war.

This was an important test of cooperation on such sites. The French agreed that even though sunk in their territorial waters, this vessel was essentially a little piece of the United States. They recognized our claim to ownership, and we recognized their control of access. They could work on the site and remove materials for display in France as long as the materials never technically left U.S. ownership, and the U.S. Navy approved the soundness of their archeological approach.

Other U.S. archeologists had been there in this observer role but we were the first who had the deep diving expertise to actually accompany the French team underwater. I was happy that so far we could honestly say the French were doing a good job—we might have done some things differently but Guerout seemed responsible in his handling of the archeology, conservation, and recording requirements.

The French divers may have been "amateurs," but as in the

United States, the avocational diving community had some of the best divers for this sort of operation. SCRU had used avocational divers at Isle Royale and in certain cave-diving missions where depth and under-ceiling environments required a high level of skill, with only modest needs for expensive surface support facilities.

The ASAM divers were good, and they were very gracious to us as professionals from a federal agency who could have given them a hard time for not doing it the way a big commercial diving firm might have. They were confident in their abilities and easy to work with.

Auxiliary boats, rubber inflatables moored to the wreck site two-hundred feet below, bobbed wildly on the surging waves. They held support personnel and a large green gas cylinder that deployed oxygen through long hoses to an in-water decompression stage. The technique was almost identical to one we had used at Isle Royale, Bikini, and many other deep sites since 1975. It was June 1993, almost 129 years to the day of the *Alabama*'s sinking.

On the main dive boat, we sat with a tender holding us steady. Fully suited, two dive teams braced themselves clumsily along the port and starboard gunnels at the stern. With more than a hundred pounds of tanks on our backs, fins strapped to our feet, and wielding a variety of lights and cameras, we would not have lasted two seconds in a standing position without crashing into the gunnel or sprawling across the deck.

The plunge had to be executed with split-second timing. Even in water 48 degrees Fahrenheit, some of the divers chose not to wear gloves, given the need for dexterity to accomplish their particular tasks. I could tell by their white-knuckle grip on the recording slates and cameras that the adrenaline had begun doing its thing.

My forty-eight years in this vale of tears weighed heavily this day. Heaving about in three to four-foot seas, the two 100-cubic-foot air cylinders on my back lightened briefly as a wave crested beneath us. The steel tanks bore down mercilessly a second later as the boat pitched into a trough.

I began my usual reflection on the ineptitude and callousness of the boat operator, the support crew, my fellow divers, and God. From

prior experience, I knew their faults would somehow transform into virtues once I got off the damn boat and started heading down. Deep diving gear is definitely not designed to provide comfort or a sense of well-being, when employed as yachting wear.

A blare from the boat horn signaled us to lunge off the back deck and to drift the few meters to the surface buoys. The current was so strong here, I knew if John Brooks or I missed the lines attached to the buoys, we would be unable to swim back to them. Because there are four other divers also in the water heading down to the wreck, a support boat would not dare motor in to help us. They would be putting the others in the dive zone at risk.

This was a very tense business because, given current windows that permitted only one dive a day, as close to slack tide as possible, and limited facilities to safely decompress, missing a dive meant we lost one of a very limited number of opportunities to be on site. The window for descent closed quickly, and we or anyone else missing it would have to bob about in a two-or-three-foot-wind chop until a boat could be spared to leave the dive zone and pick us up.

We take any variable in diving seriously. Although all of us in SCRU have dived many combinations of depth, currents, cold, and under-ceilings, none of us were familiar with the specific combination of high currents and deep, cold water here. John had been diving the past week with Larry and had grown accustomed to it. I was taking Larry's place as archeological observer, and this was my first dive in such an environment. I was uneasy, particularly with the water entry-and-exit protocols.

Locomotion to the wreck site was by pulling oneself hand over hand down a descent line that runs from the buoys to a heavy clump of weights nestled in the wreckage field. The current was strongest in the shallowest water, decreasing to reasonable on the bottom during slack tide. I grabbed the descent line, looped my arm around it for extra purchase, and began pulling and kicking for the bottom. I felt my ears clear and glanced up to make sure John Brooks was progressing behind me. Burdened with the bulky video camera, he had more problems to overcome than I, but there was no practical way to assist him.

About 140 feet down, I started to make out something on the bottom. By 170 feet, the water was dim from lack of penetration of sun-

light but reasonably clear. Our artificial lights would be effective as long as the water wasn't turbid. Except for some plankton-like particulate matter floating by, the filming conditions were pretty good. Coarse bottom sediments, which dispersed quickly in the current, created a forgiving environment for visibility. We could momentarily be sloppy with our fin kicks without having to spend the rest of the dive in a cloud of fine murk.

As we settled to the bottom, my breathing rate perceptibly decreased. We were away from that frantic surface activity and, although deep, bottom conditions were favorable. The water was crisp and fresh against my face but not frigid. My bulky dry suit was a pain to don and to swim in through the current but now I began to reap its benefits. It kept me warm enough to relax so I could start to enjoy the narcotic glow provided by seven atmospheres of nitrogen when nothing is going wrong. That same high could quickly become a disconnected, anxiety-laden low if an emergency were to develop, but at this point it was simply a mild euphoria.

Oddly enough, I felt quite comfortable at the bottom of the English Channel; it was the top thirty feet or so that I dreaded. The fourteen to seventeen minutes maximum bottom-time that the French allowed themselves because of the depth would rush by too quickly before we had to deal with the difficulties of ascent and decompression.

The wreck was an extraordinary piece of the past. Returning to the current-laden surface waters and the mandatory thirty minutes in-water stop, followed by reboarding the heaving dive boat, were simply not fun. Twenty years earlier, I kind of liked being slammed around and showing my mettle; I realized I had become surprisingly low on mettle over the years.

As the dive progressed, I was swept up in the excitement of seeing the old warrior's bones. I gradually started orienting myself to objects I had seen on the site map the French had prepared for our pre-dive briefing. There was the Blakely gun lying next to its carriage. Various pieces of rigging and the outline of some hull structure started taking form in the gloom. There was nothing resembling the shape of a ship. Sand and shell hash were mounded against what had to be disarticulated structure, though much of the wood had been processed through the bodies of teredo worms.

I glanced at a current meter the French had placed on the bottom. We were supposedly at slack tide, and its wheel was still spinning; in that respect, it reminded me of the Columbia Bar during our exploration of the *Isabella*. Maximum velocity readings taken from the meter on other days indicated the water where we were swimming would, in a matter of an hour or so, be ripping along the bottom at four knots. A diver couldn't make his way against a one-knot current without becoming exhausted; four knots would rip the mask off his face if he turned his head sideways. La Manche, eh? A serious place to go underwater swimming.

The heavier metal components of the *Alabama* seem to have fared reasonably well and much of the wood was preserved where it was covered over with sediment. In a sense, the ship acted as a foil in the current and caused heavy deposition of particulates suspended in the water. Max told me he was actually thinking of using the violent current to excavate the ship by placing large deflectors on the bottom during slack tide. He admitted in response to our critique that control might suffer from such an approach but he had a point—using the current had some definite advantages over fighting it.

The *Alabama* was a spectacular piece of naval architecture standing upright as if on display in God's own museum. We came across a huge boiler and, toward the stern, the propulsion system and the unique mechanical device that allowed this steam/sailing vessel to retract its propeller. It was also a particularly interesting feature in a commerce raider: It could be lowered to maneuver quickly when pursuing prey or to engage in battle and to be withdrawn for hydrodynamic streamlining when crossing great reaches of ocean. Both features were particularly important in a ship that was expected to roam by itself for great distances and then sprint, to hunt down fast merchant ships.

It occurred to me, running my light over the rifled Blakely, sitting just off its carriage, that the armament was well chosen. The *Alabama* could hold its own in a running battle against a decent-sized warship; indeed it had sunk the USS *Hatteras* earlier in its career, but it wasn't overburdened with too many gun tubes that took up room and were useful only in standing slugfests. The ship was a lone wolf, and the captain had a personality to match. Older and wiser than when he went down years earlier with the *Somers*, in some ways, Semmes re-

minded me of a German U-boat captain. It must have taken a similar head set.

As the dive progressed, however, I found myself coming face to face with my own aging process. At depth, I usually enjoyed the advantage that experience grants older divers. I could feel smug as I watched younger and stronger men make those myriad little judgment mistakes to which I am not as prone—having already made most of them myself during a quarter century of mucking about in deep water. Depth was, in a sense, the great equalizer. Then, without breaking our pace over the bottom, I reflexively reached for my gauge console and brought it to my face for a routine check of elapsed time and remaining air pressure. I couldn't read it.

Although I needed, and regularly used, reading glasses, I didn't cotton to the idea of a bifocal dive mask. In most cases I could see my gauges well enough, once I played a little light on them. The fact that I could see things better far than near was about to cause one of the stranger and more frustrating diving problems I have encountered.

On my decompression computer, I could tell the numbers were there, but they wouldn't come into focus. We had done prep dives before going to France in a New Mexico lake, where I used the exact same equipment profile eight times in 220 feet of water. The only difference was that I had used a less powerful dive light during the workup dives back home. The latter allowed me to shine a low-intensity beam on the console so I could distinguish the depth reading on the liquid-crystal display—my far-sightedness wasn't as severe when I could get some illumination on the subject.

Unfortunately, the movie light I was carrying on this dive to help John secure video footage was extremely bright. In addition, we had jury-rigged a diffuser on the lamp head so it would provide an even, bright light everywhere the powerful flood beam touched—no dead spots when I needed one. When I trained any part of the beam on the meter, it totally wiped out the image on the display. This was a most curious problem—if I held the meter up in the ambient light, I had to get it so close to my face to read it that the numbers blurred. If I shined the light on it, the darned image disappeared for other reasons.

This was particularly bothersome because every minute was extremely precious on this dive. I had to learn as much as I could about the site, knowing I only had, at most, a half dozen opportunities last-

ing about fifteen minutes a piece to do so. Everything was going quite well except I had no idea how many minutes had passed. At two-hundred feet deep, elapsed time is not one of those things about which one can afford to be lackadaisical.

I continued making observations and lighting features for John, but I started to lose my concentration because I knew we must be getting close to our maximum bottom time. Since John was busy with the camera, it really was supposed to be me who carefully monitored the duration of the dive. The narcosis was not debilitating, but a person simply isn't thinking quite as clearly with that much nitrogen massaging his frontal lobes. I had to figure a way to alert John to this problem.

Finally I banged him in the elbow with my light. When he turned toward me, I held my gauge up. He stared at it carefully, then back at me, a question mark written all over his face. There was nothing indicated on my readouts that was particularly noteworthy. I put the movie light between my legs and pointed again to my gauge, raised my right hand in an okay signal and extended each finger as if counting. I was trying to ask him if we were within time limits and perhaps get him to flash me with his fingers the number of minutes that had passed. He gave me a very emphatic okay signal in return and started kicking over to the next object to be filmed. I knew from the enthusiastic way he returned my signal that he completely misunderstood it.

John is a "shooter." He shoots film and is good at it. Shooters don't like to leave a place as long as there's film and light. His return okay signal didn't mean "Yes, we're still okay on time." He thought I should be able to see that. It meant, "Right on, I agree, all systems are cooking, so let's push this dive to the very limit of our safety margin." I followed, resigned to the fact that John had better be tracking time because I sure as heck couldn't.

As we continued the dive, I dealt with the fact I couldn't read my gauges by pointing toward the timer John was wearing every thirty to sixty seconds. He must have thought I was suffering a bout of early senility, but I preferred that to his thinking I was carefully monitoring our time. This let me concentrate on the wreck. I kept training the light on features—ones that I wanted John to video for archeological purposes or ones he had picked for pure visual effect.

Finally, John glanced down at his gauges, then back at me and

shrugged. I knew what that meant; we were at our limit for the dive, and he was reluctantly suggesting we leave. I gave him a thumbs-up signal to start heading for the ascent line. Now we had to face that gruesome surfacing protocol. The magic was over for the day, the rest would be work. We respected the ASAM divers, but we all (John, Larry, and I) had one quibble with their approach to the operation. They had a curious way of staging decompression. It involved running pure oxygen down through hoses from the dinghies to a depth of seven meters (good), and having four divers breathe from a flimsy manifold with hardly anything to hold onto (not good).

When everyone arrived at the decompression stage, we were greeted by a hose near our ascent line that led to a manifold. The manifold had an array of four regulator mouthpieces dangling from a contraption that resembled the spokes in a wheel. Each diver placed one in his mouth and commenced to take in pure oxygen, which, for reasons discussed earlier, is much better than air for decompression. Herein was the problem—there was nothing substantial to grasp for stability. So we hung on by our teeth while the current extended us out like flags flapping in the breeze. Then, when we were all in this uncomfortable position, the head of the dive team signaled the small boat operator above. He cast loose from the mooring, and the boat began drifting about the same rate as the divers, still dangling below by our mouths.

This was good because we were no longer flapping and straining our dental work. The down side was we were now decompressing twenty-five feet below a rubber boat, still hanging by our teeth (albeit with less strain), as we coursed with the current through the English Channel. If we let go for some reason and lost the stage, we couldn't surface until we had finished decompressing from air left in our tanks. By that time, we might be halfway to Ireland. Again, these fellows were quite competent and we felt that when in Cherbourg, do as the Cherbourgians do. However, this procedure made it feel like we were paying penance at the end of each fascinating dive on the *Alabama* for the privilege of being on the bottom. It was worth the price.

What a marvelous wreck site this was. During the first dive and the four others I had on the *Alabama* (with a magnifying lens glued inside my face mask), it spoke to me quite clearly. It was very different from the overpowering grip of the *Arizona* in Pearl Harbor. Although

twenty-six men had died on this vessel, there wasn't the crushing effect of knowing you were swimming among the remains of a thousand young men who had died hardly knowing what had happened to them. This ship had a seasoned crew of marauders and a skipper with a lot of panache, gallantly taking on another ship in the equivalent of a duel on land. This wasn't a tragedy; it was the scene of a fair fight with two willing sluggers. One lay vanquished around us on the bottom—I felt the presence of battle, not faceless annihilation.

On my last dive to the site, I was the only archeologist present when the dredge skillfully manufactured by the fellows at ASAM finally started working properly. I was lucky to be present when the first real excavation commenced on the site after years of preparation and removal of surface artifacts. Within seconds, the silt level beneath the wire grid installed by the French for precise recording of artifact distribution began to lower. Gradually, artifacts started to emerge from the sediment. There were copper coins with the denomination of forty (probably from a Brazilian port of call) and numerous delicate pieces of porcelain. I was drafted by the lead French diver to make choices, as an archeologist rather than as an observer. I pointed to a sample of material in the grid that I believed would give Max the most information while incurring the least conservation headaches. To say that coins and expensive china emerging from the sediments leaves me unfazed would be silly; this was my most memorable dive on the ship, and also the most revealing. Having just scratched the surface in one small area of a huge field of wreckage, I could say with confidence this site would be extraordinarily rich, not in coins and bullion, but in history. A thousand ideas began rushing through my head: questions regarding the battle and general questions about commerce raiders in an anthropological sense—all questions that could eventually be answered on this site. There are times when I envy those who can focus their energies on excavation. On occasion, I resent just a bit the urgency of SCRU's mission to locate and protect history underwater, which often precludes our becoming encumbered with major digging operations.

The items we removed from the *Alabama* are now preserved and being prepared for public display. Another piece of larger porcelain found on an earlier dive was to become a major conservation challenge for the French: a commode. An amazingly ornate ship's toilet,

the inside of the bowl was beautifully painted, seeming more like punch bowl than a toilet bowl. It was a multi-composite object— porcelain, copper, and iron plumbing attached plus layered wood— that would present special problems to conservators of ancient artifacts.

But this object was successfully stabilized and, I understand, is presently on display in a French museum. The group also successfully accomplished the removal and preservation of the large naval gun, the Blakely that we had seen on our first dive. Slowly but surely, the remains of a ship and a spectacular event in maritime history are returning to the light of day.

At this point, the *Alabama* is still being slowly excavated by French and U.S. divers. Work has progressed slowly with the vagaries of funding, politics, and turnover in archeologists. More important, it is being done correctly. This is not a site subject to the whims of the chance explorer; it is a major piece of the international cultural heritage.

More time on the bottom isn't going to hurt the *Alabama* significantly, but rushing the job will. This is one of those things best left to the ponderous processes of government agencies. Preserving what is removed from the site involves both an immediate and then an indefinite commitment to funding. It's owned by the public, and it will take public will to provide the resources to support its excavation and preservation. So let the wheels of preservation turn slowly, as long as they turn surely.

Meanwhile, I sometimes stare at a cheap calendar print of two ships doing battle tacked up in my study. It's by that Manet fellow, and it takes me back to a place in France. A place where I learned just a little more about touching the past—and, as I adjust my glasses writing these words, just a little more about myself.

And what of the irrepressible Raphael Semmes? The master of the *Somers*, captain of the *Alabama*, the heart of controversy internationally, the hero of the Confederacy, who was, with great effort, rescued and spirited back through Mexico and then Texas to take up residence in Mobile and live his remaining days basking in the admiration of his neighbors? The man who couldn't be caught or killed by the concerted efforts of the U.S. Navy nor suffer postwar prosecution by those who still considered him a pirate in the reunited nation?

Raphael Semmes met his demise at the age of sixty-eight from the ravages of a shrimp dinner. He died near Mobile in 1877, of ptomaine poisoning.

Three years after our work on the *Alabama*, we became involved with another vessel that has become an icon of Confederate naval history. In 1996, again at the behest of the Naval Historical Center, I held a dredge to the muck covering the cylindrical predecessor of the modern submarine, the *HL Hunley* on the bottom of Charleston Harbor. It's a strange individual who can uncover the past and not think about what it must have been like. Imagine these men, sitting side by side with their mates, staring in semi-darkness at the cold, hard texture of iron boiler plating just inches from their faces; their eyes burning from perspiration; their breathing labored from sharing an iron tube of coffin-like dimensions with eight others. The aches in their arms from muscling the crankshaft through another rotation had become a friend—at least a touchstone to some reality—some truth beyond fear and the sound of water swishing past the iron skin.

These men were volunteers, not galley slaves. One can only assume the thought of being a hero to the Confederate States of America motivated them to serve as the fleshly engine of the *Hunley*. What is particularly revealing about their level of commitment is that they took this mission in full knowledge that two entire crews had drowned during trial runs.

From the resounding "thunk," they were aware they had succeeded in leaving the spar torpedo in the wooden hull of a ship. Then they reversed arm motion and cranked wildly, attempting to back far enough away that the detonator cord could be pulled. The sounds of their labored breathing was joined by the loud pings of musket balls careening off the *Hunley*'s hatches, only a few inches under the surface. Then the shock wave of the detonation slammed them into the metal skin of their sub.

These men had carried out the first successful attack by a submarine on an enemy ship. The USS *Housatonic* buckled from the explosion of the torpedo left in her side and sank to the bottom of Charleston's outer harbor. The *Hunley* was never heard from until

131 years later, when Ralph Wilbanks, Harry Pecorelli, and Wes Hall, a team of archeologists from NUMA (National Underwater and Marine Agency) financed by novelist Clive Cussler, located the prototype sub, a prize for which they had searched long and hard. Cussler's decision to share *Hunley* with the American public without concern for personal reward stands as one of the more honorable dispositions of a significant find by a private organiztion in maritime archeological history. The NHC and the state of South Carolina requested the help of the SCRU team to confirm the find, assess its condition, and recommend options for treatment, including whether or not an attempt should be made to raise it.

From the boat to arms' length from the thirty-foot-deep bottom, you could actually see several feet, enough to tell there were other divers, even identify them. On the very bottom, the silty sand seemed homogenous, with no indication of anything buried in the area. We began digging, following only blind faith in our sensing instruments. Once the dredge had begun pumping, it was darker than the inside of a cow and all progress was by feel.

The dredge was a standard injection-type device. Water from a surface pump forced water drafted from the ocean back down a fire hose at high pressure. The water passed through an elbow joint, creating suction in a four-inch-diameter inlet nozzle the diver held in his hand. First on the dredge head, I lay flat with the exhaust hose played out behind me and the iron elbow rumbling and bouncing in my hand as I held it near a marker we had placed in an area defined by our magnetometer hits.

For some reason, a slurry of jellyfish two feet thick covered the bottom like the dregs of a strange Charleston Harbor soup. The vulnerable points on our bodies were the areas not covered by wet suit and hood: exposed lower cheeks and lips, particularly the lips. Even liberal applications of Vaseline, or pantyhose face masks were of little avail against the jellyfish. Even if dismembered by the dredge, their nematocysts kept stinging us. Each diver felt like they had been kissing the exhaust pipe of a car for an hour after their dive. One of our people, particularly sensitive to the jellyfish nematocysts would sport swollen lips to bed each night. They'd be normal after waking, at least till the first morning dive. From Fran, on the other end of the phone in Santa Fe, no questions, just one beat of silence and an extended

"Okaaay" in response to our frantic request for next-day air delivery of a dozen pair of panty hose and an industrial-size jar of Vaseline—clearly, she didn't want to know.

Currents were high, visibility low, and jellyfish thick. Upside down in the test hole, the dredge tended to suck up my gauge console and even pull the regulator out of jellyfish-numbed mouths. Through it all I felt a combination of emotions that has become standard with me: a blend of "Why am I here?" and "Damn, what a privilege it is to be here." Once the hassles associated with getting into the water and dragging a dredge head to the site are over, once I've adjusted to the cold and accepted the jellyfish as just part of the ambient discomfort quotient, once I've ascertained that the sucky-up nozzle is performing and have forcefully reclaimed my own gear appendages it has indiscriminately vacuumed—then comes the point I get to absorb the fact that I'm truly traveling through time.

The metal object I clanked against moments before, and was laboriously uncovering, was an undisputed icon of American history. The encrusted iron tube was a treasure beyond gold or silver—a direct link with the past. I stopped the dredge when I felt my faceplate rap against the sub's snorkel box. Hoping I could see it, I held a million-candlepower light next to my head—I saw very bright silt and a faint glimpse of black metal.

"You crazy bastards! You marvelous, magnificent fools! You did it, did you know that? Are you still in there? I'd give most of what I own to treat you all to a beer and hear your story." There are times when this job is not only exciting, it's downright metaphysical.

We uncovered and documented, then backfilled the *Hunley* in 1996. Our recommendations were to lift the vessel intact in its bed of sediments and remove it to a conservation tank or lab for detailed examination and preservation.

At this writing, the *Hunley* has been in a lab in Charleston for a year. Although its recovery was very much a SCRU story, it is one with which I had minimal personal involvement and would best be told by those who did. In 1999, Dave Conlin and Brett Seymour from SCRU, working with NHC head of archeology Bob Neyland, finished surveying the area around the *Hunley*, including the site of the *Housatonic*. As Dave maintains: "These aren't two sites, they are all part of one battlefield," and that's how he treated it archeologically.

Dave's archeological analysis of the remains of the *Housatonic* stands as a testament to what can be done by a team dedicated to heritage preservation rather than artifact harvesting for profit. Most of the Union warship lies under meters of mud in zero visibility water in open ocean conditions with high currents. After a month of diving he was able to compile a 250-page scientific report that precisely delineated the size and shape of the site, confirmed its identity, determined the state of preservation of the artifacts, and obtained samples for museum display. In doing all this he disturbed only 4 percent of the surface area of the site and removed the equivalent of two grocery bags full of artifacts. This surgical intrusion into an important shipwreck in difficult conditions perpetuates the respectful manner in which SCRU has handled history under the sea for a quarter century.

In June 2000, Dave was also archeological field director for the raising of the *Hunley*, with Matt Russell and Claire Peachey as his assistants and Brett Seymour as chief underwater photographer, all from SCRU. Bob Neyland from NHC was overall project director, coordinating between the different federal and state agencies involved and the engineering firm contracted to rig the lift. The operation largely followed the recommendations made in our report from the 1996 work that Larry and I, and Chris Amer from the South Carolina Institute of Archaeology and Anthropology, directed.

Of perhaps greatest significance for SCRU was the absence of Larry and me at the time of the *Hunley* raising. Dave, Matt, Brett (and Adriane Askins, whom we had assigned to a different project) were the new faces in SCRU. The young lions we had hired in 1993 to groom for running projects and carrying SCRU into the new millennium had just done an extraordinary job.

RETURN TO THE TORTUGAS

From 1993 to 1997, SCRU returned to the Dry Tortugas with a vengeance. We had shied away from large block surveys of underwater resources for the first thirteen years of SCRU's existence because we simply couldn't justify the expense for the returns. We went back to the Tortugas in 1985 to video-document known sites in the park. With the help of the Navy and Larry Nordby, we returned in 1990 to map a large metal windjammer site. We did the latter in order to create a plastic underwater trail guide to encourage visitor use of the site, thereby taking pressure off more delicate wrecks.

But comprehensive survey? No way, that was one job we weren't going to tackle with expensive, labor-intensive systems that did it half-right. Or worse, with cheap, labor-intensive systems that left us with incomplete information, inappropriate for use in a cumulative scientific data base. It wasn't only the Tortugas that we were neglecting in this manner. Many other parks ultimately required such inventories. But we were adamant that the place where we would perfect our survey approach would be the place where we had failed so miserably in 1974.

Since then, we've conducted large-area surveys only when there was an established threat, as at Biscayne in 1980, or at Point Reyes in 1982. In that case, the survey block contained the oldest shipwreck on the West Coast, the 1595 *San Agustín*. Even that project had frustrating results of a different nature. We surveyed Drake's Bay at Point Reyes in 1982, using the microwave positioning system similar to that

described in our work at Biscayne. Before we had a chance to dig for the anomalies located with our magnetometer, a salvage claim was made on the site by a treasure hunter—this plunged the park into ten years of litigation.

It is my opinion that the man hadn't a clue where the site was, except for the possible location determined by our survey effort. I had been foolish enough to share information with him because he claimed to be an archeologist not interested in selling antiquities. But that didn't stop the courts from ponderously entangling the area in a web of legalities that was too time-consuming for us to deal with. Eventually the salvage claim would go away, but we were reinforced in our conviction that surveying large areas for shipwrecks was not a winning proposition unless you had the technology and the legalities totally under control.

It is important to understand a distinction here. Locating a specific wreck in certain given areas, such as a treasure galleon off the Keys, is magnitudes more simple than conducting a scientific survey of all the submerged lands in an area. In the latter endeavor, one determines where all shipwrecks are and evaluates them scientifically and develops long-range plans to manage them as a resource for the public good. Such a survey also determines where shipwrecks aren't— this is very important for establishing visitor use patterns, and accommodating public works projects such as dredging, and building park facilities without hurting fragile resources.

We knew from historic records and common sense that places like Biscayne, Cape Cod, Sandy Hook in New Jersey, Fire Island in New York, Assateague in Virginia, and Padre Island in Texas, all had great potential for historic shipwreck finds. But we chose not to pursue block surveys for new sites until the technology changed enough to make the effort worthwhile. In 1992 the NPS released a special block of money for advancing archeological inventory of park lands, including 10 percent of the $1.5 million fund to be applied to submerged sites.

It was also about this time that the benefits of the technological advances in Global Positioning Systems (GPS), largely spurred by the Gulf War, started to become available to civilian researchers. Heretofore, we had found global positioning full of promise, but just short of practical in its civilian nonclassified form, for conducting surveys.

Part of the problem was that it didn't update positions fast enough. Also there were places and times of day when there weren't enough satellites in the heavens to obtain precise enough positions. Lastly, the military was purposely dithering the coded signals so that a potential enemy couldn't take advantage of U.S. technology to attack U.S. targets.

The chief tools needed to creditably survey an area for historic wrecks in a manner that is cumulative and complete is a magnetometer that locates iron and a side-scan sonar that images everything extruding from the bottom sediments in a photographic-type printout using sound waves. These tools are only useful, however, if you can re-create the location of the search vessel for the whole time of the survey. The positioning and the interface of positioning with the data from the search tools were the key weaknesses corrected by the marine industry in 1992.

There were no ready-made packages that configured all of these instruments in the manner we desired. But we had by this time credibility with enough people in the industry to garner support as we began building the maximum shipwreck survey system. We hired geodesist Tim Smith, a new type of employee for SCRU, and we contracted with physicist Steve Shope of U.S. Positioning to help us put together the survey package of our dreams.

What they came up with made front-page industry news in *GPS World*, *Sea Technology*, and *Geo Info Systems* magazines for several years—an underwater archeological data acquisition platform (ADAP). Given rock-bottom prices from instrument suppliers interested in seeing new applications developed and new survey monies from the Park Service, the new system was operating by 1993 in Biscayne and Dry Tortugas.

Simply put, the ADAP, when installed on a twenty-five to thirty-foot park patrol boat, made it the near-shore equivalent of a multi-million-dollar hydrographic survey vessel. It could collect magnetic data, depth, and side-scan information and interface it with positional data, accurate to plus or minus two meters, every second. These were real-world positions (actual UTM or Lat Long coordinates) gathered in real-time (as the survey progressed minute to minute, rather than having to be mathematically reconstructed later). An onboard computer stored the data at a rate of 3,600 points an hour. Each precisely

positioned point had associated with it magnetic and bathymetric data.

To top off what was an immensely powerful tool already, Murphy, in association with our young hires, discovered a new application for an existing piece of hardware called a RoxAnn. This instrument is a signal processor that uses sonar returns to classify the nature of the bottom for commercial fishing purposes. In Murphy's hands, it soon became a powerful survey tool. Sand, coral, rock, mud, or sea grass was noted for every single one of the 3,600 points collected every hour. All of the data were gathered in formats compatible for use in Geographical Information Systems (GIS).

To comprehend the power of this system, visualize the first superintendent who sat down to look at the post-plot of two days of boat operation at Dry Tortugas. The computer screen displayed a tightly positioned block of seabed a half mile in width and two miles long. At the strike of a key, it color-coded the entire block, showing the presence of coral, grasses, or sand, classifying the bottom beyond the accuracy of any existing hydrographic survey. Another keystroke and bathymetric contour lines covered the block. Then the location of any magnetic anomaly was overlaid on the other data. Within weeks of the original survey, we had input underwater photographs, drawings, and descriptors of every anomaly in the two square miles.

"What's that purple dot there signify, the one next to the stand of turtle grass?"

"Click on it and see."

"Wow, an old anchor. Nice photograph. Any drawings?"

"Click on the box with the pencil icon."

"Wow, measurements and everything. This is incredible!"

"Yes, FM is what it is."

"FM? What's that mean?"

"Fairly Magnificent."

I put Murphy in charge of the development of this package in 1992, as soon as he returned from the Micronesian sweep, described earlier. Aside from occasional forays to other parks for small projects, Larry burrowed into Fort Jefferson and ran the Tortugas survey like a man possessed. On a visit to the park in 1995, I found him in a converted powder magazine, deep in the fort, cigar in mouth, glass of Stoli's in hand, tapping away at his computer at two in the morning.

Matt Russell, Brett Seymour, Tim Smith, Adriane Askins, and Dave Conlin, the new generation of SCRU, had just retired to their bunks. They were infected by Larry's enthusiasm and worked tirelessly to hammer that survey system into existence and make it prove its worth with products. And produce it did.

"Thirty square miles already, man." Larry put down his vodka and chucked his thumb toward the general direction of the water. "And I mean it's surveyed to a gnat's ass." In Murphy's technical jargon, that meant they knew everything about that thirty square miles of the Tortugas and knew it precisely.

This was not entirely a figurative claim. If one were to drop a gnat's ass in a small medicine vial, seal it, tie the vial to a lead weight, and drop it anyplace in that thirty square miles, we could relocate it in the time it takes a fast patrol boat to get there. This was a far cry from the quality of offshore data that existed in 1974, when we found it impossible to locate again entire shipwrecks plotted by others, or even ourselves, in the maze of coral and sand reef flats.

The product of their work set a new international standard for shipwreck survey. Its applications are seemingly endless. Foreign governments have become extremely interested in the system. Larry and Matt helped the government of Mexico (INAH) develop an ADAP and trained its personnel to use it.

When the information, all collected, compatible for geographical information systems (GIS), is shown to me (and Larry will show it endlessly), I find it overwhelming in both its scientific potential and in a personal, emotional sense.

Seeing those gigabytes of data wash over a computer screen in layers of Technicolor majesty brings a certain closure to a quarter century of commitment. In the grand scheme of things, it's a very humble accomplishment. But that little piece of the world we chose to take care of is a little bit safer, and that's enough for me.

CHAPTER TWENTY-TWO

PEARL 2001: THE ADVENTURE
CONTINUES

J une 10, 2001. That odor of fuel oil that so imprinted itself in my
memory during my first dives in Pearl Harbor is particularly
strong this day. We are diving from a Navy launch tied to one of
the original quays that held mooring lines from the *Arizona* the day it
was attacked. Though freshly painted, the quay still shows clearly the
pockmark strafing scars from Japanese planes, spatters of smaller
nicks from the 7.7-mm machine guns, and fist-sized dents from the
20-mm cannon.

We are seeing the site from a perspective I never had in prior
years when we deployed from the floating dock at the Memorial. We
are downwind from the prevailing northeast zephyrs, so the oil is
being pushed toward us. Before entering, we splash our fins in the
water to create an oil-free entry hole through the rainbow film. From
there, we proceed to the ship submerged to avoid catching up the vis-
cous fluid in our hair or regulators.

Dave Conlin accompanies me on the dive, his first on the *Arizona*.
Matt and Brett are deploying from the floating dock, nearby but out
of sight. They, however, are veterans at diving the ship in this latest
round of research projects. A new superintendent has sought our help
much as Gary Cummins did in the early 1980s. Kathy Billings, a park
manager with a strong sense of responsibility toward resources under
her purview, called me in 1996 to ask, "Why has it been so long since
you've worked on the *Arizona*?"

"It's been awhile since we've been asked."

"Consider yourself asked."

So here we are. Kathy has herself become an old hand at diving

269

the *Arizona*. Like Cummins and Bill Dickinson before her, she is definitely of the hands-on persuasion and keeps us hopping with her concerns about what's happening to the ship.

This year's project has become a very high-profile operation. It's not just that this is the sixtieth commemoration of the Pearl Harbor attack. The Disney Corporation decided to do a Hollywood extravaganza and National Geographic came out simultaneously with a television documentary and magazine article. Now the History and Discovery Channels are here working on documentaries of their own. Brett is shooting all the underwater footage to be used in the latter two films and the producers are thrilled with what he's getting. We regard the hoopla with mixed feelings. It can be a serious distraction, but partnering with media is the most effective way to help us inform the public about what we're doing and about potential problems with their heritage.

Dave and I settle down on the stern, and I signal him to watch the place we had first seen oil dribbling up years before. A marble-size globule emerges from the bowels of the ship. Shimmering black, it rocks to and fro gently, stirred by some invisible force. As it makes its way slowly upward, it passes inches from my face mask. Two smaller globs follow, then four or five more, like a covey of lazy quail stirred by a hunter. Oil leaking from the bunkers of *Arizona* is still sentimentally interpreted as tears of sorrow or as blood seeping from the ship's wounds. The little black bubbles burst at the surface and spread to form a rainbow sheen—still a favorite target for thousands of cameras clutched in the hands of visitors to the Memorial each day.

This decades-long display has intrigued me since my first visit in 1983. We are at the "oil hatch" as we called it back then. In 2001, we call it "one of" the oil hatches, since there are a multitude of what was unique eighteen years earlier. Not surprisingly, added to the sentimental interpretations, there are now some less tender associations ascribed to the oil, particularly amongst those sensitive to the fragility of the aquatic environment. Personally, I find physical contact with "Bunker C" distinctly unpleasant. Only liberal applications of baby oil seem effective for removing it from skin or hair. I'm convinced something in the chemical content of this fuel affects my nervous system. I get irrationally irritable when exposed to it for any length of time.

Our dives these days are largely directed at dealing with the por-

tent of this oil. Be it tears, blood, or petroleum, there's simply too much of it to ignore. What's happening to the great steel hulk that we so laboriously mapped and photographed in the early 1980s? What about those 1.5 million gallons of Bunker C, now a viscous sludge, that was present in the ship at the time of the attack? Some obviously dispersed into the water from ruptured bunkers after the huge explosion rent the forward part of the hull. There its presence was captured in film—celluloid memories that have become an American archetype: black-and-white photographs of nineteen-year-old sailors being dragged from the harbor by shipmates, boys and men covered in an evil, black slime.

Some of the oil, probably a whole lot of it, is still there. It seems to have seeped and oozed along the overheads of the myriad compartments in the ship like lymph through the tissue planes of the body. Its point of origin is the huge and complex array of bunkers or tanks that line both sides of the hull.

We do know that there are eight sources of oil emerging from the ship where there had been one and that the overall amount is significantly greater at times. We have measured the oil coming from the old source (around two liters per day), but the new leaks are in places where it is too difficult to capture and quantify.

Somehow in the collective memory of the military and as a result of some sort of mystical calculations, there is an estimate of 250,000 gallons of oil still in the ship. How do we know this figure is correct? We don't. This is the same collective memory that forgot the forward turret was there and that ordnance for the five-inch guns is spread around the deck below the Memorial walkway. We do know that a leak of a thousand gallons released at once into Pearl Harbor would be awful, a couple hundred thousand gallons, unthinkable.

Larry, Matt, and Dave must now balance preservation with ecology, and it's a tough problem. Gone are our self-imposed restrictions on entering the vessel. We know the problems we are facing regarding oil, metal corrosion, effect of biological growth on the wreck, and structural integrity—these can't be answered by focusing on the exterior. These are inside questions.

Still the *Arizona* is a shrine where 1,177 men have died and the remains of almost a thousand are still entombed; hence we still avoid penetration by divers. Instead, we send in extensions of our eyes in

the form of tiny robots tethered to surface TV screens. Our old friend Emory Kristof has put us in touch with VideoRay, a company that manufactures and leases exceptionally sophisticated little ROVs. They let us know what's happening inside without us having to enter. It's also a lot safer—the *Arizona* has not withstood particularly well the ravages of seawater and time. This use of remotely operated vehicles for penetration ordinarily goes against my instincts as a diver, but here it feels entirely appropriate—one must have a really compelling reason to muck about inside an American icon, and we still don't think the mission requires it.

It's interesting for me to listen to Larry and the lads agonizing over these issues. They debate research strategies and question each other rigorously on the social or historical benefits of taking each step. Do the ends justify the means? Are there sufficient returns to justify each impact to the site? So on and so forth. Kathy Billings is the ultimate decisionmaker, and she works well with the team as they bounce ideas and suggestions off her.

After our dives Dave and I move to the little command center for the ROV on the Memorial. Matt stands in the room, water dripping from his face and wet suit, the latter stripped carelessly to waist level. "What did we find in those aft compartments?" He has been tending the cable in-water. Having assigned the job to another, he is now able to see some of the results of the ROV's last foray into the ship. Dave, now dry and back in uniform, has been monitoring the location of the vehicle and the various instrument outputs. He is about to pause the operation so that Matt can review the tape when he is interrupted by Bob Christ, who is piloting the VideoRay: "All Stop!"

"We're hung up again." Dave speaks into the microphone, "Slack three meters, Brendan, slack three."

"Roger that, slack three," echoes back electronically from the diver tending the cable on deck. He is speaking through wireless coms back to a receiver we have deployed just beneath the Memorial.

After some deft maneuvering on the joystick, Bob tells Dave to have Brendan bring in the cable three meters. "In three" comes the response from below.

"Yeah, okay, we're free," from Bob. "Where to now?"

Matt and Dave consult the as-built plans Brett has incorporated into a program in the laptop computer nestled between first aid boxes

on the table. The room we're in serves as a first aid station and all-around utility room—it is about the size of a family bathroom with some of the same lived-in atmosphere derived from weeks of wet feet entering and no ventilation. As usual, if there is an accident involving any of the 5,000 visitors shuttled out here from the visitor center each day, we are expected to halt operations, switch hats, and help the interpretive ranger on the Memorial deal with the emergency.

"Head aft, Bob."

This from Matt, after a short palaver with Dave. We are inventorying the second deck for sediment deposition, depth of oil on overheads, and general physical integrity of the metal bulkheads. The research problems are as complex as they are significant. Many other nations are just becoming aware of similar problems, and with the exposure our work has been generating from media our web site is full of inquiries. "Greetings, I manage many shipwrecks in Truk Lagoon." Or "Here in Australia we have such and such." Or "The warships in Scapa Flow present a similar conundrum."

"Damn, look at that!" Bob interjects. Having fixated for days on getting measurements, correcting problems with the pH meter, repairing drill heads that aren't making sufficient contact for corrosion potential sensors—one falls into the mode of seeing the ship in a clinical light. Suddenly, while moving methodically from compartment to compartment, with its little mechanical claw full of sensors, the ROV has stopped dead, the operator seemingly paralyzed by the image clearly displayed on the monitor. It's an ordinary enough scene on the surface but here it makes the hair stand up on my neck. The Video-Ray has entered a closet, or "hanging locker," in Navy parlance. It is sending back a signal that reconstitutes on the screen as an officer's dress jacket, still neatly arranged on its hangar where it was placed sixty years earlier, probably on the night of December 6, 1941. A wispy brown veil of . . . of something, delicately covers the jacket and drapes eerily from several empty wire hangars behind it. The jacket has an epaulet on the right shoulder but we can't make out the insignia without removing the underwater equivalent of cobwebs. We don't. We're not here for that.

As the robot moves on and the drone of cable directions and scientific measurements resume, the observers are silent. Dave pauses, glances back at Matt, and says, "Whew."

A slow shake of the head and a "no kidding" from Matt. We are working in a special place, and anytime we forget, it seems the ship has a way of reminding us.

The last tour boat leaves, and we can start working more openly, even spreading instruments out to the Memorial proper. Until 4 P.M. we are conscious of not wanting to interfere with the visitor's experience. Now we can yell like banshees and no one will hear. For some reason we rarely raise our voices. Even a hard-bitten group like SCRU, masters of irreverence and acerbic humor in most places, often seem like choirboys on this site.

This will probably be my last visit to the *Arizona*. I can literally find my way around the ship with my eyes closed and I still carry on my private dialogues with her sailors. I will miss this place when I make my last dive.

But I feel I leave it in good hands. And I don't just mean Larry. The Matts, Bretts, and Daves who have come into their own in SCRU are exceptional young men, rising stars in their respective fields. They've paid their dues through years of apprenticeship and are quickly adding their own special styles to the mix. There's a representative from the Canadian Park Service working with us this trip—he's about the same age as our up-and-comers and he's of the same caliber. Marc-André Bernier will be making a name for himself in this business, and he's just the kind who should.

The young Canadians, Mexicans, Australians, and Brits coming up in this field are cause for real hope that there will be a submerged heritage for future generations to enjoy. Besides being principled, they're academically well-trained, damn good divers, and very much in tune with the modern computerized world. They see applications of emergent technologies with an ease and facility that is remarkable to someone like myself—who with astounding prescience, once predicted word processors would never make it in a world in which there were perfectly good electric typewriters. I find as I begin to psychologically separate from a quarter century in SCRU that I tend to regard these young men as heroes rather than the reverse. These fellows don't need any more wolf-pup talks. They're grabbing up the reins with confidence. As fearsome as the challenges are to maritime preservation in the coming decades, I feel they're up to it. They are also up to the adventures that accompany the challenges.

They'll become familiar with the emerald green haunts of lost steamers at Isle Royale, learn to enjoy swimming with the great whites as they search for Manila galleons at Point Reyes, dive to the flooded homes of the Anasazi in Glen Canyon, pause their research to engage in rescues and recoveries, spread preservation ideals to the far reaches of the Pacific, and undertake myriad adventures I can only dream of.

In their turn, they see the importance of the generation following them. It makes me smile to see how they've taken under wing Brendan, a newbie, "fresh meat." Brendan is a senior in high school just about to launch on his great college adventure. He's logged more than forty working dives on *Arizona* during the past three weeks, served as light-man for Brett, hauled ROV cables for Dave and Matt, and labeled artifacts on the deck with Jim Bradford. On one dive, he was assigned to help carry down an urn filled with the ashes of an *Arizona* survivor, a man who had lived through the sinking of the ship, and, after a full life, wanted to be interred with his shipmates.

Brendan admires the hard-chargers he's working with and even enjoys the constant hazing from the "older guys." He's stoked—he loves the work and just being with this crowd, doing what it does. He and his regular dive partner, Aaron, come from a long line of wild-eyed Irish-Polish immigrants, unpredictable by nature. No telling what they'll do after college. But then, I'll be tracking them pretty closely—after all, they're my sons.

INDEX

ACKNOWLEDGMENTS

Critical to making this book a reality were Noah Lukeman, "an agent for all seasons"; Esther Margolis, a grand lady of publishing; and Keith Hollaman, for his calm and sure editorial guidance. For early encouragement and for the title, I thank Ron Schultz. Also, for early encouragement and assistance in writing endeavors, Bob Utley, Melody Webb, and Vittorio Maestro and the editorial staff of my favorite magazine, *Natural History*. A special note of gratitude to my sister Patricia.

For unflagging support of the Submerged Cultural Resources Unit over the years: Doug Scovill, Jack Morehead, John Cook, Bob Kerr, Deny Galvin, Don Neubacher, Rob Arnberger, Mike Finley, Karen Wade, Rick Smith, Dick Sellars, and Ernest Ortega. Thanks to all the members of the SCRU team, present and past, particularly Larry Murphy.

To my wife Barbara for counsel, for keeping it all together, and in the sincere hope she will finally recommend something I have authored to the ladies of her reading group.

ABOUT THE AUTHOR

DANIEL LENIHAN is not just an explorer, but a preservationist; not just a risk-taker, but a nationally recognized scientist, respected in the ranks of park rangers. He has been at the center of many major underwater research projects in the U.S., from the USS *Arizona* in Pearl Harbor to the first expedition to resurvey the sunken ships of Bikini Atoll after they were declared radioactive from nuclear blasts.

Lenihan has been diving as a park ranger and archeologist for the National Park Service (NPS) since 1972. In 1976, he developed the only federal underwater archeological team in the U.S. and, in 1980, was appointed the first chief of the NPS Submerged Cultural Resources Unit (SCRU).

Over the last 25 years, Lenihan and the SCRU team have been the subject of national media stories and many TV documentaries on CBS, ABC, BBC, CNN, PBS, The Discovery Channel, and National Geographic. He has written frequently for *Natural History* and *American History*, and coauthored with Gene Hackman the well-received sea novel *Wake of the Perdido Star*. A native New Yorker and former schoolteacher, he lives with his family in Santa Fe, New Mexico.